Mothers of Misery

Mothers of Misery

CHILD ABANDONMENT
IN RUSSIA

by

David L. Ransel

PRINCETON UNIVERSITY PRESS
PRINCETON, NEW JERSEY

Published by Princeton University Press, 41 William Street,
Princeton, New Jersey 08540
In the United Kingdom: Princeton University Press, Guildford, Surrey

This book has been composed in Linotron Galliard

Clothbound editions of Princeton University Press books
are printed on acid-free paper, and binding materials are
chosen for strength and durability. Paperbacks, although satisfactory
for personal collections, are not usually suitable for library rebinding

Printed in the United States of America by Princeton University Press,
Princeton, New Jersey

Library of Congress Cataloging-in-Publication Data

Ransel, David L.
Mothers of misery: child abandonment in Russia / by David L. Ransel.
p. cm. Bibliography: p. Includes index.
ISBN 0–691–05522–X
1. Abandoned children—Soviet Union—History. 2. Foundlings—
Soviet Union—History. 3. Foster home care—Soviet Union—History.
I. Title.
HV887.S58R36 1988 362.7′044—dc19
88–9726 CIP

CONTENTS

LIST OF ILLUSTRATIONS AND FIGURES

ILLUSTRATIONS

FIGURES

LIST OF TABLES

TABLES

ACKNOWLEDGMENTS

SEVERAL FUNDING AGENCIES and institutions have generously supported the research and preparation of this book. A short-term grant from the Kennan Institute for Advanced Russian Studies allowed me to visit Washington, D. C., for research at the Library of Congress and the National Library of Medicine. The American Council of Learned Societies made it possible for me to work in Finland. A combination of grants from the Fulbright-Hays scholarship fund and the International Research and Exchanges Board subsidized research in the archives of Moscow and Leningrad. Grants-in-aid from the University of Illinois at Urbana-Champaign and from Indiana University contributed support for research assistance and preparation of graphs and maps. I am grateful to these institutions and their officers.

Many individuals made important contributions. I am especially indebted to Rodney Bohac and Margarite Radler, research assistants at the University of Illinois, who organized many of the data sets and helped prepare the maps. Barbara Engel and Brenda Meehan-Waters read the entire manuscript and offered many helpful suggestions. George Alter, Elyse Rotella, Diane Koenker, Richard Hellie, and Frederic Jaher commented on individual chapters. I appreciated their good advice and took most of it, but I would not want them to have to bear responsibility for any of the calculations or conclusions in the study.

I owe a great debt to the staff of the Slavic Library at the University of Illinois at Urbana-Champaign and to its directors during the time I was there, Lawrence Miller and Marianna Tax Choldin. The Illinois collection and staff are national treasures. Murlin Croucher of the Indiana University Library also provided assistance. I am deeply appreciative, too, of the help of the people who worked with me at the National Library of Medicine, the Helsinki University Library, and the Soviet archives listed in the bibliography.

Finally, Gail Ullman and Gretchen Oberfranc of Princeton University Press were helpful at every stage of evaluating and producing the book, and Robert A. Feldmesser did an excellent job of editing the final manuscript.

ABBREVIATIONS

In CITING SOURCES from Soviet archives, I have with one exception used the standard Russian abbreviations: f. for *fond* (collection), op. for *opis'* (inventory), d. for *delo* (file), ed. khr. for *edinitsa khraneniia* (storage unit), ch. for *chast'* (part), and ob. for *oborot* (verso). I have departed from the Russian convention in using p. and pp. (page, pages) instead of l. and ll. for the Russian *list* and *listy* because of their possible confusion with numbers containing the integer 1.

Russian dates are given according to the Julian calendar, which was in force in Russia before the Revolution and which ran behind the Gregorian by eleven days in the eighteenth century, twelve in the nineteenth century, and thirteen in the twentieth century.

GME	Gosudarstvennyi Muzei Etnografii Narodov SSSR, Otdel pis'mennykh istochnikov
LGIA	Leningradskii Gosudarstvennyi Istoricheskii Arkhiv SSSR
MIMVD	Materialy dlia istorii Moskovskogo Vospitatel'nogo Doma
Otchet M. Vos. Doma	*Otchet Moskovskogo Vospitatel'nogo Doma*
Otchet S.P. Vos. Doma	*Otchet S.-Peterburgskogo Vospitatel'nogo Doma*
PSZ	*Polnoe sobranie zakonov rossiiskoi imperii*
TsGADA	Tsentral'nyi gosudarstvennyi arkhiv drevnikh aktov
TsGIA	Tsentral'nyi gosudarstvennyi istoricheskii arkhiv SSSR
TsGIAgM	Tsentral'nyi gosudarstvennyi istoricheskii arkhiv goroda Moskvy

Mothers of Misery

ONE

Introduction

THIS STUDY began when I was casting about for a way to learn more about peasant life than could be found in standard ethnographic accounts. Russian ethnographic studies, though excellent for their genre, are static, even formulaic. They do not help historians of the peasantry solve their most difficult problem, which is to penetrate the apparent stasis of village life and map the processes of change. An inventive historian like George Yaney has tried to overcome this difficulty by composing parables that describe transformations of village life.[1] To move beyond parables and ethnographic accounts, it was necessary to find an unexplored point of contact between educated society and the village. The foundling homes suggested themselves because these urban institutions had maintained regular and documented links with the countryside since the early 1760s. The records kept by the homes could shed light on at least some aspects of peasant life over the period of about 150 years during which they operated.

Before choosing the subject, I had not been aware of the magnitude of the Russian enterprise in this area or of the many possible ramifications of the data the foundling homes generated. The size of the operation was astounding. No other country's metropolitan social services handled the volume of abandoned children that Russia's did. At the height of its operations in the second half of the nineteenth century, the central home in Moscow was receiving 17,000 children a year. It dispatched the majority of these infants to wet nurses and foster families in the countryside, where at any one time the home was supervising more than 40,000 children who were spread over some thirty districts of Moscow province and six adjoining provinces, covering an area larger than 50,000 square kilometers. The central foundling home in St. Petersburg ran a similar program, taking in about 9,000 infants each year and supervising in its fosterage program over 30,000 children. It was clear that if I wanted to exploit the materials of the foundling homes for information about the behavior of peasants, I would also have to explain the appearance of these institutions in Russia and, in particular, the unusual

[1] See, in particular, Yaney, "The Village."

3

size and scope of their operations. My attempt to find an entry point into peasant life thus became a study of child abandonment in Russia.

The investment by Russians in this large institutional structure for the care of unwanted children cannot be understood apart from the development of similar institutions, albeit on a smaller scale, in western and central Europe. Russia was not like India or China, where western missionaries imported child-care facilities in order to combat established family regimes that permitted the exposure and killing of unwanted infants. Russians adopted these care facilities for their own reasons and in their own good time. But they did so very much under the influence of developments in the west that occurred as the result of new ideas about the value of human life and the need for the community or state to assist in preserving young lives.

In the ancient West, the decision about whether to spare the lives of newborns was left to the family or, more accurately, to the father. This circumstance changed little during many centuries of the Christian era. The rural people of ninth-century Europe evidently practiced infanticide on a large scale for the purpose of maintaining a balance of population and resources.[2] The church in those early Christian centuries even showed some tolerance for this practice, so long as it was not an excuse for unlicensed sexual pleasure. The early church fathers drew a distinction between infanticide to avoid the consequences of satisfying one's lust, on the one hand, and infanticide for economic reasons, on the other. Penetentials accordingly proposed much lighter penalties for infanticide arising from the poverty of the mother than for the same act on the part of a wealthy woman, a stance that was common in the West until at least the eleventh century.[3]

If the church protected poor women by conceding something to the prevailing family strategies, it was also the first institution to come to the aid of the innocents by establishing foundling homes. The religious orders of the Italian cities led the way in the thirteenth century with the establishment in Rome of the San Spirito hospital (1212), to end the scandal of women throwing babies into the Tiber River.[4] Similar hospitals soon appeared in other Italian cities. The best-documented case is the city of Florence, where in the late thirteenth and early fourteenth centuries two hospitals, the Santa Maria da San Gallo and the Santa Maria della Scala, made room for unwanted children. Like most early care facilities, these were multipurpose institutions that accepted, in ad-

[2] Coleman, "L'infanticide."

[3] Noonan, *Contraception*, 159–60.

[4] Some evidence indicates that such a hospital was opened in Milan as early as the eighth century. Buffini, *Ragionamenti storici economico-statistici*, 17–18.

dition to abandoned infants, poor people needing medical assistance. Growing pressure on the limited resources of the hospitals led in time to differentiation and specialization. In 1445, the city fathers in cooperation with the silk guild established an institution solely for the care of foundlings, the great hospital of Santa Maria degl'Innocenti. The Florentines understood the work of these hospitals to be essential to the worth and the stability of their community. The failure of a Christian community to aid exposed and abandoned children not only undermined society by reducing population and menacing family stability. It also eroded the myths of solidarity that both bound the community together in its earthly life and linked it to the heavenly city. Children left to die were not just a sanitation problem but lopped off limbs of the communal body and unbaptized souls lost to God. Efforts to save the children drew the community together, and the rescued children played an important role in the salvation of the community because of the blessings that the prayers of these innocents brought to the city.[5]

The approach to foundling care that the Italians worked out during the late Middle Ages and the Renaissance relied on large institutions supported by a combination of religious, corporate, and municipal resources. The procedure usually involved an initial screening of the infants brought to the institution, their early removal to wet nurses in the town or more often the surrounding countryside, eventual return of the survivors for education at the institution, and finally assignment to apprenticeship, military service, menial labor, or marriage. This approach became known as the Latin or Catholic system. It moved across the Alps and became rooted in France and Austria, where in the sixteenth century humanist writers began stressing the need for organized relief and other measures of public welfare to curb increasing problems of urban disorder.[6] Begging and vagrancy were chief concerns, but humanist values also promoted a new solicitude for poor children. The belief in education as an instrument for making good citizens of the poor and unsupervised children of the towns led to the establishment of institutions designed for the care and training of children. For the smallest and most helpless children, the abandoned and exposed, many towns provided foundling homes on the Italian model.

Although this model at first reached as far north as many of the German cities, it did not endure there.[7] The influence of the Reformation may have been important, because of its emphasis on personal respon-

[5] Trexler, "Foundlings of Florence," 259.
[6] For the background, see Davis, *Early Modern France*, esp. 51–59.
[7] Hügel, *Findelhäuser*, 337.

sibility and the centrality of the family as the instrument of moral guidance. But these ideas may only have reinforced a preexisting family system and moral climate, for, even in the Catholic principalities of Germany, cities soon turned away from large central foundling hospitals and sought to lay the cost of support for illegitimate children on the parents. In contrast with Latin Europe, paternity searches were legal in the north, and families were expected to maintain control over their members without the assistance of the community to dispose of the products of misbehavior.

France probably offers the best example of the development of the Latin system north of the Alps. The Grand Hôtel-Dieu de Notre-Dame-de-Pitié in Lyons was taking in children as early as the beginning of the sixteenth century, and perhaps earlier. Marseilles and Paris may have provided such assistance earlier still. By 1536, the state began to play a role. Francis I, following the example of the Florentines, opened a hospital designed exclusively for the care of foundlings and called the "Hospice des Enfants-Dieu." Better known in this field was, however, the clergyman Vincent, later St. Vincent de Paul, who devoted much of his life to caring for abandoned children. With the help of the Dames de la Charité, he opened the Hôpital des Enfants Trouvés in Paris in the 1630s, which within a few decades had difficulty managing its increasing population of foundlings.[8] These difficulties arose even before the great explosion of illegitimacy and child abandonment in Europe. By the early eighteenth century, the sight of infant corpses lying in ditches, on garbage heaps, and in sewer drains was familiar throughout Europe. Sewers, being less visible, were the most popular points of deposit. After a fire that devasted Rennes, France, in 1721, workers rebuilding the city opened the sewers and found the skeletons of over 80 babies.[9] The slaughter had been disturbing enough even earlier that the crown ordered every municipality to use its local Hôtel-Dieu as a receiving point for abandoned children. But upon seeing the cost of this burden, many local institutions discouraged admissions, and people began to bring their unwanted children to the Paris hospital, often over long distances, because the Paris home had support from the crown and accepted nearly everyone. By the second half of the eighteenth century, a brisk trade had sprung up between the provinces and the capital, as carters earned a fee conveying babies to the Paris foundling home. Some local facilities, overwhelmed by the number of abandoned infants, even organized their own expeditions to take children to the Paris institu-

[8] *La Grande Encyclopédie* 10:1040 and 31:1027.
[9] Hufton, *Poor in Eighteenth-Century France*, 349.

tion.[10] In this same period, England and Denmark briefly instituted large central foundling homes on the lines of the Paris home. It was during this time, when large centralized institutions heavily supported by the crown were in fashion, that Russians made the decision to provide public care for abandoned and unwanted children.

WHEN THE RUSSIANS started their foundling homes, the French system served not merely as an encouragement and instance of one type of institution. The Russians adopted the French system as a model; that is, they introduced it in Russia without reference to any needs or traditions peculiar to Russia and without any of the practical compromises and modifications that had been worked out in France. The Russians adopted the system as a pure form. Because the social matrix and the evolution of directing institutions were much different in Russia from what they were in France, the impact of these welfare institutions on society and the social outcomes they generated were also bound to be different. Despite these differences, the history of foundling care in Russia and the West converged at many points, if only because the Russians were keenly observant of trends and problems in the West. The daring, even utopian, approach of the Russians to foundling care and the high visibility they gave to their large welfare operations may also have had some influence on Western practices.

More important, however much the practices and policies of foundling homes may have diverged between Russia and the West, the institutions in both regions functioned as a means of easing their societies through a period of rapid change in the pattern of relations between town and country. It was a period in which the older family regime was weakening and public authorities sought institutional solutions to the resultant disorder. In the case of the Russian foundling homes, the institutions soon became hostages to their desperate clientele and to the rhetoric of tsarist care for the unfortunate. The fosterage programs of the homes evolved quickly from a temporary solution to overcrowding in the central institutions to a far-flung commercial system that came to be an important source of nonfarm income to peasant villages over a large area of central and northern Russia.

[10] Hufton, *Poor in Eighteenth-Century France*, 344–47.

TWO

Illegitimacy and Infanticide
in Early Modern Russia

THE EXPOSURE AND KILLING of infants first became a matter of government concern in Russia at the beginning of the eighteenth century. Peter I issued a decree in 1712 deploring this needless waste of human life. "Children of shame," as he called them, were being left in various places to die or were being killed outright soon after their birth. He ordered the establishment of hospitals (*shpitalety*) in every province, places where mothers of illegitimate children could deposit them in secret and thus avoid "committing the still greater sin of murder."[1]

A half-century later, Ivan Betskoi (of whom much more will be said later), with Empress Catherine II's encouragement, spoke eloquently about the fate of unwanted children. In a decree of 1763 that he composed for the empress, Betskoi told of many children abandoned in the streets of Moscow, left by their mothers to cruel fortune, and the majority of these children died. An even bigger problem, in Betskoi's view, was outright child murder. However great might be the number of children exposed in the city, he wrote, "it is indisputable that an incomparably greater number, barely having managed to draw their first breath, are deprived of it secretly by merciless mothers and their inhuman accomplices."[2] The solution undertaken by Catherine's government was to build two large foundling homes, one in Moscow and another in St. Petersburg, which would collect and care for unwanted children of those cities and the surrounding countryside.

This decision to allocate substantial resources to deal with child abandonment and infanticide is somewhat puzzling. It was not a response to a public outcry. Apart from the isolated work of a few clergymen, the initiative belonged exclusively to the central government. An explanation of this concern has to rest on three alternative premises. It is possible that before the eighteenth century, infanticide and child abandonment were so rare and aberrant in Russia as not to constitute a serious problem. If this was so, circumstances must have changed in the late

[1] *PSZ* 4, no. 2467 (January 16, 1712).
[2] *PSZ* 16, no. 11908 (September 1, 1763).

seventeenth and early eighteenth centuries so as to produce a large number of cases in a short time, and these new conditions alerted the government to the need for action. It is also possible that in early times, exposure or direct killing of infants was common but took place in the woods and marshes of rural Russia and did not come to general notice. In this case, conditions would have had to change in a way that concentrated the practice in a public sphere and made it visible to the authorities. Finally, the disposal of unwanted infants may have been customary and accepted in early Russia and therefore evoked no particular concern on the part of either the government or the people. If this was the case, the initiation of actions to combat this loss of life should be attributed to a shift in values, a new appreciation of infant life.

Validation of one or another of these explanations is difficult, owing to the thinness of the documentary record of social behavior in early Russia. To the extent that scholars have commented on infanticide, they have offered opinions rather than evidence. The prolific nineteenth-century historian S. M. Solov'ev was one of the few to take up the issue, and he firmly rejected the notion that early Russians exposed or killed their children. This custom, he wrote, belonged chiefly to warlike peoples, who did not wish to burden themselves with the weak and crippled; according to Solov'ev, it was not practiced by the Slavic tribes.[3] He failed, however, to explain why Slavic people would be more inclined to maintain weak, crippled, or simply "surplus" children. More recently, Soviet scholars seem to have adopted Solov'ev's view, implying that even during natural calamities and famines, Russians did not kill their children, because the law permitted them to sell or give the children away.[4]

THE LEGAL EVIDENCE

The lack of social data with which to test these hypotheses leaves scholarship at present with little more to go on than the surviving legal record. Though normative rather than descriptive, laws are still worth investigating for the clues they may contain about official attitudes and general constraints.

The legal record makes the nature of the old family regime clear. In pre-Petrine Russia, parental and, in particular, paternal authority was all but absolute. Characteristically, the law even allowed parents to sell their children into slavery. This provision, common in Asia and the

[3] Solov'ev, *Istoriia Rossii*, 1:97.
[4] Romanov, *Liudi i nravy*, 155; Martynova, "Otrazhenie deistvitel'nosti," 152.

Middle East as well, could be seen as evidence that children had value at least as commodities, but it did not suggest an especially high level of parental attachment to children. It is probably also significant that secular law in medieval Russia dealt with murder in a way that excluded consideration of the killing of one's own child. Murder subjected the killer to vengeance from the relatives of the deceased or to a payment (and, according to later texts of Kievan codes, to a monetary payment alone), the amount of which was linked to the social position of the deceased. Infants had no social position and therefore little or no value in the eyes of the law, whoever killed them. If a child was killed by an outsider, relatives might want to exact vengeance or monetary recompense as in an ordinary murder, but in the case of a child murdered by its own parents, no legal issue arose, since no one could claim the right to avenge the act or to demand monetary compensation for the loss. In short, the ordinary system of justice placed virtually no restraint on the disposal of one's own child.

Children were not entirely defenseless, however. Just as in the West, until the sixteenth century the protection of children and of others not provided for in secular law was left to the church. The first references to infanticide in early Russia therefore appeared in canon law, specifically in the ecclesiastical statutes associated with the names of the Kievan grand princes Vladimir and Iaroslav. Unfortunately, these largely procedural codes yield little social information.

The Vladimir statute merely mentions child murder as one of several crimes within the jurisdiction of the church.[5] The Iaroslav statute is somewhat more revealing: it commands, in article 6, that "if a woman conceives a child without a husband or with a husband and later kills it or throws it to the swine or drowns it, take [her, after she] has been convicted, into a convent: and her clan must redeem her."[6] At first glance, this seems to be a straightforward condemnation of infanticide, with the church acting as protector of unwanted children. The Soviet specialist B. A. Romanov has placed precisely this construction on it.[7] But this interpretation is surely wrong. A closer look indicates that the article was aimed not at infanticide but at fornication, for the immediately preceding and explicitly linked article prescribed the very same punishment for unmarried women who fornicated, even if these women

[5] Shchapov, ed., *Drevnerusskie kniazheskie ustavy*, 17–19. Other references to infanticide may be found in the "commandments" of Metropolitan Georgii, quoted in Romanov, *Liudi i nravy*, 185–86.

[6] Translated from the "Arkheograficheskii izvod," in Shchapov, ed., *Drevnerusskie kniazheskie ustavy*, 94.

[7] Romanov, *Liudi i nravy*, 186.

did not harm any children that might result. Article 5 said: "If an unmarried woman fornicates or conceives a child when living with her father or her mother or as a widow, take [her, after she] has been convicted, into a convent."[8] The inclusion of a legally married woman in article 6 ("or with a husband") does not contradict this interpretation but rather indicates a sanction against gratuitous indulgence in intercourse, just as Western canon law condemned any form of sexual gratification without the intention of conception.[9] In other words, the law viewed infanticide not as child murder but as a belated form of birth control. The common basis of all these crimes was unsanctioned sexual activity.

Given the church's attitude toward sexual indulgence, the emphasis was well placed. Infanticide is clearly first and foremost a population-control measure, indeed the most efficient such measure. If modern societies with low levels of infant mortality and high expectations of survival and longevity can afford the luxury of control early in the reproductive process, especially contraceptive control, people living in subsistence economies with high mortality benefit from the fine tuning that infanticide allows. By exercising control at the end point of the reproductive process, they maintain sufficient fertility to assure population replacement and yet are able to trim the number of infants in response to periodic subsistence crises. As contrasted with abortion, infanticide has the additional advantage of providing greater protection for the mother's life. It also allows families to select the sex of offspring and to remove weak, crippled, or deformed products.[10]

The first evidence that infanticide was considered something other than population control appeared in an addendum to a sixteenth-century Muscovite law code, the *Sudebnik* of Ivan IV. The issue of a child murder was not mentioned in the code itself, but the addendum, which was a borrowing from Byzantine law that apparently had practical application in Russia, drew a clear distinction between abortion and infanticide. It treated abortion more harshly than earlier statutes had treated infanticide but as something less than a capital crime: "If a woman is pregnant and lays hands on her womb so as to lose the product of conception, she is to be beaten and confined."[11] At the same time, the ad-

[8] Shchapov, ed., *Drevnerusskie kniazheskie ustavy*, 94.

[9] Noonan, *Contraception*, 143–300.

[10] The killing of deformed infants was not treated as severely as ordinary homicides in nineteenth-century Russian law. It was bracketed in the penal code with death by negligence and justifiable homicides. See *Ulozhenie o nakazaniiakh*, 497, article 1940. I have not discovered if this provision carried over an early Russian value.

[11] Liubavskii, *Iuridicheskie monografii*, 4:65.

dendum instructed that "the killer of a child shall be tried as a murderer."[12]

It is difficult to know if this was a general prescription, since it neglected the striking distinction between legitimate and illegitimate children that was made in the comprehensive seventeenth-century code, the *Ulozhenie* (1649) of Tsar Aleksei Mikhailovich. Although the Ulozhenie carried forward the distinction between abortion and infanticide, its differential treatment of legitimate and illegitimate children made explicit the concern with sexual license rather than with the life of the child. According to the Ulozhenie, if a woman gave birth to an illegitimate child and either killed it or conspired with another to have it killed, she was to be sentenced to death without mercy. The article even included the didactic note that "seeing this, others would not take part in this foul and illegal act and would cease fornicating."[13] On the other hand, if the victim was a legitimate child killed by its father or mother, the law prescribed merely a one-year prison sentence followed by a public confession in church, and it even explicitly forbade the application of the death penalty to parents convicted of killing their own child.[14] It is also significant that the article about killing an illegitimate child appeared in the code in connection with an article on pandering and not together with other homicides. This bracketing is further evidence of the lawmaker's concern with sexual matters rather than with the life of the child.

EUROPEAN INFLUENCES AND RUSSIAN EVOLUTION

The harsh condemnation in the Ulozhenie of infanticide by an unwed mother may have been an echo of the treatment of the "fallen woman" in western and central Europe, where, from the late Middle Ages to the Enlightenment, efforts to confine sexual activity to marriage brought increasingly ferocious sanctions against the unwed mother who exposed or killed her child. The Ulozhenie article in question was a direct borrowing from the Lithuanian Statute of 1588, which in turn seems to have drawn on practices then current in Germanic law.[15] In view both of this derivation and of some instructive parallels in the development of Western and Russian societies in the early modern age, it would be helpful to consider the European situation.

[12] Ibid.

[13] Tikhomirov and Epifanov, eds., *Sobornoe ulozhenie*, chapter 22, article 3.

[14] Ibid., article 26.

[15] See article 2, chapter 57, in Lappo, *Litovskii statut*, 341. See also the comments by N. Tagantsev, "O detoubiistve," 219–20, and by Liubavskii, *Iuridicheskie Monografii* 4:58.

The severity of Western justice developed from problems of enforcement and the need to maintain a satisfactory scale of retribution. Medieval princes in the West were ahead of their Russian counterparts in developing public law, but they had difficulty enforcing it. The lack of police administration made the apprehension of criminals uncertain at best, and so Western princes tried to compensate for the small number of convictions by giving a fiercely retributive character to punishments. Quality rather than quantity was to make the deterrent effective. But deterrence was not the only consideration. The community thirsted for vengeance, and this thirst too had to be satisfied. Authorities sought these objectives through public display of punishment and efforts to draw out the victim's suffering as long as possible. For further didactic and dramatic effect, punishments frequently mirrored the crime. For example, counterfeiting was punished by boiling in oil; the executioner melted down the criminal just as the counterfeiter had melted the metal used in the crime.[16]

The principles of retribution and deterrence combined to drive up penalties to ever more gruesome heights. The ordinary death penalty, usually hanging, was the lot of a common thief and provided little deterrence at a time of high fertility and high mortality, teeming life and ever-present, often agonizing death. It could even be viewed as a form of atonement and of deliverance to a life that was not only better but far more real to many people than their brief earthly visit. The more serious crimes like treason, murder, and counterfeiting demanded imposition of greater suffering. Moreover, in order to retain sufficient impact in the face of the natural tendency of people to become inured to the current punishment, penalties had to be increased with time, and, in order to satisfy the sense of fairness, they had to increase together.[17] Thus, deterrence required that penalties be periodically made more severe, and each time they went up for a particular crime, the principle of retribution demanded that they go up for all other crimes as well.

The punishment for infanticide became caught up in this rising spiral. Until the high Middle Ages in the West, there seemed to be some tolerance of nonmarital sexual activity, and perhaps fairly high levels of infanticide were also tolerated, in the interests of keeping population in line with economic resources.[18] But after the Council of Rome in the eleventh century, the church began stressing the importance of confin-

[16] Eberhard Schmidt, *Einführung in die Geschichte der deutschen Strafrechtspflege* (Göttingen, 1951), 57–93, and Rudolf His, *Das Strafecht des deutschen Mittelalters* (2 vols.; Leipzig, 1920–1935), 2:274–76, both cited in Anners, *Humanitet och rationalism*, 17–19.

[17] Anners, *Humanitet och rationalism*, 17–19.

[18] Coleman, "L'infanticide," 326–28.

ing sexual indulgence to marriage, an emphasis that was strengthened toward the end of the Middle Ages and carried forward even more vigorously by the Reformation. As a result, the position of the unwed mother became increasingly isolated and precarious. She faced social ostracism and hence the prospect of having to turn to prostitution or other unsavory means of staying alive.[19] This is not to suggest that greater pressure on unwed motherhood necessarily led to a greater number of infanticides. As Emily Coleman has suggested, infanticide may have been practiced more widely in the ninth century as an economic measure and, in this sense, with the complicity of the community.[20] The infanticide of the late Middle Ages and early modern times was of a different nature. It occurred not with the endorsement of the community but as a desperate means of escaping the censure of the community. It was a personal, not a social, act, and it both arose from and contributed to the mounting misogyny of Christian Europe, as the Roman and Protestant churches launched campaigns against social deviance, especially as personified in the most exposed and vulnerable women in the community.

The crusade against extramarital intercourse and its products, the illegitimate child and infanticide, gained particular momentum in the sixteenth century. In several European countries, unmarried servant women were regularly inspected to see if they had breast milk. The presence of milk in the breasts justified, according to article 36 of the *Constitutio Criminalis Carolina*, introduced in the Holy Roman Empire under Charles V in 1532, the application of torture to discover the cause.[21] A still more draconian provision appeared in article 131 of the code. It was evidently too easy for a woman found to have borne an illegitimate child that later turned up dead to declare that it had been stillborn or had died of natural causes. Accordingly, article 131 introduced a presumption of guilt for murder in cases in which an unmarried woman was alone at the time of birth and hid the newborn child, and the baby was later found dead. Unless the woman could prove that the child was stillborn or died naturally, she was to be convicted of infanticide.[22] Effective prosecution demanded this unusual presumption in an age when medical practitioners had no convincing method for demonstrating the cause of infant death.[23] After its appearance in the *Carolina*, the rule was

[19] Anners, *Humanitet och rationalism*, 27–30.

[20] Coleman, "L'infanticide," 328–35.

[21] Werner, *Unmarried Mother*, 29–30.

[22] The German text of these articles is in Werner, *Unmarried Mother*, 29–30. For comment, see Anners, *Humanitet och rationalism*, 30–31, 111–12.

[23] Malcolmson, "Infanticide."

written into French law in 1556 and confirmed in 1586 and again in 1708. Presumption of guilt based on similar or slightly modified conditions, usually involving the failure to register an extramarital pregnancy, subsequently found its way into the codes and practices of many other European countries, including England in 1624, Sweden in 1627, Württemberg in 1658, Denmark in 1683, Scotland in 1690, and Bavaria as late as 1751.[24] The punishment for infanticide varied from place to place. Denmark even then was relatively more humane in requiring only a simple beheading. In Sweden, women were cast into a fire. The *Carolina* more typically called for burial alive and a stake to be driven through the woman's chest, a punishment applied in Prussia as recently as the early eighteenth century.[25]

After the witchcraft hysteria of the seventeenth century, the harsh persecution of deviant women spent its force, and the next century saw a sharp downturn in indictments and convictions for infanticide. In England, a rapid decline set in during the first decades of the eighteenth century.[26] The change came somewhat later to central Europe. In a letter of 1777 to Voltaire, Frederick II of Prussia could still declare that in Germany infanticide accounted for more executions than did any other crime.[27] But, as Frederick's concern itself testified, the "humanitarian revolt" was on its way to shaping a new, more tolerant attitude toward the unwed mother, and legislators soon modified the cruel treatment of these women, eventually abolishing the death penalty for infanticide.[28]

In Russia, matters never went so far as to fix in law a presumption of guilt for an unwed mother whose child had died. Perhaps the massive slaughters during Ivan IV's reign, the Time of Troubles, and the church schism exhausted the urge for bloody sacrifices in that age and spared Russia the witch hunts and other misogynous assaults that punctuated west European history in the sixteenth and seventeenth centuries. A misogynous impulse was nonetheless at work in Russia during this period, and for a time the monastic clergy succeeded in promoting a social regime based on a combined fear and loathing of women.

[24] Malcolmson, "Infanticide," 196–200, cites the English law of 1624, which was not repealed until 1803. Others are listed in Anners, *Humanitet och rationalism*, 111–12.

[25] Anners, *Humanitet och rationalism*, 30. Frederick William I of Prussia took an especially severe view of the crime and in the 1720s restored the harsh punishments that had begun to be abolished: Werner, *Unmarried Mother*, 33.

[26] Hoffer and Hull, *Murdering Mothers*, 65–74. The shift away from the presumption of guilt was noted in England by William Blackstone, who wrote in about 1765 that "it has of late years been usual . . . to require some sort of presumptive evidence that the child was born alive": *Commentaries*, 198.

[27] Cited in Malcolmson, "Infanticide," 189.

[28] Werner, *Unmarried Mother*, 36–37, 106–7.

Before the sixteenth century, Russian women in their role as representatives of powerful families had on occasion figured prominently in political and economic life. But with the retreat of the great families before the centralizing autocracy, the public sphere became confined to state service, in which women took no part. The autocracy drew strength from its alliance with the monastic brotherhood, and the monks in turn used state authority to spread their views on the wickedness and incompetence of women. As a result, leading families learned to cloister their women, subject them to a life of celibacy, and shut them off from a public role. For families lower on the social scale, cloistering was impractical. The rules for these people were expounded in the *Domostroi*, a document associated with the monk Silvester which exuded contempt for women and advised confining them to the household (but had to recognize their important role in the household economy).[29] It was during this time of monkish rule, when official values most nearly mirrored the misogyny of the West, that Russia also came closest to the harsh Western treatment of unwed mothers by adopting in the Ulozhenie of 1649 the differentiation between the killing of a legitimate and an illegitimate child.

Although Western women endured more suspicion and persecution in this era than did Russian women, the Western attitude toward infant life may have been more solicitous than the Russian. In the West, the laws on registration of pregnancies and the presumption of guilt in cases of death after concealment of the pregnancy and birth reflected concern for the life of the child. Russian law before the eighteenth century did not express the same degree of interest in the life of the child, be it legitimate or illegitimate. (The distinction may have been more formal than practical, but it is worth noting nonetheless, because the practical similarities did not favor protection for the child.) In Russia, the differential value attached to the lives of various family members in medieval times persisted right into the late seventeenth century, and the sharpest difference was in the meager protection afforded a child. The Ulozhenie prescribed various punishments for the killing of relatives, but in every case the crime called for substantial penalties—except when the victim was a child. A wife who killed her husband received the grim fate of burial alive, in some cases after being tortured with fire.[30] Killing of parents also brought death. Even a husband had to pay for murdering his wife; although the code remained curiously silent about wife murder, the courts apparently treated this crime seriously, varying the pen-

[29] McNally, "From Public Person to Private Prisoner."
[30] Cherepnin, ed., *Pamiatniki russkogo prava*, 492.

alty with circumstances. Only the killing of children was regarded as something of a misdemeanor. The more severe penalty for killing an illegitimate child cannot be taken as evidence to the contrary; it revealed a shift since Kievan times not in attitudes toward infanticide but in the penalties for nonmarital sexual indulgence. The object of the law was not to save the life of the child but, as it said explicitly, to persuade others to "cease fornicating."[31]

The influence of the monks in Russia was brief, and the Ulozhenie's article on infanticide survived for only a half-century. A different set of values emerged under the rule of the "tsar reformer," Peter the Great (1689–1725). Historians credit Peter with introducing a major change in official attitudes toward women. Peter certainly opposed the previous cloistering of women, and he quickly set about dismantling the barriers to female participation in society. He also showed little respect for moral and religious strictures on illegitimacy. Yet in ending the distinction between the killing of a legitimate and an illegitimate child, Peter displayed no charity toward the unwed mother who murdered her child. His military articles of 1716 simply rendered the legal status of the child moot by imposing an equally severe penalty for killing any infant, legitimate or illegitimate. The punishment for child murder became equivalent to that for the premeditated murder of a father, mother, or military officer—namely, to be broken on the wheel and left to die.[32] Peter's main interest lay in preserving and expanding the nation's population. He was conversant with Western ideas about the importance of "human capital." No doubt the continual manpower shortages suffered in his armed forces and building projects did even more to convince him of the need for practical measures to increase population size.

Interestingly enough, although he set aside the Ulozhenie's distinction between legitimate and illegitimate children, Peter replaced it with a distinction between infants and older children. In editing the draft of the article in the military code that called for death on the wheel for child murder, the tsar inserted in his own hand after the word "child" the qualifier "in infancy."[33] Although Peter wanted to break down the old Russian family regime—in a sense, to pry it open and make it a public asset rather than a private haven—he was not ready to undermine paternal authority. A tension remained in Russian law between the goal of preserving life and the right of a father to maintain control. A court

[31] Tikhomirov and Epifanov, eds., *Sobornoe ulozhenie*, chapter 22, article 26. See also the comments on this article in Man'kov, *Ulozhenie 1649 goda*, 222.

[32] *PSZ* 5, no. 3003 (March 22, 1716), 369–70.

[33] Gosudarstvennaia Publichnaia Biblioteka, Otdel rukopisi, f. 1003, d. 14, p. 215, cited in Semenova, *Ocherki istorii byta*, 119.

later interpreted the article to mean that if a man accidentally killed his child (or wife) in the course of disciplining him or her, the homicide was not a capital offense. Even if he killed his child intentionally for misbehavior, the penalty should be no more than simple execution by beheading.[34] In this regard, Westerners have no reason to feel superior, since in most other European countries, including England and the American colonies, courts afforded similar protection to murderously abusive parents; as noted earlier, the distinction between Russia and the West in this area may have been more formal than real.[35] This interpretation indicates, nevertheless, that so far as child murder was concerned, the military articles of Peter I treated only the killing of an infant as a special case deserving of a sterner penalty than was imposed for ordinary homicide. In one sense, then, Peter restored the pre-Muscovite prescriptions of the Iaroslav statute, since his law also ignored the legitimacy of the victim and viewed infanticide primarily as a population-control measure. However, in Peter's code the emphasis was different. The Iaroslav statute sought to restrict gratuitous sexual indulgence, whereas Peter wanted to increase the number of his subjects. His action was both a sign and a consequence of a new appreciation of infant life.

An instance of infanticide at the Russian court made clear that Tsar Peter meant what he said about punishing this crime. In 1719, three years after enactment of the code, Mariia Gamil'ton (Mary Hamilton), a lady-in-waiting of Peter's paramour Catherine, was convicted of killing an infant she had conceived illegitimately with an officer of the guard. Catherine and others pleaded with Peter to commute the death sentence; but he not only refused, he even attended the execution. The best Gamil'ton's friends seemed to be able to secure was a reduction of her torment, for in this case the execution was by beheading instead of the prescribed breaking on the wheel.[36]

After Peter I's reign, Russian law on infanticide evolved rapidly under the influence of Enlightenment ideas. Empress Elizabeth (1741–1762) abolished capital punishment for many crimes, and the little information available on convictions for infanticide in the eighteenth century reveals that women who killed their infants did not receive the death sentence and may have escaped with as mild a punishment as exile to Siberia.[37] It was not until the penal code of 1845, however, that the Russian government introduced an explicit reversal of previous laws

[34] Liubavskii, *Iuridicheskie monografii* 4:67.

[35] Hoffer and Hull, *Murdering Mothers*, 46.

[36] Semenova, *Ocherki istorii byta*, 119.

[37] *PSZ*, no. 11222 (October 1760), as discussed in Liubavskii, *Iuridicheskie monografii* 4:67–68.

and, in fact, turned the seventeenth-century prescriptions on their head by making illegitimacy not an aggravating but a mitigating factor in cases of infanticide. According to the 1845 code, premeditated murder of a legitimate child brought the same penalty as any other major homicide: hard labor in the mines for life. Killing of an illegitimate child, if a first offense and done out of fear or shame, called for the lesser sentence of ten to twelve years of penal servitude. Further reduction of sentence applied to first offenders whose act was unpremeditated; they escaped with exile to Siberia.[38] Moreover, as time went on, forensic psychologists came to the defense of these women by explaining the psychic disorientation frequently experienced by mothers following childbirth, and the expert testimony for reduced responsibility won light sentences and often outright acquittal for defendants.[39]

INCREASED INCIDENCE AND VISIBILITY

The preceding discussion does not answer the question of whether the concern expressed about infanticide in the eighteenth century arose from an increased incidence of child exposure and murder. The absence of social data or even of reliable observations of child murder prevent analysis of this type. One exception to this generalization is the recent discovery by Richard Hellie of substantial female infanticide among slave populations in the seventeenth century.[40] In view of the startling nature of this evidence, scholars must scrutinize it carefully. Still, it could scarcely be doubted that Russians availed themselves of exposure and infanticide before the eighteenth century. Periodic subsistence crises provided incentive to kill or desert children. The widespread famines of the early seventeenth century drove the inhabitants of some areas to cannibalism.[41] It is easy to imagine that in these circumstances people also resorted to exposure and infanticide, all the more so as Russian law before the eighteenth century posed few obstacles to this type of population limitation. But whether infanticide was a commonly accepted practice, a method acceptable in the case of slave populations alone, or an extreme measure resorted to only in desperate times cannot now be determined.

[38] *Ulozhenie o nakazaniakh*, 490–91, article 1922. For some reason, Liubavskii missed the change made in this code and dated the new law from 1866: *Iuridicheskie monografii* 4:69.
[39] M.G.***, "O detoubiistve"; Davydov, *Zhenshchiny pered ugolovnym sudom*, 38–39; Liubavskii, *Iuridicheskie monografii* 4:69; Zhukovskii, "Detoubiistvo."
[40] Hellie, *Slavery in Russia*, 442–59.
[41] Maksimov, "Nachalo gosudarstvennogo prizreniia," 44.

In view of the uncertain knowledge about infanticide in early Russia, it is tempting to attribute the concern expressed for children in the eighteenth century to a shift in values. There is considerable evidence for this hypothesis, but it is also possible that new conditions, particularly those flowing from the reforms of Peter I, may have greatly increased the incidence of infanticide and exposure. Peter changed much in Russia, and some of his measures created conditions which, if they did not augment the actual number of exposures and child murders, certainly increased their visibility and hence their social significance.

One change was the creation of a new category of state serfs known as "assigned peasants" (*pripisnye krest'iane*). This policy arose from the need to provide a supplementary work force for factories, which rapidly increased in number during the early eighteenth century. Many of these factories could not recruit an adequate labor supply from the available pool of unbound workers, and so Peter decided to turn over to them a certain number of villages (or households within a village) to meet their labor needs. The peasants thus assigned had to work off their state tax and labor obligations either by toiling in the factories or, more often, by supplying raw materials and performing auxiliary services. Typically, they felled trees, chopped them up and hauled the wood to the factories, made charcoal, delivered ores, lime, and rock, prepared tar, and made boats, barges, and other equipment. Work assignments of these types had been made on a small scale before Peter I's reign, but in the first years of the eighteenth century they were extended to large numbers of people, and they continued to grow thereafter. The two principal areas using assigned peasants were the Olonets factory region of the north and the Urals mining and metallurgy complex. By the end of Peter's reign, the Olonets factories alone had drawn on the labor of 48,818 male peasants. V. I. Semevskii, a specialist on the eighteenth-century peasantry, calculated that the number of assigned peasants in state and private industry combined reached approximately 100,000 by the time of the second soul-tax census in the early 1740s and climbed to 190,000 by the third census in 1762. Twenty years later, the number stood at well over a quarter-million (263,899).[42]

Taken from their husbandry and forcibly impressed into factory work, the lot of these peasants was not happy. The factory managers used them badly, and the peasants responded with frequent and sometimes embittered rebellions.[43] The significance of their situation for the question of child abandonment lies in the separation of many of them

[42] Semevskii, *Krest'iane*, 295–305.
[43] Ibid., 322–50, 414–34, 457–503; Pushkarev, "Volneniia pripisnykh krest'ian."

from their villages and families. Some of the villages concerned were close to the factories they served, but many lay at a considerable distance: as much as six hundred kilometers or more. Since the work normally fell to able-bodied males in the age group from eighteen to forty, young men had to spend long periods far from home. In some cases, the drain of young men was so severe that it threatened, according to the provincial authorities, to leave the villages with only women, children, and old men.[44] Migration to find work was no novelty in Russia, but this forced draft of tens and even hundreds of thousands of young men to work in factories far from home for periods of a few months to a year and more was unprecedented, and it certainly must have contributed to the number of illegitimate children produced both in the villages of deserted women and near the work sites of the men.

An even greater and more visible impact was produced by another of Peter's programs, the massive recruitment of men for the armed forces. The number of military recruits ran much higher than that of assigned peasants, and the separation of soldiers from home and family was usually permanent. Recruitment had also occurred under Peter's immediate predecessors during the Smolensk War and the Thirteen Years' War, but those earlier drafts could not compare with the regular and extended service that Peter demanded for his continuous warfare. Between 1705 and 1713, the army called up 337,196 men, or roughly 11 percent of the pool of men in the age group capable of service.[45] Since several large non-Russian ethnic groups, as well as the clergy and some smaller segments of the population, were exempt from military obligations, the burden fell heavily on the peasantry and townspeople of central Russia and so drained a disproportionate share of the able-bodied males from their ranks. For the subsequent period from 1719 to 1745, the demographic historian V. M. Kabuzan has calculated that recruiting levies drew off more than 6 percent of the male population, again with an even higher proportion among the central Great Russian population.[46]

Service in the Russian army lasted twenty-five years or until disablement, and a recruit had little prospect of ever returning to his village, a fact recognized and vividly portrayed in the laments and rituals performed by peasants in taking leave of a recruit. In consequence, military recruitment created another new social category, the soldier's wife (*soldatka*), or the woman left behind. In some cases, especially if she had already produced a child, the soldier's wife found a secure home with

[44] Semevskii, *Krest'iane*, 302.

[45] Hellie, "The Petrine Army," 9.

[46] Kabuzan, "Izmeneniia v udel'nom vese," 196. The absolute number of recruits in this period was 513,000: Beskrovnyi, *Russkaia armiia*, 33–35.

her in-laws. But often the presence of an unattached young woman posed a threat to other women of the household and village, who conspired to drive her out. The cities to which the soldiers' wives migrated offered few opportunities for respectable employment and considerable inducement, because of the high proportion of males in the towns, to prostitution. Enough of the soldiers' wives took up this profession to give the whole group an unsavory reputation.[47] More to the point, when one of them became pregnant, she had no place to turn for help. Return to the village was no solution, yet caring for an infant interfered with earning a livelihood. It is in this context that one observes a rising awareness of child exposure and sufficient concern about its magnitude to elicit government intervention to stiffen laws against infanticide and to take other measures to save the children.

The programs initiated by Peter I for assignment of peasants to factories and for military recruitment combined to take as many as 10 to 15 percent of the able-bodied male population either temporarily or permanently away from home. The policies contributed to the social displacement of women and hence to the increased visibility of illegitimacy and child exposure. As noted earlier, it is impossible to calculate whether the incidence of exposures and infanticide increased in comparison with earlier times. If there had been a conscious employment of infanticide earlier to limit population, Peter's policies may merely have added to or abetted the practice while altering its character and locus sufficiently to bring it into public view. If infanticide was rare in the past, Peter's actions gave rise to a new social phenomenon.

A New Sensibility

Whatever role an increased incidence and visibility of infanticide may have played in arousing the concern expressed in the eighteenth century about child murder, the emergence of interest in this problem also owed something to a new appreciation of infant life and sensitivity to children generally. As early as the 1690s, a monk and educator by the name of Karion Istomin produced a radically new and different primer, which included graphic design and the word-object and sentence methods of teaching reading.[48] He thereby revealed his understanding that children

[47] Empress Maria Fedorovna articulated the common view in arguing against allowing the soldatki to adopt foundlings, on the ground that their behavior "can for the most part not be approved of and often it is even quite dissolute": Comment on the case of June 13, 1827, TsGIAgM, f. 127, op. 2, d. 7649, pp. 31ob–32. See also the figures on the social background of prostitutes later in the century in Stites, *Women's Liberation Movement*, 61.

[48] Okenfuss, *Discovery of Childhood*, 22–35.

occupied a different mental world, perceived their surroundings differently from adults, and had special educational needs. Not long afterward, the government issued large editions of its own civil primer, together with an etiquette book detailing proper behavior in relations between children and adults.[49] These "discoveries of childhood" in the fields of education and manners were paralleled by changes in the organization of charity and the emergence of a system of state-sponsored care for abandoned and homeless children. This expression of a new appreciation of infant life was especially important, because in the field of charity the break with the past was clearest. It was there that the new concern produced major institutional programs and unprecedented efforts to save the lives of unwanted children.

Before the eighteenth century, to judge from the silence of the documentary record, organized charity and public care facilities scarcely existed in Russia. To the extent that any institution could be said to have charge of caring for the poor, ill, crippled, insane, and orphaned, it was the church. From early times, monasteries provided a refuge for people in need, and a midsixteenth-century church council (*Stoglav*) officially imposed this obligation on the church.[50] References later in the century to church-supported almshouses indicate some activity in this area.[51] Further development occurred during the reign of Tsar Mikhail Fedorovich (1613–1645). In establishing a Patriarchal Department in his government, he again laid upon the church the charge of caring for the needy, including now for the first time its responsibility to care for abandoned children.[52] During the remainder of the seventeenth century, patriarchs and other church leaders built a number of almshouses, hospitals, and shelters. There is even a vague reference to "orphan homes."[53] Yet all this work was sporadic and scattered, and it has left little record of its operation or scope.

More significant surely than either monastic charity or facilities provided by the church was local parish help, which was within easy reach of many people and available on a regular basis. Many churches kept on their grounds wooden huts (*izbushki*) or "cells" (evidently small rooms in a dormitory) and took in at parish expense the elderly poor, invalids, and other needy. The number of cells ranged from a few up to fifty or more in large parishes. One Moscow church, St. John the Divine

[49] Ibid., 45–48.
[50] Petrov, "Blagotvoritel'nost'," 31–32.
[51] Stog, *O obshchestvennom prizrenii* 1:17–18.
[52] Ginzburg, "Prizrenie podkidyshei," 499.
[53] Snegirev, *Moskovskie nishchie*, 10–11.

(Ioann-Bogoslov v Bronnoi), had room for one hundred people.[54] No doubt orphans and abandoned children turned up at these refuges, but available records say nothing about their treatment. Even direct references to the care of orphans cannot be taken at face value because of the early Russian practice of calling all unfortunate or displaced persons, even peasants generally, "orphans."[55]

Before the eighteenth century, the financial basis of all charity was private giving. Many assets that the church applied to this work came from private donations, particularly the land and money bequeathed by wealthy patrons in remembrance of their souls. Philanthropy outside the church had the same private character. People of means would set aside large sums of money in their wills for distribution to the poor during the forty-day mourning period following their deaths (*sorokoust*).[56] This custom was bound up with the Russian belief in atoning for one's sins through charitable offerings and almsgiving. Its most familiar and generous expression in Muscovite Russia came in the form of distributions by members of the tsarist family. On holy days or on the occasion of a royal birth, marriage, or death, the ruler disbursed large sums to the poor. Tsarist pilgrimages provided another opportunity for giving. During the course of a major pilgrimage, tsars daily visited hospitals and almshouses and distributed gifts to the inhabitants. They also supplied special meals for prisoners.[57] In some instances, members of the royal family seem to have contributed so frequently and substantially to a specific shelter that one could speak of something analogous to modern institutionalized support of charitable work. (In the case of the tsarist family, it is difficult to distinguish the public sphere from the private.) Yet for the most part, Muscovite charity did not rise above the level of individual donations, and much of it took place right out in the street. Indeed, the public arena was its proper setting, since both benefactors and beneficiaries (however much the recipients may have appreciated the boon) perceived the gift primarily as an act of atonement and not as a means of support.

The first evidence of a new outlook on welfare came in the reign of Tsar Fedor Alekseevich (1676–1682). This was the period in which Russians began using terms like "state interest" (*gosudarstvennoe delo*)

[54] Sokolovskii, "Petr Velikii kak blagotvoritel'," 23n.

[55] Among the few references to an orphan that can be confirmed as accurate is that in the tale of Archbishop Iona of Novgorod: *Novgorod IV Chronicle*, Dubrovskii spisok, year 6967 (1459), pp. 492–93. (I am grateful to Eve Levine for this reference.)

[56] Petrov, "Blagotvoritel'nost'," no. 8, 30–31, 42–43.

[57] Ibid., 37–43.

and other abstractions borrowed from the West.[58] Russians were entering a century of rapid and unself-conscious adoption of Western administrative practices, and as part of this process they studied central European *polizei* notions of public welfare. This can be seen clearly in a draft degree drawn up for Tsar Fedor Alekseevich in 1682. Though not implemented at the time, the decree signaled a radical turn in Russian thinking about social policy.

This lengthy document emphasized three basic points. First, it declared the government's intention to develop philanthropy as a public service and obligation and to leave it no longer to haphazard private means or church work. Second, it sought to separate the able-bodied needy from those too old, crippled, or ill to engage in productive labor. Those who could no longer work were to be placed in hospitals, almshouses, and monasteries and supported for life, unless they could be cured, in which case they should be made well. The others, the professional beggars capable of working, would end up in what would later be known as workhouses, institutions that did not yet exist in Russia but which the tsar's advisers hoped to create. The third point concerned homeless children who wandered the streets begging for alms. According to the draft decree, the sovereign was to issue an order requiring, "as in other countries," that homes be built for these waifs.[59] The homes would provide education and training, with separate programs for boys and girls. The boys would acquire basic literacy and then learn a trade in the home or as an apprentice at a master's shop. At maturity, when they proved they could provide for themselves and a wife, they would be released as freemen. The girls were to grow up in the home and then go to convents for schooling. At the proper age, they could buy homes and marry. "Such people," the decree explained, "would in the future contribute to their communities, and there would be no reason to fear robbery from them, because they had been given the means to provide for themselves."[60]

This proposal ran counter to the Russian custom of almsgiving, which assumed the existence of needy receivers in public view. Fedor's advisers wanted to introduce the "well-ordered state," with its regulation of society, repression of the old forms of beggary and almsgiving, and removal of the unsightly crippled, diseased, and derelict from the streets. At the same time, they planned to take the able-bodied poor and street children, who constituted a threat to public safety, and harness

[58] A. Lappo-Danilevskii, "L'idée de l'état," 364.
[59] Maksimov, "Nachalo gosudarstvennogo prizreniia," 51–53.
[60] Ibid., 53.

them to productive pursuits. It had taken these ideas 150 years to reach Russia after their implementation in western Europe,[61] and Russians would have to wait another 80 years before anything comparable to the program outlined in Fedor's decree could be realized. The decree was nevertheless important as an indication of government thinking, a recognition by the government of its responsibility for public welfare, and an indication of future policy. Fedor's half brother, Peter the Great, definitely wanted to move in the same direction and, despite many obstacles, succeeded in creating some facilities for the care of unwanted children.

In this effort, Peter was preceded and inspired by the work of a churchman. If one discounts the "orphan homes" of the time of Tsar Mikhail Fedorovich, the first shelter specifically for the care of illegitimate children was established by Metropolitan Iov of Novgorod at the Kholmovo-Uspenskii Monastery just outside his diocesan capital. Contemporary sources refer to it as a *domik* or small house, but this could scarcely have been an accurate term. Although no registries from the facility have survived, a Senate document recorded the burial in 1714 of more than 500 children from the shelter.[62] If the mortality rate was similar to the 75 or 80 percent known in Russian foundling homes later in the century, the yearly admissions to Iov's facility may have run as high as 650. This figure could include admissions at more than one location, since one decree referred to Iov's operation as encompassing ten shelters housing up to 3,000 children.[63] The enterprise was large enough to attract the attention of Tsar Peter and move him to furnish Iov's home with additional revenues from other monasteries and with donations from the tsarist family and wealthy nobles.[64]

Peter was not satisfied merely to subsidize the efforts of the church. Once he gained respite from the Northern War, he set out to imitate and extend Iov's facility by establishing his own state-sponsored system of care. It was at this time, early in 1712, that Peter issued a decree calling for the establishment of hospitals for crippled and aged service people no longer fit even for guard duty, and also for the care of "children of shame" so that their mothers would not compound the sin of illegitimacy by committing the greater sin of murder. And he ordered

[61] Davis, *Early Modern France*, esp. 17–64; Kamen, *Iron Century*, 403–4.

[62] *Doklady imp. Prav. Senata v tsarstvovanie Petra I*, vol. 4, book 2, 876–77, cited in Ieromonakh Mikhail, "Prizrenie broshennykh detei," 39.

[63] This was the decree that established the Moscow Foundling Home: *PSZ* 16, no. 11908. Snegirev, *Moskovskie nishchie*, 11, mentions one of these shelters, located in Moscow at the church of SS. Kira and Ioann in Kulishki.

[64] Piatkovskii, "Nachalo vospitatel'nykh domov," 268.

that this be done "on the model of the bishop of Novgorod."[65] This first order appeared somewhat casually as the eighteenth point in a decree covering military recruitment, fortifications, penalties for soldiers absent without leave, and other military affairs. This circumstance shows how closely awareness of child abandonment was bound up with the creation of a standing army and so reinforces speculation about the importance of military recruitment in the problem. Despite this seeming casualness, Peter definitely intended to create the care facilities. He reissued the order on hospitals separately later the same month and again in 1714 and 1715 in an extended form giving more detail on the type of institution desired and its purpose.[66]

These later decrees noted that the hospitals should be built in proximity to churches. Apparently Peter meant to use clergy as administrators and thus forge a link with the established practice of parish help. In Moscow, the facilities were to be of masonry construction; other towns needed only to build in wood. But in all cases they were admonished to use Metropolitan Iov's institution as a model in organizing their work. They should allow mothers of illegitimate children to deposit them at the hospital without having to reveal their identity. The institutions were to employ capable women to care for the children, and Peter ordered that provincial revenues be assigned for the payment of staff and maintenance of the foundling population. The decrees expressed Peter's concern that in the absence of such institutions, shame compelled women to expose their illegitimate infants, and "these children die to no purpose."[67] He also noted that some women simply killed the children, and he issued a stern reminder that the penalty for this crime was execution.

At about the same time as these decrees appeared, Peter was working on the military articles, which increased the punishment for killing a legitimate child. He was obviously much concerned with the question of labor supply. The sight of potentially productive subjects exposed and dying in the streets must have struck him as intolerable. At one point, he even had to scold the Holy Synod about killings of illegitimate infants born in the convents, noting that many bodies of babies had been found at cleanings of the convent cesspools.[68] Concern about this loss of life would explain why he fastened so eagerly on the example of

[65] *PSZ* 4, no. 2467 (January 16, 1712).

[66] Ibid., no. 2477 (January 31, 1712), and 5, no. 2856 (November 4, 1714), and no. 2953 (November 4, 1715).

[67] *PSZ* 5, no. 2856 (November 4, 1714), and no. 2953 (November 4, 1715).

[68] Addendum to the Spiritual Regulation, cited in Semenova, *Ocherki istorii byta*, 119–20.

Metropolitan Iov and sought to extend this model of care for unwanted children to the whole country. The further disposition of the children thus saved likewise supports the notion that Peter saw them as raw material for his expanding military forces and construction projects. In 1723, when a number of the youngsters in the hospitals were approaching puberty, orders went out to send the boys over ten years of age to the Admiralty in St. Petersburg for inscription into the navy.[69] The following year, Peter turned others of the children over to craftsmen to be apprenticed in trades.[70]

Within the limits of these objectives, Peter seemed to be interested in supporting and expanding foundling care. He insisted on prompt payment of salaries and maintenance expenses for the hospitals, and he granted churches a monopoly on the sale of candles specifically to assure them of sufficient revenue for running their almshouses and care facilities.[71] But, as with many of his projects, Peter's successors did not share his enthusiasm. After the great reformer's death, the need to bring government expenditures into line with revenues rapidly led to the dismantling of many reforms and institutions, including the foundling shelters.

The extent to which Peter's design for provincial shelters came into being is not known. A Senate decree of 1726 noted that at the time in Moscow province (*guberniia*) alone, 440 children were in foundling care at various shelters, with 120 wet nurses attending them. The Senate apparently had no clear idea of the state of care facilities elsewhere.[72]

By 1729, the persistent problem of displaced adults and abandoned children turning up in the towns and creating a nuisance forced the senators to look more closely into the matter. The issue came up in connection with the case of two boys, ages ten and four, the children of a townsman from Nizhnii Novgorod, who out of dire need brought them to Moscow and then died.[73] The orphaned boys wandered the streets collecting alms. A Senate decree on the matter raised the question of what to do with the large number of runaway soldiers and other people,

[69] *PSZ* 7, no. 4335 (October 23, 1723).

[70] Ibid., no. 4421 (January 20, 1724), repeating an order given by Peter in the Senate on January 14, 1724. See also ibid., no. 4516 (May 29, 1724), concerning schools for instruction in reading and mathematics at "monastery orphanages."

[71] *PSZ* 6, no. 3502 (February 1, 1720), and no. 3746 (February 28, 1721). Peter's orders to use the candle money to develop care facilities further was apparently resisted by the church authorities: Avramenko, "Iz istorii russkoi tserkovnoi blagotvoritel'nosti," 378.

[72] *PSZ* 7, no. 4844 (March 3, 1726).

[73] Nizhnii Novgorod was one of a number of relatively large towns without an almshouse as late as 1766. Others included Voronezh, Tambov, Kostroma, Kazan, and Vladimir: Avramenko, "Iz istorii tserkovnoi blagotvoritel'nosti," 359.

young and old, who roamed the back alleys of the towns and lodged in taverns, public bathhouses, brothels, and eateries. According to the Senate, they were a public menace and endangered life and property. It ordered that those of suitable age be sent to the military and that youngsters be turned over to the Economic Collegium to be cared for as instructed in Peter I's decrees on "children of shame." At the same time, the government called for the compilation of information about illegitimate children, orphans, and soldiers' children and about the available care facilities (*shpitali*) for illegitimate children.[74] The information must have convinced the authorities that they could not meet the current burden of welfare, for a short time later they moved to discharge the government from any responsibility for the care of girls and women. Young girls went to whoever wished to take them in as servants, and older girls were to be sent to factories or into service work. Boys were apparently still to be reared until old enough to enter the military. Otherwise, the government agreed to maintain only the aged and the mentally or physically disabled.[75]

In making these dispositions, the government was following the practice established in the seventeenth century of trying to fit each subject into a well-defined niche of a castelike society. This objective was explicit in two decrees of 1744 that reiterated the order to empty state care facilities of all but the old and the handicapped. Everyone else was to be attached to some taxpaying group, as a proprietary serf, a town dweller, or a guild member, unless he was entering government or military service.[76] So in one sense this solution marked a regression toward the old family regime, while at the same time the government was searching for corporate bodies beyond the family that could take responsibility for the behavior and obligations of persons who could not be fitted into the old family. But this was the last effort in the eighteenth century to deal with orphaned and abandoned children through the old family regime or the caste system. A few years later, under the influence of Enlightenment values, Catherine II ushered in a new approach which in some respects went beyond anything known in the West.

THE AVAILABLE EVIDENCE is consistent with all three of the proposed explanations for the emergence in eighteenth-century Russia of public

[74] *PSZ* 8, no. 5450 (July 25, 1729).

[75] Ibid., 5584 (June 25, 1730), and no. 5674 (January 20, 1734).

[76] *PSZ* 12, no. 8966 (June 13, 1744), and no. 9011 (August 3, 1744). The same concern that "no one should be wandering about" and that everyone should have a defined position was expressed in instructions for the second soul census: *PSZ* 11, no. 8836 (December 16, 1743).

concern and action in regard to child exposure and infanticide. Some combination of the three possibilities may provide the best explanation. The feeble protection given to infant life in early Russian law suggests that infanticide may have been commonplace, especially in rural areas, where often neither the prince's nor the patriarch's writ ran. Hellie has made a strong case for significant levels of female infanticide among slaves, but in the absence of information about other groups, little more can be said. It seems beyond doubt that the social changes wrought by the reforms of Peter the Great and his immediate predecessors increased the incidence of infanticide and the visibility of the victims. The efforts to open up the old Russian family and put its individual members to work for the state led to the uprooting of large numbers of people and their detachment from their familial nests, with attendant increases in illegitimacy. It is difficult, however, to disentangle the issue of increased visibility from the final factor considered, a new sensibility and concern for infant life. In the absence of a visible problem, the concern of the authorities may have remained unexpressed. If it could be shown that exposure and infanticide were common in the past, the argument for an altered sensibility would become much stronger. Even so, there seems to be convincing evidence for the emergence of a new understanding and appreciation of children, influenced by the arrival from the West of humanist learning and populationist economic doctrine.

THREE

"You Too Shall Live":
The Betskoi System

THE ACCESSION of Catherine II to the throne in 1762 brought to Russia the optimism of the midcentury European Enlightenment. The empress had read widely in the fashionable juridical and social tracts of the age and shared the assumptions of most educated people about the power of social institutions to mold and perfect the individual. These beliefs moved her to attempt a redrafting of Russian laws on the model of the most advanced political theories of the day. It led to an order to ban torture in criminal investigation and to the initiation of a series of educational and social-welfare projects. The most ambitious of these ventures was the establishment of imperial foundling homes in Moscow and St. Petersburg, which stood as the symbol and chief embodiment of the new regime's commitment to implement enlightened policy in charity and education. In the area of foundling care, Catherine went far beyond her predecessors' concern with saving lives for use in the military and on construction projects, beyond even the most advanced West European welfare schemes. She envisioned the homes as incubators of an entirely new type of individual. The schools connected with the homes were to inculcate enlightened morality, the work ethic, civic-mindedness, and respect for constituted authority, and thus to create from unwanted children the educated, urban estate that Russia then lacked.

BETSKOI'S EDUCATIONAL PLANS

The person who inspired Catherine's foundling-homes project and was her collaborator in other charitable and pedagogical projects was Ivan Ivanovich Betskoi. This cultivated and well-traveled official undertook his reform work at the unlikely age of sixty. Born in 1704, the bastard son of a member of the powerful Trubetskoi family (of which his name was a truncation), he was educated in Denmark and during his younger years served as a functionary for various Russian embassies in Europe. The 1740s found him back in St. Petersburg assisting at the grand-ducal court of the heir designate Peter and his consort Catherine

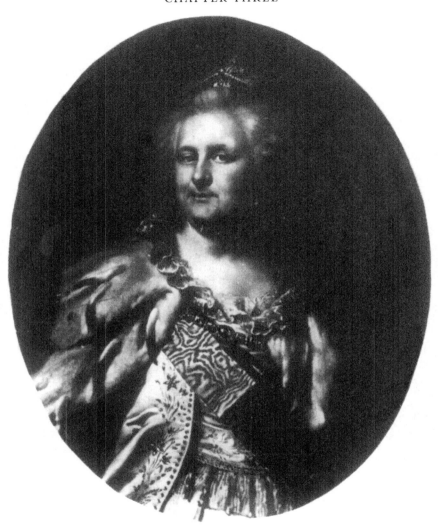

3.1 Empress Catherine the Great.

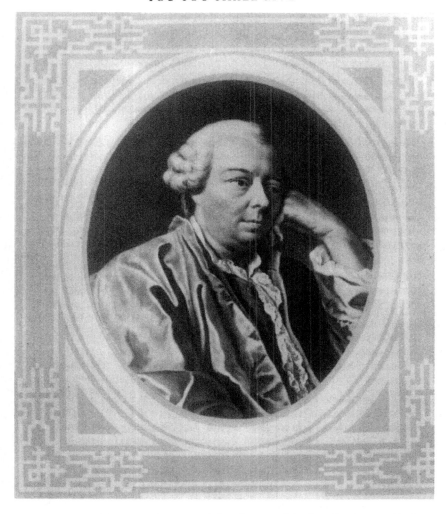

3.2 Ivan Ivanovich Betskoi, founder and first director of the foundling homes (1763–1795).

(later Catherine II), but involvement in a court intrigue in 1747 led to Betskoi's exile in western Europe for most of the remaining fifteen years of Empress Elizabeth's reign.[1] During this period of enforced leisure,

[1] His name appears in the imperial court register only during 1753–1754: Maikov, *Betskoi*, 24.

he developed contacts with leading writers of the Enlightenment, fa-
miliarized himself with the latest ideas on education, and visited insti-
tutions of welfare and learning. These experiences nurtured in Betskoi
an interest in educational and social reform. A deeper psychological mo-
tivation may also have been at work. Betskoi later admitted his discom-
fort in Europe at not knowing anything about many of the collections
and curiosities he saw. Russians, he contended, needed to learn about
the world instead of traveling it in ignorance.[2]

Upon his return to Russia in 1762, he was eager to put to practical
use the knowledge he had acquired in his travels, and in the new em-
press he found an ideal patron. Catherine's embarrassment at the rude-
ness of her adopted nation (she had been born in the north German city
of Stettin) made her receptive to schemes for improving Russian school-
ing and public services, and her attachment to fashionable "philosophic"
ideas was well known in court circles. She liked to advertise her interest
in these views in correspondence and in gestures toward prominent En-
lightenment thinkers. Recognizing Catherine's aspiration to rule as an
enlightened monarch, Betskoi cutivated this conceit by basing his re-
form proposals on the current educational clichés and popular philo-
sophic literature while carefully pointing out the advantages of his ap-
proach for strengthening the social order and the authority of the
monarchy. The empress, in turn, supplied the material and political sup-
port required for implementing Betskoi's proposals.

Betskoi's first report, "A General Institution for the Upbringing of
Children of Both Sexes," outlined his approach.[3] He noted that, since
Peter I's time, an Academy of Sciences had existed in Russia and much
money had been spent in sending Russians abroad for study, but these
efforts had yielded few results. No one had expanded Peter's initiatives
into a broad base of educational institutions. More importantly, noth-
ing had been done to produce what elsewhere was known as the "third
estate": the stratum of trained urban dwellers that constituted the dy-
namic core of West European societies. With this criticism, Betskoi
touched a central concern of Catherine's government, the desire to form
corporate groups on the European model. During the early years of the
reign, several officials floated proposals for the organization of a third
estate.[4] Betskoi took the matter one step further. He proposed to create
this class of people through educational reform and to build a substan-

[2] Ibid., 31–60, 342.
[3] Betskoi, "General'noe uchrezhdenie." The project presented in this report was con-
firmed by Catherine on March 12, 1764. The report was republished in 1774 and 1789,
together with other writings by Betskoi.
[4] Troitskii, "Dvorianskie proekty sozdaniia 'tret'ego china.' "

tial segment of the estate from the raw material of the foundling population.

It is important to understand the limits of Betskoi's conception of the third estate in Russia. In Europe, this term referred first and foremost to commercial and entrepreneurial people: large merchants, financiers, and capitalists at one end of the scale and small shopkeepers and vendors at the other. Included also were lawyers, doctors, teachers, journalists, and other professionals. When Betskoi spoke of building a third estate out of foundlings, he had such people in mind only as exceptions. Wards of the foundling homes could, if talented and highly motivated, progress through elementary and preparatory school to professional and university education.[5] But the expected route for these children was an apprenticeship and a life as an artisan, scribe, or other low-level technical specialist. Betskoi even outlined the three groups into which he intended to direct the foundings: "The first should consist of those who obviously possess the talent to earn distinction in science and art; the second should be artisans and craftsmen; and the third, the dullards, should be unskilled laborers."[6]

Betskoi's overall education plan embraced much more than schools for foundlings. In addition to the Moscow Foundling Home, opened in 1764, he established during the first eight years of Catherine's reign schools for daughters of the nobility (1764) and daughters of townspeople (1765), preparatory schools connected to the Academy of Arts (1764) and the Military Academy (1766), and a business school intended for sons of merchants (1772). Though aimed at different social strata, all the schools shared certain principles. The main feature was a program of moral training (*vospitanie*). The object of the new education was to forge the good citizen, a person of judgment with a cultivated moral awareness, who would actively promote the welfare of his country and his fellow citizens. "The chief task of education," Betskoi proclaimed in a speech at the Academy of Arts in 1769, "is to make a person honorable."[7] The absence of this dimension, he believed, was the major failing of the schools begun by Peter the Great. The pupils of that time may have mastered a body of knowledge, but this accomplishment did not make them better persons. Without an improvement in morality, Betskoi wrote, academic success merely gave people the ability to in-

[5] Maikov, *Betskoi*, 174–76.
[6] Ibid., 175–76. At first, all foundling youngsters were exposed to music, dance, and representational arts. The most gifted went to the Academy of Arts and could become performers and artists in the expanding cultural world of late eighteenth-century Russia, but the number who achieved even modest professional distinction was small.
[7] Ibid., 324.

35

dulge their vices more effectively. Betskoi also stressed patriotism, a common theme in reform projects of the day. The ranks conferred by education were mere vanity, he asserted, if the schooling failed to make people useful to their nation. His institutions were therefore designed to instill patriotic as well as moral sentiments. The effects would be sustained and reinforced when the graduates married among themselves and passed on their training to their children and successive generations.[8]

Betskoi was no egalitarian and did not intend that youngsters from different social estates should intermarry. The schools trained each group for a given position in the social hierarchy, and members of each category were expected to remain within their group. The transformation Betskoi sought was in the mores of individuals, within a range appropriate to their particular group.[9] As the idea worked out in practice, for example, girls from the foundling home and from the school for daughters of the townspeople could become servants or tutors in the school for noble girls. The noble girls themselves were educated for more genteel pursuits.

The educational program for all groups was based on the Lockean notion that the mind at birth was a blank slate possessing no inborn inclinations to evil or vice. Accordingly, Betskoi saw the tightly controlled environment of a boarding school as the logical means of raising the cultural and ethical level of his pupils. His system ideally required control over the children from their first days, and, in hopes that parents and nannies would adopt his principles of child-rearing before the children started school, he produced a detailed handbook of up-to-date procedures of child care and moral guidance.[10] The handbook was also designed for the foundling home, which was the only place in which its principles could reliably be applied to children in their earliest years. For others, enforcement had to await the age of admission to the new schools, normally five or six years. From then on the children were strictly supervised. They remained at the schools until age eighteen or twenty without returning to their homes. During that time, no spontaneous or independent socializing was permitted between pupils and society. School authorities fostered selective contacts with the outside

[8] Betskoi, "General'noe uchrezhdenie" (unpaginated); Betskoi, *Uchrezhdenie Imperatorskogo Vospitatel'nogo Doma*, preface and 35–37.

[9] The difference between Rousseau's idea of the liberating power of education and Betskoi's limited aspirations for his pupils is discussed in Strange, "Jean-Jacques Rousseau," 518–19.

[10] Betskoi, *Kratkoe nastavlenie*. At least six editions of this work, under slightly varying titles, appeared between 1766 and 1768.

world but kept them formalized and under tight scrutiny. In the case of the schools for nobles and townspeople, even visits by members of a child's own family took place in the presence of a school supervisor. Betskoi believed that he could form his students into a new generation of enlightened citizens only by isolating them from the surrounding coarseness, and he made no exceptions, even for the nobility, which by all accounts was in the 1760s still rather rude.[11]

The boarding-school idea had evolved in Europe from medieval confraternities, the merger of student living quarters with extracurricular and eventually curricular instruction, and as an offshoot of cloistered religious life. Institutional confinement arose from the desire to inculcate moral values and restrain youthful excitability, and as Europeans became more concerned with these matters in the eighteenth century, the boarding school gained in popularity.[12] Betskoi, in his quest to make students entirely different from their parents, found the internment regime irresistible, and nowhere outside the religious orders was it practiced so thoroughly as in his schools. They provide an example of the extremes to which the unformed social environment of eighteenth-century Russia allowed reformers to carry their borrowed European models; no effective resistance arose to the rather harsh internment program put in place by Betskoi, even if from time to time individuals criticized the methods and results of his schools.

The internal design of the schools came from the educational ideas of the past century associated with the names of Comenius, Locke, Fenelon, Voltaire, and others. The stress was on "naturalness," the need for young people to develop a sound body and positive outlook. Physical coercion was frowned on. This was a strict point with Betskoi. He took it further than Locke, who permitted the rod in some cases. Betskoi enjoined beatings absolutely, not only of students but also of all school personnel, however lowly. The instructional programs avoided rote learning of facts and figures and instead emphasized engagement of the students' senses by the examination of objects first. Then they could proceed to learning what could be grasped by the mind alone.

Another aspect of Betskoi's educational plan was his rejection of narrow technical training and his insistence on a general curriculum as the

[11] On the treatment of noble children in the conventional schools of the time, see excerpts from memoirs cited in Maikov, *Betskoi*, 473. Betskoi was not the first to advocate isolating pupils. In establishing the Military Academy in 1731, Empress Anne had told Count Munnich that the noble children would have a better education if they were away from their families, villages, and homes: Maikov, *Betskoi*, 358.

[12] Durkheim, *L'évolution pédagogique*, 126–45; Ariès, *Centuries of Childhood*, 155–75; Richard Trexler, "Ritual in Florence."

basis for specialized study. He also fought against a special, which is to say limited, education for females. Although he sought in his girls' schools to produce informed, cultivated mothers to rear the next generation, he saw no reason why girls should receive an education inferior to that of boys. He even made a foray into comparative social analysis and observed that the cleanest, most productive regions of Europe were those in which women had sufficient training to participate in the workaday world.[13]

THE FOUNDLING HOMES

The foundling homes were naturally different from Betskoi's other institutions. He may initially have intended them to be like the others—that is, places for children to come only at age five or six for schooling and moral training. This may explain their unusual designation as "homes of moral training" (*vospitatel'nye doma*) rather than the more common European name of foundling home or hospital. His institutions would then have resembled a number of facilities in northern Europe, like the Stockholm Children's Home, which admitted children who had spent their early years in local shelters or private care.[14] Some scholars have argued that Betskoi made a serious error in eventually deciding to accept infants, because the task of assuring the survival of thousands of nursing babies diverted attention from his educational goals. Moral nourishment (*vospitanie*) succumbed to the demands of physical nourishment (*pitanie*).[15]

If at first Betskoi had meant to exclude infants, the thought apparently passed quickly. The early official announcements of the Moscow Foundling Home referred to its models in Paris, Lyons, and elsewhere, which admitted infants. The initial project or "general plan" stressed the humanitarian aim of providing a refuge for innocent children who were being deserted and sometimes murdered by desperate or cruel mothers.[16] In fact, far from wishing to exclude anyone, the home opened in 1764 with the most liberal admissions policy ever instituted in Europe. Virtually any child was welcome. The chief exception—that serf children could be admitted only with the agreement of the landowner to whom they belonged—was difficult to enforce because of rules against interrogating the persons giving up a child. The staff was to inquire only

[13] Betskoi, *Uchrezhdenie Imperatorskogo Vospitatel'nogo Doma*, preface and 3.
[14] "Almänna barnhuset," *Svensk uppslagsbok* 1:661–62.
[15] Puteren, *Istoricheskii obzor prizreniia*, 76–77; Ginzburg, "Prizrenie podkidyshei," 505–10.
[16] Betskoi, *Uchrezhdenie Imperatorskogo Vospitatel'nogo Doma*, 2.

whether a child being offered to the home was baptized and, if so, its name. Regulations directed the staff to record any additional information given voluntarily, but employees who tried to learn more or who hindered persons wishing to deposit children were subject to disciplinary action and even dismissal.[17] With minor modifications this policy remained in effect for over one hundred years, but as long as Betskoi was personally in charge, he refused to allow even minor modifications in the policy of unrestricted admissions.

Active measures were also taken to find children for the home. Since children were often left at parish churches, guard stations, and private doorways, Betskoi sought to gain the cooperation of the clergy, police, doormen, and others who might come across abandoned infants. The decree announcing the establishment of the Moscow Foundling Home warned these people against impeding anyone wishing to bring a child to the home and, on the contrary, enjoined them to facilitate the journey and, if necessary, to bring the children in themselves.[18] A major reason for the liberal admissions policy was the contemporary view of child exposure and infanticide, which saw the cause of these crimes in the shame of the unwed mother. A policy of open admissions that shielded the mother's identity seemed the most effective method of persuading unwed mothers to bring their babies to the home rather than desert them in the streets and ditches.

In Betskoi's case, a glimpse of the darker side of Russian village life reinforced this view. Before the opening of the Moscow home, he employed an agent by the name of Pokhvisnev and dispatched him on a mission to find wet nurses in the countryside. In writing to Betskoi about conditions in the villages, Pokhvisnev told of rural priests known as *zakashchiki*, who subjected unwed mothers and women living alone to brutal inquisitions, punishments, and fines. Though done in the guise of piety, the real motivation, according to Pokhvisnev, was the clergy's well-known greed. Fear of harassment by the priests drove the women to child murder, a course they found preferable to humiliation and financial ruin.[19]

To inform people of a more humane response to illegitimacy, Pokhvisnev advised the distribution in the villages of pamphlets explaining the goals and regulations of the foundling home.[20] It is far from clear who would have read such pamphlets, and evidently Betskoi did not

[17] Ivan Ivanovich Betskoi, "General'nyi plan Imperatorskogo Vospitatel'nogo Doma v Moskve," in his *Uchrezhdenie Imperatorskogo Vospitatel'nogo Doma*, 12–13.
[18] Ibid., point 2; Also cited in *MIMVD* 2:30.
[19] *MIMVD* 2:32–33.
[20] Ibid.

produce any. He did nevertheless prevail upon the Holy Synod to say something about clerical interference. At the time of the Moscow home's opening, the Synod reminded the clergy of the rule about facilitating the journey of people to the home and admonished priests to show mercy, "not in the mitigation of the sin" of illegitimacy but to prevent still worse sins like child murder. The church leaders also warned priests against invoking strict fulfillment of God's law as an excuse for lining their pockets.[21]

Encouragement of admissions went even further. In contrast to the usual practice in European foundling homes of limiting admissions to illegitimate children, Betskoi placed no obstacle to the entry of legitimate children and even made specific mention of desertions of legitimate children by destitute parents. He believed that the foundling homes should be available not just to unwed mothers but also to people too poor to care for their children.[22] He seemed to fear that not enough women would deposit babies and he would then lack the material to fulfill his promise to create a new class of people. Betskoi's eagerness to build admissions initially led him to offer an honorarium of two rubles as compensation for the trouble of delivering a foundling to the home. This naive measure immediately gave rise to abuses, as people brought in dead and dying infants to collect the delivery fee. The home ended this abuse by denying payment for unhealthy children and refusing to accept corpses.[23] Soon after, officials ceased payment altogether, probably for fear that people might snatch healthy babies and "sell" them to the foundling home.

Another source of admissions was the Lying-In Hospital, which was attached to the Moscow Foundling Home and was established at the same time. Betskoi had observed facilities of this type in Europe and wanted to provide a place needy unwed women could have their babies in safe conditions and in secret. The existence of this facility would in his view reduce abortions and infanticide and so preserve more children for the state. As it turned out, not only poor women but wealthy and prominent ones also availed themselves of the hospital. Its popularity soon precluded the provision of private rooms for all the women, and

[21] Piatkovskii, "Nachalo vospitatel'nykh domov," 284.

[22] Another source of concern was abortions, and Betskoi hoped to reduce the loss of life involved in this practice. In the end, he did not make a policy of admitting legitimate children, and the homes were intended primarily for illegitimate children. As a practical matter, however, the policy of anonymous admissions made it impossible to learn about the marital status of the parents, if they chose to conceal it. See Betskoi, *Uchrezhdenie Imperatorskogo Vospitatel'nogo Doma*, 20; Piatkovskii, "Nachalo vospitatel'nykh domov," 296–97.

[23] Betskoi, *Uchrezhdenie Imperatorskogo Vospitatel'nogo Doma*, 12–14; Piatkovskii, "Nachalo vospitatel'nykh domov," 298–99.

officials divided the hospital into a general ward for ordinary women and a "special section" with private rooms for wealthy or educated women. They apparently rationalized this separation by the greater need for anonymity in the case of prominent women, but the policy also reflected expectations of privileged treatment for "better people" and carried through the hierarchical social values evident in all of Betskoi's projects. All women were nevertheless guaranteed anonymity, even to the point of being furnished with masks that they could wear throughout their stay in the hospital. Children born in the facility became wards of the foundling home, and during the late eighteenth century babies from the Lying-In Hospital accounted for approximately 15 percent of the foundling home admissions.[24] A similar hospital was attached to the St. Petersburg Foundling Home when it was opened in 1771.

STATUS AND FINANCING OF THE HOMES

An original aspect of Betskoi's work was his effort to insure the autonomy of the foundling homes. He pursued two objectives in this regard: to free the institutions from interference by government offices and to engage society directly in the work of the homes. Betskoi's success was most evident in the corporate privileges he obtained for the homes. They remained free of the usual police obligations, enjoyed freedom from tariffs on imported wares, and disposed of judicial authority over their employees and wards.[25] Their administrative autonomy surpassed that of the self-governing zemstvo boards of the late nineteenth century, since the homes stood directly under the personal protection of the empress and were not subject to an intervening authority.[26] Finally, a written guarantee of freedom was the right of all children reared by the homes, no matter what their original station in life, the only exception being in cases of specific legal challenge by a landowner deprived deceitfully of a serf child. Even in the case of such a challenge, though careful to abide by the letter of the law, Betskoi tried to persuade the landowner to leave the child with the home. He also wanted to publish decisions to return children with explanations of the reasons, an indication of the growing importance of public opinion in the 1760s and of Betskoi's didactic aims.[27]

The other side, the involvement of the public in charitable work, was

[24] *MIMVD* 1, part 1:66.
[25] These and many other unusual exemptions and advantages are listed in the general plan: Betskoi, *Uchrezhdenie Imperatorskogo Vospitatel'nogo Doma*, 42–61.
[26] Maikov, *Betskoi*, 148–49.
[27] See the cases in ibid., 164–65; MIMVD 2:34–35; Piatkovskii, "Nachalo vospitatel'nykh domov," 275–77.

of especially great interest to Betskoi. This was the Enlightenment spirit and, more practically, a hedge against undue dependence on government subsidies. In his general plan for the Moscow home, Betskoi told of how the nobles, wealthy burghers, and high clergymen of Lyons took their turns as managers of the city's charitable institutions and even went about the streets collecting donations for them. The implication was that civic-minded Russians would want to do no less.

The response was gratifying and, in the beginning, private contributions played a large role. The empress and Grand Duke Paul, heir to the throne, made regular and substantial monetary donations. Members of the court elite followed their example, and Betskoi amassed a substantial endowment.[28] He himself devoted the bulk of his personal fortune to the institutions.[29] Contributions from other groups, in particular from the people of Moscow, were slower in coming. The resistance of the Muscovites was finally broken in 1768 with the donations of the eccentric millionaire industrialist Prokofii Demidov, who committed over a million rubles for the construction of a huge complex of buildings for the home in the center of the city. Assistance then flowed in from many other smaller donors among Moscow's nobles and merchants.[30]

As a spur to giving and a means of moving people beyond this passive involvement, Betskoi established channels by which private citizens could participate more closely in the work of the foundling homes. One method was to designate contributors and other persons expressing sympathy with the enterprise as "Honorable Philanthropists," giving them the right to report to the governing board about administrative abuses in the institutions or other problems that might come to their attention. Betskoi made the designation of Honorable Philanthropist especially attractive by having the empress grant its bearers freedom from corporal punishment; the educated elite much desired this guarantee, which until 1785 was not accorded even to nobles by statute.[31] So Betskoi and Catherine were not only using the homes to create artisans from foundlings; they were also using them to Europeanize the upper classes, to convert them from the almsgiving in the street on holy days to an institution-oriented form of charity.

Betskoi encouraged civic leaders in provincial cities and towns to follow the example of St. Petersburg and Moscow and to set up foundling homes in their localities. Despite the very different social makeup of

[28] *MIMVD* 1, part 3:42–69, contains extensive lists of contributors.

[29] Maikov, *Betskoi*, 204–5.

[30] Miller, "Iz proshlogo Moskovskogo Vospitatel'nogo Doma," 43–46; Piatkovskii, "Nachalo vospitatel'nykh domov," 285–87.

[31] Piatkovskii, "Nachalo vospitatel'nykh domov," 278–79; Maikov, *Betskoi*, 187.

Russian as compared to European towns and the absence in Russia of a tradition of institutional giving, the initial response was good, and nearly thirty private shelters sprang up under the sponsorship of nobles and commoners alike.[32] This activity may have provided a forum for uniting local elites of nobles, merchants, and clergy and for building an urban ethos that did not previously exist. Betskoi had strong hopes for this local contribution and believed that, like the St. Petersburg home in its early years, the provincial shelters would serve as feeder institutions and send their children at age four or five to the Moscow home for schooling and job training. The local foundling homes, however, failed to live up to Betskoi's expectations. As in many other cases in Russian history, state action undermined local initiative. After 1775, departments of public assistance were introduced in each province, and they partially eclipsed the local shelters and ended government encouragement of private action in this sphere. Moreover, the local facilities proved deadly for the children; the mortality rate in many of them ran to nearly 100 percent.[33] As a result, early in the nineteenth century the government imposed a ban on private foundling care and closed most of the existing facilities. Not until the 1890s, when the number of children being abandoned threatened to overwhelm state resources, did the government lift this ban.[34]

Long-term financial support for the metropolitan foundling homes was a matter of concern. The governing boards realized that they could not count on public-spirited contributions indefinitely,[35] and so they sank a portion of their endowment into revenue-producing enterprises, including a pharmacy, workshops, factories, savings-and-loan banks, and a life-insurance society. Special monopoly rights ensured the continued sufficiency of these revenue sources. One of the Moscow home's factories, for example, manufactured playing cards and held exclusive rights to the production and sale of this commodity.[36]

The most lucrative and lasting financial ventures were the banks and the life-insurance society. Their public service aspects made them favorites of Betskoi, who believed that ordinary moneylenders preyed on the

[32] Among the towns with shelters were Orenburg, Novogorod, Smolensk, Olonets, Ostashkov, Voronezh, Kazan, Penza, Tobolsk, and Kiev: Puteren, *Istoricheskii obzor prizreniia*, 82–83; Sokolovskii, "Ekaterina Velikaia kak blagotvoritel'nitsa," 48.

[33] Puteren, *Istoricheskii obzor prizreniia*, 82–83.

[34] Maikov, *Betskoi*, 150.

[35] Indeed, contributions fell sharply toward the end of Catherine's reign: M.G.***, "O vospitatel'nykh domakh," 99; Maikov, *Betskoi*, 152–53.

[36] *MIMVD* 1, part 3:14–26; Miller, "Iz proshlogo Moskovskogo Vospitatel'nogo Doma," 73–74.

weak. The life-insurance society, known as the "Widow's Fund," filled a need, Betskoi pointed out, since women and children frequently suffered destitution after the death of the family provider. To pay off debts, the survivors pawned valuables, which were never recovered on account of excessive rates. In other cases, widows fell into the clutches of moneylenders charging "triple interest." Laws enacted against these rapacious practices were impossible to enforce, Betskoi asserted, and the consequences went beyond the victimization of the persons involved and their families. The state also suffered, because children were deprived of the means to a good education and the chance to become useful citizens.[37] Betskoi was sure that the insurance society, by guaranteeing an annuity to widows and children of members, would end this type of exploitation.[38] Contrary to expectations, the Widow's Fund began disappointingly. Launched in 1772, it attracted few subscribers in the first decades, perhaps because of the novelty of the enterprise and the complexity of its regulations. After a regulatory reform in 1803, however, business picked up, and the fund operated with some success until the middle of the nineteenth century.[39]

The savings-and-loan banks, on the other hand, immediately won public confidence and prospered. The capital base of the Moscow home's savings bank grew from 236,025 rubles at the time of its opening in 1772 to 1,368,486 rubles three years later, and to over 8 million rubles twenty years later. By 1803, deposits at the Moscow bank stood at 15.5 million rubles, placing it among the most important financial institutions of the time.[40] As with the Widow's Fund, the purpose of the banks, apart from their revenue-producing function, was to protect the public from unscrupulous private operators.[41] But an important reason for their success was a provision in their charter forbidding confiscation of deposits by government or private interests, a provision that protected both depositors and their descendants. Like freedom from corporal punishment, this protection was one of the guarantees of person and property most sought after by the Russian elite, and it encouraged a flow of capital to the banks.[42] The banks functioned effectively

[37] Betskoi, *General'nogo plana . . . kazny*, 19–25.
[38] Ibid., 27–62.
[39] The business nevertheless remained insignificant in comparison with the potential market: Maikov, *Betskoi*, 210–11.
[40] Kahan, *Plow*, 314. Figures on the capital holdings vary somewhat in other reports: see Maikov, *Betskoi*, 222, and Miller, "Iz proshlogo Moskovskogo Vospitatel'nogo Doma," 74.
[41] Betskoi, *General'nogo plana . . . kazny*, 63–90.
[42] See the letter by Nikita Panin and Ernst Minikh in support of this policy, in Piatkovskii, "Nachalo vospitatel'nykh domov," 281.

and provided a good income for the foundling homes until the financial and credit reforms of 1859 and 1861 limited their activity.[43]

CARING FOR THE CHILDREN

Despite the solid political and financial support for the foundling homes, implementation of Betskoi's program proved troublesome. The problem was not in attracting sufficient children. Efforts to promote admissions succeeded only too well. The rapid increase of numbers in both the Moscow and St. Petersburg homes through the late eighteenth century threatened to overwhelm the considerable physical plants and staffs provided for them. The chief difficulty, rather, was the inability of doctors and officials to keep large numbers of children alive in an institutional setting. Plans for the nourishment and education of the children, which appeared reasonable on paper, proved to be ineffective in reality.

When the Moscow home opened in 1764, the expectation was that all the children would remain in the institution, initially in the care of hired wet nurses and later of teachers and other persons. Betskoi's plan for creating a new generation of enlightened citizens required the kind of controlled environment that could be achieved only in a closed setting. His plan for rearing the children emphasized management, supervision, and training. No one gave sufficient thought to the problem of survival, despite ready examples of the failure of large-scale institutionalization of infants. As recently as 1756, the Foundling Hospital in London had opened its doors to indiscriminate admissions and had been swamped by a flood of babies whom the institution had no way of keeping alive. Within four years, Parliament, which had initiated the new policy, reversed itself and ordered a sharp reduction in admissions.[44] But Betskoi was so enthusiastic about the positive, instrumental possibilities of foundling homes that he remained blind to their deadly effect on the infants and so repeated the murderous experience of the London hospital.

Admissions in 1764, the first year of the Moscow home, amounted to 523 children, of whom 424 or 81 percent died in that same year. The next two years saw an improvement, but in 1767 calamity struck. Nearly the entire complement of children admitted, 1,074 of 1,089 (slightly less than 99 percent), died before the year was out. Although this carnage owed something to a smallpox epidemic then raging, it riveted

[43] Maikov, *Betskoi*, 222.
[44] Nichols and Wray, *Foundling Hospital*, 54–55.

attention on the failure of the home's methods and forced a change in infant-care arrangements.[45]

The main problem in keeping the infants alive was an inadequate supply of wet nurses. Imbued with the sentimental idea of the bucolic life, doctors and officials believed that the most wholesome wet nurses came from the villages.[46] But few peasant women could forsake their families and farm work to serve for months as nurses at the foundling home. The limited number who did come had to carry an inordinate burden, often breast-feeding two or more children at a time. To increase the supply of milk, the home established a dairy. Betskoi understood that human breast milk was superior to nonhuman milk—doctors did not yet know how to modify cow's or goat's milk into a formula easily digested by infants—and in his initial plan for the home, he even cited experiments done in England and France showing high mortality among infants not fed on mother's milk.[47] Now desperate to find adequate nourishment for the babies, he changed his mind and declared that good goat's or cow's milk was better than "bad breast milk,"[48] by which he may have meant inadequate or older mother's milk. But even with the dairy, the home did not always have sufficient supplies of milk and had to turn to purchases from private sources, where it encountered the practice by distributors of diluting the milk to increase its volume and then thickening it with grain to conceal the dilution.[49] It was also difficult to insure the freshness of purchased milk. Milk of the wrong composition or freshness brought on digestive disorders, and, because the disorders prevented absorption of nutrients, ultimately death.

After the disastrous mortality of 1767, the governing board of the Moscow home decided on a new approach to increase the number of wet nurses. Since peasant women could not stay for long periods in the central institution, the board encouraged them to fetch a child at the home and return with it to the village for nursing. During the second half of 1768, when the policy went into effect, the home placed 432 infants with village women. The wet nurses received a stipend of two rubles per month, plus a bonus of two rubles for the return of a living child after nine months (the age of weaning recommended by the home's doctor, Antonio Sanchez).[50] During the first two years of the village-care program, the children resumed residence at the central

[45] *MIMVD* 1, part 1:46.

[46] Piatkovskii, "Nachalo vospitatel'nykh domov," 300–301.

[47] Betskoi, *Uchrezhdenie Imperatorskogo Vospitatel'nogo Doma*, preface.

[48] *MIMVD* 1, part 1:5.

[49] Ibid, 4.

[50] Piatkovskii, "Nachalo vospitatel'nykh domov," 300–301.

home after the nine-month period. Later, they remained with their peasant foster families until age five, returning to the foundling home at the time they began formal schooling.

Betskoi vigorously opposed the new policy of wet nursing in the villages, because village fosterage ran counter to his objective of molding a new type of citizen. He saw no point in making careful arrangements for rearing the children in enlightened conditions if they were going to spend a crucial phase of their upbringing in the brutish environment of rural Russia. The contrast in methods of care could scarcely have been greater. Three pillars of peasant child-rearing were swaddling, rocking babies for hours on end, and, at later ages, frequent beatings. The foundling home dressed the children in loose-fitting clothes, strictly forbade cradles, and declared corporal punishment grounds for dismissal. Betskoi bent every effort to persuade the governing board that the shift to village fosterage was as unnecessary as it was destructive. The great mortality in the Moscow home arose not from feeding problems, he argued, but from bad air, overheated rooms, and poor hygiene. Strict attention to these matters, he assured the board, would bring better results. To another of the board's concerns, that institutionalization cost more than village care, Betskoi rejoined that it was wasteful to spend money on a method that failed to produce positive results and that no expense was too great if it achieved the intended goal.[51] Neither Betskoi nor the board had any notion of the unhealthy effects of institutionalization itself. For Betskoi the danger obviously lay in the alternative. The wet nurse shortage, however, forced him to give way, and beginning in 1772 the Moscow home sent as many infants as could tolerate the journey out to nurses in the villages.

The shift to village care failed to improve significantly the survival rate of the infant foundlings. The failure was not, however, evident in the official accounts, which recorded declines in the death rate after 1774. During the best years, 1778, 1786, and 1796, mortality, according to official reports, reached lows of 8 to 11 percent.[52] These astounding figures were purely cosmetic, arrived at by a deceptive method of reckoning. Instead of calculating mortality for the cohort arriving at the home during a particular year, administrators counted the number of deaths among each year's cohort—and apparently only deaths occurring in the home itself—compared to the total number of children in the system, the majority of whom had already left the home. The true rate of loss among the children who stayed in the central home, now in more

[51] Ibid., 301–2.
[52] *MIMVD* 1, part 1, chart between pp. 64 and 65.

manageable numbers, was about 68 percent during the last quarter of the eighteenth century. Mortality among infants who had been brought to the countryside was even greater. From 1769 to 1797, nearly 33,000 children were delivered to village care, and they died at a rate of over 80 percent. A comparison of death rates before and after the initiation of village fosterage reveals its limited effect on the children's chances of survival. In its first four years of operation (1764–1768), the Moscow home admitted 3,147 children, of whom 82.1 percent died before reaching their majority. During the next twenty years (1768–1787), admissions ran to 23,947 and over 75 percent of these children went to village fosterage; yet 19,469, or 81.3 percent, of the children died before reaching their majority, an improvement of only .8 of a percentage point over the entire 1764–1787 period.[53] More graphically, with regard to Betskoi's objectives for the home, of 42,674 children admitted during the first thirty-four years of the Moscow home, only about 5,500 (12.9 percent) survived in the home or in village care to eventually enter the schools of the central home, and fewer still survived in the schools long enough to benefit from the training Betskoi had planned for them there. A contemporary critic of Catherinian government pointed out with some justice that the foundling homes had produced "few or scarcely any artisans."[54] Building a new social group from unwanted children was no easy matter.

Despite the difficulty of housing and keeping alive the many children entering the homes, Betskoi never gave up his aspiration to exercise tighter control over their behavior. As late as 1779, he was still arguing for abolition of the village fosterage program and concentration of the children in a single location. He suggested that they might spend the warm months in the healthy atmosphere of a suburban encampment and reside in the metropolitan foundling homes only during the winter.[55] When this proposal met defeat, Betskoi pressured for a stricter oversight of the children living in village foster care, a proposal that eventually won approval. In 1789, the Moscow home hired a circuit overseer (*raz'ezdnyi nadziratel'*) and issued instructions for his regular visits to the children. It is difficult to imagine what impact a single overseer could have had on a system that by 1796 included over 5,000 chil-

[53] Based on total intake and death rates; see table A-1. Percentage sent to villages taken from M. G.***, "O vospitatel'nykh domakh," 109. This author makes the point about the limited effect of the change on the basis of other data. It is possible, of course, that village care may have kept the death rate from rising even higher as the result of increasing annual admissions.

[54] Shcherbatov, *Corruption of Morals*, 253.

[55] *MIMVD* 1, part 2:3.

dren dispersed across 269 villages in eleven districts of Moscow province, and indeed this method was soon abandoned—but it marked the first of many attempts to create a satisfactory mechanism for supervising the children in village care.[56]

Neither did Betskoi relinquish his aspiration to rear the surviving children in accordance with his principles. For example, he learned in 1784 of the mistreatment of some boys from the foundling home who had been put to work in factories owned by the home, a revelation that prompted a sharp letter from him to the governing board. He reproved the board for permitting the abuses and even more for allowing assignment to factory work in the first place. Did the board members not understand, he asked, how little this type of work conformed to his plan of upbringing? He reminded them of their commitment to rear free citizens of the middle estate, not factory workers. The youngsters needed to acquire training appropriate to their station. How were they going to do this if they mixed with the coarse people of the factories? Moreover, Betskoi scolded, the foundling home ought not to operate like a private manufacturer and for the sake of maximizing profit relegate the children to labor that did not prepare them for anything better in life. The first duty had to be to the children. The plan was to train them in good morals and diligence, for these virtues would be their sole capital. The foundling home's official medal showed Charity lifting up a child and saying, "You Too Shall Live," Betskoi continued. "But what is life without a proper upbringing? It is only a burden to oneself and others."[57] When these unfortunate children later realize that they have been deprived of a decent education, when, as a result, they find themselves shut out of society and abandoned to immeasurable sadness, he wrote, "they will curse their life and accuse with tears those who preserved it for misfortune."[58] In other words, the institution had to be the family for the foundlings and instill in them the middle-class values that would strengthen the social order while enfolding these young people into it.

Betskoi may have been trying to reassert his failing influence with the governing board, and he certainly was deluding himself about the opportunities for the foundlings. His melodramatic appeal nevertheless seemed to have an effect, since the homes soon afterwards divested themselves for a time of their factory holdings. But this incident marked the end of the aging Betskoi's personal influence on the homes. Al-

[56] A table showing distribution of children in the system is in *MIMVD* 1, part 2:5–6.
[57] Maikov, *Betskoi*, 180–81.
[58] Ibid.

though he survived until 1795, dying at the age of ninety-one just a year before the end of Catherine's reign, blindness afflicted him in the early 1780s, and a stroke in 1785 caused further debilitation. Five years later, he served briefly as acting director of the St. Petersburg Foundling Home, but he could scarcely have been more than a figurehead. Catherine described him in this period as a blind, driveling old fossil who went about asking young men if they were personally acquainted, as he had been, with Peter the Great.[59]

Despite the waning of Betskoi's personal involvement, his program for the foundlings continued until 1796 much as he had designed it three decades earlier. The only major compromise was in early childhood care, which over his objections the governing board entrusted to women in the countryside. The rest of the original system remained intact. Betskoi's emphasis on training the foundlings for urban occupations continued. Fosterlings who survived childhood in the villages returned to the metropolitan homes in their sixth year to receive a general education, as well as training in a craft or in a manufacturing or service job. Depending upon the children's abilities, their education could include training in foreign languages, theater, and ballet, and a few of the most gifted continued on to higher studies. At maturity, the foundlings entered the free population of the towns.

CONTEMPORARY REACTIONS

The purposes of the court in establishing the foundling homes were to make Russia more like the West and to advertise the enlightened policies of Empress Catherine. The homes stood as an expression of the concern for children of the "mother of the fatherland." The policy of open admissions, intended to facilitate the deposit of children and so their salvation, also displayed understanding for the plight of the "fallen woman." Liberal admissions regulations of this kind had been tried briefly in some West European foundling homes and had operated without official sanction for several decades at the Paris hospital, but Russia was the first country to proclaim such policies formally and to stay with them over an extended period. Much fanfare accompanied the opening of the Russian homes, including great processions through the capital cities, ringing of the bells of the churches, cannonades, and galas with the feeding of hundreds of needy persons and distribution of dowries to artisan youth—ceremonies that on a smaller scale were repeated year

[59] Betskoi was officially replaced as chief guardian of the home in 1792: Maikov, *Betskoi*, 195–201, 447 (on his condition see also ibid., 458, 460).

after year, symbolically reasserting the link between the tsarist family and the common people.[60] The government published the regulations of the institutions in many editions, translated them into foreign languages, and circulated them at home and abroad. The speeches and odes given on ceremonial occasions left no doubt about the significance that the empress and high officials accorded the foundling homes as a symbol of tsarist benevolence.

The feelings of the public did not, however, precisely reflect those of the government. As a rule, foreign visitors saw only external appearances and accepted the government's accounts of the good results the foundling homes were achieving. Criticism was more likely to come from Russians. They were closer to what was happening and could scrutinize it. They were also the persons who had to bear the costs of the operations and the responsibility for them.

As was often the case with government-sponsored innovation, the project for establishing the foundling homes did not win immediate sympathy from the people whose help was needed to implement it. Right at the outset, difficulties arose in the form of passive resistance from the clergy and minor officialdom. The government had hoped to enlist the support of the parish priests in disseminating information about the Moscow foundling home and facilitating the journey of women and children to the institution, but the priests proved to be a great disappointment. Some apparently regarded the institution as an incitement to immorality. Others resented state interference in a sphere that had long been the concern of clerics and had provided opportunities for priestly profit.[61] If the clergy's failure to cooperate limited the effectiveness of the government's program, footdragging by bureaucrats threatened to undermine it altogether. Though instructed by a Senate decree to assist the founders of the Moscow home, local officials threw up obstacles at every turn. At first, they said they had not received the Senate orders, and Betskoi's agents had to visit the offices responsible for providing land and materials for the foundling home and personally deliver the edicts and demands for action. Even then, officials wrangled over details and delayed the project for months on end. The obfuscation seemed to arise less from ordinary bureaucratic procrastination than from antipathy toward aid to illegitimate children.[62] This posture may have reflected a wider local prejudice against the project, since Betskoi's

[60] Miller, "Iz proshlogo Moskovskogo Vospitatel'nogo Doma," 39–40; Piatkovskii, "Nachalo vospitatel'nykh domov," 291–93.

[61] Piatkovskii, "Nachalo vospitatel'nykh domov," 284–85; S. E. Termen, *Prizrenie neschastnorozhdennykh*, 7–8.

[62] Piatkovskii, "Nachalo vospitatel'nykh domov," 285–87.

agents in Moscow reported great difficulty in obtaining charitable contributions for their work. Muscovites closed their doors to them, and the agents had to rely on support from St. Petersburg until Prokofii Demidov made his large donations in 1768.[63]

Other criticism was more articulate and focused on specific aspects of Betskoi's work. The writer F. A. Emin took exception to Betskoi's efforts to produce a "spirit of liberty" in his schools.[64] This criticism could scarcely have applied to the regimented internal organization of the schools; evidently, it referred to Betskoi's rejection of swaddling, beating, and other edifying methods of child-rearing, and to the whole cluster of attitudes associated with these methods. The leader of the conservative nobility, Prince M. M. Shcherbatov, deplored the foundling homes as one more example of the moral corruption that had set in since the beginning of the eighteenth century. He also attacked them in terms of their own objectives, pointing out that they killed more children than they educated.[65] Perhaps most of all, Shcherbatov was upset about the independence and dictatorial powers with which Betskoi managed the imperial institutions entrusted to him,[66] a concern echoed by some state officials and private landowners, who warned the empress about the special status and privileges of the foundling homes. The rights of the homes to freedom from taxation, tariffs, and policing of their personnel prompted charges that the institutions constituted a state within a state and as such a menace to imperial power. Another indictment, emanating from serf owners, contended that the homes wrongly deprived landlords of their property, since some of the children admitted to the facilities had been born in privately owned villages. The landed interests also expressed concern about the banks controlled by the Moscow home, believing that they would cause the ruin of landlords who could not repay their loans.[67]

Betskoi did not let these criticisms go unanswered. Without special privileges and exemptions, he told the empress, her philanthropic work would long ago have succumbed to the predatory habits of the bureaucracy and the courts. He had to admit that serf children occasionally ended up at the homes, despite the rule against their admission. But, he added, these children would not have been an asset for the landlords. The children were unwanted and would have suffered neglect, pain, and

[63] Ibid., 285. See also comments by Zabelin, *Vekovye opyty nashikh vospitatel'nykh domov*, 17.

[64] Maikov, *Betskoi*, 464–65.

[65] Shcherbatov, *Corruption of Morals*, 253.

[66] Ibid., 241–43.

[67] Maikov, *Betskoi*, appendixes, 116–18.

death. If by chance some of them survived, they would have grown up to be brigands and so a threat to propertied interests. As for the role of the banks, Betskoi accused his critics of being "stupidly malicious," since everyone knew that the foundling-home banks treated defaulters more leniently than did ordinary state credit institutions and that the homes had no means of retaining or profiting from property confiscated by their lending institutions.[68] Betskoi was undoubtedly right about these specific issues, but his opponents nevertheless had reason to be concerned about an institution that granted liberty to all its graduates and so allowed them to ply their trades freely in any part of the empire, a rare privilege in a society in which not only serfs but nearly everyone else was formally bound to a specific locality. The foundling-home graduates constituted an anomaly and possibly a dangerous model of free people in an otherwise unfree society.

The crucial problem with the homes lay elsewhere, however. It was bound up with the dual aims of its founders, who undoubtedly wished to do good but who even more wished to impress upon the world their commitment to enlightened policy and paternal care. They therefore launched a large program and housed it in monumental edifices. The fanfare with which each opening took place and the yearly reprises in gala parties, the publication of books and pamphlets about the institutions and their regulations—in short, the "advertising" function—took precedence over all else. Only a few people saw through the rhetoric and facades to the essential problems. One of these people was the German scholar August Schlötzer, a longtime visitor at the St. Petersburg Academy of Sciences. He pointed out that the government had moved too fast and on much too grand a scale. Right from the beginning, he wrote, bigness was the order of the day. "The first thing they did was build for the home's own use a magnificent church costing thousands, while in regard to the main point—the physical rearing of the foundlings and whether it was necessary to breast-feed them or use other means, and when and in what circumstances—it turned out that the author of the plan was not speaking from experience and had not even read up adequately on the subject."[69]

Most people did not look into the homes with Schlötzer's critical eye. Indeed, the court and much of high society that contributed money to the homes touted them as models of care and encouraged visitors to the capital cities to pay a call at the institutions. The memoirs of diplomats and travelers make clear that a stop at one of the foundling homes fig-

[68] Ibid.
[69] Quoted in Maikov, *Betskoi*, 114.

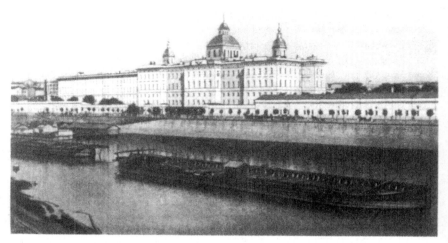

3.3 Moscow Foundling Home, built by the architect Karl Blank between 1764 and 1770; now the Dzershinskii Artillery and Engineering Institute.

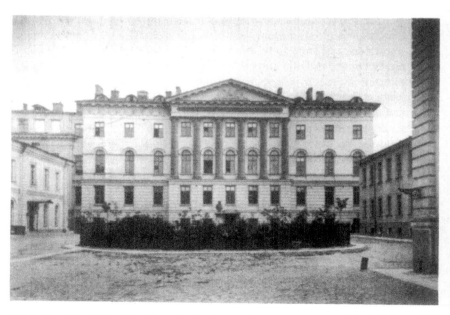

3.4 St. Petersburg Foundling Home in the nineteenth century; now one of the buildings of the Herzen Pedagogical Institute.

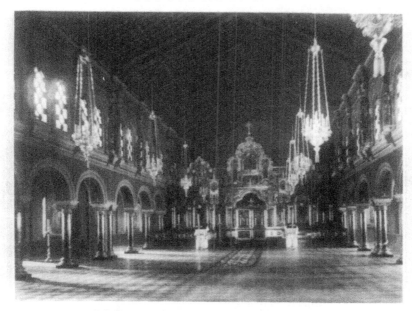

3.5 Chapel of the St. Petersburg Foundling Home.

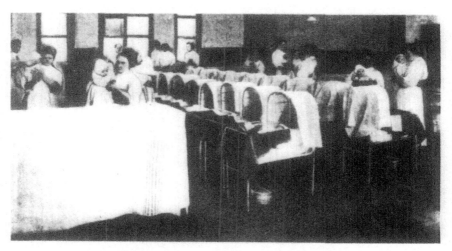

3.6 A room in one of the foundling homes.

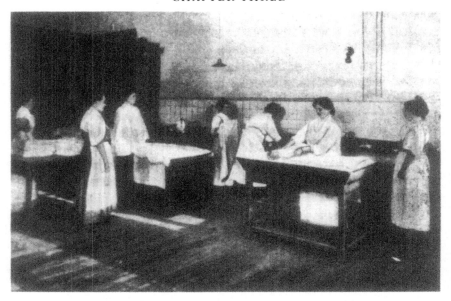

3.7 Medical assistants bathing infants at one of the foundling homes.

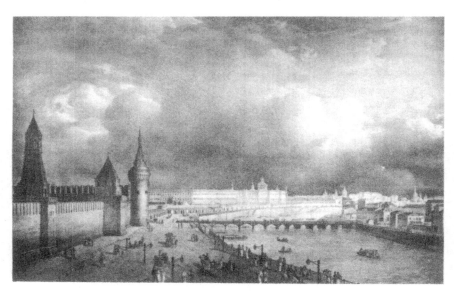

3.8 The Moscow Foundling Home (center rear) rivaled the Kremlin for dominance of the central Moscow skyline and served as an imposing symbol of tsarist solicitude for the unfortunate.

ured on nearly everyone's sightseeing agenda, and the generally favorable, if superficial, comments of the visitors testify to the empress's propaganda success. The French envoy and memoirist Corberon, for example, remarked on the good order in the Moscow home and the politeness of the children, and he judged a ballet produced by the children to be well done, even as he wondered what this training in the fine arts would do for poor orphans later in life.[70]

The English traveler William Coxe also praised the Moscow Foundling Home. He told of the neat rooms for the children, the excellent quality of their food, and the satisfaction and happiness they seemed to exude, and he spoke of how the home had curbed "the horrid practice of destroying infants, so prevalent in these parts before the institution of this hospital."[71] It is impossible to say whether this last observation was an implication Coxe drew from the comments in Betskoi's general plan about children dying in the streets or whether it was based upon some reliable report. In any event, it was cited by another foreign visitor, the scientist and historian William Tooke, who used it to prepare his readers for a favorable final judgment that, "of all the children hitherto brought up in [the Moscow home], not the hundredth part would have been alive but for that institution; and that consequently, even in times of the greatest mortality, it preserves to the state a very considerable number of young citizens."[72] Tooke probably borrowed this evaluation from two of his German colleagues at the St. Petersburg Academy of Sciences, Heinrich Storch and Johann Gottlieb Georgi. Some time earlier, Storch, who was aware of the high mortality at the foundling homes, had nevertheless praised the institutions for saving a large number of children,[73] a judgment to which his position as an economist and statistician lent weight. Storch also showered praise on the administration and educational programs of the homes. Georgi, an ethnographer, naturalist, and author of a descriptive survey of St. Petersburg, echoed Storch's dismissal of the high mortality among the foundlings, writing that "under any other circumstances, an even greater number of these children would die, so that this institution is a gain for the state."[74]

Storch and Georgi were not typical foreign visitors to Russia, since they both settled permanently at the Academy of Sciences and eventually became Russian subjects. They were doubtless inclined to make

[70] Corberon, *Journal intime* 1:75, 123.
[71] Coxe, *Travels into Poland*, 2:68.
[72] Tooke, *Russian Empire* 1:462–70.
[73] Storch, *Tableau historique* 1:313, 320–21.
[74] Georgi, *Ville de St. Petersbourg*, 219.

apologies for imperial institutions, especially those like the foundling homes in which Empress Catherine took a personal interest. But their judgment and that of others may also have been affected by the concern being expressed about infanticide in central and eastern Europe at the time. Child murder was thought to be widespread, and lurid fictional accounts of desperate mothers driven to desert or kill their children were common. In Germany, essay contests were launched to find solutions to the problem of the unwed mother.[75] In this atmosphere, it was not difficult for people to believe that all unwanted children were doomed and that the few who survived in foundling homes were a gain for society. The Russian homes, which displayed grown youngsters at work and play in spotless, well-appointed buildings, easily won the praise of those who did not look deeply into the impact of the institutions on the behavior of mothers and the survival chances of infants delivered there.

The Russian homes were, however, subjected to a more accurate accounting of their effects by at least one foreign visitor, the Englishman Thomas Malthus. In connection with his interest in population control, Malthus investigated foundling hospitals throughout Europe, and in 1789 he visited Russia. His trained eye and skill in statistical analysis allowed him to discern quickly the reality behind the official reports and the clouds of rhetoric about imperial philanthropy. Assessing the mortality at the Russian homes, he remarked dryly that "if a person wished to check population, and were not solicitous about the means, he could not propose a more effectual measure, than the establishment of a sufficient number of foundling hospitals [like these], unlimited in their reception of children."[76] This accusation of institutionalized infanticide was aimed not so much at the quality of care in the Russian homes, which was no worse than elsewhere, as it was at the practice of indiscriminate admissions.

For the Russian officials too, despite their rhetoric about the many lives the homes were saving, the results were disappointing. In anticipation of a better outcome, Betskoi had announced in his general plan that the governing board would publish regular reports on the status of the children, including the number of admissions and the mortality and morbidity among the children and staff.[77] But after a few years, the home's officials, faced with the appalling mortality among the children, ceased publication of the promised yearly reports.[78]

[75] Werner, *Unmarried Mother*, 69–104.

[76] Malthus, *Population*, 220.

[77] Betskoi, *Uchrezhdenie Imperatorskogo Vospitatel'nogo Doma*, 30–31.

[78] The reports, entitled *Izvestiia*, appeared intermittently from 1778 to 1786 and then stopped. See *Svodnyi katalog russkoi knigi*, 1:378–79.

If the life-saving work of the homes was less than expected, so too were the educational results. The small minority of children who survived to be brought up in the homes failed to become the shining examples of happiness, industry, and morality that Betskoi had predicted. Empress Catherine, who had shared Betskoi's vision, realized after a visit to the Moscow home in 1775 that something had gone wrong. She found the children awkward, reticent, and gloomy.[79] Four years later, Betskoi himself complained in a letter to the governing board that the upbringing he prescribed was scarcely evident in the older foundling girls sent as servants to the Institute for Noble Women. Their manners were worse than those of peasants, he wrote, and the girls showed "no inclination to studiousness or diligence; nothing but ignorance, disobedience, and stubbornness."[80] In later years, few of the foundlings completed sufficient training to make them enterprising and prosperous subjects. As a group, they failed to contribute significantly to the building of a third estate in Russia. The judgment of Empress Maria Fedorovna, who took charge of the homes after Catherine's death, was harsh but accurate. Looking back on nearly a half-century of state foundling care, she wrote that "the results of the upbringing turned out to be the near-total mortality of the children, and the educational significance was evident in the utter unsuitability of the graduates for an independent working life. They proved of all citizens the least beneficial to the country, and they sank to the lowest level of morality."[81]

CONCLUSION

In view of the failings of the Betskoi system almost from the beginning, one might well ask why, with the sole exception of the change to early childhood care in the countryside, the program of the general plan of 1764 remained in effect until the end of Catherine's reign thirty-two years later and then continued in modified form for another forty years. One explanation is Betskoi's timely adoption of late Enlightenment attitudes toward the unwed mother. The aspiration embodied in his institutions responded so well to the progressive social values embraced by the court elite that, until Russian leaders exhausted their faith in the most naive tenets of Western rationalism, they could not muster the will to reform the foundling homes even in the face of evidence of their lethal effects. The humanitarian campaigns against infanticide and child

[79] "Pis'ma Betskogo k Ekaterine II," *Russkaia starina*, 1896, no. 20:404; Maikov, *Betskoi*, 183–84.
[80] Maikov, *Betskoi*, 176–77.
[81] In a letter to Count E. F. Sievers, cited in Oshanin, "O postanovke prizreniia," 691.

exposure in eighteenth-century Europe emphasized protection of the unwed mother. People who thought of themselves as enlightened understood that the persecutions of these unfortunate women in the past had driven them to desperate measures. It seemed that a system allowing an unmarried mother to turn her baby over to public care, conceal her identity, and resume a normal life provided the most effective protection for both her and her child. Although the rationale was salvation of the child, the concern was chiefly for the mother. She was the central object of pity in the literature of the period. In other countries and regions—especially in Roman Catholic communities, which, like Russia, protected family autonomy by rejecting paternity searches—this concern with the plight of the unwed mother and her child also led to programs of open access to foundling homes with a guarantee of confidentiality. The Russian system, which began fresh with a positive, even utopian, outlook and with no anticipation of the difficulties it would create, took the principle further and maintained it longer than did other European foundling systems.

Betskoi's aspirations for the children likewise coincided with faddish educational ideas. Sense-impressionist notions of the human psyche persuaded many people that children could be formed in accordance with a preordained plan. All that was needed was a controlled institutional environment and the latest pedagogical techniques, so it seemed, to mold skilled and conscientious citizens from society's cast-off children. Although some critics challenged these beliefs before the end of Catherine's reign, broad acceptance of them among the educated elite sustained the educational policies based on them well into the nineteenth century and, in the case of the foundling homes, despite the failure to achieve anything like the promised outcomes. Not until the reaction following the Napoleonic Wars and the reign of Nicholas I did Enlightenment values suffer an eclipse in Russia. This change, together with a more sober assessment of the practical problems of institutional child care, finally led to a dismantling of the Betskoi system.

Betskoi nevertheless bequeathed three powerful legacies. The first was bricks and mortar and what they symbolized. The huge buildings of the Moscow and St. Petersburg foundling homes stood as imposing statements of the tsarist family's commitment to collect and care for unwanted children and reinforced the paternalist ideology of the regime. The structures attracted the admiration of foreign visitors and so assured other nations of Russia's enlightenment and validated its inclusion in the European family. At the same time, the foundling homes attracted an ever-increasing number of Russian children and gradually became dumping stations for cast-off infants from vast areas of pro-

vincial Russia. Betskoi also left to his successors a foundling-care system with a rich endowment, profitable financial enterprises, and unstinting imperial patronage, all of which provided such ample support for the expanding population of foster children that the homes had little incentive to devise programs for reducing child abandonment at its source. Finally, Betskoi firmly implanted the confidential admissions policy in the charter of the homes and advanced such persuasive arguments for it that Russian officials shrank from discarding it until the 1890s. Through these legacies, Betskoi's work continued to shape Russian foundling care until the end of the tsarist regime.

The Era of the Turning Cradle
in Europe and Russia

SINCE THE ESTABLISHMENT of foundling homes in Russia owed much
to the desire of Russian leaders to make their country more like Europe,
the experience of Europe continued to influence the operation of the
Russian homes. France and Belgium were especially important, because
these countries adopted large nationwide systems of foundling care in
the early nineteenth century. Moreover, the French municipal homes
had served as Betskoi's principal model in erecting the Russian institu-
tions, and France after the Revolution continued to hold the attention
of Russians, providing a standard of progressive legislation in social af-
fairs. Yet what happened in France was part of a larger European trend
in dealing with child abandonment. An exploration of these trends can
thus help in the assessment of developments in Russia. But, although
Russian policy was sensitive to European influences, it also diverged
from them in ways that reveal peculiar traits of the Russian political and
social system.

THE EUROPEAN EXPERIENCE

The idea of unrestricted admissions to foundling homes arose in west-
ern Europe, where it was often referred to as the *tour*, a French word
for an opening in the side of the home fitted with a revolving cradle.
The mechanism was so arranged that persons approaching from the
street could deposit a child in the cradle without being observed from
within the building. In some cases, the depositors then rotated the cra-
dle to the inside of the building; in others, they pulled a cord attached
to a bell or otherwise made a signal that alerted a worker in the home
to turn the cradle and receive the infant.

An Italian invention, the turning cradle appeared as early as medieval
times and was a feature of foundling facilities in many Italian towns
during the Renaissance and the early modern period. From Italy, the
device had spread to other Roman Catholic and even some Greek Or-
thodox lands by the late eighteenth and early nineteenth centuries. For
most of Europe the use of the turning cradle remained limited to this
later period, the time of the Enlightenment revolt against persecution

of unwed mothers. The farther south one went in Europe, the more tenacious was the tour. It was most often found, and endured longest, in strongly Catholic lands, with their strict norms against premarital sex and opposition to paternity searches in cases of illegitimacy.

Conservative Catholic authorities defended the turning cradle as much for its role in protecting the honor and sanctity of the family as in preventing desperate women from killing their infants. By concealing the identity of unwed mothers, the device shielded families from scandal and from the property claims of illegitimate offspring. The integrity of the family—its control over the marriage choices of its members and over inheritance—was crucial to the social order. If the family was unable to constrain the activities of its members, it could not be relied upon to meet its other obligations. Communal solidarity required protection of family interests in places where the family still formed the essential building block of society. It was characteristic that the country in which families most effectively dominated social and political life, the kingdom of Sicily, was also the quintessential home of the tour, or *ruota*, as it was called there. By law, every town in the kingdom had to erect a foundling home with a ruota and keep it open day and night.[1] The Sicilians further protected community solidarity with the fiction that the children passing through the ruota were legitimate "children of the madonna."[2] Peasant foster families were said to rear these children as if they were their own.

The turning cradle was common in other Mediterranean lands and their dependencies. Spain had facilities for foundlings equipped with a turning cradle in each of its forty-nine provinces.[3] In Portugal, shelters for foundlings operated in many towns and were known either by the local term for the turning cradle, *roda*, or more formally as *casa da roda*.[4] A law of 1806 made admission by means of the roda mandatory everywhere in the country.[5] The tour traveled to Spanish and Portuguese territories in the New World. In Brazil, the Misericordia home in Bahia opened with a turning cradle in 1726, as did a hospital in Rio de Janeiro in 1738, and a foundling home with a turning cradle opened in Buenos Aires in 1774.[6]

To the east of Italy, the tour appeared in the Orthodox lands of the

[1] "In ogni città, terra e paese qualunque sia vi dev'essere la ruota col campanello." (In every city, province, and land whatever, there must be a turning cradle equipped with a bell.) Cited in Lallemand, *Enfants abandonnés*, 401–2.

[2] Ibid., 404–5.

[3] Hügel, *Findelhäuser*, 301–3.

[4] Ibid., 304–5; da Costa, *Descripção topografica*, with tables on the Oporto home.

[5] Lallemand, *Enfants abandonnés*, 444.

[6] Ibid., 449–55; Russell-Wood, *Fidalgos and Philanthropists*, 298–300.

Balkans in the nineteenth century. A foundling home in Athens used a turning cradle equipped with a bell. The Romanian town of Yassy had a tour in the early years of the century. Bucharest supported a foundling home but apparently did not furnish it with a tour.[7] In the other sizable Balkan country, Serbia, large central homes on the southern European model did not take root.

After the Reformation, the German lands conducted no further experiments in large-scale foundling care, but on the northwestern periphery of Europe, large homes like those in Catholic countries operated for a time. At Dublin, a hospital opened in 1702 and remained in operation for over 150 years. This facility adopted a turning cradle as early as 1730. Despite a steady rise in the number of admissions and the cartage of infants from distant points—practices that invariably developed in connection with open admissions—the Dublin hospital retained its turning cradle into the first two decades of the nineteenth century. The extended use of this device at a large central home would seem to place Ireland in the same category as other Roman Catholic countries and suggest that similar attitudes and objectives underlay the use of this method. Oddly, however, the Dublin hospital was not a Catholic institution. On the contrary, it was sponsored by leaders of the Reformed Church with the explicit purpose of "strengthening the Protestant Interest in Ireland" by collecting unwanted children and making good Protestants of them.[8] The desire for Anglicanization, more than the typically Catholic concerns for the souls of innocents and family honor, sustained the Dublin hospital's efforts through its relatively long history.

The Danes and the English also instituted open admissions systems in the eighteenth century, but in these cases the practice was more episodic than characteristic and revealed the weak development of the social structures and values that supported the retention of the turning cradle in the lands of southern Europe. In Denmark, a tour attached to a lying-in hospital opened at the Copenhagen workhouse at midcentury and soon provoked the usual problems of rising admissions and the importation of unwanted infants from outlying areas, even from Sweden across the sound.[9] The Danes lost little time adjusting for these problems and in 1774 simply replaced the turning cradle with a system requiring unwed mothers to rear their own children, if necessary with

[7] Lallemand, *Enfants abandonnés*, 515–17.
[8] Wodsworth, *Foundling Hospital of Dublin*, 4.
[9] Lallemand, *Enfants abandonnés*, 554.

financial assistance from the community.[10] In other words, they went over to the method prevailing in the neighboring German lands.

Much the same thing happened in England. The Foundling Hospital of London, a private charity organized by the retired sea captain Thomas Coram in 1740, instituted a policy of "indiscriminate admissions" similar to the turning-cradle system in 1756. The decision was made not so much out of benevolence as out of the desire to obtain a large government grant that could be had only on condition of general public access to the facility. The result was the same as in Dublin and Copenhagen: a rapid increase in admissions and the carting of unwanted children from towns and villages far from London, a tide that soon swamped the hospital. The charity responded at first just as the Russians did a few years later under similar circumstances; it farmed the babies out to wet nurses and foster families in the countryside. But as soon as Parliament received the bill for this operation and understood the cost of continuing down this path, it called a halt to the tour-type admissions policy, and the London hospital reverted to its previous highly restrictive procedures, which permitted entrance to only as many children as the hospital could care for on its premises. The rest had to seek parish help, as in the past.[11]

What turned England away from large centralized foundling operations was the structure of their financing and the values that underlay it. The arrangement differed from that in the Catholic Mediterranean lands and in Russia. In England and the continental Protestant countries, the cost of foundling care was borne directly by the community or its immediate representatives and was not cushioned by large private endowments, self-generated revenues from associated enterprises, or church and central government subsidies not subject to review by elected bodies. In the Protestant lands, ratepayers or their representatives soon imposed limits on the amount of money available for this service and forced tighter admissions policies. Underlying this approach to public welfare were the Protestant emphasis on personal responsibility and the strength in Protestant countries of corporate bodies other than the family. The disclosure of illegitimacy and the assignment of responsibility for it were lesser threats to community solidarity in these lands than were its concealment and the laying of its cost upon the public. Since the Reformation, the temporal powers had been more and more enforcing the rules of social life, and the family, which accordingly exercised

[10] Hügel, *Findelhäuser*, 289–90.
[11] Nichols and Wray, *Foundling Hospital*, 90–91.

less autonomy in maintaining social discipline, required less protection from the disorderly behavior of its members.[12]

Between the wholly Catholic lands to the south and the Protestant dominated polities to the north stood France and Belgium, whose experience revealed an ambivalence about the application of one or the other of the two prevailing systems of foundling care. The turning cradle came late to these lands and then it briefly swept all other systems aside. Before the nineteenth century, foundling care was a local matter, and the large area encompassed by Belgium and France subsumed a variety of value systems and a corresponding diversity of approaches to the problem. The method used in Flanders and Brittany, for instance, resembled the German or British approach. In Flanders, the parish alone bore responsibility for abandoned infants or illegitimate children whom parents could not support; in Brittany, a similar subdivision, the *générale des habitants*, played the same role. Hence, unlike other jurisdictions of France and Belgium, these two permitted, even demanded, paternity suits so that the father could be made to support his illegitimate child and relieve the parish of the burden. An accused man had to prove his innocence. In one instance, Breton magistrates accepted a mother's accusations against five men and divided the cost of supporting her child among them.[13]

Morals in Brittany were severe and illegitimacy was consequently low. But by the same token, nearly all unwed mothers sought to abandon their children. In the factory areas of northeastern France, by contrast, illegitimacy was judged less harshly, its incidence was higher than in Brittany, and a smaller proportion of women abandoned their children. There, people were more likely to condemn an unwed mother for abandoning her child than for keeping it, especially after the initiation of aid for unwed mothers in the middle of the nineteenth century.[14] This attitude contrasted sharply with the moral climate of southern France, which in its concern for family honor and solidarity was more like that in the neighboring Mediterranean lands.

Despite these varied value systems, both the adoption of the turning cradle early in the nineteenth century and its abandonment after 1840 occurred as a single process throughout France and Belgium, an example of the leveling and universalizing effects of the French Revolution.

Turning cradles may have operated here and there in southern France prior to the nineteenth century, but not until 1811 did the national

[12] For background, see Dorwart, *The Prussian Welfare State before 1740*, and Raeff, *The Well-Ordered Police State*.
[13] Hufton, *Poor in Eighteenth-Century France*, 323–24.
[14] Potash, "Foundling Problem," 68.

government, making good on a promise of the Revolution to care for all illegitimate children, order foundling shelters throughout the country to use the tour. The object was again to shield the identity of the unwed mother and thereby encourage her to consign her child to the care of the community rather than to kill it. Just as in Betskoi's system for Russia, the imposition of the turning cradle nationwide in France owed something to the sentiments of publicists of the eighteenth century who reacted against two centuries of persecution of "fallen women." This stance and the conservative Catholic preference for concealment of the disgrace of illegitimacy combined to produce a consensus in favor of the tour.

The adoption of the device, however, complicated fulfillment of the promise to care for illegitimate children. Since the tour made it impossible to restrain the abandonment of legitimate children, the shelters attracted increasing numbers of unwanted children of every provenance and exhausted resources that might have been sufficient to support illegitimate children alone. After trying several adjustments to discourage "improper" entries, the French decided to phase out the turning cradle and go over to a system of financial assistance to unwed mothers, the *admissions à bureau ouvert*, which screened the women for proof of illegitimacy and financial need.

Catholic conservative opinion continued to argue against abolition of the tour, on grounds that the reform would increase infanticide, cause scandal in family and community, and, by encouraging unwed mothers to keep their children, entrust the rearing of these youngsters to women of demonstrated immorality. But at a debate on the question in 1849, the bourgeois officials of the new monarchy advocated what they saw as the less hypocritical and more cost-effective approach of verifying illegitimacy and dealing with it through subsidies. The recommendations for a subsidy program gained the support of the National Assembly in the 1850s and ultimately won the day as disenchantment with the turning cradle increased.[15] By 1851, only 69 tours out of an original 301 were still operating in France.[16] Ten years later, the number had dropped to 25, and 20 of those were scheduled for closing soon after.[17]

Meanwhile, subsidy programs were phased in. The Paris Hospital took the lead in 1837 by requiring women at the Lying-In Hospital to nurse their children at the facility and then take them home at the end of their stay. Other *départements* adopted the idea in the following years,

[15] Ibid., 82–89.
[16] Many of the *hospices dépositaires* themselves had closed; in 1860, of the original 301 only 168 were still functioning. Ibid., 93–94.
[17] Ibid., 93.

and by 1849 fifty-five of the eighty-six départements were providing aid to eight thousand children, or about 8 percent of the nation's abandoned children.[18]

The Belgian experience paralleled the French. Indeed, the adoption of the turning cradle in early nineteenth-century Belgium seems to have been a direct result of the French decision. And like the French authorities, the Belgians became disillusioned with the device. The Belgian government established a commission in 1845 to investigate the foundling-care system, and it recommended discouraging the use of the foundling homes altogether, since they invited abandonments and cost more on a per-person basis than the provision of care in rural foster homes. The same commission condemned the tour and urged that mothers abandoning illegitimate children at town hospitals be questioned about their place of domicile and that the charge for care of these children be laid upon the communities from which they came.[19] Belgium, in effect, returned to the methods in use earlier in Flanders—and with the predictable unhappy consequences. When the Belgian towns in the 1850s implemented the recommendations of the commission, they evidently provoked a sharp increase in the number of infanticides, a turn of events that stood as a lesson and a source of concern to others who wanted to reform tour-type admissions systems, including influential officials in Russia.[20]

Not only in France and Belgium was the turning cradle being abolished. Spain began to phase out this system of admissions during the 1850s.[21] In Portugal, a law of 1867 closed down the device in most areas of the country. Only the Misericordia in Lisbon, an institution established and subsidized by the government, continued to have a turning cradle for four more years, but it too went to a more restrictive policy in 1871.[22] Even in its Italian birthplace the device fell into disfavor. The province of Ferrara shut down the turning cradles in its jurisdiction in 1867. Milan followed in 1868 and was joined between 1871 and 1877 by Modena, Naples, Genoa, Florence, Venice, and Catania. By 1878, of the sixty-nine provinces in Italy, turning cradles operated in only thirty-three.[23]

[18] Ibid., 81–82.

[19] Hügel, *Findelhäuser*, 293–94.

[20] *Issledovaniia o vospitatel'nykh domakh*, 3–4; S. E. Termen, *Prizrenie neschastnorozhdennykh*, 63.

[21] Hügel, *Findelhäuser*, 301–3.

[22] Lallemand, *Enfants abandonnés*, 444.

[23] This statistic overstates the degree of retreat, since many provinces had never adopted

The arguments put forth for ending open admissions in western Europe fell into two broad categories: moral considerations and practical ones. The Austrian writer Friedrich Hügel emphasized the moral issues, pointing out that the turning cradle encouraged people to disregard their parental responsibilities, gave parents a virtual right of life and death over their children, and helped only those whom it was not supposed to help, such as the parents of legitimate children, who could not consign their children to a foundling home if their identity were known.[24]

The French scholar Léon Lallemand advanced historical and practical points against the tour. He argued that the family had been more important in the past and had needed the protection afforded by the secrecy of the turning cradle, whereas now that family bonds had weakened, the tour acted as an inducement for people to abandon their legitimate children. In other words, the family had been a key to social discipline in the past and had therefore needed protection from property claims and the demoralization that could result from illegitimacy, whereas concealment tended to harm the modern family, to which individual members did not feel the same commitment. Lallemand also contended that the turning cradle did not, as intended, prevent infanticide immediately after birth, because hospitals with tours were seldom close at hand, and a facility miles away was little help to women in regions of severe moral sanction of illegitimacy. In these places infanticide continued to occur frequently. A foundling home might curb infanticide in the days or weeks after delivery, Lallemand wrote, but the turning cradle played no role in this case, since people already knew of the birth. Lallemand likewise contested the assertion by supporters of the tour that it reduced the number of abortions.[25] On the other hand, it did prevent desperate women from obtaining guidance and encouragement that might have persuaded them to keep their children. Finally, he made a darker accusation: the anonymity of the turning cradle permitted murderers to deposit infant corpses there and so escape punishment.[26] In these arguments one sees the emergence of a central idea of modern social-work intervention: the imposition of public standards on personal decisions about the size and character of families.

the tour. The results of a survey in 1881 of 8,200 Italian towns are reported in ibid., 427–28.

[24] Hügel, *Findelhäuser*, 409–13.

[25] The object of abortion, he noted, was to terminate a pregnancy and not the life of the child as such—a subtle point, to be sure.

[26] Lallemand, *Enfants abandonnés*, 666–83.

CHAPTER FOUR

The Reforms of Maria Fedorovna

Long before the fashion for the turning cradle came and went in France and Belgium, the Russians were struggling with the consequences of the open admissions system bequeathed to them by Ivan Betskoi. As early as 1796, the last year of the reign of Catherine II, the Russian homes could no longer find acceptable job training situations for all the children. The governing board therefore ordered that only a select group of children returning from the five years of village care—a number of children equivalent to the number of placements available for training in craft and manufacturing jobs—be given primary schooling and training in urban skills. For these children, apprenticeships were to begin at age eight and last sixteen years for the boys and twelve for the girls, at the end of which time the boys received 300 rubles and the girls 150 rubles to set themselves up in an independent life. The other children, for whom no placements were available, skipped the urban training and went directly to agricultural colonies in thinly populated outlying provinces.[27] This arrangement evidently arose more from immediate administrative difficulties than from a considered policy shift, for it did not last long. But the change pointed in the direction of future measures.

The following year, the new empress, Maria Fedorovna, wife of Emperor Paul, took charge of the foundling homes and their associated medical and financial institutions. No figurehead director, Maria energetically managed these facilities and other imperial charitable and educational enterprises until her death in 1828. In honor of her contributions, the tsarist charities continued thereafter to be designated "The Institutions of Empress Maria."

Maria launched an assault on the Betskoi system early in her tenure by announcing a reform that carried forward the basic principle of the change introduced in the last year of Catherine's reign, severely limiting the number of children who could receive training in urban occupations and culture, and she thereby assured that most of the foundlings would grow up in the countryside, though more often in families than in agricultural colonies. Each foundling home was to keep no more than five hundred children for rearing. The rest had to go to wet nurses or foster families in the villages, and, except for a brief return visit to the central home at age three for smallpox inoculation, the foundlings would spend their entire childhood and adolescence among the peasants. The foster families earned a stipend, which varied with the sex, condition, and age of the children. Slightly more money was given for the care of girls, and

[27] *MIMVD* 1, part 2:7.

70

4.1 Empress Maria Fedorovna, director of the imperial charities from 1796 to 1828.

more still for the physically or mentally disabled, in order to make up for the expected lower return on the families' investment in the care of such children. The stipend diminished when the children were old enough to contribute to the household and field work, and it ended altogether at age seventeen. The girls were expected to marry at this time and received a dowry of twenty-five rubles. Boys who set up household on their own piece of land were entitled to an eighteen-ruble grant for the purchase of equipment. On coming of age, the foundlings were registered as state peasants in their village of residence and so ended up

in a life far different from the aspiration Betskoi had for them.[28] Only the minority of foundlings retained in the central homes had the opportunity to become educated city dwellers, and this aspect of the program became a mere window dressing as the reform channeled more and more children to the countryside.

Two considerations motivated this reform. The first was the continuing high mortality among the foundlings. In Maria's initial instruction to the administrative head of the St. Petersburg home, she stressed the urgent need to reduce the death toll. There was scarcely any point, she wrote, for the home "to accept children merely to be a witness to their untimely death."[29] Since overcrowding in the homes was one cause of the high mortality, Maria believed that the villages, despite the ignorance and filth that abounded there, offered the children as good or perhaps a better chance of survival. In any event, the central homes could effectively care for only five hundred children. The rest had to be supported elsewhere.

The second motivation for the reform was the failure of Betskoi's program of moral training. The actual results of the special schooling, Maria remarked, made a mockery of the idealistic hopes of the founders. Instead of becoming enlightened, enterprising citizens, many graduates joined the criminal element and added to the problems of the towns.[30] With this observation, the empress identified a problem that would become fully apparent only later in the nineteenth century, when better statistics were available: a portion of each cohort of foundlings came to constitute a self-perpetuating subgroup of urban society, which each year reproduced itself by depositing a predictable number of offspring at the foundling homes. Other large-scale foundling-care systems in Europe also produced this type of "caste."[31]

Maria tried several other reforms. The most innovative was a program like that introduced in France thirty years later, providing subsidies for unwed mothers to allow them to keep their children. Though familiar on a small scale in some municipally run shelters in German Protestant countries, this method had not yet been tried in any of the large found-

[28] Ibid., 7–8.

[29] Letter to Count E. F. Sievers (Betskoi's successor as head of the St. Petersburg home), cited in M. G.***, "O vospitatel'nykh domakh," 38.

[30] Oshanin, "O postanovke prizreniia," 691.

[31] Hügel claimed that, in France, from the descendants of 130,000 former foundlings, every year on the average 36,000 new foundlings were born: *Findelhäuser*, 402. The annual reports of the Russian foundling homes published in the late nineteenth and early twentieth centuries contained a separate category for infants deposited at the homes by former foundlings.

ling systems of Europe. The empress, who grew up in a Protestant principality of Germany, may have become aware of such a program in her home country. In any event, she initiated the program in reaction to a proposal submitted in 1804 by her assistant, State Secretary Grigorii Villamov. Villamov, like the empress, was disheartened by the high mortality among the foundlings and the poor results of village care, but he concluded that the time had come to close the homes. He saw the problem alluded to by Malthus and pointed out that not only children likely to be deserted or killed were coming to the homes but others as well, including legitimate children, who would stand a better chance without the homes. The trip to the homes itself often weakened or killed the children, and once admitted, they either received inferior older milk from staff wet nurses or went to the countryside where they might receive no breast milk. Moreover, Villamov contended, the peasant foster mothers neglected their own children to make money on foundling care and so native village children, too, needlessly suffered and died. He added that if the homes continued in operation, at the very least the empress should sever all ties between the children deposited there and their parents, so as to discourage parents from abandoning their children with the expectation of retrieving them after the homes had paid for their upbringing.[32]

Although Maria recognized the gravity of the problems Villamov described, she rejected as too harsh his advice to close the homes or to rupture parental ties permanently. Instead, she sought to strengthen the parental bond by offering financial aid for seven years to unwed mothers who agreed to rear their children. The program began in 1805 but ran into difficulties because officials did not understand the problems of control. They made the mistake of launching the program while retaining the system of confidential admissions. As a result, the homes experienced a sharply rising curve of admissions, as married and unmarried mothers alike rushed to take advantage of the child allowances. The experiment stemmed the rising mortality in the homes, but these gains had to be weighed against the great increases in admissions to the subsidy program, which soon became prohibitively expensive.

In hopes of salvaging the good aspects of the program, Maria decided to abolish the open admissions policy in 1810 and require mothers to demonstrate their children's illegitimacy with identification papers that the police could check for authenticity. She also saw this change as an

[32] Zabelin, *Vekovye opyty nashikh vospitatel'nykh domov*, 23–29. Zabelin refers to the full text of Villamov's proposal in *Russkii vestnik*, vol. 210, no. 9–10 (September 1890):341–49.

opportunity to solve a problem that concerned her throughout her time as director: the identification of children of soldiers' wives, whose up-keep was to be borne by the military administration, not by the found-ling homes. Anticipating an increase in street desertions as a result of the reform, she opened four reception offices staffed by wet nurses and scattered around Moscow so that children found in weakened condition would not face a long journey to the central home before receiving care.[33] Her precautions proved warranted so far as Moscow was con-cerned. As soon as women were required to document the illegitimacy of their children, admissions to the subsidy program in Moscow dropped more sharply than they had risen five years before, and in a grim trade-off the number of street desertions and children arriving in poor condition increased so greatly that mortality rates jumped to the highest level in forty-five years.[34] Admissions at the St. Petersburg home likewise dropped precipitously (see table 4.1). By 1815, the empress conceded defeat and return to the pre-1805 system of confidential ad-missions without subsidies to unwed mothers.

The later years of Maria's experiment took place during the disrup-tion and suffering of the Napoleonic invasion, and that, together with the misleading way in which mortality was reported, vitiated the value of the Moscow experience. The patterns at the St. Petersburg home, located far from the invasion route, differed in some respects from those in Moscow. The curve of admissions was similar—a sharp rise followed by a drop during the 1811–1815 period—but mortality did not show the same large increase as in Moscow during the period of restricted admissions (1810–1815).[35] Moreover, according to a government com-mission of 1839 on the foundling question, street desertions did not rise in St. Petersburg during the experiment of 1811–1815 as they had in Moscow.[36] These observations about operations under more normal conditions failed, however, to elicit useful ruminations about further experiments with restricted admissions. The empress evidently concen-trated on the less satisfactory outcome in Moscow and the fact that, despite no increase in street desertions, the mortality rate in St. Peters-burg continued to rise. She came to the conclusion that changes in the admissions policy could not improve the survival chances of illegitimate children. Reforms led either to abuses and intolerable expense or to de-sertions and intolerable mortality.

[33] This order was given on November 19, 1809. TsGIAgM, f. 46, op. 8, d. 280, pp. 1–2.

[34] Ginzburg, "Prizrenie podkidyshei," 512.

[35] Tarapygin, *Materialy*, part 2:49 and tables.

[36] TsGIA, f. 758, op. 9, d. 526, p. 98.

TABLE 4.1

Admissions and Mortality at Moscow and St. Petersburg Foundling Homes, 1803–1820

| Year | Moscow | | St. Petersburg | |
	Admissions	Mortality[a]	Admissions	Mortality[b]
1803	2,598	23.6	2,172	67.6
1804	2,742	36.3	2,388	70.3
1805	2,960	31.4	2,411	65.6
Average, 1803–1805	2,767	30.5	2,323	67.8
1806	3,175	31.1	2,460	69.4
1807	3,202	29.2	2,634	61.3
1808	3,337	30.9	2,707	70.9
1809	3,570	33.7	2,826	69.6
1810	3,740	42.8	2,857	72.9
Average, 1806–1810[c]			2,697	68.8
1811	3,605	40.3	2,104	75.4
Average, 1806–1811[c]	3,438	35.0		
1812	2,612	54.2	2,319	77.5
1813	1,674	53.7	2,153	76.7
1814	2,387	49.6	2,492	77.2
1815	3,082	50.7	2,741	79.8
Average, 1811/1812–1815[c]	2,439	51.9	2,362	77.3
1816	3,518	49.2	2,933	75.4
1817	3,784	51.5	3,023	79.4
1818	4,340	47.9	3,063	74.5
1819	4,260	57.0	3,079	73,2
1820	4,227	49.6	3,309	68.4
Average, 1816–1820	4,026	51.1	3,081	74.2

Sources: *MIMVD* 1, foldout table; Tarapygin, *Materialy*, tables, part 2; S. E. Termen, *Prizrenie neschastnorozhdennykh*, appendixes.

[a] Proportion of children dying during the calendar year in which they were admitted.

[b] Proportion of children dying within one year of birth.

[c] Changes in admissions policy went into effect in St. Petersburg in October 1810; in Moscow, at the beginning of 1812.

When the French introduced the same type of program a generation later, they moved more slowly, supplanting the turning cradle with subsidies in gradual phases until they provided aid only to women who could demonstrate financial need and the illegitimacy of their children. As a result, the French system reduced pressure on the foundling hospitals while keeping financial outlays within manageable limits. There were also other powerful reasons for the success in France. First, in a significant long-term shift in behavior, the nation was entering a period of decreasing rates of illegitimacy, which was ameliorating the problem at its source. Second, the social matrix in France was much different from that in Russia. With France's much higher percentages of educated and middle-class citizens, the problems of communication and control were less severe than in Russia. The French had also operated institutions for foundling care since the mid-seventeenth century and had acquired experience with a number of different methods of admissions and foster care, experience that clearly served them well in implementing their subsidy program. Most important, perhaps, was the character of French political life. A free press and national assembly allowed for debate on policy options, so that social critics could argue against state intervention to protect the former family regime and advance proposals for the privatization of responsibility and care, while regular elections and intermittent *coups d'etat* brought to the fore governments that were not wedded to former policies and their attendant symbolism and could therefore take fresh initiatives. In Russia, the linkage of charity with the tsarist family and the unshaken political position of autocracy made for less flexibility.

THE END OF THE BETSKOI SYSTEM

If the reforms of Empress Maria undermined the Betskoi system, they did not entirely destroy it. A majority of the foundlings now ended up in a peasant setting, but even into the 1830s a portion of them continued to receive schooling in the homes and then to go on to apprenticeships in the towns. A favored few with exceptional ability acquired more rigorous schooling, including classes in Latin and French, and could attain professional careers. To this limited extent, Betskoi's dream of turning foundlings into members of the third estate lived on.

This minority of children retained in the cities for schooling served the government's purpose of using the homes as a showcase of tsarist benevolence. Visitors to the capital cities saw only this favored group

and were apt to regard them as typical.[37] Though useful, this illusion also held dangers. Ordinary Russians might act on it and in so doing overburden the homes and challenge the regime's ideology by breaching established social barriers. The government became concerned about just this possibility when it looked at the alarming rises in admissions to the homes during the decade from 1825 to 1835. In St. Petersburg, admissions jumped from 4,060 in 1825 to 5,226 in 1835, the number of children in village fosterage increased from 8,116 to 13,396, and the costs of running the home went up from 394,300 rubles to 605,000 rubles.[38] The Moscow home witnessed similar rises. Tsar Nicholas I (1825–1855), Maria's son, came to fear that an illusion of salvation and social advancement for poor or enserfed children was feeding the ever-increasing admissions to the homes. He believed that, whether the foundlings went into urban occupations or to peasant villages, the mere fact that they received the passport of a free person encouraged serfs to give up their children in hopes of lifting them out of bondage.

In the case of poor urban dwellers, the tsar pointed to other inducements. He thought that the special schooling provided by the homes motivated townspeople to abandon even their legitimate offspring in the expectation of their attaining not only a higher social position but also reduced taxation and the possibility of government careers. This misuse of charity, the tsar declared, was "harmful and contrary to nature."[39] Being especially solicitous of the army, Nicholas found it galling that the educational opportunities available to foundlings surpassed those provided for many orphaned legitimate offspring of military officers. For these reasons, he ordered a halt to special training for the foundlings in 1837 and denied them further access to the schools connected with the metropolitan foundling homes. These schools were turned over to the military for use in educating orphan children of military officers.[40]

The tsar expected that this reform would halt the rise in the number of admissions to the foundling homes, since parents could no longer hope to advance their children by sending them to the homes. All the foundlings now had to go to the countryside for rearing and would likely spend the rest of their lives as peasants. The alternative, which became an option only if peasant foster families did not adopt the

[37] Among the many examples of the false impression thus gained, see Kohl, *Russia* 1:342–52; Hamilton, *My Russian and Turkish Journals*, 94–96; Zagoskin, *Young Muscovite* 2:214.

[38] S. E. Termen, *Prizrenie neschastnorozhdennykh*, 60.

[39] Ibid., 60–61.

[40] Ibid., 20, 165–68.

foundlings or the foundlings did not otherwise establish themselves in the village economy, was even less attractive. Girls returned to the city to toil as launderers or servants, and boys could look forward to unskilled manufacturing work or assignment to the hated military colonies.[41] But despite the strong measures, the new policy yielded disappointing results. The closing off of educational opportunity to foundlings failed to reduce the regular annual increases in admissions. The government seems to have based its policy on unfounded upper-class notions of the behavior of peasants and poor townspeople, who turned out to be less foresightful or manipulative than the government believed.

Soon afterward, the homes' governing boards took note of a policy recently implemented in France that, it was thought, suggested a way of curbing admissions in Russia. The French system of small foundling hospices scattered throughout the country, with each handling only a limited number of children, had made it possible for abandoning mothers to keep track of their children in foster care through informal means. A mother might deposit an infant at the local hospice and then contrive to become a wet nurse for it by way of exchange with another nurse, or she could enjoy the services of a wet nurse at the hospice's expense and, knowing of her child's whereabouts, reclaim it after weaning. To discourage these practices, French officials instituted transfers of nurslings and foster children from one département to another, with the object of breaking the link between the mother and her child. The women would not abuse the system, it was believed, if they understood that they could never again see or retrieve their children. The French government announced the transfers ahead of time to allow women an opportunity to reclaim their children before they were moved to another département. During the first two years of the policy, 1835 and 1836, about 25 percent of the children in the foundling-care system were reclaimed by their mothers or by foster mothers who had grown attached to them and could not bear to lose them even if it meant relinquishing the child-care payments. Later transfer announcements, however, yielded small returns; the number of abuses had diminished, and foster mothers had learned to maintain an emotional distance from their charges. Indeed, some of the women who had reclaimed children before the first two transfers later found that they could not afford to care for them without subvention and returned them to the hospital.[42] In other words, the policy had a short-term impact on abuses but then proved counterpro-

[41] Iablokov, "Prizrenie detei," 423–24.
[42] Potash, "Foundling Problem," 77–80.

ductive. Moreover, the modest gains came at a high cost in personal suffering for mothers and children. By 1840, the French abandoned the policy.

Members of the governing boards of the Russian foundling homes believed that, as in France, some Russian parents were shifting the burden of child-rearing to the foundling homes with the intention of reclaiming their children at an age when the youngsters could contribute to the household economy. The parents were not trying to advance the child socially or educationally, as in the previous instance of perceived abuse, but merely to avoid the costs of upbringing without losing the opportunity to exploit the child's productive capacities at maturity. In Russia, potential abusers could employ this strategy because the homes provided the deliverer of a child with a ticket for future identification. This was the problem that Empress Maria's assistant Villamov had wanted to solve in 1804 by severing all ties between abandoning parents and their children. Another Russian official proposed the same policy in 1818, and Maria again rejected it. When the St. Petersburg governing board raised the issue with Nicholas I in the late 1830s, he too brushed it aside at first as being inconsistent with his mother's aim of strengthening ties between mother and child. But after the closing of the foundling-home schools failed to stem admissions, Nicholas agreed to end distribution of the tickets that allowed parents to reclaim children left at the homes.[43]

The effect on admissions at the two metropolitan homes can be seen in table 4.2. After a government announcement in 1839 of the end of ticket distributions effective January 1, 1840, both homes saw an immediate, sharp decrease in admissions. But within two years, the upward movement resumed, and by 1845 admissions at both homes were higher than the levels of 1839. As in France, the impact of this type of reform was limited and temporary.

The unsatisfactory results of these reforms led to the establishment in 1851 of a committee under the direction of the chairman of the St. Petersburg governing board and member of the imperial family, Prince Petr Georgievich Ol'denburgskii, to consider other means for controlling admissions. The committee boasted a distinguished membership, including the minister of state domains, the minister of the interior, and the St. Petersburg military governor-general, as well as leading members of the foundling homes' governing boards. But right at the outset, the powerful minister of state domains and adviser to the tsar, Count P. D. Kiselev, hobbled the committee's search for solutions. Fearing that

[43] S. E. Termen, *Prizrenie neschastnorozhdennykh*, 58–59.

TABLE 4.2

Admissions to Moscow and St. Petersburg Foundling Homes,
1839–1845

Year	Moscow	St. Petersburg
1839	7,249	5,474
1840	6,965	4,604
1841	6,437	4,615
1842	6,986	5,156
1843	7,274	5,032
1844	7,801	5,277
1845	8,235	5,808

Source: Table A-1.

an abrupt end to open admissions would produce a rapid rise in the number of infanticides, as had happened in Belgium, Kiselev urged that the committee's recommendations not break sharply with previous practices.[44] Kiselev himself came up with proposals that placed some limitations on the open admissions policy. On the assumption that infants delivered in the first weeks of life were the offspring of mothers who had to dispose of them to conceal an illegitimate birth, he proposed that the homes accept with no questions asked all babies brought in within three weeks of birth and that they continue the policy of not issuing a ticket for reclaiming the children. The homes should accept children over three weeks of age only with a baptismal certificate testifying to their illegitimacy, with a certification of need, and under certain conditions. The homes would suggest to an unwed mother that she keep her child for one year while receiving a subsidy from the institution; if she refused, the home would accept the infant and not issue a ticket for reclaiming. If the child was a serf, it would be brought to the serfowner; if the owner was not in the city, a subsidy for home care could be given for one year, and the owner sent official notification. If the child's mother was a soldier's wife or daughter, she would receive a subsidy for a year and the home would notify the military authorities (who were responsible for the upkeep of these children). Kiselev also recommended admitting legitimate children of parents too poor to rear

[44] Ibid., 63.

them but then allowing the children to remain with their own parents and providing a subsidy for their support.[45]

The committee refined Kiselev's proposals and in 1853 drew up a set of proposed regulations prescribing that the homes accept illegitimate infants up to ten days of age with no questions asked (the condition of the umbilical cord was to be a key to the age); that they accept illegitimate children beyond that age only with baptismal certificates and allow the children to be reclaimed only until they were one year old; that they accept illegitimate children over one year of age only if the mother had died (or in other cases of extreme necessity); and that they receive legitimate children only for temporary care and feeding in cases of the death or serious illness of the mother. This set of rules seemed to mark a radical departure, but the reform committee failed to explain how the homes were to identify legitimate children brought in within ten days of birth. In any event, before this issue could be put to a test, the Crimean War broke out and distracted the government from experiments with the foundling homes.

The proposals of the closing years of the reign of Nicholas I were nevertheless important in this area of government activity, as they were in others, because they pointed to new directions that the government would attempt to take in the reform era of the early 1860s. The work of the Oldenburg committee was also significant as a measure of the influence that the reforms of the foundling systems in western Europe were exerting in Russia. Yet, despite the lessons of European experience, the Russians, as the efforts of the next era revealed, found it difficult to change over to a modern system of dealing with child abandonment.

Even though the policies of Nicholas I failed to stem the rise of admissions, the reforms of his reign had one lasting effect: they delivered the final blow to the Betskoi system. The work of Empress Maria had earlier dismantled much of Betskoi's program for producing skilled artisans to populate the towns, yet a contingent of each year's admissions continued to have an opportunity to obtain an education, learn a trade, and enjoy the kind of civilized town life that Betskoi had envisioned for all the wards of the homes. The changes introduced by Nicholas I completed the reversal of the Betskoi program. By the 1850s, official instructions for foundling-home inspectors in the field warned against placing any of the children in foster care in urban areas. Placements in the district towns of Moscow and neighboring provinces were permitted only in cases of an acute shortage of wet nurses in the villages, "lest

[45] Ibid., 63–64.

the towns become overpopulated with foundlings."[46] In the towns of Serpukhov, Kolomna, and Kashira, which housed fosterlings from the Moscow home, the instructions strictly forbade further placements and advised enforcement of measures that would eventually remove all foster children.[47] Betskoi had hoped to fill Russia's towns with a third estate composed of foundlings trained in the values of industriousness, patriotism, and civic pride. Ninety years later, his dream had turned into a fear that a large number of children from the foundling homes might indeed find their way to the cities and disrupt public order.

Conclusion

In view of the fact that the Russian foundling homes introduced open admissions a half-century before the policy became a national law in France, one might be tempted to believe that adoption of the system in Russia under Catherine II contributed to the decision to introduce a similar system in France after the Revolution. Although it is possible that the favorable attention the Russian homes received in the West could have exerted some influence on policy in France, the employment of the peculiarly south European device of the turning cradle and the earlier experience of its use in Italy, Lyons, and Paris suggest that west European policy emerged from local traditions and needs. Influence in the shaping of foundling home practice ran for the most part in one direction: from Europe to Russia. The curious thing is that Russia at one point leapfrogged Europe. Having borrowed the European model of open admissions from the example of scattered private and municipal hospitals, the Russians realized it in large, state-sponsored institutions several decades before a similar system appeared in France and Belgium. As a consequence, the Russians ran up against the problems of operating this type of facility before they had a European model of how to solve those problems, and they had to cope as best they could, devising their own solutions.

In one early experiment, soon after the death of Ivan Betskoi, the homes tried to deal with overcrowding and the lack of job opportunities for foundlings by establishing agricultural colonies. Though ultimately unproductive, the approach was innovative and provided for many years an arena for the energies of some graduates of the homes. More important was Empress Maria's effort between 1805 and 1815 to introduce a program of subsidies to unwed mothers. Had she persisted, she might have guided Europe to a modern organization of state-supported

[46] Instruction of 1857 to district overseers: TsGIAgM, f. 108, op. 1, d. 462, pp. 17ob-18.
[47] Ibid., p. 18.

assistance to needy women and children. But for reasons that are not altogether clear, the empress and her officials dropped this promising policy before they had given it a fair trial. The lack of experience and of a climate of opinion supportive of strict enforcement of the rule requiring proof of illegitimacy seems to have played a role. The absence of a public opinion and especially of a middle class that could play a critical role in assessing the effects of the foundling homes and exploring other options was probably also a factor. But even if a public opinion had existed and could have been expressed openly, it is by no means certain that it would have supported Maria's reforms, for in this as in so much else, Russians were likely to mistrust their own judgment and to lack confidence in methods that had not yet been tried in the European foundling systems that they took as their models. Their failure to stay with a tightly controlled admissions procedure is all the more understandable in this period, when France and Belgium were going over nationwide to the turning-cradle method of admissions.

The initiatives taken by the Russians in the 1830s to stem admissions did not alter the rules of entry directly but aimed instead at making the foundling homes less attractive to certain categories of parents. In this case, the government addressed conditions that were peculiarly Russian, since it was concerned about enserfed peasants and soldiers' wives using the homes as an escape to freedom for their children and about poor townspeople using them as a route of upward social mobility. But after this failed experiment, policy ideas came from Europe, where demands for change in open admissions had begun to mount. Although the Russians tried strategies like the suspension of the distribution of tickets for reclaiming children, they shrank from the radical revisions of rules introduced in Belgium and France. The reasons are easy enough to discern. In the societies of western Europe, a lively public discussion of the failures of foundling care had developed and opinion leaders pressured governments to change their policies, but the regime of Nicholas I permitted no public debate on this issue. More important, the public perception of the foundling homes in Russia was positive, so much so that the government was concerned about the role of that perception in encouraging child abandonments. At the same time, the government wished to exploit the homes for their symbolic value. With few other state-sponsored charitable institutions and none so prominently displayed as signs of tsarist solicitude for the unfortunate, the regime had reason not to undermine the common belief in its good work by a radical shift in rules that would block public access to the foundling homes. An ensuing increase in infanticides and street desertions could damage the regime's paternalistic rationale. If the tsarist father could not protect his most vulnerable children, could he protect any of them?

Public Criticism and
Piecemeal Reform

RUSSIA'S DEFEAT in the Crimean War (1853–1856) prompted a reevaluation of nearly all social and political institutions, and the foundling homes did not escape scrutiny. Even aside from that impulse, the flow of abandonments had mounted so rapidly after the failed measures of the 1830s and 1840s that nearly everyone associated with the homes had come to realize the need for a fresh approach. Some people argued that Russia should do away with large central homes and shift to the Protestant system of giving responsibility to local agencies. Others doubted that either the Protestant system or the "Latin" one of large metropolitan hospitals was appropriate for Russia and advised against imposing any foreign model. This view, which was one expression of a more general nativist reaction against Western influences in mid-nineteenth-century Russia, held that the country should work out a method appropriate to itself by relying upon distinctive national attitudes and conditions (*samobytnost'*). A third point of view acknowledged the problems confronting Russian foundling care but valued the current structure and held that the system merely needed improvements in its technical aspects and in supervision.

A new element in discussions of foundling-home policy after the Crimean War was the participation of the public. During the first half of the nineteenth century, deliberation over policy and recommendations for reform were exclusively the province of persons associated with the homes or with other government agencies. The government's success in promoting the institutions as examples of imperial benevolence may have restrained potential criticism from the public, but even if critics had wished to speak out, censorship would have smothered their voices. The foundling homes enjoyed direct imperial patronage and could not be made the target of public attack. Without this obstacle, the type of criticism leveled at foundling homes in western Europe would undoubtedly have appeared sooner in Russia than it did. In fact, when the first public assault on foundling-home policy was made in Russia in 1860, an accompanying letter of transmittal indicated that the author had prepared the text as early as 1851. The nine-year delay in publication was proba-

bly due to the harsh enforcement of censorship laws under Nicholas I, a condition eased by his successor only in the late 1850s. The public discussion and proposals for reform that now began to appear waxed and waned in rhythm with the success or failure of the foundling homes' efforts to manage the growing burden of admissions.

THE BEGINNINGS OF CRITICISM

The vehicle for the first attack on foundling-home policy in Russia was a collection of articles and documents appearing in 1860 in the *Transactions of the Society of Russian History and Antiquities* (Chteniia v Imperotorskom Obshchestve Istorii i Drevnostei Rossiiskikh pri Moskovskom universitete), a prestigious Moscow publication devoted to monographic and documentary studies of national history. The editors compiled the feature on foundling homes from two main sources. The opening historical section came from a comparative study of European foundling homes written in French by a Russian author, Gurov or de Gouroff.[1] This introduction was followed by a hard-hitting critical commentary (whose author or authors are unknown) stressing the worst aspects of the Russian foundling-care system as exhibited in operations at the Moscow home. The timing of the presentation and its introductory historical survey made clear that the authors had gained inspiration from the reevaluations and reforms taking place in western Europe at midcentury. Yet if the critical impulse penetrated from the West, much of the argumentation in this initial attack drew on native Russian values and conditions.

The *Transactions* and its editor, O. M. Bodianskii, were closely allied with the Moscow Slavophiles,[2] and the nativist attitudes of this group left their mark on the article about the foundling homes. The homes were criticized as alien and inappropriate for Russian conditions.[3] Betskoi's idea of rearing enlightened citizens was wonderful in the abstract but bore no relationship to everyday life, the authors of the critique asserted. Children needed a family. Only in this way could they learn about real life and the mutual obligations and assistance that were vital to it. A foundling-home upbringing was sterile, because it was not tied to real-life situations. Teachers and caretakers were merely employees who took orders from others and therefore could not command the respect of the children. Training was divorced from the life situations in which it would be applied. Of course, the article also pointed out the

[1] Gouroff, Introduction to "Istoriia imperatorskikh vospitatal'nykh domov."

[2] Petrovich, *Emergence of Russian Panslavism*, 21, 64, 133–34, 208.

[3] Gouroff, Introduction, 98.

great loss of life in the foundling homes. In an understatement that revealed the effectiveness of the homes' public image as providers of reasonably good care, the *Transactions* critique noted that the mortality among the homes' populations was higher than for children reared in families.[4] Finally, wrote the authors of the critical commentary, the homes exerted a pernicious influence on fundamental social bonds. By encouraging illegitimacy, they weakened the moral fiber, deadened the feeling of maternal love, and undermined the parental responsibility demanded by religion, nature, and society. And these values were being sacrificed without any persuasive evidence that good was being accomplished.[5]

The commentary went on to point out that the harsh climate in Russia made foundling homes especially deadly. Children were brought in from distances of more than one hundred kilometers, and many arrived in their death throes. The practice of "baby carting" by the female entrepreneurs known as *kommissionerki* accounted for many fatalities, as these women brought in wagonloads of half-dead infants. The bitter cold in Russia even killed pregnant women who traveled great distances to avail themselves of the lying-in hospitals attached to the homes.[6] Much more might have been said about the high death rates in the homes if the authors of the critique had enjoyed access to the facts. But writing before the era of regular annual reports on the homes' activities, they accepted uncritically the notion that mortality at the Russian homes was lower than at comparable institutions in Europe, and they seemed to believe that the death rate among Russian foundlings was only a bit higher than for children generally in Russia.

The highly charged patriotism of the authors also found expression in the critique. They could not refrain from boasting of what they described as the typical generosity and grand scale with which Russians carried out this charitable activity. "Nowhere in Europe did there exist facilities like those in Moscow either in the colossal size of the building itself or in the internal order, cleanliness, and other attributes."[7] The facilities were staffed by devoted doctors and nurses. But this level of commitment was precisely the problem, the article went on. Ironically, it was just these generous features that made the homes so deadly, since they led to an ever-increasing number of children being brought to the homes, more than even the finest staff and physical plant could provide for. The home could not effectively recruit and supervise several

[4] Ibid., 99–102, 138.
[5] Ibid., 136–38.
[6] Ibid., 95–96, 143–44.
[7] Ibid., 139.

hundred "healthy and honorable" wet nurses or assure the necessary attention and nutrition for the thousands of infants in their charge. Wet nurses could not stay on duty full time, and sometimes they even quit the institution without notice. As a result, the babies were passed around from nurse to nurse, producing an arrangement that the authors labeled "phalansteries in diapers." They then emphasized the harmful effects of this "communistic feeding."[8]

The article ended with a call for a study by an independent medical expert to determine whether the current system of admissions and care of the children at the Moscow home was conducive to preservation of their health and life. This amounted to a polite demand for removal of the open admissions system. The authors had already pressed this view by quoting from a study done in Paris in 1846 for the General Council of Charitable Institutions. The study had concluded that "the tour constitutes the most important source of all evil attributed to foundling homes and provides ground for abuses and deceit of the government."[9] It also reported that loosening or tightening of the restrictions on admissions, and keeping or removing the tour had produced no impact on the number of infanticides in the areas investigated. This observation was aimed at those who feared that the closing of the turning cradle would lead to more deaths in the street. It remained, wrote the authors of the commentary in *Transactions*, only to test these findings in Russian conditions and see whether local circumstances made them equally valid or, as was implied, even aggravated the harm done by open admissions.[10]

This critical study may have prompted the renewal of activity by a government reform commission in the early 1860s. The reform commission, in turn, probably gained some time by the appearance in 1863 of a more favorable treatment of the homes: the first volume of an imposing two-volume jubilee publication entitled *Materials for a History of the Imperial Moscow Foundling Home* (Materialy dlia istorii Imperatorskogo Moskovskogo Vospitatel'nogo Doma). This work dealt mainly with the early history of the home and stressed the positive efforts on behalf of foundlings during the one hundred years since its founding. Understandably, it glossed over or distorted the mortality rates among the children and the costs of providing for their care, while devoting much space to comments on the many prominent people—members of the imperial family, archbishops and other church leaders, wealthy aris-

[8] Ibid., 144–45.
[9] Ibid., 137–38.
[10] Ibid., 138.

tocrats, businessmen, military officers, and civil servants—who contributed large sums to and in some cases directly participated in the work of the foundling home. This initiative and the renewed work of the reform commission seemed to quiet criticism of the homes for a time. The appearance in 1868 of the second volume of the *Materials*, which featured more detailed information on current conditions in the home, however, provoked a reaction and new calls for change.

One of these calls came from a former official of the foundling system. Evidently he had tried to reform the institutions from within but had encountered so many obstacles that he decided to leave his position and take his case to the public. In a book written anonymously and entitled simply *Researches on Foundling Homes*,[11] this official indicted several aspects of the foundling-care system in Russia, and he stressed in particular the need to abolish the practice of open admissions. A sense of the bitterness of the struggle he had engaged in came out in his complaint that those who opposed abolition of open admissions had hurled "black epithets" at would-be reformers and portrayed them as people who courted a return to widespread infanticide. He countered this charge by citing a number of Western writers and government studies that showed the lack of a connection between foundling-home policies and infanticide, and he related the testimony of a Belgian judge who reported no increase in infanticide in his district after the abolition of open admissions.[12] Using comparative statistics with some abandon, the former official tried to strengthen his case by juxtaposing rates of child murder in regions of France that had a tour and regions that did not. These indicated that infanticide was just as prevalent in districts having a foundling home equipped with a turning cradle as in districts having no tour at the foundling home. Since, however, there were no controls for other variables, this method did little more than reveal the variety of local customs and needs in France.

With another argument he was on more solid ground. He contended that infanticide was the result of psychological stress and disorientation at or shortly after parturition and hence could not be prevented by the availability of a foundling home.[13] His information about the psychosomatic factor in infanticide may have come from recent medical literature, for at about this time the same theme had begun to appear in the

[11] *Issledovaniia o vospitatel'nykh domakh.* The work is labeled "volume 2," but no "volume 1" can be found at the State library (Publichka) in Leningrad. The name of the author is also not traceable, although it is clear from the content that he had been an inspector for the village fosterage system of the Moscow home.

[12] Ibid., 3–4.

[13] Ibid, 28.

doctoral dissertations of medical students and in a new journal, *Archives of Forensic Medicine* (Arkhiv sudebnoi meditsiny).[14] These publications gave the courts and the public a better understanding of the psychological aspects of infanticide and helped to soften the penalties for child murder in Russia.[15] By revealing the lack of calculation and premeditation in many cases of infanticide, these writings also indirectly undermined one of the chief rationales for open admissions at the foundling homes.

In another way, the medical specialists exerted a direct impact. They knew something about statistics, and in the long series of data published in the Moscow Foundling Home's jubilee publications they found grist for their analytical mills. Shortly after the appearance of the second volume of *Materials for a History of the Imperial Moscow Foundling Home*, a doctor published in the *Archives of Forensic Medicine* a lengthy study of the foundling homes. While praising some aspects of foundling care, the doctor used the data published by the homes themselves to point out distortions and cover-ups of the mortality rates among the children delivered to the homes. He explained that the rates of 30 to 40 percent that the foundling homes reported masked the true mortality of an entering cohort of infants, because the homes measured deaths, which occurred mainly among the youngest children, against the entire population of children under the protection of the institutions. By calculating mortality separately for different age groups, the doctor revealed that the death rate among foundlings in any single cohort was actually in the range of 80 to 90 percent.[16] In other words, he showed that mortality in the Russian homes, contrary to the assertions of previous domestic critics, was at least as bad as it was in the foundling facilities of other countries, and perhaps it was even worse. These analyses could not help but sap public confidence in the ability of the homes to achieve their main purpose, the preservation of young lives.

GOVERNMENT ACTION

Adding to the public pressure for reform was the government's own desire to reconsider social policy. This urge had been evident during the previous reign, when Nicholas I appointed several commissions for re-

[14] This journal also raised important questions about living conditions among the working people of Russia and was an unmatched source of empirical data and fresh analysis on a number of social problems.
[15] See, for example, M. G.***, "O detoubiistve"; Zhukovskii, "Detoubiistvo"; Davydov, *Zhenshchiny pered ugolovnym sudom*, 38–39.
[16] M. G.***, "O vospitatel'nykh domakh."

form, including the Oldenburg committee to examine and recommend changes in foundling-home policy (see chapter 4). The need for change became even more apparent after the Crimean War, because the new ruler, Alexander II (1855–1881), planned to abolish serfdom, the institution upon which most of the other political and social institutions of the country rested.

Of the options for foundling care being urged in the period following the war, the Protestant system was not seriously considered; few officials trusted Russian peasants to treat child abandonment with anything remotely corresponding to the cultural attitudes of Protestant Europeans. Later in the century, something of the style of the local initiative of the Protestant countries, combined with the approach recommended by the nativists of allowing Russian conditions to shape the system of care for unwanted children, received a trial in the form of shelters sponsored by the local elective administrations known as zemstvos. These facilities did not, however, displace the large central homes and in some cases even increased the burden on them by expediting the dispatch of children to them. The Moscow and St. Petersburg homes remained the central receiving and processing points for abandoned children. Initially, then, the practical measures that arose from the reevaluations in the reform era followed the point of view of those—for the most part officials in the homes and in the Institutions of Empress Maria—who hoped to avoid a general overhaul or destruction of the homes and believed they could control the flow of children to them by modifying current rules and regulations.

The first of the changes dealt with the legal position of illegitimate children and sought to give parents of illegitimate boys greater incentive to keep them. A law of 1859 granted to male children born out of wedlock but registered with a family the same protections in respect to military service as other young men. Although special regulations had protected wards of the foundling homes from unfair recruitment burdens, this new law was the first to accord similar protection to all males of illegitimate birth. In the past, mothers and parents of illegitimate sons had had little incentive to rear their boys, since, if healthy, they invariably fell victim to military conscription at age twenty-one, even if the young men were the sole support of aging parents.[17] The parents could spare themselves the expense of rearing illegitimate boys and the grief of later separation by giving them to the foundling home at birth.

This equalization of the rights of illegitimate children in families should have influenced unmarried mothers or couples to keep their sons

[17] Aleksandrov, *Sel'skaia obshchina*, 290.

and should thereby have reduced the burden on the foundling homes, assuming constraints on keeping the children other than the fear of conscription were not great. It is difficult, however, to determine whether that did in fact occur. When the sex ratios of children admitted during this period are computed for the two central homes, the figures do not reveal a clear-cut effect. Both homes experienced a drop in the number of admissions of boys during the decade following enactment of the new law, but this decrease accompanied a general leveling off of admissions during the 1860s and so there was only a slight change in the number of boys relative to the number of girls (see figure 7.1). The best that can be said is that the law may have played a role, along with other influences, in flattening the rising curve of admissions that characterized earlier decades.

Before any results of this reform could be registered, the head of the St. Petersburg home, Maksim Tseimern, complained to the governing board about the rising admissions and about the connection he saw between these increases and the ease with which mothers were able to reclaim children left at the home. This situation did not conform to the purpose of the home, he argued, which was founded, as it was expressed at the time, not for indulgence toward sin but to avoid an even greater sin. The homes were not effectively enforcing the rule instituted under Nicholas I about not allowing reclaimings, a circumstance that revealed ambivalance on the part of officials about this policy. Although they knew that Empress Maria had wished to maintain a link between a mother and her child and that European foundling programs were adopting this policy, Russian officials also knew that women abused this concession by using the homes for free wet-nursing services. But they could not decide whether they should punish the women who abandoned their children and thereby possibly deter abandonments or treat the mothers as victims who with sufficient support and guidance might be able eventually to fulfill their parental role.

In February 1861, with the prospect of general changes following from the abolition of serfdom and a specific change for the homes by way of a transfer of their banking facilities to the Ministry of Finance, a special committee of three leading charity officials studied the current rules governing admissions to the homes. Instead of resolving the ambivalence completely, however, they sought only to moderate its effects, by declaring that mothers should be allowed to reclaim their children left at the homes only within the first six weeks after admission. The following year, Alexander II issued an edict enforcing that decision and at the same time reaffirming his father's decree of 1839 by ordering that

91

the homes hinder in every way possible an abandoning mother's ability to keep track of her child.[18]

Altered conditions and the general spirit of reform compelled a more thorough consideration of the foundling-home rules, and in 1862, Emperor Alexander II reconstituted the reform commission that Nicholas I had convened in the early 1850s, assigning it the task of investigating and improving the arrangements at the St. Petersburg home. The new commission was associated with the name of the court physician who headed it, Dr. Karrel', and it included subcommittees consisting of other prominent physicians.[19] One of these subcommittees studied admissions to the St. Petersburg home and observed that a majority of the children (60 percent) arrived at the home within one week of birth and that, of these, almost half (43 percent) were not baptized. Since a baptismal certificate indicated the legal status of the child, the high percentage of unbaptized children suggested that many were the offspring of married mothers who either could not or would not rear them. These observations strengthened suspicions that the homes served not only as refuges for babies who might otherwise be killed by terrified unwed mothers but also, and almost as often, as dumping grounds for the infants of poor married women. Accordingly, the head of the subcommittee, Dr. Rosov, advised that questions be put to the women to determine whether shame or poverty was the motivation for abandoning their child. If it was poverty, Rosov recommended that the home offer them a subsidy of three rubles per month to enable the women to retain their children.[20] This recommendation clearly echoed the reforms recently carried through in France and Belgium; if implemented, it would have turned Russia toward a modern system of care for dependent children at the same time as the leading West European countries.

Although some commission members supported this approach, the proposals eventually forwarded for government action and put into practice were more limited. A majority on the commission regarded as far too radical the current practices of the central foundling homes of Paris and London, which involved a formal investigation of a woman before accepting her child. Even the policy at the Vienna foundling home, of forcing women who used the adjoining lying-in hospital to nurse babies at the home for four months unless they paid a fee, struck

[18] S. E. Termen, *Prizrenie neschastnorozhdennykh*, 65.

[19] Puteren, *Istoricheskii obzor prizreniia*, 79. Prince Oldenburg was still active as director of the committee dealing with the St. Petersburg home. S. E. Termen, *Prizrenie neschastnorozhdennykh*, 66.

[20] S. E. Termen, *Prizrenie neschastnorozhdennykh*, 66–67.

92

Russian officials as unfair and ineffective.[21] Officials still held the belief that a sharp turn away from past practices would lead to an increase in infanticides. The members of the reform commission recognized the wisdom of demanding a baptismal certificate to prevent use of the homes by parents of legitimate children, yet again, in their concern about provoking infanticide, they left a giant loophole. They did not want to encumber access to the homes for desperate unwed mothers needing to be rid of their babies in the first days after delivery before the birth became known. The final draft of the new rules therefore permitted the deposit of an infant without a baptismal certificate as long as its umbilical cord remained attached (the first six to ten days of life). If a woman took this option, however, she would be denied the right to reclaim her child. The only exception was that, during a six-week grace period following abandonment, the mother could reclaim the child and either keep it permanently or reenter it with a baptismal certificate and in this way retain her right to take the child back at a later date. In either case, the woman could submit the baptismal certificate in a sealed envelope so as to avoid disclosure and humiliation at the time of admission.[22]

Another proposal advanced by the reform commission responded to the issue of the cost of child care. When a child admitted to the homes with a baptismal certificate was reclaimed, a decision was required about who would pay the cost of the child's upkeep while it had been in the home's care. The commission voted that a woman should be permitted to reclaim her child free of cost within two years after birth, but thereafter, the full cost of the child's maintenance both in the home and in village fosterage should be reimbursed. This proposal met strong opposition from the director of the St. Petersburg home. He pointed to the intersection of foundling-home activity and the services of private wet nurses and explained that the proposal of the commission would be an open invitation to abuse. Married parents in service employment, not having a home of their own and thus obliged to hire a private wet nurse, would contrive to have their infant admitted to the home, enjoy the services of a wet nurse for two years, and then reclaim the child at no cost. The arrangement could also act as an incitement to child abandonment, whether or not the mothers were married, the director pointed out, because the women would perceive the separation as temporary and not treat it as a final desperate step. Once unburdened of the child, however, a mother might either fail to achieve a material position satis-

[21] *MIMVD* 2:124.
[22] LGIA, f. 8, op. 1, d. 219, pp. 6–23.

factory, in her view, to care for the child, or she might simply become accustomed to her freedom and not want to reclaim her child.[23] In response to these objections, the board of governors of the St. Petersburg home rejected the proposal for a two-year period of "free" care and ruled that upon reclaiming a child the parent or parents had to pay all the expenses incurred up to that time for its upkeep.[24] This modification carried through the emphasis on using separation of mother and child as a sanction.

The Karrel' commission complemented this emphasis with borrowings from the recent reforms in western Europe, the object being to discourage married women from abandoning their children. Officials recognized that continued open admissions prior to the loss of the umbilical cord was a potential source of abuse, because parents of legitimate children could deposit them anonymously during the first six to ten days. But members of the reform commission believed that the prospect of never again being able to reclaim a baby abandoned in this way would be sufficient to deter most mothers of legitimate children from using this option. In other words, they placed great reliance on the desire of parents to be reunited with their child. The reasoning behind the reform appeared sound. Retention of open admissions was meant to protect the lives of newborn infants whom unwed mothers might murder to hide their shame. Officials could reasonably demand proof of illegitimacy after six to ten days, since the child's existence would then be known and concealment of the mother's identity would no longer be a factor in the child's survival. This approach appealed to officials because it promised to reduce the total number of children admitted while increasing their average age. These changes would in turn help reduce mortality rates, since overcrowding in the homes was a major cause of mortality and the greatest number of deaths occurred at the early ages.

The reforms went into effect in 1869, not only in the St. Petersburg home but also, by tsarist degree, in the Moscow home as well.[25] In Moscow, the results appeared positive at first. Admissions, which in 1868 had totaled 12,490, were down two years later to 10,661. Moreover, the rule change brought about the hoped-for decline in the percentage of infants entering the Moscow home in the first few days of life. But both these improvements lasted only a short time. By 1875, admissions at Moscow were once again in the range of twelve to thirteen thousand per year, and they continued to rise steadily through the next decade.

[23] Official entry in commission records, August 1867, attached to report in ibid.
[24] Ibid., pp. 24–29.
[25] Krasuskii, *Kratkii istoricheskii ocherk*, 47.

The trend toward admissions at a later age reversed itself even sooner and more drastically. Within five years of the reform's introduction, the percentage of children arriving during the first six days after birth had not only returned to its previous level but had even surged beyond it (see table 5.1).

At St. Petersburg, the change was a still greater failure for the results proved contrary to expectations from the very beginning. The number of children coming to the St. Petersburg home increased steadily during the 1870s, and the number brought in during the first week grew just as it had in Moscow. As a result, the mortality rate for those under one month of age mounted alarmingly into the middle of the decade.[26] In other words, instead of encouraging people to retain their babies through the dangerous early days of life, in both cities the rule change produced a rush to deposit infants before the umbilical cord fell off. It is not clear whether this was the result of unwed mothers wishing to avoid the humiliation or expense of having to obtain a baptismal certificate or the result of married couples wrongfully depositing legitimate

TABLE 5.1
Admissions to Moscow Foundling Home within Six Days of Birth,
1868–1875

Year	Number of Admissions	Admissions within Six Days of Birth	
		Number	Percentage
1868	12,490	7,964[a]	63.8
1869	11,140	7,531[a]	67.6
1870	10,661	6,230	58.4
1871	10,756	5,929	55.1
1872	11,234	6,249	55.6[b]
1873	11,324	7,338	64.8
1874	11,818	8,906	75.4
1875	12,383	8,747	70.6

Source: Krasuskii, *Kratkii istoricheskii ocherk*, 50.
[a] These data are not entirely reliable; the Moscow home began making precise reckonings only in 1870.
[b] Incorrectly shown in the source as 55.1.

[26] S. E. Termen, *Prizrenie neschastnorozhdennykh*, 74–75 and tables on 76–77.

children and therefore not having to present a baptismal certificate. In any event, instead of bringing an improvement in mortality rates, the reformed procedures, which remained in effect for ten years, until 1879, proved to be more murderous than the system they replaced.

To reinforce the purpose of the reform, which was to encourage unmarried mothers to keep and nurse their babies at least through the first weeks of life, officials made adjustments in the new rules not long after their enactment. For example, in June 1871 the Moscow home began to offer a prize of ten rubles for children brought in between the ages of six weeks and two months. The deliverer could earn an additional three rubles for bringing the child in with a smallpox vaccination. The results were not encouraging. In the first full year of the program, 388 of these prizes were awarded, and the number rose to 696 in 1875, but this represented only a tiny fraction of the total number of admissions. Meanwhile, the awards encouraged entrepreneurs of the kommissionerki type, women who treated the program as another opportunity for making money. They intercepted mothers coming to the home, took their infants, kept them alive as best they could, and then after six weeks appeared at the home and demanded payment of the prize.[27] This kind of abuse and the fact that the prizes did not bring about any reduction in early admissions convinced officials to repeal the program in 1876.

Not long afterwards, the St. Petersburg home introduced a similar program. In addition to awarding ten rubles if children were not brought in until they were six weeks old and another three if they had been vaccinated, the St. Petersburg facility extended from two years to three the period in which parents could reclaim a child if they left it at the home with a baptismal certificate. Beyond the usual objective of lowering overall admissions, the policy was aimed at raising the percentage of children arriving in good health and increasing the number eventually returned to parents. None of these hopes was realized. During the period the policy was in effect, from 1878 to 1882, admissions showed an average yearly increase of 275 children. Some success was achieved in lowering mortality in the home among children under one year of age, but that was only temporary; by 1881, deaths had risen to the pre–1878 levels. Most discouraging of all, the one-year extension on reclaiming of children did not increase in the slightest the number of claims made for the return of children.[28] Officials had much overrated the attachment of parents to their abandoned children.

[27] Krasuskii, *Kratkii istoricheskii ocherk*, 52–53.
[28] S. E. Termen, *Prizrenie neschastnorozhdennykh*, 78–80.

RENEWED CALLS FOR REFORM

Criticism subsided somewhat during the 1870s, possibly because critics were waiting to see if the experiments then under way would improve matters. A popular polemical work by S. S. Shashkov, *The Historical Fate of Woman: Infanticide and Prostitution*, devoted some attention to the current arrangements for dealing with child abandonment, but the major works on the foundling question in this decade were standard historical or institutional studies.[29] The climate of opinion shifted again, however, when admissions began to climb in the late 1870s, generating a new sense of urgency.

Once again, the main concern was directed toward the open admissions policy, which, even with the recent modifications, remained subject to misuse by married parents. In 1880, V. K. Pfel', a member of the governing board of the St. Petersburg home, proposed the strict exclusion of all but illegitimate children and the introduction of a subsidy program for unwed mothers that would encourage them to keep their children. This proposal was essentially a revival of an idea often advocated before, but Pfel' added a recommendation for controls to assure that the subsidies would go only to women who would otherwise abandon their children.[30] Support for the proposal came from another governor of the home, Baron Aleksandr Pavlovich Nicolai, who served during 1881 and 1882 as minister of public education. Nicolai pointed to the strong trend in Europe toward strengthening the bond between an unwed mother and her child, and he recalled the introduction by Empress Maria seventy years earlier of measures to effect this end, measures that were withdrawn because of the expense. This consideration should not have halted the reform, Nicolai wrote, because a Christian state had the duty to reinforce the tie between mother and child whatever the cost. Yet just at the time when Europe was seeing the wisdom of this principle, the Russian homes, following the recommendations of the Karrel' commission of 1862, turned in the opposite direction and set out to destroy the link between a mother and her child. Nicolai judged this most unfortunate and urged a speedy return to a policy that would encourage mothers to nurse their children. He was also in favor of providing child-assistance payments to married parents who, because of

[29] Shashkov, *Istoricheskie sud'by zhenshchiny*; Piatkovskii, "S.-Peterburgskii vospitatel'nyi dom" and "Nachalo vospitatel'nykh domov"; Krasuskii, *Kratkii istoricheskii ocherk*; Tarapygin, *Materialy*.

[30] Pfel', "Programma dlia pereustroistva."

their poverty, tried various stratagems to have their legitimate children admitted to the foundling homes.[31]

These proposals, which came in reaction to the disappointing results of the reforms of the late 1860s and the 1870s, led to the introduction in 1882 of another rule change. Having found that the threat of losing the chance to reclaim children had little effect on admissions, the governing boards decided to heed the advice of Pfel' and Nicolai and move in the direction of strengthening the link between a mother and her child. This approach also conformed with the conservative bent of the regime of Tsar Alexander III (1881–1894), which had recently come to power with a distaste for the experiments of the previous reform era. With the proposals of Pfel' and Nicolai opinion was finally shifting against open admissions in any form. The notion that the state should provide substitute mothers for abandoned children was in retreat, and the government and society were now nearly ready to demand that mothers and families meet their obligations to their own children. As a first step, the foundling homes reinstituted the practice of ticket distribution and expanded opportunities for reclaiming a child at any age. Along with this, they introduced the first serious attempt at a subsidy program on the model adopted by several of the large West European foundling homes over the preceding half-century.

Under the new rules, illegitimate children continued to be accepted up to age one with or without a baptismal certificate. Certificates, as before, could be submitted in a sealed envelope. The mother received a ticket identifying her child and had the option of staying at the home and nursing her child for six weeks with pay. If she then wanted to continue to care for her child at her own home, she could do so and receive a regular subsidy for the next three years. (Otherwise, the child would be sent to village fosterages.) Any woman who deposited a child with a baptismal certificate had the right to reclaim the youngster within three years at no cost, and thereafter until age five by payment of twenty-five rubles. However, if the woman nursed the child in its first six weeks, she could reclaim the child within ten years at no cost, and the child could not be given up for adoption until age fourteen without the mother's consent.[32] The objective was to encourage more mothers to nurse their children in the early weeks of life, when the new milk of the mothers was crucial to the children's health and development. The change was also clearly designed to increase the number of children who

[31] Nicolai, "Mnenie pochetnogo opekuna Barona Nikolai."
[32] S. E. Termen, *Prizrenie neschastnorozhdennykh*, 81–82; *Otchet M.Vos. Doma* (1891), 5–6.

remained permanently with their mothers. The reform included nothing that would discourage admissions, and they continued to rise disconcertingly; but even so, to judge by the figures for the St. Petersburg home, the impact on mortality and on reclaimings was positive. The mortality rate dropped several percentage points following the rule change, and the proportion of children returned permanently to mothers rose from 5.6 percent in the late 1870s to 10 percent in the mid-1880s.[33]

Despite this success in modifying the behavior of the clientele of the foundling homes, officials were not able to solve the most critical problem for the institutions: the continually rising admissions. In just twelve years between 1876 and 1888, the St. Petersburg home saw annual admissions increase from about 7,600 to nearly 10,000. In the same period, admissions to the Moscow home rose even more rapidly: from about 12,500 to over 17,000 (see table A-1). These jumps of 32 and 38 percent in little more than a decade sent shock waves through the system. The jolt was all the more severe in that the increases took place during a period of adjustments and reforms aimed at controlling the growth of child abandonment.

The problem for the homes was not only that the new policies had misfired. They did not go far enough, certainly, and some of the expectations on which they were founded proved faulty. Yet the rules governing admission to the homes were only one factor influencing the rate of child abandonment. Two other influences played a much greater role: rising illegitimacy and a rapid increase in migration from rural to urban areas. Unlike the countries of western Europe, which experienced a stabilization or decline in illegitimate births beginning in the middle of the nineteenth century, Russia encountered an upward movement in nonmarital fertility through the end of the century. The number of illegitimate births rose from 88,167 in 1870 to over 130,000 in 1899, an increase of nearly 50 percent in less than thirty years. In other words, quite apart from measures introduced by the foundling homes, Russia was having to cope with a growing number of illegitimate children.[34]

The increase in rural-to-urban migration was being fueled by a rapid expansion of the Russian railway network. Between 1855 and 1881, the railway system grew from 1,200 versts to 21,000 versts; in the next fourteen years, it jumped again by more than half, to 33,000 versts. Coming before the great transcontinental lines were built, these in-

[33] S. E. Termen, *Prizrenie neschastnorozhdennykh*, 82.

[34] Further analysis and sources may be found in Ransel, "Problems in Measuring Illegitimacy."

creases represented a growth of networks extending out from and serv-
ing the capital cities. The railways facilitated the movement into the
metropolitan areas of people from greater distances than before—and
along with them arrived ever greater numbers of unwanted children.
Figure 6.2 shows the increase in the proportion of children deposited
at the Moscow Foundling Home from areas beyond Moscow province
during the 1870s and 1880s. Even this graph does not tell the whole
story. The railways also brought increasing numbers of unattached
women from the provincial towns and villages into the capital cities,
where they hoped to find work. These migrants added to the pool of
women in the urban areas at risk of having illegitimate births, which
would contribute to the increase in admissions to the foundling homes
registered as coming from Moscow and St. Petersburg proper. In short,
the railways ferried from the provinces both more unwanted children
and more women who would eventually produce illegitimate children
in the cities (see chapter 9).

It was not these larger dynamics, however, that attracted the attention
of Russian observers and critics in the late nineteenth century. They
focused instead on the correlation between the elimination of the open
admissions systems in western Europe and the decline of child abandon-
ment there. The relationship appeared impressive and raised questions
about Russia's failure to adopt the same evidently beneficial reforms. As
the number of children coming to the metropolitan foundling homes
reached alarming heights in the 1880s, dissatisfaction with the open
admissions system mounted both among government officials and
among outside critics.

Reinforcing this new concern was a shift in the climate of opinion.
The sympathy of the public had for some time been moving away from
the unwed mother and toward the child. The shift arose in part from a
more realistic understanding of the situation of the women who aban-
doned their infants, a perception that popular literature reflected and
communicated. In the late eighteenth and early nineteenth centuries,
European and Russian literature had been filled with lurid stories of
child abandonment and child murder. Writers and the public believed
that unwed mothers preferred infanticide or desertion to living with the
consequences of an illegitimate birth, and few people questioned the
premise that concealment of the shame of an unwed mother served
the well-being of her child by reducing the temptation to expose or kill
the infant. Some of the most popular tales and poems of the period by
Russian authors treated the fallen woman with great sympathy and with
the sentimentality typical of the age. Probably the best known is Nikolai
Karamzin's heroine *Poor Liza*, although this story left unclear whether

an illegitimate child was on the way at the time of Liza's suicide. Aleksandr Pushkin affectingly described the feelings of an unwed mother in the process of abandoning her baby in one of his early poems, *Romans* (1814).[35] European writers turned away from the sentimentalized view of the fallen woman earlier than did the Russians, and this altered perception may have contributed to the pressure for reform of admissions procedures in European foundling homes toward the middle of the nineteenth century. In Russia, the literary exaltation of the fallen woman was just culminating at midcentury with the portrayals by Fedor Dostoevskii in *Notes from the Underground* and *Crime and Punishment.*[36] This continuing romanticization of the fallen woman may have delayed the introduction of procedures that would expose unwed mothers to public disgrace.

The shift in the literary portrayal of the unwed mother began in Russia in 1877, with the appearance of Leo Tolstoy's novel *Anna Karenina*, and it was continued a decade later in Anton Chekhov's story "An Attack of Nerves." At the end of the century, in the novel *Resurrection*, Tolstoy offered a fully developed picture of the fallen woman in the story of Katerina Maslova. For these new heroines, illegitimacy was more an inconvenience than a danger or disgrace, and the emotional or physical damage they suffered came from other circumstances. At the same time, more information was reaching the public about the misuse of the foundling homes by married parents and about trafficking in unwanted children by women who used the foundling homes as a source of income, sometimes even giving up their own children so that they would be free to make money as carters of the children of others to the homes or as wet nurses. Again, Tolstoy made this point in 1886 in the drama *The Power of Darkness*, by juxtaposing to a scene of peasants killing an illegitimate infant the comment of an old farmhand: "There is a foundling home for that. Throw out anything you please, and they will pick it up. Give them all the babies you want, they won't ask questions. They even give money; all a woman has to do after that is to become a wet nurse. Nowadays these things are done simply."[37] Tolstoy was attacking not so much the unwed mother as the corrupting influence of

[35] The poem begins; "Pod vecher, osen'iu nenastnoi / V pustynnykh [*variant*: dalekikh] deva shla mestakh, / I tainyi plod liubvi neschastnoi / Derzhala v trepetnykh rukakh." (On an autumn evening when the weather was foul / A young woman was walking in a deserted spot / And holding in her trembling arms / The secret fruit of her unhappy love.— My translation.) A. S. Pushkin, *Polnoe sobranie sochinenii*, 17 vols. (Leningrad, 1937), 1:84.

[36] See the discussion in Siegel, "Fallen Woman," 92–105.

[37] Tolstoi, *Polnoe sobranie sochinenii* 14:51–52.

the foundling homes, which he accused of offering peasants the option of state-arranged infanticide.

The child-welfare movement had been gaining strength in Europe since the middle of the century, and its echoes now became heard in Russia. Although Russia lacked a middle class to act as bearers of this new concern with infant mortality, morbidity, and child abuse, the professional employees of the zemstvo agencies served in much the same role. For example, the publication by zemstvo statisticians and doctors of public-health surveys and magazine articles and their presentation of papers at medical conferences brought to public consciousness the degree to which Russia had fallen behind Europe in dealing with infant and child mortality.[38] Not only did study after study point out that Russia's child mortality rate exceeded that of the most advanced Western countries by four to five times, but the publication of annual reports by the foundling homes beginning in the 1870s also gave critics statistical material with which they could demonstrate that the homes did more to contribute to the problem than to solve it. Finally, as more information became available on the great superiority of breast-feeding by a child's mother, findings that were strongly reinforced by the authority of the Roussel Law of 1874 regulating wet nursing in France, Russians began to see that enforcement of maternal responsibility, not protection of a mother's identity, best served the well-being of her child.[39] By the 1880s, Russians were no longer satisfied to leave action on child welfare to the government alone. In Moscow, a society for the care of needy children appeared in 1883. At about the same time, a society was organized in St. Petersburg under the name of "Child Assistance." In 1885 it began publication of a magazine with the same name that printed information on infant mortality, infanticide, and child abuse.

When the government finally gave official encouragement to discussion of the crisis of rising admissions at the foundling homes by publishing in 1886 the reform proposals of Pfel' and Nicolai, the new magazine *Child Assistance* responded with a series of articles and commentaries over the next several years. In one of the first of these, the

[38] Among the zemstvo-sponsored surveys of public-health conditions most often cited in the large circulation press were Peskov, *Opisanie durykinskoi volosti*, and Matveev, *Ocherk statistiki*. Among the most important magazines were *Arkhiv sudebnoi meditsiny*, begun in 1865; *Prakticheskaia meditsina* (1885); *Detskaia meditsina* (1896); *Detskaia pomoshch'* (1886); and, from 1891 onward, *Zhurnal Russkogo Obshchestva Okhraneniia Narodnogo Zdraviia*. For a history of the medical congresses, their concern with infant mortality, and the role of zemstvo doctors, see Frieden, *Russian Physicians*.

[39] On the Roussel Law and its background, see Sussman, *Selling Mothers' Milk*, 101–21. The law was referred to frequently in Russian publications on the problems of foundling care and infant mortality.

editors launched a vigorous attack on the failure of the Russian homes to profit from the example of foreign institutions and root out the misuse of the homes by married couples and by unscrupulous entrepreneurs involved in the baby traffic. People no longer looked upon the homes as an example of humanity that influenced all society for the better, wrote the editors. This was a naive view that belonged to the eighteenth century. People now treated the facilities practically and cynically as a means of ridding society of unwanted children. Despite these strong words, the magazine did not propose abolition of the homes and indeed argued for more resources to be invested in them. But it wanted these resources directed toward new efforts at protecting the homes from misuse and toward improvement of the level of care so that more children could be saved.[40] This same approach of tightening controls and concentrating more effort on the care of the children in the system was also supported by the liberal magazine *Russian Thought* (Russkaia mysl').[41]

Another interest of the editors of *Child Assistance*, decentralization of foundling care, harkened back to the eighteenth century. It will be recalled that, with Betskoi's example and encouragement, local foundling shelters began to spring up in small towns throughout central Russia soon after the founding of the Moscow home. But this development sputtered after the establishment in 1775 of departments of public welfare in the provinces. These official bureaus apparently stifled local initiative, even though they themselves did not provide much in the way of care for children. A half-century later, in 1828, the government imposed an absolute ban on private or communal care for foundlings, and as a consequence care for abandoned children virtually ceased to exist in the provinces. The advent of the zemstvo boards after 1864 stimulated a new interest in care for unwanted children at the local level and even created a mechanism for the support of care facilities. But the law of 1828 remained in effect and prevented the zemstvos from becoming involved in the work on more than a temporary basis, no matter how badly foundling care might be needed in provincial towns.[42] Some zemstvos did make an effort to shelter children locally for a short time, but with unsatisfactory results; the death rates were higher than at the central homes. Since resources for the work were scarce, most of the zemstvos simply refused to consider it or collected children locally and sent them to the central homes as soon as possible.

A questionnaire sent to provincial governors in 1888 to learn where

[40] *Detskaia pomoshch'*, 1886, no. 23:713–14.

[41] See, for example, *Russkaia mysl'*, August 1886.

[42] *Detskaia pomoshch'*, 1887, no. 23:751–52. For history and comment, see D. Orlov, "O zhelatel'noi postanovke voprosa."

the foundlings collected at local shelters ended up revealed that of four-teen provinces reporting, eight sent their children to the metropolitan foundling homes—from as far away as Tambov on the Volga River and Ufa in the foothills of the Ural Mountains. The Tambov shelter sent about one hundred children each year to the Moscow home.[43] This practice, reminiscent of what happened in France in the eighteenth cen-tury when the Paris Hospital became a magnet for unwanted children from all over the country, added to the already intolerable burden on the metropolitan institutions. Noting this unhealthy situation, the edi-tors of *Child Assistance* proposed restricting the activity of the metro-politan homes to their immediate vicinities and establishing district and provincial foundling homes elsewhere. The work could be coordinated nationally through the Institutions of Empress Maria. According to this plan, fosterage, too, could be localized. Instead of the Moscow and St. Petersburg homes continuing to expand their fosterage systems ever far-ther into the countryside and even into many surrounding provinces, as was the case now, a system of local care for local children could be set up.[44] Some officials and governors of the foundling homes also favored this proposal and were able to realize certain aspects of it in the found-ling-home reforms that were enacted in the 1890s.

Finally, an article published in 1889 in the journal of the Ministry of Justice articulated many of the common concerns about the Russian foundling system. The author, Anton Stanislavovich Okol'skii, a law professor at Warsaw University, strongly condemned open admissions and, like Baron Nicolai, pointed out that it was a costly anachronism. Okol'skii drew on data from a German study of illegitimacy, abortion, and child abandonment to bolster his point.[45] Although the statistical correlations adduced in that study to show that foundling homes en-couraged abandonments and failed to diminish infanticide or abortion were tenuous and in some instances bogus, they helped Okol'skii con-vey his view that foundling homes brought harm to the family and so to society as a whole. He accompanied the statistics with a passionate attack on the failed promises of the homes and an appeal to the values of family and personal responsibility. Far from fulfilling the sanguine expectations of supporters and providing a "family" and a refuge for illegitimate children, Okol'skii asserted, the homes had a quite different impact. The existence of the homes prompted the abandonment not

[43] Oshanin, *O prizrenii pokinutykh detei*, 17–18. For earlier evidence of the same phe-nomenon, see *Issledovaniia o vospitatel'nykh domakh*, 75–78.

[44] *Detskaia pomoshch'*, 1889, no. 19:553–56, and 1891, no. 17:507–8.

[45] Oettingen's *Die Moralstatistik* (1874), cited in Okol'skii, "Vospitatel'nye doma," 393–99.

only of illegitimate children but also of "a significant number of legitimate children whose parents leave them there forever." The inevitable consequence was the weakening of family bonds and the demoralization of society, maladies which in Okol'skii's view were especially evident in places having foundling homes with the turning cradle or an open admissions system.[46] He followed this indictment with a criticism of foundling homes as child-rearing institutions. The atmosphere, wrote Okol'skii, was not conducive to the training of children, for they failed to receive the love and moral guidance required for a successful adult life. Graduates of the homes entered adulthood resenting this experience, and a high proportion of them turned to antisocial and criminal behavior.[47] In other words, he denounced what might be called a lack of social economy. At a cost for the homes in the 1880s of 2.5 million rubles annually, Russia was paying a high price for an inferior product.

The article by Okol'skii was probably less an appeal for reform than an effort to shape a reform that the author knew was already on its way. Just four months prior to the appearance of the article, Tsar Alexander III had decided to undertake a major transformation of foundling-home policy. With the homes reeling under the impact of increases of 30 to 40 percent in admissions and with the growth of railways and of the urban population aggravating the problem, the powerful voices for reform persuaded the tsar to act. In December 1888, he ordered the governing boards of the two metropolitan homes to devise means for decentralizing the care of abandoned children and reducing the numbers coming to the capital cities. During the next six months, the governing boards selected representatives to sit on a joint commission of reform, and this commission then worked out the practical steps for implementing the general goals that had been stated in the tsar's initial order and further defined by the separate governing boards.[48] The reforms recommended by this commission finally ended compromises with the system of open admissions and placed the Russian foundling homes, after many years of hesitation and delay, on the path to a modern program of support for children born out of wedlock.

[46] Okol'skii, "Vospitatel'nye doma," 399.

[47] Ibid., 402, 408–11.

[48] The commission was composed of governing-board members B. A. Neidgart (chair), V. I. Akhsharumov, V. K. Pfel', K. N. Korf, N. V. Kidoshenkov, T. A. Oom, A. L. Gagemeister, and A. E. Zurov; the director of the Moscow home, Germanov, and the director of the St. Petersburg home, Gorchakov; and five private citizens: S. E. Termen, *Prizrenie neschastnorozhdennykh*, 83.

A Break with the Past

THOUGH LONG DELAYED, the reform put into effect in 1891 was well thought out and thorough. The homes ended the previous compromises on the central issue of admissions and tried for once to maintain a consistent policy in regard to the link between a mother and her child. Finally, officials implemented the reform with sufficient firmness and coherence to convince potential clients that they could not bend the new rules to their convenience. In short, the reform of 1891 radically reordered admissions procedures in the midst of a rising curve of illegitimacy and abandonment and so allowed the foundling homes to reassert control over the previously unmanageable increases in the number of abandoned children.

THE SHAPE OF REFORM

The most important feature of the reform was the abolition of open admissions. Children could enter the home in the future only with documentation, the purpose being to restrict use of the homes to unwed mothers clearly in need of the service. The institutions continued to provide care for infants whose mothers had died or were too ill to care for them, at least until the children could be returned to their families or sent to a private charity. But except for these special cases, all infants brought to the doors of the foundling homes came under much stricter controls.

In justifying this step, the reform commission referred to Betskoi's original objective in setting up the homes. He had intended them initially, the commission wrote, as refuges for children who would otherwise be deserted or killed by their parents, and it was to this limited purpose that the homes should return. The commission neglected to point out that Betskoi had, in practice, given a much broader scope to the activity of the homes and that he had vigorously opposed all challenges to the open admissions system. The commission members preferred Betskoi's stated goal to his actual methods, for they clearly intended to eradicate the last vestiges of his legacy of anonymous shedding of parental responsibility. However, they did not carry their

purpose to its logical conclusion and restrict admission to children found deserted in the street. They recognized that this policy would simply encourage people bent on abandonment to leave their infants in the street rather than bring them to the home[1]—an observation confirmed in the case of zemstvo shelters that operated on this basis[2]—and the result would have been more rather than fewer infant deaths.

Henceforth, a person could deliver a baby to the homes only with full documentation of its birth, together with the identification papers or address registration of the person bringing the child to the home. Initially, the reform commission also wanted to require an affidavit from a parish priest or other reliable agent testifying to the mother's "helplessness"—that is, her inability for financial or other reasons to care for the child. The full governing board rejected this proposal with a warning that it would mark too sharp a break with past practices. Such an affidavit would cost money, and the reformers did not wish to build the barriers so high that women truly in need could not afford to use the homes. Even the birth certificate and identification papers involved an expense for the abandoning mother, but the reform commission, with the board's apparent concurrence, judged this cost to be the price of immorality, which, the commission report declared, "should not be left entirely unpunished."[3]

Mothers whose familial or other circumstances made it necessary for them to conceal their identities could as before hand over the baptismal certificate in a sealed envelope and dispense with other documentation. At first, when the commission was still thinking of asking women for proof of their "helplessness," it wanted those who used sealed envelopes to have to pay a fee of one hundred rubles. The purpose of this very high fee was to protect the homes against improper use by women who could not pass a needs test. Since, however, the board later decided to dispense with the documentation of "helplessness," a high fee no longer made sense, and in the final draft of the reform the cost of using a sealed envelope was lowered to the manageable sum of ten rubles.[4] In cases of special delicacy, a baby could be admitted with no indication of the mother's name and a fifteen-ruble fee, but this form of admission demanded the direct intervention of a home official or other trustworthy citizen connected with a welfare, charitable, or religious organization.[5]

The only other children who could enter the homes without a baptis-

[1] *Otchet S.P. Vos. Doma* (1891), 6–7.
[2] D. Orlov, "O zhelatel'noi postanovke voprosa," 23.
[3] *Otchet S.P. Vos. Doma* (1891), 8, 22.
[4] In the mid-1890s, it was raised to twenty-five rubles.
[5] *Otchet S.P. Vos. Doma* (1891), 8, 22.

mal certificate attesting to their illegitimacy were those found in the street. These truly deserted children could be admitted solely through the offices of the local police. This provision was meant to guard against the ruse of mothers or their intermediaries who might bring in infants whom they *supposedly* found in the street.[6] The involvement of the police was necessary in any event, because child desertion of this type was a criminal offense requiring formal investigation.

The second major change was an emphasis on keeping a child with its mother even if the baby qualified for admission to the homes. The reforms of the previous decade had already introduced this principle, but now it was taken much further. The new rules not only encouraged but in many instances obliged mothers to stay on at the foundling home and nurse their infants through the early weeks of life. If at the time of admission the home did not have enough wet nurses on its staff to provide one for each child, officials could require the mother to stay at the home and nurse her child until the supply of wet nurses improved or the child was ready to go to village fosterage (after five or six weeks). The homes were authorized to reject the infants of mothers who refused to cooperate. Experience had taught home officials of the unworkability of placing more than one infant with a single wet nurse. As early as 1872, the head doctor of the Moscow home, A. I. Klementovskii, had discovered the effect of the emotional attachment of wet nurses to their nurslings. He found that, for every 100 infants in excess of the number of available wet nurses, 92 died, whereas only about 13 percent of the infants in the exclusive care of one nurse died (while at the home). Klementovskii observed that nurses feeding two infants became attached to only one of them. That one usually survived, and the other child died.[7] Evidently, wet nurses could form a life-sustaining bond with only one infant at a time.

The members of the reform commission acknowledged the homes' obligation to deal fairly with the mothers. They understood that most of the women giving babies to the homes needed to support themselves by their own efforts and that the need to be free of parental responsibility in order to retain employment was often the principal factor in the decision to abandon a child. For this reason, the commission recommended that mothers who nursed their babies at the home should receive the same pay and amenities as regular staff wet nurses.[8] The commissioners also ruled that no distinction should be made between

[6] Ibid., 7–8.
[7] *Otchet M. Vos. Doma* (1898), 47, 54.
[8] *Otchet S.P. Vos. Doma* (1891), 11.

mothers who entered the home to nurse voluntarily and those whom the new rules compelled to do so: all should receive the same benefits. The object was to induce as many mothers as possible to nurse, because experience at the foundling homes had demonstrated conclusively that the milk of an infant's own mother afforded the greatest likelihood of sustaining the child's life.[9] The commission accordingly determined that any unwed mothers who wished to enter the home to nurse their children could do so, whatever the supply of staff wet nurses.[10]

The members of the commission also wanted to give the women an opportunity to continue to care for their children after the initial stay of five to six weeks at the foundling home and so proposed to offer a subsidy to the mothers for child care at their own residence until the baby reached one year of age. This was designed to assure the child continued nourishment by its mother and spare the foundling home the expense and danger of overcrowding. Anticipating objections that the subsidy was a reward for fornication, the commission proposed to limit participation to one time for any one woman and thus avoid the possible emergence of unwed motherhood as a means of subsistence. Moreover, the child would remain under the jurisdiction of the foundling home for the duration of the subsidy and could be removed from its mother should she prove unfit.[11]

The full governing board, in reviewing the recommendations of the commission, approved the subsidy proposal in principle, but decided to extend it in certain respects and limit it in others. Most important, the members of the governing board were not concerned about the perception of the subsidy as a reward for sexual immorality, so long as the child benefited. They therefore rejected the recommendation that the program be limited to one time for any one woman, and they extended the duration of the subsidy from one year to two. At the same time, they confined the distribution of subsidies to women residing within the cities of Moscow and St. Petersburg; only in the cities, they believed, could an effective check be made on the quality of care given to the children.[12] The success of the program made possible four years later an extension of this opportunity for home care to women in rural areas.[13]

Another objective of the reform commission was to encourage the greatest possible number of returns of children to their mothers or rel-

[9] Erisman-Gasse, "K voprosu o vskarmilvanii detei." See also *Otchet S.P. Vos. Doma* (1891), 10.

[10] Ibid.

[11] Ibid., 12.

[12] Ibid., 23.

[13] *Otchet S.P. Vos. Doma* (1895), 56–60.

atives. The understanding was that the mother or, if she had died, members of her family would provide the best atmosphere for the growth of the child. Accordingly, the new rules forbade adoptions of foundling-home children before age ten and gave mothers or relatives the right to reclaim children until that age. People reclaiming children were to pay up to ten rubles per year for the time the children were in the care of the homes, but, as an incentive for mothers to nurse their children at least through the early weeks of life, the homes waived reimbursement of the cost of a child's upbringing all the way to age ten for mothers who nursed their babies at the time of admission. (In 1894, the age in both these cases was lowered from ten to seven.) Those who gave babies up with baptismal certificates, but did not nurse them, could reclaim them until age three without cost. Infants who entered without documentation received only six weeks of free care. Children deserted in the street and brought in by the police were returned to the individuals or families legally responsible for them as soon as the police located the persons in question. They had then to reimburse the home for the child's upkeep at a rate that could go as high as thirty rubles per year.[14] In practice, however, the homes rarely demanded reimbursement from women found to be deserters; most of those who were apprehended had so few resources that they could not possibly have paid.[15]

These were the principal features of the 1891 reform. Abolition of the tour-type open admissions was the core around which everything else revolved. Fifty years of tinkering with the admissions rules had demonstrated that anything short of full removal of the open admissions system produced only limited and temporary effects and that people determined to be rid of their babies soon found loopholes in the regulations that allowed them to abandon their children to the homes.

POSITIVE RESULTS

The reform brought dramatic changes. The most critical indexes of the foundling system improved immediately. At the Moscow home, admissions declined from a yearly high in 1888 of over 17,000 to 9,814 in 1895. St. Petersburg likewise saw a rapid fall during the same period, from nearly 10,000 admissions per year to about 6,500 (table A-1). Home officials credited the decline largely to the exclusion of two categories of children previously admitted: children born of the unions of married couples and "quasi-legitimate" children (*zakonno-nezakonno-*

[14] *Otchet S.P. Vos. Doma* (1891), 29.
[15] Examples in *Otchet M. Vos. Doma* (1904), 15–16, and (1905), 14.

rozhdennykh)—that is, children born of a married woman but conceived with someone other than her husband. Officials knew that legitimate and quasi-legitimate children had been coming to the homes in the past—the clue was the petitions by married couples to regain custody of children deposited at the homes[16]—but no one knew exactly how many. Some crude reckonings had been made. In the 1860s, for example, a retired official who had worked as an inspector for the homes hypothesized that, since in France about 24 percent of infants born illegitimate went to foundling hospices, the rate was probably about 50 percent for Russia, where morals were stricter. Applying that rate to the yearly pool of illegitimate births in the seven provinces surrounding the city of Moscow and subtracting the result from the annual admissions to the Moscow home, he calculated that nearly half the children entering the home around midcentury must have been legitimate.[17] A subcommittee of the Karrel' commission in the 1860s had estimated that as many as 25 percent of entering children could be legitimate.[18] In his reform proposal at the beginning of the 1880s, V. K. Pfel' had estimated that roughly one-third of admissions were legitimate children entering under the guise of illegitimacy.[19] If these educated guesses were anywhere close to the mark, the barrier posed by the new rules to the entry of legitimate and quasi-legitimate children can be credited with much of the reduction in admissions at both homes.

Yet other categories of children surely also contributed to the drop. The rule requiring mothers to enter the homes and nurse their babies through the first six weeks undoubtedly drove away some women with illegitimate children. The demand for documentation must have caused problems for other women, even with the provision for using a sealed envelope; they still had to obtain certification of illegitimacy from a parish or other authority and so expose themselves to humiliation and expense.

In addition to the drop in admissions, the reforms produced another positive and closely related effect: a decline in the mortality rate at both homes. Because of the methods used by the homes to report deaths, it is difficult to give a precise measure of the degree of improvement, but it must have been in the range of 15 to 20 percent. In Moscow, total mortality for cohorts from the time of entry to adulthood fell from

[16] *Otchet M. Vos. Doma* (1892), 4.

[17] *Issledovaniia o vospitatel'nykh domakh*, 38–40.

[18] This subcommittee based its judgment on the time of entry and the number who entered without baptismal certificates. See S. E. Termen, *Prizrenie neschastnorozhdennykh*, 66–67.

[19] Pfel', "Programma dlia pereustroistva," 32.

nearly 90 percent to 70 percent and sometimes less, and in St. Petersburg from nearly 80 percent to a little more than 60 percent.[20] A number of factors contributed to the decline. Some importance must be given, first of all, to the requirement to obtain certification of illegitimacy, because this change forced mothers to spend more days with their newborn infants before bringing them to the foundling home, a circumstance that had both statistical and behavioral impact. The sharp decline in the percentage of babies admitted within a week of their birth (see table 6.1) removed from the mortality rolls of the foundling home many of the weak infants who died in the first days. It also meant that more infants received from their mothers the important immunizing effects of fresh breast milk before they came under the home's care.

The effect of later entry on the viability of the infants brought to the home can be judged by the rapidly increasing proportion of children entering the home at what were deemed developmentally adequate weights. Before the reform, nearly 40 percent of the infants admitted to the Moscow home weighed less than 3,000 grams, weights that led doctors at the home to designate such children as "weak" and "poorly developed." Table 6.2 shows how this percentage declined during the first decade following the reform. The year 1900 represented the peak of this improvement; afterwards, the decline in the proportion of "poorly developed" children halted, and the percentage of children weighing more than 3,200 grams at entry fell back by ten to fifteen points.

In addition to the early immunizing effects and statistical exclusion of the least viable infants, another factor that was probably conducive to a decline in mortality was the policy of having mothers nurse and care for their babies at the foundling home. The chance of survival for an infant that was nursed by its birth mother through the dangerous early weeks of life was approximately 20 percentage points higher than for an infant fed by a wet nurse.[21] Table 6.3 displays the number and percentage of infants nursed by their own mothers at the two central foundling homes in the years before and after the reform.

This table also shows that there was a striking difference between the percentages of mothers nursing their own children in St. Petersburg and in Moscow. One reason for this difference is that the Moscow region contained a larger pool of women qualified and willing to work as wet

[20] See the tables in the appendix and the analysis in S. E. Termen, *Prizrenie neschastno-rozhdennykh*, 91–99, and in Iablokov, "Prizrenie detei," 11.

[21] Calculation based on data compiled at the St. Petersburg home from 1901 to 1905. See the discussion of the results of experiments done there and at the Saratov zemstvo shelter, in Ptukha, "Bespriiutnye deti-podkidyshi," 381–82.

TABLE 6.1
Infants Brought to St. Petersburg and Moscow Foundling Homes within Seven
Days of Birth, 1890–1909

	St. Petersburg		Moscow	
Year	Number	Percentage[a]	Number	Percentage
1890	4,672	50.7	14,765	89
1891	3,341	39.1	11,216	81
1892	1,558	24.0	7,275	67.8
1893	1,302	20.6	7,184	67.7
1894	1,179	19.2	5,419	56.1
1895	1,208	19.5	5,072	52.8
1896	1,187	18.6	5,131	52.7
1897	1,079	16.8	5,082	50.3
1898	984	15.4	5,147	49.9
1899	933	14.0	4,871	46.3
1900	640	9.2	4,791	45.8
1901	536	7.8	5,823	56.8
1902	633	8.5	5,642	51.5
1903	475	6.3	5,526	50.3
1904	439	7.3	5,132	45.4
1905	450	10.5	4,848	38.9
1906	466	7.1	4,375	36.8
1907	450	6.4	3,263	32.3
1908	440	6.4	3,704	35.7
1909			3,570	34.9

Sources: *Otchet S.P. Vos. Doma* (1908), 27; *Otchet M. Vos. Doma* (1900), 18, and (1909), 32.

[a] These percentages were apparently calculated on the basis of smaller admissions totals than those shown in table A-1 of this book, but the differences do not change conclusions about the trend.

nurses, so that the home did not have to demand that mothers stay on to breast-feed their babies as often was the case in St. Petersburg. But the different character and mores of the two cities may also have played a role. At the Moscow home, beginning about 1900, a far higher percentage of women entered their babies under the provisions for concealment of the mother's identity (see figure 6.1). There, too, a sharply

TABLE 6.2

Distribution by Weight at Entry of Infants Admitted to Moscow Foundling
Home, 1889–1900

Year	Weight at Entry (percentage)		
	Over 3,200 Grams	3,000–3,200 Grams	Under 3,000 Grams
1889	29.2	32.3	38.6
1890	32.6	30.0	37.4
1891	33.9	29.5	36.6
1892	38.2	28.8	33.0
1893	39.6	28.5	31.9
1894	44.6	26.8	28.6
1895	43.0	27.7	29.3
1896	54.6	15.2	30.2
1897	39.3	28.5	32.2
1898	49.3	22.5	28.2
1899	62.1	13.2	24.7
1900	62.4	13.5	24.1

Source: *Otchet M. Vos. Doma* (1900), 17.

increasing proportion of women submitted excuses from medical personnel to claim that they were unable to stay at the home and nurse their infants because of illness. Indeed, even though total admissions declined from 1891 to 1895, the number of medical excuses—most of them surely fictive—rose from 98 to 2,479 during the same period.[22] Although the part that women's need to work played cannot be discounted, the indexes of concealment and medical excuses probably reflect stricter attitudes in the Moscow region with respect to the shame of illegitimacy and child abandonment. The St. Petersburg home did not publish the number of medical excuses given there, possibly an indication that the number was not significant. Surely it was much smaller than at Moscow; in 1896, for example, when nearly one-quarter of the abandoning mothers at Moscow took medical excuses (and only 46 percent nursed their babies), well over three-quarters of the mothers in St. Petersburg were breastfeeding their infants. St. Petersburg was a more cosmopolitan city than Moscow and was further removed from peasant

[22] *Obchet M. Vos. Doma* (1896), 10–11.

TABLE 6.3
Infants Nursed by Own Mothers at Moscow and
St. Petersburg Foundling Homes, 1888–1905

	St. Petersburg		Moscow	
Year	Number	Percentage	Number	Percentage
1888			429	2.5
1889			408	2.5
1890	1,051	11.4	550	3.3
1891	2,091	24.5	1,873	13.7
1892	3,882	59.9	3,134	29.2
1893	4,486	73.1	3,388	31.8
1894	4,596	75.5	4,378	44.5
1895	4,666	76.0	4,625	48.2
1896	4,862	77.3	4,525	46.3
1897	4,990	78.0	4,797	47.2
1898	5,180	82.7	4,727	45.8
1899	5,480	83.2	4,821	46.9
1900	6,848	84.7	4,786	46.9
1901	5,992	85.4	4,716	45.1
1902	6,328	85.7	5,361	50.4
1903	6,321	86.5	5,511	52.0
1904	8,127	90.4	6,011	52.9
1905	8,801	92.3	7,273	58.8

Sources: *Otchet S.P. Vos. Doma* and *Otchet M. Vos. Doma* for the years indicated.

life and traditional values. As a result, quite apart from the greater short-ages in St. Petersburg of hired wet nurses, administrators and the unwed mothers themselves may have had less concern about possible public exposure of the illegitimate birth through the mother's stay at the foundling home. As time went on, the difference in the admissions be-havior at the two homes increasingly diverged, until after 1905 at St. Petersburg more than 90 percent of the children were entered with open documentation, whereas in Moscow between 34 and 68 percent entered anonymously, either with sealed documents or through deser-tion in the streets. (For further information of differences between the two cities, see chapter 7.)

The different environments in which the two homes operated may

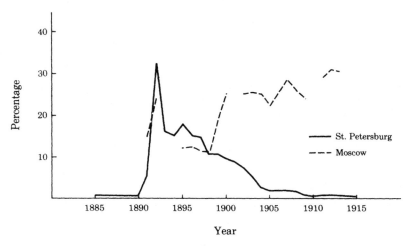

Fig. 6.1 Children entering Moscow and St. Petersburg foundling homes with documents in sealed envelopes, 1885–1915

also explain the anomaly evident in table 6.1, which shows a much higher percentage of women bringing babies to the Moscow home in the first seven days after birth than to the St. Petersburg home. From a purely mechanical standpoint, the place of residence of abandoning mothers would suggest that just the opposite should have occurred. Since nearly 40 percent of the mothers coming to the Moscow home were from outside the city (compared to only 10 percent at St. Petersburg), a large proportion of the mothers entering babies at the Moscow home had to spend time traveling there. More important, however, was undoubtedly again the shame of illegitimacy and the consequences of its exposure. The mothers arriving from outside Moscow lived in small towns and villages, in which the censure for illegitimacy must have been severe, and this circumstance motivated them to go to the foundling home with their unwanted infants as quickly as possible. For these women, distress overcame distance.

Apart from these other factors, both homes saw a steady increase in the number of women nursing their own babies in the early days of life, and this change much improved the fit between the needs of the infants and the age and quantity of the milk. Table 6.4 shows the rise from 1888 to 1894 in the proportion of wet nurses with high milk production and "young" milk at the Moscow home. (The category of "wet nurses" includes mothers nursing their own infants.) Over this period, the total number of available wet nurses increased absolutely, and in

TABLE 6.4

Number of Wet Nurses and Quantity and Age of Their Milk, Moscow Foundling Home, 1888–1894

Year	Daily Average Number of Wet Nurses Available	Number of Wet Nurses for Quantity of Milk[a]	Quantity of Milk (%)			Number of Wet Nurses for Age of Milk[a]	Age of Milk (%, in months)			
			Abundant	Average	Little		Less than 1	1–3	3–6	More than 6
1888	585	12,351	7.0	44.0	48.5	11,731	10.6	28.3	34.3	26.7
1889	572	11,292	4.0	48.9	46.9	11,292	10.8	27.5	35.4	26.3
1890	563	12,341	5.7	50.9	43.3	12,341	10.9	29.7	36.1	23.2
1891	964	14,030	8.8	47.3	43.9	13,962	18.0	27.5	30.9	23.5
1892	933	13,396	8.0	46.2	45.9	13,390	24.9	24.8	22.2	28.1
1893	1,001	12,507	9.0	50.3	40.7	11,837	28.9	18.9	28.3	23.8
1894	1,051	11,939	13.0	49.2	37.7	11,939	34.3	21.0	17.4	27.3

Source: Peshch——v, "Moskovskii Vospitatel'nyi Dom," 73, 76.

Note: "Wet nurses" include both the home's staff and mothers who were nursing their own infants at the home.

[a] The number of wet nurses for age of milk is sometimes lower than the number for quantity of milk because of the difficulty the home's doctors had in determining precisely the period of time since the onset of lactation. See LGIA, f.8, op. 1, d. 187, pp. 101–103.

view of the much-reduced admissions, this increase represented a vastly improved ratio between the number of children and the number of wet nurses. Before the reform, the chronic undersupply of wet nurses often created a pathetic situation in which one nurse had to try to nourish three or four infants at one time. By contrast, in the first years after the reform, there were usually enough wet nurses to go around and at times even a surplus.[23] So not only did the wet nurses produce on the average more and younger milk, but the infants also avoided having to share a nurse or move to bottle feeding.

The importance of a baby receiving its own mother's milk in the early days and weeks of life was convincingly demonstrated by the reform. Earlier experiments at the foundling homes in Russia and abroad had shown that infants nourished by their mothers' breast milk on a continuing basis did far better than babies fed on a bottle or nursed by other women.[24] Under the new rules of admission, the homes could now test the value of even short-term sustenance on the milk of a child's birth mother, for many women entered the homes to nurse their own babies during the first few weeks and then gave them up at the time the children went into village fosterage. This situation generated sufficient data to compare the survival rates of the children nourished first by the milk of their own mothers and those nourished exclusively by wet nurses. Although both sets of children lived in comparable conditions once delivered into the fosterage system, the infants initially fed by their mothers at the foundling home had a markedly better survival rate in fosterage, confirming in yet another way the benefit that a mother conferred on her child through early nursing.[25]

Another factor leading to the better nourishment of the children was the discovery and distribution of improved methods for artificial feeding. In the past, some people had spoken out in favor of artificial feeding, regarding the risks of this method to be preferable to the risks of consigning children to untidy and possibly unscrupulous village women. Ivan Betskoi was among the first to argue for artificial feeding,

[23] *Otchet M. Vos. Doma* (1892), 6.

[24] Erisman-Gasse, "K voprosu o vskarmlivanii detei," 261–69. See also the field reports on the perceived ill effects of older milk of wet nurses on foundling babies in fosterage, in LGIA, f.8, op. 1, d. 187, pp. 101–3.

[25] In Moscow during the first years following the reform, babies nourished by their mothers had a survival rate that was more than 8 percent higher: *Otchet M. Vos. Doma* (1892), 7. See also Ustinov, "O smertnosti grudnykh detei," and his report in *Detskaia meditsina* 6 (1901). As noted earlier, data for 1901–1905 at the St. Petersburg home show that, while in the home, babies fed by their own mothers died at a rate of 7.5 per 100, whereas babies fed by hired wet nurses died at a rate of 27.8 per 100: Ptukha, "Bespriiutnye deti-podkidyshi," 381–82.

which he promoted in connection with his campaign to keep all the children housed at the central homes. The problems of keeping animal milk fresh and of using it without modification for the digestive needs of human infants, however, made it impossible to rely more heavily on this method. The situation changed in the late nineteenth century with the discovery by the Nestlé company of Switzerland of a formula that approximated the characteristics of mother's milk and, moreover, could be packaged in dry form for long preservation. This resource eventually became an important supplement to other means of nourishment used by the foundling homes.[26]

In St. Petersburg, besides the great improvement in the feeding of infants, the new rules brought about a rapid increase in the number of children cared for on subsidy at their mothers' residences after an initial stay at the foundling home. This option had been available on an experimental basis in the 1880s, but relatively few mothers had taken advantage of it. The difference after 1890 was the requirement that mothers feed their babies at the home during the first weeks. This gave more mothers an opportunity to develop an emotional attachment to their children, thus increasing their desire to continue caring for them. The stay at the home also allowed the women to learn about the subsidy program in detail and to give consideration to using it. So again, the value of the tough new admissions rules was demonstrated. The increase in children being cared for on subsidy in the St. Petersburg and Moscow systems can be seen in table 6.5.

At the Moscow home, the subsidy program was started late and was implemented erratically. In percentage of total intake of children, it never amounted to much. The home's annual reports offer no explanation of this pattern, which was so different from the situation at the St. Petersburg home. The one similarity in the two programs was the peak usage—especially pronounced in the case of Moscow—in the years 1904–1906. The annual reports likewise say nothing about this bulge, but it was unquestionably related to the war with Japan and the virtual civil war that followed and may have reflected a need for income by women who were out of work or had been left behind by husbands or lovers who had joined the combat.

Unresolved Problems

The results of the 1891 reform were not uniformly positive. As some critics had warned, the radical change in foundling-home rules led to

[26] S. E. Termen, *Prizrenie neschastnorozhdennykh*, 100–101.

Table 6.5
Mothers of Illegitimate Children Receiving Subsidy in St. Petersburg and Moscow, and Illegitimate Children Returned to Mother's Care in Moscow, 1882–1914.

| | St. Petersburg | | Moscow | | | |
| | Mothers Receiving Subsidy | | Mothers Receiving Subsidy | | Children Returned to Mother's Care | |
Year	Number	As Percentage of Illegitimate Children Admitted	Number	As Percentage of Illegitimate Children Admitted	Number	As Percentage of Illegitimate Children Admitted
1882	13[a]	—	—	—	—	—
1883	142[a]	—	—	—	—	—
1884	267	—	—	—	—	—
1885	35	—	—	—	—	—
1886	97	—	—	—	6	—
1887	92	—	—	—	—	—
1888	4	—	—	—	—	—
1889	5	—	—	—	—	—
1890	221	2.3	1	—	64	—
1891	509	5.9	1	—	—	—
1892	424	6.5	1	[b]	267	2.4
1893	487	7.9	—	—	—	—
1894	660	10.8	—	—	—	—

Year						
1895	667	10.9	—	—	385	3.9
1896	774	12.3	—	—	522	5.2
1897	902	14.1	—	—	435	4.2
1898	1,306	20.8	27	0.2	535	5.0
1899	1,521	23.1	39	0.3	660	6.3
1900	1,912	27.9	52	—	—	—
1901	2,406	34.3	168	1.6	773	7.1
1902	2,869	38.9	722	6.6	878	8.0
1903	3,326	45.5	680	6.2	926	7.9
1904	4,977	55.3	681	5.8	2,092	16.8
1905	5,572	60.4	2,002	16.1	2,484	20.9
1906	1,179	18.5	2,387	20.0	—	—
1907	2,141	31.5	81	—	—	—
1908	1,801	27.0	153	—	—	—
1909	—	—	156	—	—	—
1910	—	—	139	—	—	—
1911	2,141	23.7	165	—	—	—
1912	—	—	178	—	—	—
1913	1,234	26.9	234	—	—	—
1914	1,497	33.5	718	—	—	—

Sources: *Otchet S.P. Vos. Doma* and *Otchet M. Vos. Doma* for the years indicated.

[a] Estimated

[b] Less than 0.1 percent.

increased desertion of children in the streets. Soon after the new rules went into effect, the journal *Child Assistance* began publishing lists of newspaper items from Moscow on this byproduct of the reform. The list that appeared early in August 1891 included the following:

- 3 August. 34-year-old peasant woman arrested for intending to desert a two-day old infant. Said she had gone to the foundling home and been refused entry.
- 6 August. Woodsman found corpse of a baby boy, newly born, wrapped in a cotton cloth.
- 8 August. Woman left girl child with a townswoman who turned it into the police when the woman did not return.
- 8 August. Boy found abandoned.
- 10 August. In cemetery near Pokrov Church, a girl not more than six days old was found among the graves.
- 10 August. Ten-day-old girl abandoned in an apartment.
- 10 August. Woman turns in a baby she said was left on a train.[27]

Similar lists, incomplete even for the days indicated, were published regularly, with from one to four desertions reported nearly every day. On the list above, the first item may be the most revealing and significant. In the period from July 1, 1891, when the new rules went into effect, until January 1, 1893, there were 500 refusals of admission to the Moscow Foundling Home either because the babies did not qualify or because the mothers would not agree to stay at the home and nurse their infants. During the same period, the police found 494 babies deserted in the streets.[28] Apparently, most women who were refused the services of the home simply deserted their children elsewhere in the city.

This type of desertion, which had been infrequent prior to the rule change at the foundling homes, threatened to become an everyday occurrence. At the Moscow home in particular, where the clientele was less educated and came in far greater numbers from nonurban areas than was the case in St. Petersburg, the new rules created misunderstandings that sometimes drove women to desert children unnecessarily. The inability of the home to disseminate information on the new rules over the huge area served by the home was one source of problems, but the language of the rules itself also caused confusion. For example, the rules did not explicitly state that the home could accept only children who were baptized, although the requirement was implicit in the demand for documentation, and so in the first year after the reform the home had

[27] *Detskaia pomoshch'*, 1891, no. 17:505–6.
[28] *Otchet M. Vos. Doma* (1892), 7.

to refuse entry to nearly one thousand infants who arrived unbaptized. (Many of these children later were admitted with documentation.) In another instance, one rule provided for the admission of illegitimate infants with documentation but did not specify that no fee was required, whereas another rule stated that infants brought in with a baptismal certificate in a sealed envelope could be accepted only with a fee of ten (later twenty-five) rubles. This second rule was to aid women who for personal reasons had to keep an illegitimate birth secret, but many women believed that they had to pay the fee under any circumstances. Clerics, too, frequently confused matters and sealed in envelopes the baptismal certificates sought by women who had no need to conceal their identity. In both these kinds of cases, the women who could not afford the fee often ended up deserting the children in the streets.

Other causes of desertion also existed. Kommissionerki, the women who collected unwanted babies in the villages for delivery to the foundling homes, continued to ply their trade and arrived with baskets of infants, some with documentation, others without, and often these illiterate women could not say which children the papers pertained to. When the home rejected some of these infants, they too became candidates for desertion. Since the Moscow home no longer accepted children deserted in areas outside Moscow province, when consignments of these children arrived, they might be left in the streets of the city, a circumstance that then made them eligible for admission.[29] Over time, the number of refusals of children decreased as women began to understand the rules better. Desertions, however, continued to increase, because they offered one way of circumventing the new rules.

Statistics on desertions during the years preceding and following the introduction of the reform confirm the picture given in the newspaper stories and foundling-home reports (table 6.6). The problem was obviously worse in Moscow than in St. Petersburg, yet in the early years after the reform, desertions as a percentage of children brought to the homes were not especially high at either of the two homes. Infants found in the cities and brought to the homes by the police accounted for about 7 percent of the Moscow home's admissions and about 1 percent of those in St. Petersburg. After the turn of the century, strict new enforcement procedures in Moscow drove up the proportion there until it reached nearly 30 percent in 1913, whereas the deserted children in St. Petersburg never rose above 5 percent of admissions.[30] Apart from what has already been said about the different character and mores of

[29] Ibid., 7–9.
[30] On these enforcement procedures, see *Otchet M. Vos. Doma* (1899), 8–9.

TABLE 6.6
Street Desertions in Moscow and St. Petersburg, 1885–1914

Year	Moscow	St. Petersburg
1885	32	—
1886	28	—
1887	18	—
1888	22	—
1889	25	—
1890	15	—
1891	148	27
1892	356	49
1893	452	69
1894	689	36
1895	685	32
1896	642	46
1897	602	68
1898	652	60
1899	729 (6.9%)	68 (1%)
1900	798	82
1901	—	76
1902	796	94
1903	733	105
1904	858	98
1905	1,012	119
1906	1,324 (11%)	153 (2.1%)
1907	1,774 (18%)	187
1908	1,953	226
1909	1,995 (20%)	201
1910	—	198
1911	2,089	203
1912	2,375 (25%)	—
1913	2,545 (28%)	—
1914	2,366	204 (3.8%)

Sources: Peshch—v, "Moskovskii vospitatel'nyi dom," 68–69; S.E. Termen, *Prizrenie neschastnorozhdennykh*, 179; *Otchet M. Vos. Doma* for years indicated.

Note: The percentages shown are the proportions of deserted children among total admissions for the year.

the two regions, which would explain why women coming to Moscow might prefer to desert children rather than to suffer humiliation through registration of illegitimacy, the cause of Moscow's difficulties lay in the larger and more heavily populated hinterland that the city served. Despite a growing awareness of the changes in rules at the homes, abandoning mothers continued to arrive without knowledge of the required registrations. In addition, women registered in areas outside the jurisdiction of Moscow province could not always qualify for the services of the foundling home. Rigorous enforcement of the rules meant that officials of the Moscow home had to expect more desertions, but they believed that the alternative would have been far worse: a flood of unwanted children from all over the empire.

Commentators adopted differing stances toward this increase in street desertions. One point of view stressed personal responsibility and the need to reinforce the family's obligations. Besides, declared a writer for the magazine *Work Assistance* who was a proponent of this view, the sharp rise had been anticipated, and although the number of desertions was lamentable, this unfortunate outcome of the tightening of admissions rules had to be weighed against the thousands of infants who would have entered the homes under the old rules but who now remained with their parents. Given the impossible conditions that prevailed in the foundling homes during the 1880s, only a small proportion of these infants would have survived. Their chances were better now that the reforms forced their parents to take responsibility for them.[31] But mere survival was not the issue, responded Dr. S. E. Termen, a representative of the new social-work approach of "intrusive guidance." Consideration also had to be given to the quality of life for the children refused entry to the homes, the character of their upbringing, and the dangers for the society they eventually came to inhabit. Since no other institutions were provided for the children, they remained with parents who did not want them and who could not bring them up properly. The result was a substantial rise in the incidence of juvenile delinquency, begging, and hooliganism.[32]

Neither point of view considered the possibility that many of the children excluded from the metropolitan homes by the new rules may have ended up in private or provincial shelters. It is impossible to say for certain if this happened, since no one recorded the fate of the thousands of children who would have come each year to the homes under the old rules but were now barred. Only the children that were deserted in the

[31] Iablokov, "Prizrenie detei," 12–13.
[32] S. E. Termen, *Prizrenie neschastnorozhdennykh*, 179.

street could be tracked, for the police registered them and turned them over to the homes. Many other children no doubt stayed with parents who would rather have given them up. Married couples who were determined to be rid of an infant now had to find agencies that did not look carefully into the legal status of the child. Unwed mothers who needed to give up their children but wished to avoid the humiliation of obtaining a certification of illegitimacy must also have sought out shelters with less demanding admissions policies, perhaps in towns other than Moscow and St. Petersburg. Indeed, some of the provincial shelters run by the zemstvos experienced increases in admissions during this period.[33] Other municipal and private agencies existed to take in unwanted children and may have served as an option for mothers whose babies were rejected by the metropolitan homes. Registrations of illegitimacy rose markedly between 1890 and 1895 in the largest provincial and district towns (excluding Moscow and St. Petersburg), and this observation adds weight to the surmise that a share of the children blocked from the central homes were now staying in the provinces.[34]

In this connection, it should be noted that in Moscow the proportion of abandoning mothers registered as residents of the metropolis increased steadily after the rule change. Before 1890, the proportion of mothers registered outside the province of Moscow had been trending upward, but that was reversed beginning in the early 1890s (see figure 6.2). The change could be seen as confirmation of the view that unwed mothers from small towns and rural areas were either depositing their illegitimate children in shelters closer to home or deciding to rear the children themselves. The same data could, however, mean that women were moving to Moscow at the time of their pregnancy in order to avoid problems of residency when bringing their infants to the foundling home. The Moscow home strictly enforced a rule against accepting deserted children (that is, those left in the street) from outside Moscow province,[35] and awareness of this policy may have discouraged women in outlying areas from attempting to enter children at the home before registering an address in Moscow. It is interesting to observe that residence patterns were different at the St. Petersburg home (see figure 6.3). This home did not keep records of the mother's place of residence prior to 1891, but from that year until 1898, the proportion of women

[33] The Riazan' shelter showed a sharp rise in admissions, while increases at the Nizhnii Novgorod and Smolensk shelters were more gradual: Puteren, *Istoricheskii obzor prizreniia*, appendixes, 61–64.
[34] See graph 4 in Ransel, "Problems in Measuring Illegitimacy," 120.
[35] *Otchet M. Vos. Doma* (1892), 9, 18.

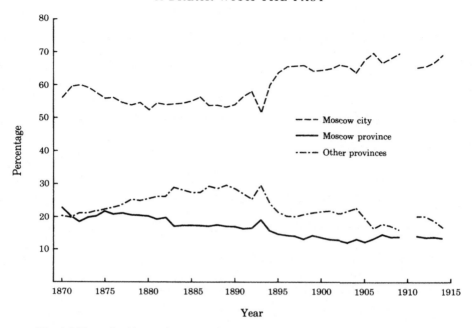

Fig. 6.2 Place of residence of mothers of children brought to Moscow Foundling Home, 1870–1914

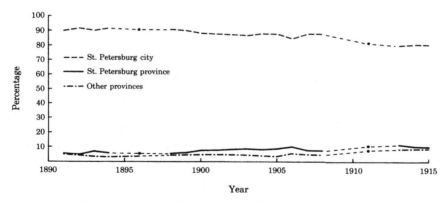

Fig. 6.3 Place of residence of mothers of children brought to St. Petersburg Foundling Home, 1891–1915

127

coming from the city of St. Petersburg, the province, and other provinces remained constant; and afterwards, in contrast to the case in Moscow, there was a small and gradual decline in the percentage of abandoning mothers from the city.

Another problem not solved by the reform of 1891 was that of the mounting admissions. At first, there was a precipitous drop in admissions, resulting from the exclusion of large groups of infants previously permitted refuge at the homes, but once the effect of this measure was absorbed and stability was restored, admissions resumed their climb, just as in the case of earlier reforms. The decline initiated by the reform ended by 1895, and both the Moscow and the St. Petersburg homes then experienced an average yearly rise in admissions of between 2.5 and 4 percent over the next ten years. Moscow did not again attain the level of admissions of the 1880s, but St. Petersburg slightly exceeded its previous record year (1888) in 1905, when the home admitted 9,408 children. After 1905, however, both homes recorded a gradual decline in admissions through 1914.

The critical variable in the trends in admissions to the homes was not the reform of 1891 but population dynamics. Demographics overcame administrative measures; the reform merely reduced the plateau from which admissions continued to grow. A reversal of the long-term trend in admissions had to await a change in demographic behavior—specifically, a downturn in the frequency of illegitimacy. As mentioned earlier, in contrast to most countries of Europe, nonmarital fertility in Russia did not fall in the late nineteenth century but instead followed a slightly rising curve. Only at the very end of the century, in response apparently to the increased use of abortion and contraceptive devices,[36] did the rate of illegitimate births stabilize and then begin to decline. Stabilization and abatement of admissions to the metropolitan foundling homes conformed closely to the same curve.

While the number of admissions was rising, the problem of finding an adequate supply of wet nurses reappeared. The surpluses of nurses that followed the reform in the early 1890s were soon replaced by deficits once more, and the homes again faced periodic crises of high mortality as infants had to share nurses or go onto bottle feeding. Mortality levels, however, never again reached those of the 1870s and 1880s.

[36] Boiarkovskii, "O vrede sredstv, prepiatstvuiushchikh zachatiiu"; Lichkus, "Iskusstvennyi prestupnyi vykidysh,"1359; Vigdorchik, "Detskaia smertnost' sredi peterburgskikh rabochikh." See also the observations in Novosel'skii, "K voprosu o ponizhenii smertnosti," 349–50.

Conclusion

Despite some unresolved problems in admissions to the metropolitan foundling homes, the importance of the reforms of the early 1890s cannot be doubted. They clearly marked a watershed in the management of the Russian foundling problem. They finally set Russia on the path to a modern welfare system consistent with the demands of a new family regime. The state had long before ended its efforts to substitute for the old family and inculcate middle-class values in the castoff children of the nation. But instead of compelling people to care for their children themselves, the government had provided, in the form of the foundling homes, a processing point for moving unwanted children out of the towns and into the care of those least capable of keeping them alive and molding them into citizens of a modern polity. And it had done this in the name of tsarist solicitude for the unwed mother and her child, a sentiment that was belied by the carnage among the children and the misuse of the homes by married parents. The new pleas for family responsibility under public guidance gave the tsarist government the rationale it needed to break away from its discredited symbolism of paternal protector of unwanted women and children and move toward enforcer of the bond between mother and child under the supervision and tutelage of the state. This stance finally allowed officials to end the worst abuses of the system and to bring mortality among their charges within a range close enough to the average for Russian children generally that critics could no longer describe it as institutionalized infanticide.

SEVEN

Sex Ratios of
the Abandoned Children

PEOPLE in most cultures greet the birth of a boy with greater enthusi-
asm than the birth of a girl. Russians have expressed this preference in
many popular sayings and proverbs. It is revealed in simple positive
statements such as, "When a son is born, even the coals rejoice."[1] It can
also be seen in many direct comparisons with the less valued daughters:
"Your son stays at home; your daughter goes off to others," and "Feed
a son and do well by yourself; feed a daughter and you provide for other
people."[2] These sayings stress the usually early departure of daughters
from their natal household. The marriage of Russian peasant girls in
their teens delivered their labor to the household of their husbands, and
the investment in the upbringing of the girls was "lost" to their parents.
As still another saying put it: "Feed my parents and I repay a debt; bring
up my boys and I make a loan; but provide for a daughter and I throw
money out the window."[3]

Russian villagers loved their daughters, as many other sayings and
observations attest. Yet the practical, common-sense evaluation of the
labor contribution and the costs of girls suggests that in times of crisis
Russians would be more likely to sacrifice girls than boys. Among cer-
tain especially unfortunate groups, the disposal of girls may have oc-
curred with great frequency. Richard Hellie, writing about slavery in
Muscovy, claimed to have found evidence of widespread, even cata-
strophic, female infanticide.[4] Although Hellie could produce no conclu-
sive statement attesting to the killing of female infants, he made reason-
able assumptions about the completeness of the record and hence the
validity of the sex ratios derived from it. It seems likely that, among the
people to whom he refers, those who sold themselves into full and then
limited contract slavery (the most destitute and displaced social group
in Muscovy), infant girls had little value and little claim on the meager
resources of their families.

[1] Ivanovskaia, "Deti v poslovitsakh," 121.
[2] Ibid.
[3] Ibid.
[4] Hellie, *Slavery in Russia*, 442–53.

Sex ratios highly skewed in favor of boys can also be found in the records of baptismal certificates of the Nizhnii Novgorod region in the early eighteenth century, but again the absence of direct evidence of female infanticide compels caution in the interpretation of these records.[5] There is a strong likelihood that the imbalances are an artifact of underregistration in this locale, since a count of the total Orthodox population in all the archdiocesan records for 1737 indicates only small differences.[6] Most of the population counts made by the St. Petersburg Academy of Sciences in the late eighteenth century also showed sex ratios that, if not as highly skewed in favor of boys as those for Nizhnii Novgorod in the early decades of the century, still went well beyond what would be expected for a normal population.[7] Again, however, there is reason to believe that these imbalances, too, resulted from the underregistration of baby girls. The government based taxation and military recruitment on the number of male "souls" and did not have an equally compelling need for an accurate count of females. But if these cases and the evidence about slaves are burdened with some uncertainty, the records of the foundling homes established at Moscow and St. Petersburg in the 1760s and 1770s are clearer.

SEX RATIOS OF ENTERING CHILDREN

The foundling homes are the one place in imperial Russia for which thorough and reliable sex ratios among young children are available. Since the foundling homes were a means of disposing of unwanted children and in that sense were a functional equivalent of desertion or infanticide, the sex ratios of children delivered to the homes provide a clue to the value of girls and boys in the reckoning, if not of the entire society, at least of parents destitute or desperate enough to give up some of their children. Data on the sex ratios at the two large metropolitan homes in St. Petersburg and Moscow reach back into the last decades of the eighteenth century and reveal a fascinating pattern of, at first, marked and then gradually attenuating discrimination against girls.

The St. Petersburg institution published a complete series of admis-

[5] The registers, copied from the reports of the archdiocese of Nizhnii Novgorod, show many more baptisms of boys than of girls in the rural areas, though the ratios were more nearly normal in the towns and especially in the city of Nizhnii Novgorod itself: Makarii, comp., "Materialy dlia geografii i statistiki nizhegorodskoi gubernii," 635–57.

[6] Totals for the Orthodox population were 5,752,626 males (51 percent) and 5,514,888 females (49 percent): *Opisanie dokumentov*, 20:891–902.

[7] See the figures compiled by B. F. J. Hermann in *Nova Acta Academiae Scientiarum Petropolitanae*, ser. 4, vol. 4:62–68, and by Storch, *Tableau historique*, 1:269.

sions by the sex of the entering child covering the years from 1781 to 1912. Data on admissions by sex at the Moscow home are available only for the years from 1886 to 1913, but there are records on the numbers of boys and girls going into village fosterage during earlier years (1780–1809 and 1819–1885), and these provide a satisfactory proxy. All of these data are plotted in figure 7.1.

In St. Petersburg, there was a large disproportion in the number of girls abandoned at the time of the establishment of the home in the late eighteenth century. Near the turn of the century, the number of males began to increase, resulting in approximately equal numbers by 1830 and then fluctuating around a mean of 98 for the next forty years. However, the normal sex ratio at birth is about 105 males to 100 females, and so these ratios seem to indicate a continued, though slight, preference for abandoning girls until the early 1870s.

The preference may have been even slighter than these data suggest, because the sex ratio in the population of children at risk of becoming foundlings would differ from that of a normal birth cohort. There are two related reasons for this variance. First, the mean age of entry of children into the foundling home was not birth but two to four weeks. Second, both prenatal and perinatal mortality among illegitimate chil-

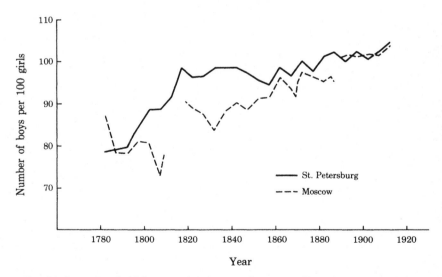

Fig. 7.1 Sex ratio of children entering St. Petersburg Foundling Home, 1781–1912, Moscow Village Fosterage, 1780–1809 and 1819–1885, and Moscow Foundling Home, 1886–1913

dren were much higher than among legitimate children and could not have been evenly distributed between boys and girls because both in the womb and after delivery boys die in greater proportions than girls. For the population at risk, therefore, the sex ratio at the time of abandonment may have been much closer to 100 than to 105. From 1874 onward, the ratio is unexceptional, indicating that at the St. Petersburg home boys and girls were being abandoned in the same proportion as they were being born.

The number of girls sent into village care by the Moscow home exceeded that of boys by 20 to 25 percent prior to 1809. After 1819, the sex ratio fluctuated between 80 and 90 until the mid-1850s, when it began to exceed 90. These ratios cannot, of course, be taken as exact equivalents of sex ratios at admission. The children remained in the central home for a period of a few days to a few weeks before being transferred into fosterage, and the home released into village care only those infants who appeared healthy enough to survive the rigors of the transfer.[8] In all, about 85 percent of the children admitted eventually went out to fosterage; the other 15 percent either died or were retained for a longer than usual time in the home. In view of the inferior survival rate of boys, it is likely that they accounted for a high proportion of the 15 percent not going into village fosterage. At St. Petersburg in the early part of the nineteenth century, the difference between the mortality for boys and girls retained in the home was about six percentage points.[9] If Moscow's situation was similar, the disproportionate number of girls going into village fosterage there reflected with some exaggeration an imbalance in the sexes at the time of admission. Although the difference between sex ratios at admission and at entry into village fosterage is not strictly comparable with the excess mortality of male infants in the institution, it is interesting to note that sex ratios in Moscow and St. Petersburg differ on the average by just about six points; in the years for which data exist on the sex of entering children at the Moscow home, the average sex ratio at admission and the average sex ratio of children sent to the countryside differ by exactly six points.[10] Therefore, it seems clear that during the late eighteenth and early nineteenth centuries the Moscow home, too, saw a marked preference for the abandonment of girls. And, just as in the case of the St. Petersburg home, this bias (with a lag, to be discussed later) lessened and eventually disappeared as the nineteenth century wore on. By 1886, when regular reports of admis-

[8] Miller, "Iz proshlogo Moskovskogo Vospitatel'nogo Doma," 69.

[9] Calculated from the manuscript records for the years from 1812 to 1825: LGIA, f. 8, op. 1, d. 1236, 1237, 1238 . . . 1246.

[10] See Shter, comp., *Otchet po upravleniiu*, 31.

sions by sex became available for the Moscow home, the sex ratio for entering children had stabilized in the usual picture of slightly more males than females.

Since this measurement of sex ratios is in part a test of possible bias toward the disposal of girls through infanticide, it is worth mentioning that scattered data from the 1850s suggest that there were slightly more girl than boy victims of infanticide during those years.[11] But crime data and dissertations on forensic medicine that began to appear in the second half of the nineteenth century show that by the 1870s Russians no longer showed a preference for the killing or abandonment of girls. The record of infanticides indicates, if anything, a bias toward the disposal of boys.[12] Thus, the trend of sex ratios in infanticide corresponds to that seen in the foundling homes.

SEX RATIOS OF ADOPTED AND RECLAIMED CHILDREN

The obvious problem is how to explain the shift in sex ratios that took place in the later part of the nineteenth century. The three possiblities that need to be considered are that girls acquired greater value, boys declined in value, or among this particular population children of both sexes were so little valued that the sex ratios have no special significance.

The last proposition has little appeal on its face, since the trend in the sex ratios, despite a good deal of fluctuation, shows a quite marked change over the long term. Corroborative evidence that the change in ratios reflected a revaluation can be found in other records of the foundling homes: the registers of adoptions and of children reclaimed by parents or relatives. In the case of the Moscow home, from 1810 through about 1860 adoptions and returns to relatives followed a distinctive pattern of sex ratios. Initially, they showed a preference for the adoption and reclaiming of boys, but in the 1830s the numbers in both categories swung heavily in favor of girls. In the case of children reclaimed by relatives, the numbers are fairly small, and until 1830 boys and girls were reclaimed in about the same numbers on the average. In view of the larger pool of girls available for reclaiming, however, this balance indicates a preference for boys. After 1830, in only four out of twenty-seven

[11] Zhukovskii, "Detoubiistvo," 9.

[12] In the years from 1875 to 1887, in the fifty-nine provinces of European Russia, the yearly average of deaths by infanticide was recorded as 509.5 boys and 341.3 girls (sex ratio of 149), and the rate for boys was higher in all but three provinces (Estland, Sedletsk, and Simbirsk):2–57.

years were more boys than girls reclaimed, and the average annual number of girls reclaimed increased dramatically.[13]

Much the same pattern can be seen in the case of the more numerous adoptions, albeit with a lag of eight years. From 1810 through 1838, the number of boys adopted exceeded the number of girls in every year but one. Altogether, 858 boys were adopted (29.6 per year), compared to 268 girls (9.2 per year). The next twenty-two years witnessed a startling reversal. In only three of these years did the number of boys adopted surpass the number of girls, and these three years were also atypical in having unusually low adoption rates. Overall, 3,411 boys were adopted in this period (155 per year), while 7,350 girls were adopted (344 per year).[14] In short, prior to 1839 the preference for boys was more than three times that for girls; from 1839 onward the preference for girls was more than twice that for boys. (See figure 7.2, which, it should be noted, shows the number of girls per 100 boys, a change from figure 7.1 made necessary by the quantitative relationships involved.)

This shift to a preference for girls ran counter to the demographics of the foundling homes. As figure 7.1 showed, the number of boys entering the homes relative to the number of girls was on the increase in this period, and one would expect that this expansion of the pool of boys available for adoption and reclaiming would lead to an increase in the relative number of boys adopted or reclaimed instead of to what actually occurred: a dramatic rise in the number of girls adopted or returned to relatives. The two trends together—toward more boys among those abandoned and toward more girls adopted and reclaimed—demonstrate that a conscious preference was being expressed. Either girls had acquired a new value during the early nineteenth century, or the retention or adoption of boys no longer served as useful a purpose as it had in the past.

The records on adoptions and reclaimings at the St. Petersburg Foundling Home in this period do not reveal the distinctive shift in favor of girls that characterized the Moscow situation. Until the 1860s, the numbers of both returns to relatives and adoptions in the northern capital were fairly small, and their sex ratios fluctuated considerably. By smoothing them into five-year averages, as has been done in figure 7.3 (which once again shows number of boys per 100 girls), it can be seen

[13] From 1810 to 1830, the figures were 129 girls reclaimed (average of 6.1 per year), and 116 boys (5.5 per year). The figures for the period from 1831 to 1857 were 489 girls (18.1 per year) and 275 boys (10.2 per year). Calculated from data in *MIMVD* 1, sec. 2: 50.

[14] See table in *MIMVD* 1, part 2:56–57.

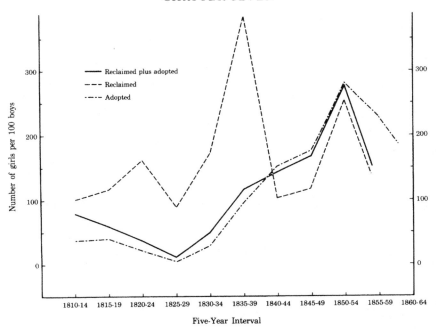

Fig. 7.2 Sex ratio of adopted and reclaimed children at Moscow Foundling Home, 1810–1814—1855–1859

that from 1810 to 1860 more girls than boys were adopted and re-turned. At first, the ratios remained stable in the range of 50–60 boys per 100 girls. After 1835, the proportion of boys increased steadily in both categories but only subsequent to a sharp drop in the sex ratio for the larger category (adoptions), with the result that the sex ratio for the two categories together did not again reach 60 until the late 1850s. Thereafter, the numbers in these categories increased greatly, and the sex ratios moved toward 100 (equality), just as in the case of the entire entering population of foundlings. It is clear that the conditions that motivated reclaimings and adoptions in the Moscow and St. Petersburg regions were different and that in St. Petersburg a preference for girls had been established long before the same preference began to be expressed in the Moscow region.

It is not easy to discover what lay behind these shifts in preference. The altered behavior of abandoning mothers and adopting parents could have been influenced by changes in the law, in enforcement prac-

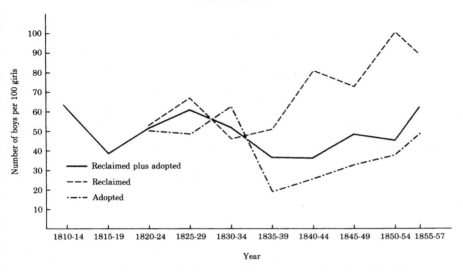

Fig. 7.3 Sex ratio of adopted and reclaimed children at St. Petersburg Foundling Home, 1810–1814—1855–1857

tices, in the economic environment, or in cultural values. It may help to look at returns and adoptions separately.

In the case of returns of children to relatives, no legislative or procedural change seems to have coincided with the shift. The policy on returns had remained the same since the early part of the century. The chief requirements were (1) proof of close relationship to the child and good references, (2) no adherence to the church schism, (3) a written pledge that the child would be reared in the Orthodox confession if the petitioner was not Orthodox, and (4) assurance that girls would not be residing with unmarried men.[15] In addition, the existence of serfdom occasioned some special considerations. Since children given to the foundling homes were legally free persons, officials did not return children to a serf parent unless the serfowner also joined the petition, presumably in the interest of recovering his lost property.[16] It is a revealing comment on the values of the era that the desire of a parent or parents to be reunited with an abandoned child could be ignored if it meant that the child would fall into servitude, and yet a serfowner's right to reclaim his human property overrode a government grant of freedom.[17]

[15] *MIMVD* 1, part 2:44–47.
[16] Ibid., 49.
[17] See the cases of returns in LGIA, f. 758, op. 9, d. 172, passim. The rule on not

This conflict did not arise very often, however, since only a minority of the reclaimed children went to the countryside. Judging by evidence from St. Petersburg, the largest number of returns were made to families of low-income urban dwellers (*meshchane*).[18] As it happened, these people in many instances did not provide adequate care, giving a bad name to the whole program of allowing relatives to reclaim children, and the government eventually had to impose stricter requirements for reclaimings. But these changes, which came only in the 1850s, do not explain the shifts in the sex ratios that occurred in the first half of the century.

One arena that needs to be examined in this connection is the military, since rules governing recruitment into the army were likely to influence the behavior of people and institutions. And indeed, here was one possible impetus for the shift in preference from boys to girls. A series of legislative acts in the first half of the nineteenth century, especially during the reign of Nicholas I, had the effect of directing larger numbers of orphaned, illegitimate, and vagrant children to the military schools for soldiers' sons. Beginning in 1830, male children given to the Moscow and St. Petersburg foundling homes by women suspected of being soldiers' wives, as well as children under the supervision of the provincial departments of public welfare, were supposed to be sent to the "cantonist battalions" that had been established for training young boys in the arts of war in preparation for a life of soldiering.[19] The available records yield no information on the actual number of boys turned over to the battalions by the foundling homes, but if the number was substantial it could have sufficiently reduced the proportion of boys in the pool of children available for reclaiming by relatives to explain the shift to more returns of girls. Since the total number of returns to relatives in any year was not great, even a small shift of this kind could make a noticeable difference in the sex ratio. However, the large fluctuations in the number of returns and their somewhat different movement at

returning a child to its serf mother lest a ward of the home fall into unfreedom is explained in a decision of the governing board on June 2, 1825: TsGIA, f. 758, op. 9, d. 513, pp. 3–4. A serfowner also lost the right to reclaim a child if a year had passed with no petition, the ground being that serfowners might allow or even encourage their women to have children reared at the foundling home's expense and then reclaim them at a productive age: TsGIA, f. 758, op. 9, d. 514, pp. 1–46 (case from 1843).

[18] See the lists for 1849 to 1853 in LGIA, f. 8, op. 1, d. 50, pp. 118–91, and LGIA, f. 759, op. 30, d. 185–216.

[19] See the series of orders referring to the foundling homes' efforts to identify children of soldiers and to send them at age eight to the cantonist ranks, an initiative coming from the homes' governing boards: S. E. Termen, *Prizrenie neschastnorozhdennykh*, 59–60.

Moscow and St. Petersburg do not permit of much certainty in pin-pointing the causes of this behavior.

The matter of adoptions was somewhat different. The turn to more girls than boys in the 1830s coincided with two changes in the rules governing the foundling homes. The first of these was the closing off of opportunities for education of the foundling children at the schools in the homes. Ever since the death of Betskoi, the chances for a foundling to acquire an urban education had declined steadily. But Tsar Nicholas in 1837 declared that the foundling-home schools were to be reserved primarily for the children of noncommissioned officers. Henceforth, foundlings could enter only with special permission. All the other children from the homes had to be reared in rural villages and could leave them only as needed to fill quotas at the few agricultural and manufacturing enterprises and schools run by government bureaus of charity.

The second change was the expansion of opportunities for the adoption of foundlings by state peasants. The rules before this time had required that a child be at least eight years of age, that the adopting parents have the permission of their village authorities, and that proof be given of their fitness for adoption. Moreover, the adopting parents could have no children of the same sex and had to agree that, if such children were born later, the rights of the adopted children would be equal to those of the biological children. This highly restrictive policy was changed in 1837 by a tsarist decision that state peasants could adopt male children even if they already had male children of their own.[20] These changes do not, obviously, provide an explanation for the shift toward adoption of a larger number of girls than boys. Adoption in Russia was a factor of demand, not supply, and adopting parents were able to choose a child of whichever sex they wanted.

A wider view of the relative opportunities available to each sex may, however, shed some light on the question. For example, now that virtually all the children had to be brought up in peasant villages, there were more options for boys than for girls. The choices open to young males included military service, trades, and removal to the towns in search of work. Moreover, if a family adopted a boy, it had to provide him with a share of any inheritance equal to that of the other males in the household. Another hindrance to the adoption of boys, as an inspector from the Moscow home learned when talking to peasant foster families about adoption in the 1850s, was the lack of any assurance that their boys would escape conscription. He wrote that peasants often sought adoption but that, even with a subsidy recently introduced for

[20] *MIMVD* 1, part 2:54.

the adoption of boys, the problem of losing them later to the army continued to retard the adoption of boys relative to that of girls.[21] This danger had existed earlier, it is true, but its continuation after the easing of adoption generally may have contributed to the increase in the proportion of girls adopted.

As far as girls were concerned, the new rule excluding foundlings from the urban schools, together with the limited options otherwise available to young females, meant that most of them were consigned to village life and marriage to a peasant. Since they were thus likely to be staying on in the village, personal ties of affection and the chance to enjoy their labor services until marriage may have been incentives for peasant families to adopt their girl foster children, especially since the girls would not reduce the inheritance share of their own sons and the foundling home contributed a small dowry (although until 1871 the dowry was small enough that many peasant foster families preferred to delay a foundling girl's marriage until age twenty-one, when they received a special monetary award at her official majority).[22]

The shift toward the adoption of girls in the Moscow area must also have owed something to the importance in the mid-nineteenth century of cottage industry among the peasants most heavily involved in the foster care of foundlings there. Some information about the occupations of families in the fosterage program was provided by a doctor from the St. Petersburg Foundling Home who investigated the Moscow system in 1834. He visited a western area of Moscow province densely populated with foundlings in foster care and noted the frequency of trades and crafts. The largest contingents of peasant fosterers were so-called "economic peasants"—former monastery serfs, who, unlike private serfs, could adopt the children they fostered for the foundling home.[23] This period saw the growth of cottage industry in the areas in question, and girls were a valuable labor resource in such an economy. Descriptions of peasant spinning and weaving trades in the 1830s and 1840s told of the intensive application of female laborers of all ages in household production, and the official reports of the governors of Moscow province depicted the prominence of these occupations in the western districts of the province. One such report said, for example: "Peasant women nearly everywhere, in the time free from agricultural work, occupy themselves with the spinning of flax and the preparation of linen

[21] TsGIAgM, f. 108, op. 1, d. 472, 120–23.

[22] Ibid. See also Krasuskii, *Kratkii istoricheskii ocherk*, 218. Krasuskii reports (ibid., 216) that peasants adopted girls out of affection only if the girl was the only daughter; in all other cases, girls were adopted for doing "the most difficult peasant work."

[23] Afanas'ev report, in TsGIAgM, f. 108, op. 1, d. 444, pp. 62–63.

and homespun cloth, which go not only for domestic consumption but partly also for sale in the towns and rural markets."[24] A report by an inspector from the Moscow Foundling Home who examined the foster-age program in the mid–1850s likewise noted the importance of this labor input to the peasant households and described the devices, such as adoption by unenserfed third parties, that even privately owned serf families used to insure the continuance of their fosterlings' contributions. He wrote:

A foster parent of serf status seeks out a neighboring peasant of non-serf status who for a specific fee agrees to adopt the foster child into his family on the understanding that the child will remain with the foster parent. Besides the expense involved, the foster parent loses a certain amount of money from the foundling home as well as the protection of the institution. The reason, as we observed, is that the peasants fear the government will take the child at an age when, after feeding it and caring for it, it could become a helper in the work of the family. [The older children were sometimes re-cruited for work in establishments owned by the foundling home or by the Ministry of State Domains.] This fear affects the actions [of the peasants] not only in regard to boys but also to girls, who rarely are taken away.[25]

These personal accounts are reinforced by the work of V. A. Fedorov on the importance of family labor and female inputs in enterprises run on serf estates at this time.[26] Statistical data on male and female labor participation, however, are available only for periods before and after the middle of the nineteenth century. Meshalin's study of the peasant textile industry in Moscow province includes village-by-village break-downs of male and female workers at the end of the eighteenth century, and these indicate a high concentration and in many cases a predomi-nance of female labor.[27] Toward the end of the nineteenth century, when the zemstvo bureaus compiled detailed lists of the labor resources of peasant households, Moscow province stood out as one of only two provinces in the country that had a preponderance of females involved in household manufactures (121,333 women as compared to 94,306 men).[28] These scattered data and personal observations do not demon-

[24] Meshalin, *Tekstil'naia promyshlennost'*, 29. There is other interesting information on the issues of women and household work in ibid., 24–32.
[25] N. I. Trubetskoi, in TsGIAgM, f. 108, op. 1, d. 444, pp. 1–1ob.
[26] Fedorov, *Pomeshchich'i krest'iane*, 88–91.
[27] Meshalin, *Tekstil'naia promyshlennost'*, 249–50.
[28] Svavitskaia and Svavitskii, comps., *Zemskie podvornye perepisi*, 98–99.

strate conclusively that the demand for female labor in cottage industry was high enough to account for the increase in the adoption rate for girls, but they do suggest that the rise of cottage industry and the important role of female labor in it may have been a major factor at least in the Moscow area.

This surmise may gain strength from a comparison with the records of adoptions and returns to relatives at the St. Petersburg home, for the peasant fosterers in the 1830s in the St. Petersburg system were quite different. The director of this home noted in the margin of the 1834 report on the Moscow system that "we have court peasants, appanage peasants, and privately owned serfs on labor obligations; they are all in farming; none anywhere are working quitrent, and artisans you won't find anywhere."[29] In other words, cottage industry was not a factor in the St. Petersburg system at that time—and, as noted earlier, the St. Petersburg records of adoptions do not reveal the large shift in favor of girls that characterized the Moscow situation in this period.

It is also worth recalling that the sex ratio of entering children showed that the bias in favor of abandoning girls declined in St. Petersburg from 1780 to 1820. The ratio then remained at or near equality for the next sixty years. In Moscow, the proportion of girls abandoned actually increased in the three decades before 1810, and although it had decreased by 1820, the sex ratio at the Moscow home continued until about 1840 to lag substantially behind the trend in St. Petersburg; thereafter the gap closed. With the roughly six-point understatement in the Moscow curve taken into account, it can be said that the sex ratio there reached parity by 1870. Clearly, then, the inclination to abandon girls more readily than boys began to fade in St. Petersburg sooner than in Moscow. The comparison of the records of adoptions and returns supplies evidence of the different timing of a change in the valuation of girls in the two locales, which will be discussed further later on.

[29] TsGIAgM, f. 108, op. 1, d. 444, p. 63. A survey done four years later by Baron Shtakel'berg showed the following breakdown of wet nurses in the St. Petersburg system for 1838 (TsGIA, f. 758, op. 9, d. 526, p. 58):

Administering agency	Staff Nurses[a]	Village Wet Nurses	Total
Court estates	15	0	15
Appanage estates	13	762	775
Treasury	16	0	16
Landlords	912	3,658	4,570
Military	400	0	400
Other	353	0	353

[a] Including full-year and half-year nurses.

CHANGES IN VALUES

The larger issue of the change in the sex ratios among the entire population of entering children remains to dealt with. Although it is possible to propose a number of hypotheses about the motives for abandoning more girls than boys, data for testing them are difficult to find. For example, it seems logical that the village and urban communes must have played an important role. These bodies were more likely to extend assistance to an unwed mother for the rearing of a boy than a girl, because until the introduction in 1874 of universal male conscription, the communal leaders could use the boys they helped to rear to fill the commune's quota of recruits, or they could even sell these young men to other communes that sought additional recruits. The best study of recruitment procedures among the peasantry in the late eighteenth and early nineteenth centuries, though it is far from being as thorough and detailed as would be desirable, does point to an increasing "commodification" of recruitment transactions.[30] This circumstance should have led to the retention of more illegitimate boys, yet the data show a convergence in this period in the numbers of boys and girls being abandoned to the foundling homes.

To take a second example, male children of soldiers' wives and soldiers' daughters belonged legally to the military administration, and their mothers were supposed to retain and rear them until they entered military schools at about age eight. Accordingly, changes in the military's enforcement of this rule or in the mothers' ability to evade compliance by abandoning their boys in greater numbers to the foundling homes could lead to a change in sex ratios, but it is difficult to see why this factor would behave differently in the Moscow and St. Petersburg regions.

Another hypothesis would suggest that mothers would likely have regarded boys more than girls as a guarantor of their future security and so would have retained boys more often than girls. Even if one assumes that unwed mothers were rarely in a position to choose to keep a child of either sex, it should be recalled that a large portion of abandoning mothers in the period before 1890, perhaps as many as one-third, were married and thus were better able to keep some children while abandoning others. Indeed, the change in sex ratios may be explicable entirely in terms of the behavior of married parents. Unfortunately, however, for the period in which the changes were taking place, children from this group cannot be separated from the overall population of entering children.

[30] Aleksandrov, *Sel'skaia obshchina*, 242–93.

Finally, one might hypothesize that selection by sex was more an urban than a rural behavior, because its gradual disappearance followed the increasing use of the homes by women from the countryside. The period in which the numbers of boys and girls were most divergent was the period of the highest participation of urban dwellers. This hypothesis, however, founders on the fact that the proportion of urban participation in the St. Petersburg system was evidently always much higher than in Moscow, yet the sex-ratio difference was extinguished earlier in St. Petersburg than in Moscow.

The difficulty of finding a satisfactory specific explanation for the gradual equalization of the numbers of boys and girls abandoned to the foundling homes should not put an end to the search. It seems unquestionable, for example, that the convergence in sex ratios after the mid-1870s showed the influence of the introduction of universal male conscription. This change ended the commune's concern about providing recruits, and, combined with the growing land hunger after the emancipation of the serfs, it may have turned "excess" males into more of a burden than a benefit for the commune, since every adult male had a right to receive a portion of the communal land. But the more significant and interesting change took place earlier, in the late eighteenth and early nineteenth centuries, and because it occurred both at St. Petersburg and at Moscow gradually over a period of about one hundred years, the best explanation may not be a specific action or calculation but a more general change in values and behavior that affected both regions. The different timing of the change at St. Petersburg and Moscow suggests that a shift in cultural values, specifically in the value attached to females, may have been at the root of converging sex ratios.

West European culture and mores had earlier and greater influence in St. Petersburg than in Moscow. If in the past the peoples of Western Christendom had been apt to kill or desert girls more often than boys—as some evidence indicates[31]—this bias had faded by the eighteenth century. The Milan foundling hospital reported sex ratios of from 94 to 104 boys per 100 girls in all but three decades from 1660 to 1843.[32] Claude Delasselle's study of the Paris Foundling Hospital in the 1770s revealed no preference for abandoning girls. The sex ratio was 101, which would not be out of line for a cohort of illegitimate and foundling children.[33] Data on the Paris hospital and on France as a whole during the nineteenth century show no significant variance from birth cohorts

[31] Coleman, "L'infanticide"; Trexler, "Infanticide in Florence"; idem., "Foundlings of Florence," 267–68.

[32] Buffini, *Ragionamenti storici economico-statistici*, 109–11 and tables 1–5.

[33] Delasselle, "Les enfants abandonés à Paris," 149.

for the same period and make clear that circumstances other than the sex of a child led to its abandonment.[34] For the London Foundling Hospital, published statistics are available only for the 1760s, but these too record normal sex ratios for entering children. Registrations of abandoned children in the city of Oporto in Portugal from 1770 to 1785 yield a sex ratio of 117 boys to 100 girls.[35] Figures are also available for Austrian and Swedish institutions; although they are not strictly comparable, either because they counted total populations rather than entering children or because they accepted children only beyond a certain age, it is worth pointing out that they, too, exhibit no propensity toward the abandonment of girls in greater numbers than boys.[36]

If the value attached to girls was rising in western European countries earlier than in Russia, it is natural that Russia's most westernized city would be the chief entry point for the change. Not only did St. Petersburg lie closer to the West and therefore was more accessible to its influence, but a large portion of the city's population shared directly in western Christian culture. The usual population breakdowns of the late eighteenth and early nineteenth centuries, which list people by social estate, fail to make this fact apparent, since they show the category of "foreigners" as being only a little more than 3 percent of the population of St. Petersburg.[37] But many westerners migrated to St. Petersburg from within the boundaries of the empire at the time; the most prominent of them were Germans, Balts, Finns, Swedes, and Poles. The parish records of these ethnic communities in St. Petersburg indicate that they accounted for approximately one-quarter of the births in the city at the end of the eighteenth century.[38] So large a settled "western" population undoubtedly exerted a significant impact on the cultural norms of the city, including the relative valuation of males and females.

[34] Fuchs, "Abandoned Children in Nineteenth-Century France," 110–12; Potash, "Foundling Problem," 279.

[35] For London, see Nichols and Wray, *Foundling Hospital*, 86. Figures for Portugal calculated from table entitled "Expostas" in da Costa, *Descripção topografica*.

[36] Indeed, the opposite seems to be true in most cases. See the figures for Vienna, Prague, Brno, and Olmutz in the mid-nineteenth century in Hügel, *Findelhäuser*, 195, 205–7. The Stockholm facility, which until 1785 took only older children, showed the following interesting progression in its sex ratio among the total population of children: for 1672–1690, 102; for 1691–1710, 104; for 1711–1720, 108; for 1721–1755, 193; and for 1756–1785, 206. In some five-year periods of the late seventeenth century, girls outnumbered boys. It is possible that these data reveal a fairly recent shift in Swedish views toward the value of girls. Ratios calculated from table in Utterström, *Fattig och föräldralös*, 136. Figures are also presented on entering children: 205–7.

[37] Bater, *St. Petersburg*, 74.

[38] Calculated from enumerations in Engman, *S:t Petersburg och Finland*, 297.

Another consideration of importance in assessing the role of culture in the valuation of girls is the proportion of the urban population in the total population of the area served by the foundling system. A high urban proportion would normally correlate with more modern attitudes and thus less prejudice against girls. The evidence also supports this basis for St. Petersburg's lead over Moscow. Since the great majority of children entering both of the metropolitan homes came from the cities themselves or from their immediate provincial hinterland, the populations of the respective provinces are a relevant reference point. The difference is enormous: in 1832, the population of St. Petersburg province was 74.8 percent urban, whereas in Moscow the corresponding figure was only 26.1 percent.[39]

Other indexes that would test the degree of modernity in the two cities, such as distribution of wealth and level of education, are not well documented for the late eighteenth and early nineteenth centuries. At that time, the government classified the population into the rather vague categories of "social estate." However unsatisfactory, even this type of breakdown can give some impression of the larger segments of "modern" and therefore better-educated population groups in St. Petersburg. The concentrations in St. Petersburg of state officials, as reflected in the figures for nobility and *raznochintsy*, of merchants and low-income townspeople (*meshchane*), and of the military (which included complements of noncommissioned officers), testify to the more educated and modern aspect of that city. (See table 7.1.) The great disproportion in the percentages of peasants (even if many of the military were of peasant background) portrays the same picture from a different angle of vision.

A final consideration is the difference in opportunities for the employment of young females. If mothers (or parents, in the case of legitimate children) could expect to find jobs for girls in their early teens, to the same degree as for boys, they would have greater incentive to keep them. In at least two fields of employment, conditions in St. Petersburg differed from those in Moscow in ways that may have affected such decisions.

The first was the service sector. Unfortunately, analysis of occupational variables is hindered by the lack of reliable breakdowns of the population by occupation before 1869. Even so, it seems clear that St. Petersburg had a much larger service sector than Moscow in the early nineteenth century in relative and, because of its much greater population, also in absolute terms. The greater numbers of government offi-

[39] Rashin, *Naselenie Rossii,* 11–12, 114–15.

TABLE 7.1
Distribution of Population by Social Estate, St. Petersburg, 1801,
and Moscow City, 1788–1795

	Percentage of Population in City of	
	St. Petersburg	Moscow
Nobility	6.5	4.9
Clergy	0.3	2.1
Merchants	7.1	6.8
Lesser townspeople	11.6	5.2
Military	19.3	4.0
Raznochintsy and officials	17.3	10.1
Peasants and house serfs	37.9	65.7
Foreigners	—	1.2
Total	100.0	100.0

Source: Calculated from data in Kopanev, *Naselenie Peterburga*, 25, and *Istoriia Moskvy* 2:307.

cials and military officers in St. Petersburg provided a large market for domestic servants, and indeed evidence confirms a strong demand for free servants.[40] The imbalance in the sex ratio in the city's population—there were only about half as many females as males—would also suggest a greater need for female domestics than for male.[41] It was this demand that attracted many young Finnish women to St. Petersburg in the period when serfdom and early marriage restricted the flow of young Russian women from the hinterland.[42] Poor urban mothers could therefore anticipate that their daughters would find a job in this favorable market for unbound servants.

Another arena that could provide work for children and young women was mechanized manufacturing, especially the textile industry, and St. Petersburg was well ahead of Moscow in this type of development. Interestingly enough, enterprises owned by the St. Petersburg

[40] Kohl, *Russia* 2:98.

[41] Rashin, *Naselenie Rossii*, 273–83, 276–81. The differential between Moscow and St. Petersburg in the percentage of females employed in the service sector can be plotted through the second half of the century quite clearly; see the statistics compiled in Ransel, "Problems in Measuring Illegitimacy," 126, table 3.

[42] Engman, *S:t Petersburg och Finland*, 86–88.

Foundling Home itself were among the most important in the country. Its famous Aleksandrovskaia factory, established in 1799, featured three steam engines and between four and five hundred carding, spinning, and winding machines when John Quincy Adams visited it in 1810. At that time, five hundred foundling youngsters, about evenly divided between males and females, worked at the facility.[43] By 1828, the Aleksandrovskaia operation employed four thousand workers.[44] Another foundling-home enterprise, which produced highly praised paper products, provided employment and training for eight hundred foundlings.[45] The youngsters apprenticed in these plants could look forward to jobs in a burgeoning modern manufacturing sector in and around the city, for, compared to other parts of the country, St. Petersburg enjoyed a high concentration of large mechanized enterprises. In the middle of the nineteenth century, 54 percent of the work force in the city's industrial sector labored in factories employing over 750 workers. A single factory, the Nevskaia, operated 10 percent of the cotton textile spindles in the entire country,[46] and St. Petersburg province accounted for nearly 40 percent of all the nation's spindles.[47]

Moscow province, too, was important in the textile industry, but it could not boast the same level of mechanization and so lacked the same opportunities for the employment of youngsters and women. At mid-century, for example, the Moscow area had only about half as many cotton textile spindles as St. Petersburg. Of the 2,000 mechanical looms in the country, half were in St. Petersburg or its suburbs and only 150 in Moscow.[48] The difference in the level of mechanization can also be measured by the output per worker. In 1852, the value of industrial production in St. Petersburg province was 31.5 million rubles, with a labor force of 21,000. In Moscow province, output was 45 million rubles, but with a labor force nearly five times as large—103,000 persons.[49]

The role that the greater opportunities for employment of children and women may have played in the decision of people to abandon or keep their girls should not be overstated. The opportunities for employment in industry, if not in service, followed rather than preceded the

[43] Adams, *Memoirs*, 111. A detailed description of the enterprise can be found in Tarapygin, *Materialy*, 25–32.

[44] Khromov, *Ocherki*, 185.

[45] Kohl, *Russia* 2:16.

[46] Bater, *St. Petersburg*, 94.

[47] Khromov, *Ocherki*, 185–86.

[48] Ibid.

[49] Bater, *St. Petersburg*, 54.

beginning of the trend toward a more equal abandonment of the two sexes. Moreover, a young woman or a couple faced with rearing an unwanted child may not have given much thought to future opportunities for the child's employment. Perhaps the early development of mechanized manufacturing can better be evaluated as another aspect of St. Petersburg's earlier westernization and modernization, which in all its dimensions apparently played the decisive part in ending sex as a factor in the decision to abandon children in Russia.

The Abandoning Mothers

SOME INFORMATION about the women who abandoned children to the foundling homes has been presented in previous chapters. A clearer picture of the social and occupational status of these women is needed, however, if we are to understand their motives for abandonment. A profile of this type could also provide fresh perspectives on social and personal relations in Russia during the imperial period. Unfortunately, Betskoi's policy of shielding the identity of women coming to the homes greatly restricts the amount of information about them that is available for the first one hundred years of the homes' existence. In the early years, officials recorded impressionistic judgments of a child's social background on the basis of the mother's appearance or of notes or clothing sometimes left with a child. But these data were not analyzed systematically and the impressions could not in any case be generalized, since children often arrived not with their mothers but in the arms of midwives or other couriers. Occasionally, whole cartloads pulled up to the homes in the care of the notorious kommissionerki, the enterprising women who prowled the villages and district towns collecting unwanted infants and for a fee taking them to the metropolitan homes. Under these conditions, officials could not form a reliable picture of the family and social position of the foundlings. It was not until the changes in the second half of the nineteenth century that the authorities were able to obtain a clearer idea of the abandoned children's provenance and of the social processes at work.

SOCIAL BACKGROUNDS IN THE EARLY NINETEENTH CENTURY

Even in the early period, it was clear that not only poor and middling people availed themselves of the homes. Wealthy people, too, deposited children there. A few infants arrived in richly adorned clothes and conveyances. Fashionable trinkets and even precious stones of considerable value occasionally accompanied children given to the homes—an apparent source of pride in Russian foundling homes as well as in others throughout Europe, as officials everywhere made attractive display cases

of such objects for the edification of visitors. Large sums of money also turned up in the clothing of some of the children at the Russian homes, often with notes asking that the money be applied to the care of the child. The sum of these contributions was impressive. In the thirty-five years from 1799 to 1834, they amounted to 54,100 rubles at the St. Petersburg home and 178,715 rubles at the Moscow home.[1] That meant annual averages of 1,546 rubles and 5,106 rubles, respectively, at a time when the salary of a teacher at a military school, for example, was roughly 15 or 20 rubles a year.[2] The policy of the homes was to place the funds accompanying a child in trust and to turn the principal and accumulated interest over to the child at majority, a practice clearly designed to encourage contributions from conscience-stricken people of means. If the child died, the money reverted to the foundling home.

The experiment undertaken by Empress Maria in the early years of the nineteenth century provides some data with which to test the impression that a significant portion of the children given to the homes came from people of means. It will be recalled that the empress introduced subsidies for unwed mothers in 1805, but after a few years it was found that misuse of the program by married women was so great as to require a screening of applicants for eligibility. From 1810 to 1815, the open admissions system was suspended and information was collected on the parents of children given to the homes. The survey was far from rigorous or comprehensive. Not only were the categories used in some cases not especially revealing, but the invasion and disruption of the country by Napoleon's armies also hindered implementation of the program. Even so, the surviving registers give a few clues to the social groups making use of the foundling homes.

The most complete data were generated by the St. Petersburg home. Because it lay beyond the invasion route of the Napoleonic armies, it was able to obtain information through the entire five-year period. As the figures in table 8.1 show, of the 7,205 children whose social background was known (the first five categories, or 69 percent of the total), 17 percent had one or both parents who were from the nobility. Another 62 percent came from the large and unfortunately vague category "people of various ranks" (*liudi raznogo zvaniia*). This rubric embraced all the abandoned children whose parents belonged neither to the nobility nor to the peasantry and therefore included artisans, meshchane, soldatki (soldiers' wives and daughters), clergy, and merchants. At the upper range of merchants, artisans, and clergy were people who enjoyed

[1] M. G.***, "O vospitatel'nykh domakh," 57.
[2] Salary data from Kimerling, "Soldiers' Children," 107.

CHAPTER EIGHT

TABLE 8.1
Source of Children Entering St. Petersburg Foundling Home, 1810–1815

Source	Number	Percentage
SOCIAL BACKGROUND KNOWN	7,205	68.8
Noble father and mother	243	2.3
Noble father and non-noble mother	862	8.2
Noble mother and non-noble father	128	1.2
People of various ranks (*luidi raznogo zvaniia*)	4,465	42.9
Peasant serfs	1,507	14.3
SOCIAL BACKGROUND NOT KNOWN	3,274	31.2
People improperly registered		
(*liudi nespravedlivo pokazannykh*)	62	0.6
Children from outside St. Petersburg (*inogorodnye*)	647	6.1
Children deserted in the street	307	2.9
Children accepted by tsarist order	45	0.4
Children from Lying-In Hospital	2,025	19.3
Children from other hospitals		
and workhouses	188	1.8
TOTAL	10,479	100.0

Source: *Issledovaniia o vospitatelnykh domakh*, 55.

a comfortable life, and so it is probably safe to say that at least 20 percent of the people of known background using the home were offspring of the privileged or well-to-do.

The proportion of children from the privileged groups may have been even higher in the previous era. The mores of European eighteenth-century high society were notoriously loose, and this was also reflected in relations with subordinates. Judging from the figures that Jacques Depauw has unearthed for France, female servants in noble households were regarded as fair game for their masters. In Nantes during the 1740s, relations between masters and servants accounted for more than one-third of known (i.e., registered) illegitimate pregnancies.[3] The Russian court and high society aped the French in the eighteenth century, and illicit relations were much in fashion. This vogue may also have affected the behavior of the metropolitan nobility in its relations with

[3] Depauw, "Illicit Sexual Activity," 165–67.

152

domestic servants, if indeed they needed an additional incentive to exploit their servants sexually. In any case, social critics of the time, both conservative and radical, observed an increase in exploitation of this type and blamed the court for setting an example of debauchery.[4]

Toward the end of the century, attitudes in European high society turned sharply against the free behavior of the past; in as abrupt a change as has ever occurred in European social mores, the courts and aristocracy shifted to a modest style of life focused on the nuclear family. Depauw could observe this change in a large decline in the number of illegitimate births produced by relations between masters and servants.[5] The same shift in mores took place at the Russian court in the early nineteenth century and could have led to a change in behavior more widely.[6] The number of abandoned children shown in table 8.1 to be sprung from relations of nobles with people of their own estate or of other estates may therefore be a pale reflection of the level of illicit relations during the earlier era.

Another figure in the table of some interest is the number of serf children given to the home. Officials must have found it troubling, if not surprising, that more than 20 percent of the children of known social status were the offspring of bonded peasants, for the law forbade the delivery of serf children to the home without the knowledge and approval of the serfowner. (Limited data for Moscow indicate that about 15 percent of children admitted there from 1812 to 1815 were offspring of serfs or former serfs.)[7] From these bare statistics, it is impossible to judge precisely what was happening in this regard, but it would seem likely that bonded peasants were smuggling the children off the estate behind the back of the lord, either to escape the possible stigma of illegitimacy or to afford a legitimate child the chance at a future of freedom.

Perhaps the most striking thing about these figures, when compared to information on the later period, is the relatively low percentage of children from peasant origins. Even if all those in the category of "children from outside St. Petersburg" were the offspring of free peasants, as was probably the case, and were included among those whose social estate was known, the proportion of peasants in this subset would still be less than 30 percent. By contrast, as we shall see later, in the early years of the twentieth century at both the St. Petersburg and Moscow

[4] Shcherbatov, *Corruption of Morals*, 223, 233–35, 239–41, 245; Chulkov, "Prigozhaia povarikha." See also the remarks by Aleksandr Radishchev in the chapters "Iazhelbitsy," "Valdai," and "Erdrovo" in *A Journey from St. Petersburg to Moscow*.
[5] Depauw, "Illicit Sexual Activity," 167.
[6] Wortman, "The Russian Empress as Mother," 60–66.
[7] TsGIA, f. 758, op. 9, d. 526, pp. 95–96.

homes well over 80 percent of the abandoning mothers whose social status was known came from the peasantry. Of course, the homes were urban institutions and therefore best known initially to people living in the cities. Only with the introduction of the fosterage system and its extension into the countryside during the first half of the nineteenth century did knowledge of the foundling facilities spread widely in the rural areas. The German traveler J. G. Kohl, who visited the St. Petersburg home in 1837, remarked on the rapid development in the preceding period, when the fosterage system was growing, and he noted that the home, which had supervised only a few hundred children forty years earlier, now had in its charge nearly 26,000.[8]

One constraint on the use of the foundling homes by rural women in the first half of the century was serfdom. The famous novel *The Golovlev Family*, by Mikhail Saltykov-Shchedrin, may give a different impression, with its tales of landlords dispatching to the foundling home the children they sired by servant women. While this was arguably the practice in regard to illegitimate children of nobles, as was noted above, the serf-owners of central Russia were not likely to have encouraged the delivery to the foundling homes of children sired by their serfs and who constituted the future labor force of the estate. Indeed, the homes sometimes received petitions from landlords demanding the return of serf children illegally placed in the institutions.[9] Since a high percentage of the peasants in the central provinces and within easy reach of the homes were bonded, the impediment posed by serfdom was no doubt significant in limiting the flow of rural children to the homes in the early decades of their operation.

Before the 1860s, transportation was also a problem. Even if rural women knew of the existence of the homes and could freely choose to abandon their children, they still had to make a trip over poor roads to the city with an infant at breast. As time went on, this barrier was overcome by the intervention of the kommissionerki, who served as "middlewomen" in the villages in the provinces surrounding the capital cities.

SOLDIERS' WIVES

Not surprisingly, soldatki appear prominently in these early records. The St. Petersburg data shown in table 8.1 submerge them in the category of "people of various ranks." However, fragmentary information

[8] Kohl, *Russia* 1:343.
[9] Maikov, *Betskoi*, 245; TsGIA, f. 758, op. 9, d. 172 (seven cases from 1839 to 1841).

from the Moscow home during the time of the experiment by Empress Maria separate out the male children of soldiers' wives and daughters and indicate that these infant boys may have accounted for as many as 10 percent of the children who entered the home.[10] When data on the estate of mothers again become available in the late 1860s, soldatki constitute 25 percent of the women using the home, and this figure is at the beginning of a sharply downward curve, suggesting that the percentage was higher in the preceding period (see figure 8.1 below). It should be noted that these children of soldiers' wives entered the home during an era when officials were trying to exclude children who were supposed to be the responsibility of the military administration.[11]

These wives and daughters of the men drafted into virtual lifetime military service were often unwanted and uncared for in the villages, and many of them departed for the cities. But the cities could not offer unskilled women many opportunities for employment or a refuge from disease and want. Statistics on urban epidemics, for example, show that marginal urban dwellers like the soldatki suffered twice as high a death rate as peasants who resided in town.[12] The explanation was undoubtedly that most of the peasants either enjoyed the protection of a master or had an escape route back to the village. The soldatki had neither.

To support themselves, soldiers' wives adopted various expedients. Many turned to prostitution, a circumstance recognized in a late eighteenth-century literary portrayal by Mikhail Chulkov. His novel *The Comely Cook* narrated the adventures of a soldier's widow who supported herself handsomely through a series of lovers. Evidence that her occupation, if not her wealth, was shared by others in her position came when Emperor Paul in 1800 ordered that prostitutes be rounded up and sent to the Nerchinsk factories in the Far East, and it turned out that half of the women arrested in Moscow were soldatki.[13] Whether or not this percentage was typical, enough of the soldiers' wives resorted to prostitution that the entire group acquired an unsavory reputation. Empress Maria, for example, sought to deny to soldatki the right to reclaim their children from the foundling homes on the ground that these mothers would lead the children into vice.[14]

It seems reasonable to assume that soldiers' wives and daughters were

[10] Based on a partial breakdown of Moscow home admissions from March 1812 to April 1815 in TsGIA, f. 758, op. 9, d. 526, pp. 95–96.

[11] S. E. Termen, *Prizrenie neschastnorozhdennykh*, 165–68.

[12] McGrew, *Russia and the Cholera*, 96.

[13] Babikov, *Prodazhnye zhenshchiny*, part 3:27.

[14] TsGIAgM, f. 127, op. 2, d. 7649, pp. 31ob–32. See also Aleksandrov, *Sel'skaia obshchina*, 296–97.

vulnerable to sexual exploitation or might even themselves have sought protection and companionship in voluntary unions and consequently contributed significantly to the problem of child abandonment. Soldiers' wives who worked regularly as prostitutes were likely candidates for unwanted pregnancies and subsequent delivery of their children to the foundling homes. The soldatki contributed to the number of abandoned children in yet another way. Some who resisted a life of professional prostitution were nevertheless desperate enough for a means of support that they prostituted themselves for a time in order to become pregnant and therefore be in a position to gain employment at the foundling home. Their tactic was to deliver their babies to the home and return soon after to serve first as a staff wet nurse and then as a paid foster mother in the village system. Dr. Klementovskii of the Moscow Foundling Home, having uncovered "this business" on his inspection tours, noted that it was most often carried on by soldiers' wives and widows.[15]

Even soldiers' wives who stayed in the village or worked at more conventional trades had reason to use the foundling homes. Although soldatki enjoyed the advantage of being freed from serfdom, this boon came at the price of their sons' automatic conscription into garrison schools at age seven and eventually, like their fathers, into a life of soldiering. The loss of a son at about the time he could begin to contribute to the household economy was a severe blow, and soldatki sought through various ruses to conceal the existence of their children from the authorities and avoid their registration with the military administration. A report of the State Council on this matter in 1838 noted, for example:

> Experience shows that soldiers' wives often leave their real residence when the time of birth arrives and, returning with the newborn babies, call them foster children or foundlings [and claim] that it is not known to whom they belong; sometimes even after delivery in their place of permanent residence, they immediately send the newborn child away for upbringing under various names, to other villages and even to other provinces.[16]

Other tactics resorted to by soldatki were to conceal the identity of their children and then give them to a local board of public welfare or, if they could reach the capital cities, to the central foundling homes.[17] This

[15] *Issledovaniia o vopitatel'nykh domakh*, 53. This practice was also noted at the St. Petersburg home, though not associated with the soldatki. See "Vospitatel'nye doma," *Entsiklopedicheskii slovar'* (Brokgauz-Efron) (St. Petersburg, 1892), 7:280.

[16] *PSZ*, ser. 2, vol. 13, no. 11745, cited in Kimerling, "Soldiers' Children," 74.

[17] Kimerling, "Soldiers' Children," 74; *Issledovaniia o vospitatel'nykh domakh*, 52–53.

action spared the women the expense of rearing a child whose productive life would be of no benefit to her.

In many cases, soldatki hoped to be reunited with the children they abandoned to the foundling homes. Some were able to do this right away by becoming foster mothers of their own children, a trick they managed by striking a deal with a worker inside the home or with a wet nurse in the rural fosterage system. Though a serious breach of foundling-home rules, this practice was difficult to control, and officials on inspection tours frequently uncovered violations.[18] Other soldiers' wives who abandoned their infants may have hoped for a change in the laws on military service that would someday allow them to retrieve and keep their children. Indeed, in 1856, the government did modify the regulations that had called for automatic conscription of soldiers' children, and soon after many soldatki appeared at the foundling homes to reclaim youngsters they had earlier abandoned.[19]

In addition to legitimate soldiers' children, there were a great many who were illegitimate. Whether soldiers' wives remained in the village or drifted into town, these unattached women were at great risk of becoming pregnant and giving birth to an illegitimate child. Under Russian law, it will be recalled, even married women could have "illegitimate" or what might be more accurately called quasi-illegitimate children. If the mother proved unable to support such a child, it could fall into serfdom through a legal provision—essentially a welfare measure—that directed a local serfowner to provide for the child's upbringing. The situation of illegitimate soldiers' children was therefore far more precarious than that of their legitimate counterparts. Legitimate soldiers' sons entered garrison schools and served in the army, but with success at technical training they could possibly win a reduced tour of duty of fifteen and in some cases even twelve years instead of the prescribed twenty-five.[20] Mothers might thus eventually be reunited with their legitimate sons and expect some assistance from them. In contrast, if an illegitimate son fell into serfdom, his labor was at the disposal of the serfowner until adulthood. At that time, if fit, he would be handed over to the army as a recruit for a full term of service, since illegitimate sons dependent on villagers for their upbringing and without family to protect them were invariably drafted out of turn.[21] Nor was a child in

[18] The mechanism is described in detail in a report of 1874 by a village inspector: LGIA, f. 8, op. 1, d. 187 ch 3, pp. 32–35ob.

[19] TsGIAgM, f. 127, op. 2, d. 7649, pp. 1–6.

[20] On these provisions for early discharges, see Kimerling, "Soldiers' Children," 70. See also "Rekrutskaia povinnost'," *Entsiklopedicheskii slovar'* (Brokgauz-Efron) 26a:531–32.

[21] Aleksandrov, *Sel'skaia obshchina*, 290.

this position likely to receive the kind of training that would win a shorter term of service. No wonder, then, that soldatki frequently preferred not to run the risk of investing in sons that they might lose forever and instead turned them over to the foundling homes.

As the populations of the homes grew in the early nineteenth century, officials suspected that soldiers' sons were being admitted improperly, and they took measures to discourage this practice. In April 1828, the empress ordered that persons bringing children to the homes should be asked directly if the children belonged legally to the military administration, and when that was so, officials should obtain a written declaration of this fact. As became clear in subsequent directives, the point of this inquiry was to have grounds for demanding from the Ministry of War the cost of caring for their wards. In the next two years, further steps were taken to the effect that children deposited at the homes and known to be soldiers' sons were to be brought up in the homes' care until age eight but were to be inscribed as cantonists of the military colonies. The homes would receive from the administration of the colonies the amount set aside for the upkeep of a military cantonist and after age eight the boys would be transferred to the colonies.[22] It is difficult to judge if these measures had any deterrent effect; as mentioned earlier, as late as 1869 one-quarter of the women bringing children to the Moscow home were soldatki.

The observations about the behavior of the soldiers' wives have implications for interpretation of the trends in the sex ratios. If soldatki represented a large proportion of the abandoning mothers in the pre-reform period and if they abandoned boys more readily than girls, the sex ratios of children abandoned by other social groups must have been even lower than those seen in chapter 7. In other words, these other social estates were abandoning yet more girls relative to boys than the aggregate figures indicate.

THE LATER NINETEENTH CENTURY: SOCIAL ESTATES

More information about the abandoning mothers becomes available from about 1870, when the foundling homes started publishing annual reports on their activities. The bulk of the reports present medical statistics and survey the status of children in village fosterage. Data on the mothers are less satisfactory, because the continued use of open admissions inhibited the systematic collection of information on the women

[22] S. E. Termen, *Prizrenie neschastnorozhdennykh*, 59–60.

giving up babies to the homes. Even so, a majority of the women went along with the modifications of the entry procedures introduced in the second half of the nineteenth century, and this cooperation made it possible to learn more about the social position of the abandoning mothers.

Beginning in 1869, the Moscow home annually published a breakdown of the social estate of many of the mothers. It is important to point out the limitations of this particular record. First, the estate character of Russian society was in decay during the late nineteenth century, as an ever larger number of people worked at occupations not corresponding to their estate designation. Second, many of the estate categories embraced a wide range of social and economic positions and are therefore not especially useful analytically. Third, between 18 and 35 percent of the mothers who deposited their infants at the home did so without documentation and were not counted in the tabulation. Despite these limitations, the data, plotted in figure 8.1, reveal a much fuller picture of the social background of the women than did the spotty information from the first half of the century. The small numbers of "guild people" (artisans) have been combined with the meshchane, and the clergy, merchants, and nobility have been combined into a single category of "privileged estates."

The graph shows, first of all, a decline in the proportion of soldiers' wives and daughters contributing children to the foundling population.

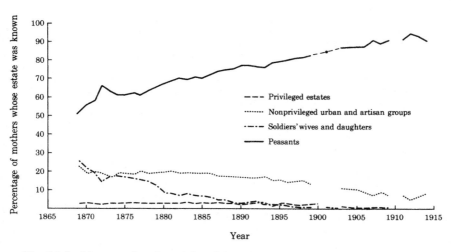

Fig. 8.1 Social estate of mothers giving children to Moscow Foundling Home, 1869–1914

159

This change, most of it coming in the 1870s, was clearly related to the military reforms of that era, which reduced the term of service and increased benefits for dependents of soldiers. During a soldier's period of service, he no longer lost his rights in the peasant economy; his land allotment might even be kept and worked by his father and brothers in his absence. The money the soldier earned in service did not go to his family but could be kept by him, yet he retained property rights equal to those of his brothers. His wife and children also maintained their rights in the household economy and furthermore received a subsidy from the state.[23] Following these changes, the soldatki disappeared from the population of abandoning mothers.

Another more gradual change occurred in the proportion of abandoned children coming from the urban and artisan groups. Their share was between 15 and 20 percent until the foundling-home reforms of the 1890s, after which it declined to about 5 percent.

The data also indicate that the privileged estates no longer resorted to the foundling homes with the same frequency as they did in the eighteenth and early nineteenth centuries. Perhaps they were now taking greater care to conceal their identity by entering the children without documentation, but it is more likely that the decline shown in figure 8.1 was a real one, since contemporaries also had the impression that wealthy people had ceased to use the foundling homes and preferred to give their illegitimate children to midwives,[24] who may or may not have turned them over to the central homes. A number of factors seem to have contributed to this change. Apart from the effects of the shift in mores among the court and high society mentioned earlier, the erosion of the belief in the foundling homes as saviors of infant life must have played a role. Even more important, the great influx of peasant women to the cities and the identification of the homes as depositories mainly for the babies of these poorest people probably discouraged further use by those who were well off. The foundling institutions were no longer the bright pennies that people in the eighteenth and early nineteenth centuries had naively believed them to be. Finally, the new rules, which at first encouraged and then after 1890 required disclosure of the mother's identity, surely also deterred women of "respectable" station from using the homes.

In contrast to the trends in the other social groups, the percentage of children coming to the Moscow home from peasant backgrounds rose steadily, from 50 percent in 1869 to nearly 90 percent in the first decade

[23] GME, f. 7, op. 1, d. 1813, pp. 33–35.
[24] M. G.***, "O vospitatel'nykh domakh," 57.

of the twentieth century. This change was due in part to the increase noted earlier in the share of abandoning mothers coming from outside the immediate Moscow area (see figure 6.2). As was pointed out then, the growth of railways facilitated the movement of unwed mothers from distant villages and towns into the city. For example, in the town of Klin, about 80 kilometers northwest of Moscow, a contemporary observer said it was well known and accepted that unwed mothers more or less automatically took their babies down the rail line to the foundling home in Moscow.[25] This attitude must have existed in many other places as well. Tolstoy, in his novel *Resurrection* (1899), which was based on newspaper items of the day, described the casual way in which Katerina Maslova turned her illegitimate infant over to a kommissionerka for delivery to the city; the fee for this service, he indicated, was twenty-five rubles.

However, the flow of babies directly from the countryside and small towns was not the principal source of abandoned children from the peasant estate. Village-born women resident in the cities contributed an even larger share, and this circumstance betokened a profound change taking place in the character of the large metropolitan centers during the late nineteenth century. Moscow and St. Petersburg, whose populations in the first half of the century had contained from one-third to one-half more males than females, experienced a great influx of women from the countryside in the second half (see table 8.2). This movement of women to the cities resulted directly and indirectly from the emancipation of the serfs, which accelerated the dissolution of the traditional structure of authority in the peasant household.

Even before emancipation, changes were occurring in the position of village women. The mean age at first marriage was rising, and this trend, which continued through the late nineteenth century and was accompanied by a declining rate of remarriage among widows, indicated a breakdown of traditional village norms, which had favored early first marriage and almost universal remarriage of widows of child-bearing age.[26] Another sign of the weakening of traditional patterns in connection with the anticipated and then actual abolition of serfdom was an increasing number of household divisions—that is, the separation of the large Russian joint or stem families into their component nuclear families. Since the serfowner's power had been deployed through and rein-

[25] Stepanov, "Svedeniia o rodil'nykh i krestinnykh obriadakh," 222–23.

[26] On the increasing age at first marriage, see Semenova-Tian'-Shanskaia, *Zhizn' "Ivana,"* 4; Czap, "Marriage and the Peasant Joint Family," 103–23; Vishnevskii, "Rannie etapy," 114–20. On remarriage of widows, see Tol'ts, "Brachnost' naseleniia Rossii," 142–52.

TABLE 8.2
Sex Ratio in Moscow and St.Petersburg, Selected Years between
1789 and 1915

	Number of Males per 1,000 Females in		
	Moscow		St. Petersburg[a]
1830	1,534	1789	2,141
1871	1,429	1792	2,114
1882	1,348	1843	1,945
1897	1,325	1864	1,389
1902	1,304	1869	1,302
1907	1,245	1881	1,219
1912	1,186	1890	1,160
1915	1,122	1900	1,198
		1910	1,096

Source: Calculated from data in Rashin, *Naselenie Rossii*, 273–83, 276–81.
[a] Including suburbs, except in 1869.

forced by that of the patriarchal heads of these large family households, the withdrawal of landlord authority brought in its wake a diminution of the power of the patriarchal family leaders.[27] As a result of these changes, more women were free from the authority of a husband for a longer time, and the abolition of serfdom opened up the opportunity for many of these women to leave their villages and seek work in town.

It is true that the abolition of serfdom did not greatly alter the condition of peasants who were tied to the agricultural commune. Prior to emancipation, they had been able to leave temporarily for work in factories and in cities with permission from the landlord, and they could do so afterwards only with the approval of communal elders (or by buying off their obligations at exorbitant prices). But the former servants of the landlord's household were free to go at will; and even among the peasants bound to the commune, unmarried women from needy fami-

[27] Reports of this change in the power of the family head came from informants participating in the Tenishev survey in the 1890s; for examples, see GME, f. 7, op. 1, ed. kh. 1470, pp. 30–31, and d. 1832, 11–12. Intimations of the change can also be seen in Shinn, "The Law of the Russian Peasant Household"; Bohac, "Family, Property, and Socioeconomic Mobility"; and Hoch, *Serfdom and Social Control*.

lies or women who had passed the age of twenty-one and become diffi-
cult to marry off were readily permitted to depart for jobs on estates or
in the towns and cities. Indeed, departure was becoming a necessity for
many of the Russian rural women in this era, just as it had been for
French village women one hundred years earlier: demographic expan-
sion was creating a surplus of people on the land, and the consequent
"push" created by the excess of female labor in the villages was at least
as important as the "pull" of the city in provoking the migration of
women from rural to urban areas.[28]

Of greatest interest is what happened to these women in the cities,
for the opportunities and problems they encountered there would influ-
ence their decisions about whether to keep or abandon their children.
Data on the occupations of abandoning mothers provide insights into
the situation and outlook of these women.

THE LATER NINETEENTH CENTURY:
OCCUPATIONS

Long before accurate statistics on the social and occupational back-
ground of abandoning mothers became available, officials had reason to
suspect that the broad categories designated simply as peasants and
"various ranks" concealed a high percentage of women employed in do-
mestic service. Surveys of West European foundling homes had dem-
onstrated a link between abandonment and the occupation of servant.[29]
Toward the end of the century, similar evidence became available closer
to home: the Prague lying-in hospital registered over 88 percent of its
patients as domestics. In Russia itself, the Riazan' zemstvo foundling
shelter, established after the 1864 local government reforms, kept rec-
ords on the mothers and showed nearly the same proportion of domes-
tic servants (85 percent).[30] Further confirmation might have been seen
in a study of sixteen female child murderers; these women were proba-
bly in much the same situation as the abandoning mothers but took a

[28] On France, see Maza, *Servants and Masters*, 36; on Russia, Zelnik, *Labor and Society*,
227–29.

[29] For the case in England, see Nichols and Wray, *Foundling Hospital*, 99. In France,
too, servants were a large component of abandoning mothers, second to those who
claimed to be seamstresses: Hufton, *Poor in Eighteenth-Century France*, 324, and Potash,
"Foundling Problem," 256. Delasselle's data from the Paris Foundling Hospital again
suggest that women in domestic service and the dress trades were main contributors to
child abandonment, but his sample is quite small: "Enfants abandonnés à Paris," 201.

[30] The Prague data are in Alois Epstein, *Studien zu Frage der Findelanstalten*, 9; the
Russian figures (for 1895) in Ginzburg, "Prizrenie podkidyshei," 491–93.

more brutal way out of their dilemma. The study revealed that fifteen of them had worked as menials.[31]

The composition of the female work force of Russian cities would in itself have told a great deal. As late as 1900, when women were entering the ranks of industrial labor in substantial numbers, domestics still constituted a large majority of working women in the towns. In St. Petersburg, over 92,000 women worked in domestic service, as compared to 57,848 in industry.[32] In Moscow as late as 1912, domestic servants represented the largest single component of the female work force, amounting to 25 percent of all independently employed women.[33]

The overlap between women working in domestic service in the towns and peasant migrants was clear. During the early 1880s, over 92 percent of the female servants in Moscow had been born outside the city, and nearly 50 percent of all employed female migrants worked in domestic service. The figures for St. Petersburg were similar: about 90 percent of female servants there had been born outside the city, and 54 percent of female migrants were servants.[34] This pattern of migration and occupation, it is worth noting, duplicated the experience of towns elsewhere in Europe. The proportions cited here for Russia were almost exactly the same as, for example, those found by Maza for Aix and Marseilles during the eighteenth century.[35]

For the Russian migrants, few of whom had technical skills, employment as domestic servants was about all that was available. Some probably obtained jobs even before migrating through personal contacts: summons from landowners seeking workers among the unattached women in villages of their former serfs or jobs located by women from the same village who were already at work in the city. But many women apparently found work through primitive labor markets. In the first half of the century, there were at least three of these in St. Petersburg: one in front of the Chernyshev palace, one on the square by the Kazan Cathedral, and one at the corner of Nevskii and Vladimir streets.[36] Another market of this type, in operation later in the century, was described by Fedor Reshetnikov in his novel *Where Is It Better?* The

[31] All the women in this small sample were peasants; four of them were unemployed at the time of their crime: Tarnovskaia, *Zhenshchiny ubiitsy*, 320–42.

[32] *S.-Peterburg po perepisi 15 dekabria 1900 goda*, part 2:42–105. The number of women in industry does not include those in commerce, hotels, or restaurants.

[33] Rashin, *Naselenie Rossii*, 333.

[34] *Perepis' Moskvy 1882 goda*, part 2:246; *S.-Peterburg po perepisi 15 dekabria 1881 goda*, vol. 1, part 2:306–9.

[35] Maza, *Servants and Masters*, 31.

[36] Iatsevich, *Krepostnoi Peterburg*, 102–3.

author, who drew on his own experience of lower-class life in St. Petersburg, told of the women who gathered each morning at the Nikol'-skii market and squabbled and shoved to obtain one of the few, mostly servant, jobs that were offered by prospective employers. After the turn of the century, when the cities established regular employment agencies with registries of available jobs, well over half of the business of these offices involved the employment of domestic servants.[37]

Many of these peasant women who became domestic servants for urban households were vulnerable economically and personally. Fewer than one-third of them were married, even though the vast majority were beyond the usual marriage age, the late teens and early twenties. The average age of female domestics in Moscow and St. Petersburg during the late nineteenth century was thirty-three to thirty-six years, and only 16 percent were under twenty years of age.[38] Apparently, few of these women, whether married or not, lived with members of their own family. In the 1880s, only 15.4 percent of persons employed as servants in Moscow were residing with their families, fewer than was the case for any other population groups except members of the armed forces and workers in rope manufacturing.[39] Compared to other working women, servants had a minuscule number of dependents. The Moscow census for 1912 reveals that female factory workers, who numbered just under 50,000, had 50,393 dependents, and other nonservant female workers, who numbered nearly 30,000, had 20,603 dependents; in contrast, servant women, over 92,000 in number, were reported to have a mere 3,549 dependents.[40] Moreover, the servant women often worked alone; over half the households in Moscow and St. Petersburg that hired domestics employed only one, and nearly 30 percent of the domestics employed in Moscow in 1882 were the only person on the household staff.[41] Women who worked in factories, difficult though their lot was, were not isolated. A large proportion came from families of factory

<hr/>

[37] Reshetnikov, *Izbrannye proizvedeniia* 2:466–86. On the Moscow employment bureau, see "Deiatel'nost' moskovskoi gorodskoi posrednicheskoi kontory za desiat' let, 1906–1916," *Izvestiia moskovskoi gorodskoi dumy, otdel obshchii,* 1917, no. 2.

[38] Calculated by Rodney Bohac from data in *Perepis' Moskvy 1882 goda,* part 2:41, and *Pervaia vseobshchaia perepis', 1897 god* 24:151 and 37:410. I am grateful to Professor Bohac for these and other statistics on servants presented below.

[39] *Statisticheskii atlas goroda Moskvy,* part 1:66.

[40] *Statisticheskii ezhegodnik goroda Moskvy,* 73.

[41] The St. Petersburg census of 1869 shows that 47.9 percent of the households employed domestics and that, of these households, 53.4 percent had only one servant. In Moscow, 39.1 percent of households employed domestics in 1882, and 55 percent had a single servant. *Sanktpeterburg po perepisi 10 dekabria 1869 goda,* part 2:86; *Perepis' Moskvy 1882 goda,* part 1:107–8, 112.

workers, and the overwhelming majority were married and living with their families.[42] Moreover, women factory workers could form ties with other women in the workplace for emotional support and personal protection.

The female domestic in the city—frequently isolated, without a family life, and deprived of the minimal legal protections enjoyed by some categories of factory workers—lived in a kind of personal bondage. With a good employer, she might have had a better situation than the factory worker and been shielded against the worst shocks of urban life. But a female servant was usually far from secure and could easily become the target of economic and sexual exploitation. If she fell ill or refused to fulfill the master's whims, she could be turned out into the street. The familiar, if confining, conditions of village life were replaced in the city by an alien society that often treated domestics as commodities and subjected them to economic deprivation and personal humiliation. Women in this position must have suffered high levels of stress. In Germany, where women servants also lacked protection and were "virtually certain of dismissal without reference" if they became pregnant, the number of "miscarriages, stillbirths or early death of infants of such girls was extremely high."[43] Theresa McBride reports that servants in a similar situation in France had higher suicide rates than people in other occupations.[44] It is impossible to say with certainty whether this was also the case in Russia, since the Ministry of Justice, which published detailed accounts of the linkage between occupation and most crimes, did not do so for suicides. The portrayals of servant women in Reshetnikov's novel nevertheless suggest that their lives were difficult and degrading, and it is known that servant women in Russia accounted for a disproportionate number of convicted child exposers and child murderers.[45]

It is not surprising that many servant women sought escape from their loneliness in sexual unions, perhaps tempted by the expectation of matrimony and a more secure and respectable existence. This was the motivation in the case of female domestics in France, who submitted to the sexual advances of men, usually men of their own social level, in the hope of finding a marriage partner.[46] Whether or not Russian servant

[42] For statistics and background, see Glickman, *Russian Factory Women*, esp. 88–104.

[43] I. Weber-Kellerman, *Die deutsche Familie* (Frankfurt, 1974), 124, as cited in Sagarra, *Social history of Germany*, 487–88.

[44] McBride, *The Domestic Revolution*, 108.

[45] For examples from criminal law statistics, see *Svod statisticheskikh svedenii po delam ugolovnym*, for 1873, part 2:74; for 1880–1881, part 2:107; for 1902, part 1:94–95. See also Tarnovskaia, *Zhenshchiny ubiitsy*, 320–42.

[46] Fairchilds, "Female Sexual Attitudes" and "Masters and Servants"; Maza, *Servants and Masters*, 68–72.

women were similarly motivated, when children issued from their illicit unions, the easiest course was to turn to the foundling home.

The data on social estate and occupation bear out the special vulnerability of the peasant women working as domestic servants. Even after the place of birth of abandoned children swung back to the cities after the reform of 1890 (see chapter 6), the proportion of abandoning mothers from the peasant estate continued to rise. Peasant women in the towns—the bulk of the servant class—were contributing the largest share of the abandoned babies born in the cities. Data on occupation are even more specific though they cover a more limited period. A full occupational breakdown for abandoning mothers is available only for the St. Petersburg home and only for four years between 1910 and 1914. Yet these data are very convincing. They show that at this late date, when the number of female domestics relative to the total female work force in St. Petersburg had long been in decline, domestic servants still predominated among the mothers abandoning children at the city's founding home, representing a proportion greatly in excess of their share of the total urban population (see table 8.3).

Fragmentary data for the preceding twenty years suggest that the overrepresentation of domestics among the abandoning mothers had been even greater then. In this period, the St. Petersburg home recorded the occupation only of those mothers who, after delivering babies to the facility, agreed to accept a subsidy to care for the children in their own homes or at their place of work. Although the proportion of women receiving subsidies varied widely during the period—from 2.3 percent to 56 percent of all abandoning mothers—one can assume that the occupational breakdown reflected a strong bias in favor of settled urban women with families that could provide living space and help to care for the children. Accordingly, the proportions of factory and craft workers were much higher than they were in the more complete data for the 1910–1914 period. Indeed, for the two years in which the records overlap (1910 and 1911), mothers engaged in craft work are overstated by 65 percent (see table 8.4). Correspondingly, domestic servants are understated by about 45 percent. Although the data are too variable to allow these differences to be used as adjustment factors for the subsidy sample in the earlier years, it is clear that domestic servants as a percentage of abandoning mothers in those years must have far exceeded the 47 percent recorded for 1910 and may have run as high as 80 percent in some years. When one recalls that domestics made up only 33 percent of the female work force in St. Petersburg at the time, this overrepresentation testifies to their inability to defend themselves against economic and sexual exploitation. It also indicates their isolated position in the

TABLE 8.3

Occupations of Mothers Delivering Children to St. Petersburg Foundling Home, 1910, 1911, 1913, and 1914

Occupation	1910		1911		1913		1914	
	Number	Percentage[a]	Number	Percentage[a]	Number	Percentage[a]	Number	Percentage[a]
Servants	3,035	47	2,482	51	1,788	42	1,434	34
Day laborers (podenshchitsy)	1,637	26	1,172	24	1,077	25	1,063	25
Seamstresses	783	12	442	9	629	15	761	18
Farm workers	362	6	342	7	367	8	397	9
Factory workers	185	3	132	3	181	4	244	6
Other craft workers	199	3	132	3	129	3	186	4
Living at relatives' expense	80	1	55	1	44	1	28	
Unemployed	38		53	1	23		24	
Teachers and governesses	21		26		20		16	
Artisans	21		6		20		16	
Marketwomen	16		27		22		17	
Medical workers	8		9		8		2	
Students	5		1		7		3	
Professional beggars	2		0		2		1	
Prostitutes[b]	1		3		1		2	
Total	6,393		4,882		4,318		4,194	
Occupation unknown[c]	315		—		275		283	

Source: Otchet S.P. Vos. Doma for the years shown.

[a] Based on number of mothers whose occupation was known.
[b] Some prostitutes probably declared other occupations.
[c] Women whose children were admitted under provisions for concealing the mother's identity.

TABLE 8.4

Percentage of Mothers Receiving Subsidy, and Their Occupation, St. Petersburg Foundling Home, 1890–1911

	Percentage on Subsidy	Among Those Receiving Subsidy, Percentage Who Were				
		Servants	Artisans	Factory Workers	Day Laborers	Other[a]
1890	2.5	65.1	16.5	8.3	8.7	
1891	5.7	60.8	12.4	12.4	10.8	3.5
1892	6.5	48.3	22.6	12.5	14.3	
1893	7.6	52.2	22.1	15.7	8.5	
1894	10.1	44.5	15.7	11.2	13.1	
1895	10.2	44.9	29.2	12.2	13.1	
1896	11.5	41.3	27.2	12.6	17.4	
1897	13.3	31.4	26.2	21.8	18.2	
1898	19.4	28.4	25.8	25.8	16.5	3.5
1899	22.1	27.7	25.2	25.2	17.5	4.3
1900	26.2	38.3	6.6	35.2	19.2	
1901	31.9	47.0	31.7	10.3	1.9	8.7
1902	36.4	51.7	32.4	8.8	6.4	
1903	41.5	45.5	32.0	8.4	2.5	11.7
1904	50.3	47.6	29.5	10.6	6.3	5.9
1905	56.0	47.5	17.8	13.0	6.3	15.0
1906	16.4	61.0	22.0	11.8	4.7	
1907	28.2	17.0	61.9	6.7	6.5	7.3
1908	23.5	19.5	69.1	7.2	4.0	4.6
1909	28.9	21.7	59.4	9.7	6.2	3.1
1910	34.9	5.1	77.3	6.2	6.5	4.8
1911	21.1	3.2	82.4	4.6	8.2	

Source: *Otchet S.P. Vos. Doma* for the years shown.
[a] Not shown is less than 3 percent.

city, where they were without relatives or friends to help care for their children.

Data for the Moscow Foundling Home confirm the point (see table 8.5). Though covering a shorter period (1900–1914), they reveal that the average proportion of domestic servants in the group for which information could be obtained was 63 percent during those years, when the proportion of domestics in the female work force was between 25 and 32 percent. Again, this subset of mothers, which on the average included somewhat more than half the abandoning mothers in Moscow, probably greatly understates the percentage of domestic servants in the

TABLE 8.5

Illegitimate Children Admitted to Moscow Foundling Home, and Their Mothers' Occupation, 1900–1914

	Illegitimate Children		Percentage of Their Mothers Whose Occupations[a] Were			
Year	Number	Percentage of All Admissions	Domestic Servants	Craft and Factory Workers	Agricultural and Day Laborers	Workers at Home
1900	5,673	62.5	56.4	29.1	14.3	—
1901	6,099	60.9	51.2	24.5	18.4	5.7
1902	6,995	66.6	48.7	24.4	16.7	10.1
1903	7,025	66.3	49.6	26.2	15.0	8.8
1904	7,395	65.1	54.3	24.2	13.4	7.8
1905	4,852	40.1	55.9	36.5	—	7.4
1906	7,015	60.8	43.4	35.5	11.2	9.7
1907	4,779	49.7	67.4	17.6	10.2	4.6
1908	5,032	50.7	79.0	12.4	5.4	2.9
1909	5,118	52.2	69.3	16.4	9.3	4.6
1910	—	—	—	—	—	—
1911	4,309	45.3	59.7	20.4	13.3	6.2
1912	4,512	47.7	65.8	19.7	7.6	6.6
1913	5,458	60.9	74.7	14.0	7.5	3.6
1914	3,947	47.6	45.9	26.8	17.5	9.6

Source: *Otchet M. Vos. Doma* for the years shown.

[a] Some women were registered as white-collar workers, but they never constituted more than a fraction of 1 percent.

total population of abandoning mothers; the actual proportions could easily have been as high as 85 percent, like those noted earlier for the Prague lying-in hospital and the Riazan' zemstvo shelter.

The figures for both Moscow and St. Petersburg show a decline at the end of the period in the percentage of servants as against other groups, in particular craft and factory workers. This shift in the clientele of the foundling homes reflected, with a lag, a similar change in the character of the female urban work force as a whole. The same period saw declines in the rate of illegitimate births and in the number of children abandoned at the metropolitan foundling homes. This suggests that the decrease in illegitimacy and abandonment may have been a result of the movement of women into more modern jobs. It is difficult, however, to isolate this variable from other obviously critical ones like enforcement practices at the foundling homes and, perhaps more important, the increasing use of contraceptive techniques and devices.[47] The spread of knowledge about contraception would have touched first the women in modern jobs and especially those in a type of work in which they came into regular and frequent contact with other women of their social rank and age.

MOTIVATIONS

The problem of determining the motivation of the mothers who abandoned children, addressed earlier in connection with the discussions that led up to and followed the major reforms of the 1890s, is a complex one. Historians of this issue in France are fond of creating composite pictures of the typical child abandoner. Janet Potash, for example, portrays her as an unmarried woman in her midtwenties, employed as a seamstress, servant, or textile worker (Potash's study concerned two major textile centers). She resided or claimed to reside in the city, although she was often born in the countryside. She made the decision to abandon her child before it was born, and so the sex of the baby played no role. She often left a note of identification with the baby, an indication that she retained some hope of being reunited with her child. Finally, it was not so much a fear of dishonor that motivated the decision by the French mothers, according to Potash, as the social and financial obstacles that hindered a single working woman from caring for a child.[48] This picture, drawn for the nineteenth century, was similar in most re-

[47] Boiarkovskii, "O vrede sredstv, prepiatstvuiushchikh zachatiiu"; see also the discussions at medical congresses—for example, *Obshchestvo Russkikh Vrachei v Pamiat' N. I. Pirogova, Dvenadtsatyi Pirogovskii s"ezd*, part 2 (St. Petersburg, 1913), 88.

[48] Potash, "Foundling Problem," 243–44.

spects to that presented by Olwen Hufen for abandoning mothers of eighteenth-century France.[49] If these portraits are accurate, the situation in France remained remarkably stable through two centuries.

In Russia, as the data and discussion presented so far have indicated, the proportions of abandoning mothers from various groups shifted over the course of the century and a half in which the metropolitan foundling homes were in operation. The early period saw a fairly high proportion of urban and even privileged people availing themselves of the homes. Until the military reforms of the 1870s, soldiers' wives and daughters also contributed a large number of children to the foundling population. Then, toward the end of the nineteenth century, peasant women, both those residing outside the large urban centers and those who had come to town to find work, mainly as servants, came to be the chief clientele of the homes.

Another difference in the Russian case was the significant role played by the sex of the child. As the data in chapter 7 revealed, girls were more likely to be abandoned than boys, at least during the first century of the homes' operations, and this would seem to indicate that considerations other than shame were at work in the decision of mothers to retain or abandon their infants. This is clear in the case of the apparently large, though undeterminable, proportion of children who were given to the homes by married couples. Since the decisions of married couples could account for the entire variability in sex ratios, it is impossible to say what proportion of unmarried mothers who abandoned children gave consideration to the sex of the child.

Commentators in Russia often framed the question of motivation in terms of whether poverty or shame was the more important cause of child abandonment. But these attributes do not adequately cover the situation of many of the women. The soldatki, for example, seemed in many instances to have wanted to keep their children if they could have counted on the children being allowed to stay with them. Although they were unwilling to rear a child that the government would take from them at maturity, many soldiers' wives sought to reclaim their children left at the foundling homes after a change in the law that reduced the chances of the loss of their grown children. It is not surprising that these women, who had few resources, would prefer illegitimate children to none at all; the children were an investment in both the emotional and financial security of the mothers.

The French women described in Potash's study reportedly did not fear dishonor and were not desperately poor, but they were poor

[49] Hufton, *Poor in Eighteenth-Century France*, 324.

enough to be unable to provide an adequate level of care for a child. This explanation seems to fit many of the Russian women who brought babies to the foundling homes. They could not afford to quit work to care for a child, and few factory or craft work situations provided care facilities. Nor could servants, most of whom worked singly or in small home situations and had to be available the entire day and well into the night, retain employment while caring for a small child. Things were scarcely better for the minority of female domestics who were married. Since husbands and wives often worked in different homes, it was just as difficult for these women to keep their children as for their unwed counterparts.[50] Here indeed may have been the source of many of the legitimate children who entered the homes before the reforms of 1890. Russians analyzing child abandonment by women in these circumstances would have labeled the reason for abandonment as poverty, but it was the conditions of employment as much as poverty per se that interfered with the ability of these women to keep their children.

Of course, the shame of having an illegitimate child must certainly have been a motive for some of the women. Administrators who argued for retention of the turning cradle method of admission to the homes obviously regarded this sense of dishonor as a major factor in the decision of women to abandon children. Even when they were finally convinced to restrict admissions and require women to declare their identity when delivering a child to the homes, officials included in the new rules a provision that allowed a woman to conceal her identity if she could furnish confirmation from a priest or trustworthy citizen that her child was illegitimate. This provision was used by over 30 percent of the women delivering babies to the St. Petersburg home just after the introduction of the reforms of 1890. But the proportion concealing their identity dropped below 20 percent by 1895 and continued a steady decline during the next ten years; by 1905, scarcely any women resorted to this method of admission at the St. Petersburg institution. A much higher percentage of women bringing in babies made use of this provision at the Moscow home: the percentage hovered at about 30 percent in the first decades of the twentieth century (see figure 6.1).

It is difficult to know whether this difference was due to differences of attitudes between the two regions with respect to the shame of illegitimacy and child abandonment, or to differential enforcement policies, or to some other factor. St. Petersburg, as has been pointed out, was a more westernized and cosmopolitan city, further removed from peasant life and traditional values. These circumstances may have acted

[50] *Issledovaniia o vospitatel'nykh domakh*, 52.

on both the women and the home administrators to make them feel it was not important to use the special concealment provisions. Administrators may not have regarded exposure to dishonor serious enough in these conditions to remind women of the option to conceal their identity. In addition, the women may have been too far from their home village to be able to obtain the local priest's certification of illegitimacy or, alternatively, far enough away not to worry about exposure to shame.[51]

Much more needs to be known about the stigma attached to illegitimacy in Russia, in particular among the common people. Most studies of peasant life note that sexual mores were strict, and yet available informant reports make clear that censure was far from universal and apparently varied considerably from region to region. An informant from Vologda province made these observations at the end of the nineteenth century:

> There are women and girls with families of illegitimate children who live on what is given in the name of "Christ." The people do not persecute or chase out these women, but laugh at them and say: "Let them live as they wish. They also want to flirt and there are no husbands. They bear children?—so, there'll be an extra soldier." To women who in the absence of their husbands have amorous liaisons they respond indifferently: "The husband isn't living at home, and the woman, it's clear, must have a man."[52]

Even were mores more severe, a move to the city distanced women from the strictures of the village. Indeed, this was perhaps part of the difficulty for them: their pregnancies may have been the result of traditional behavior—the desire to marry and establish a family and the expectation that the man who slept with them would feel an obligation toward them—transplanted into a context in which the social controls of village life no longer operated to provide them with a husband once a child was on the way. In these straits, a sense of shame may well have existed but have been secondary to the problem of survival, since most of the women were working as domestics and day laborers and could not perform their jobs while caring for an infant. Faced with losing their means

[51] For a discussion of the policy implications of the St. Petersburg situation, see Oshanin, *O prizrenii pokinutykh detei*, 36–37.

[52] GME, f. Tenisheva, Vologodskaia guberniia, Sol'vychegodskii uezd, Afanasyskaia volost', Puchuzhskii prikhod, 1899. See also Stepanov, "Svedeniia o rodil'nykh i krestinykh obriadakh," 222–23. Many other reports from the same survey also indicate tolerance for sexual breaches, especially among unmarried women beyond the usual age of marriage; see, for example, GME, f. 7, op. 1, ed. kh. 1470, pp. 6–7 and 31–31ob; ed. kh. 1471, pp. 21–22; d. 1832, p. 8.

of subsistence or publicly renouncing their children, they chose the latter course. They may have felt shame, but their economic situation was desperate enough to obscure the moral strictures impinging on them.

Conclusion

Through most of the history of the foundling homes in Russia, officials had only general impressions of the clientele of the institutions and the mothers' motives for abandoning their children. These impressions and the frame of reference provided by discussions of the foundling question in Europe were the basis of decisions on home policy. The founder of the homes, Ivan Betskoi, stressed the need for open and anonymous admissions because of his conviction that fear of censure caused women to conceal illegitimate births and then desert or kill their "children of shame." This assumption was part of the unexamined baggage of the European Enlightenment and may or may not have had anything to do with the reasons for child abandonment in Russia. It nevertheless gained some confirmation when Empress Maria suspended open admissions early in the nineteenth century, for the data collected at that time revealed that about one-fifth of the clientele of the homes were people of means who might well value the provisions of secrecy. Likewise, the perception at the time that the requirement of declaring the name of the child's mother was causing increased street desertions and greater loss of infant life reinforced accepted notions about shame and motivated the decision to return to the system of anonymous admissions, which again hid from officials the social origins of the abandoning mothers.

Later in the nineteenth century, officials realized that one group contributing heavily to the number of children abandoned was soldiers' wives, and this discovery led to measures to control misuse of the homes by these women. People then expressed concern that many legitimate children were entering the homes under the guise of illegitimacy, and policies were instituted to discourage this practice. In fact, officials were operating in the dark and had only personal observations and guesswork from which to build a profile of the abandoning mothers. When they finally closed down the open admissions system and were able to obtain a fuller picture of these women, it was clear that the profile had changed dramatically since the last point of information supplied by the experiment of Empress Maria in the early nineteenth century. By the 1890s, the vast majority of women using the homes were peasants who had come directly from the countryside or who had recently relocated to the cities, whereas at the beginning of the century women of this category made up only a minority of the homes' clientele.

NINE

Fosterage: The First
One Hundred Years

NOT LONG after the foundling homes started their work, they began sending infants out to fosterage in the rural areas surrounding the two cities in which they were located. Within a few years, the majority of the children in the care of the homes resided in the countryside, and it could be said that the main work of the homes became the placement of foundling children with wet nurses and foster families. Increasing admissions and the closing of the urban training centers for foundlings in the first half of the nineteenth century brought an intensification and spread of the fosterage operations of the homes. By the 1850s, the "Village Department" of the Moscow institution—the office responsible for the placement of children with foster mothers—was supervising over 40,000 children; its counterpart in St. Petersburg, over 30,000. The administrative districts or *okrugs* of the two homes ranged far beyond the immediate hinterland of the cities and beyond even Moscow and St. Petersburg provinces into the surrounding provinces. The cost of running the fosterage systems ran to more than a million rubles a year, and the monthly payments from the foundling homes to the foster families amounted to a major source of nonfarm income for many villages. Child care provided a vital income supplement for a large number of Russian women and families.

This livelihood was bought with death. For a woman to qualify as a village wet nurse for the foundling homes, it was thought best that her own child had been weaned or had died. Death of her child was almost preferable as a qualification, because her milk would then be "younger." In the great majority of cases, the child she took from the foundling home also died. To make matters worse, the presence in the peasant home of an infant from the foundling home placed the other children of that family at increased risk of disease and death. In other words, the opportunity for village families to earn a subsidy from the urban welfare institutions could cost between two and three young lives per foster mother.

Subsequent chapters will pursue in detail the economic aspects and the social and medical consequences of the fosterage programs of the

176

foundling homes. This chapter surveys the origins of the programs and some of the difficulties they encountered in the century before 1860.

GETTING STARTED

An experiment in farming out foundling children to wet nurses began in the very first year of the Moscow home's operation (1764), when Ivan Betskoi sent ten babies out to nurse with village women. Unfortunately, the home did not record the results of the experiment, but they evidently were poor, since Betskoi forever after opposed this method of caring for the children. Just four years later, however, he was overruled by the home's governing board. Following the devastating 97 percent mortality in the Moscow home in 1767, the board insisted that a substantial portion of the children admitted be sent to nurse in the countryside. At first the children were to go for only nine months, but by the next year it was decided to leave the fosterlings in the villages for up to five years.[1] Later, the stay was extended to age eight and beyond. This procedure had the desired effect of reducing the mortality in the central home and no doubt gave the governing board and officials a sense of greater control; they escaped the demoralizing effects of witnessing the deaths of nearly all the infants brought to the homes. The foundling children of course continued to die at a high rate, but they did so in the countryside in less obvious concentrations.

During the four decades of foundling-home operations in the eighteenth century, the fosterage program remained rudimentary. The homes sought women qualified to work as wet nurses by public announcements or recruitment through parish priests. Women could work either as staff wet nurses on a long-term basis or take an infant to nurse in their homes. The infants were registered by a number in the books of the institution and the same number was placed on a bone tag or cross hung around their necks with a thong. The prospective wet nurses underwent an examination to see that they were healthy and had breast milk; those planning to return to the countryside with a nursling stayed in the home with the child assigned to them for a period of observation and acclimatization before being released. They received shirts and diapers for the baby, and their pay varied in the early years between one and two rubles per month, depending on the need at any particular time to encourage more women to apply. To some extent, the pay rate was ad hoc. The chief overseer in the 1770s, for example, often ignored the official pay scale and tried to persuade wet nurses to take children

[1] *MIMVD* 1, part 2:1–2.

for less than the going rate. Villagers themselves were apparently not averse to this method of fixing wages, and when circumstances warranted they tried to bid up the price for their child-care services. The foundling homes also had a policy of granting special monetary bonuses for good care; if a wet nurse returned her nursling to the home in good health after a certain period (nine months at first), she received a one-ruble award.[2]

By the end of the eighteenth century, the increasing numbers of children in fosterage made it necessary to improve the administration. In 1797, the governing board called for adjustments in the program and standardization of procedures and practices. As it stood, the system was hard on foster mothers and administrators alike. No organization was in place for regularly visiting the wet nurses and foster mothers in the villages. Either the women had to appear in town each month personally to collect their pay or they had to employ an intermediary. At longer intervals, the women had to bring their fosterling to town for inspection. The infrequency of these contacts made it difficult for home officials to be sure that the child brought in for these examinations was the same one they had turned over to the woman earlier. It was evidently fairly easy and not uncommon for women to substitute their own children for deceased foundlings and to collect the subsidy from the home for the care of their own offspring.[3] Moreover, with time the fosterage program spread to more remote villages, from which it was impractical for nursing mothers to travel regularly into the city.

The results of village care also left much to be desired. To take the case of the Moscow home, by 1797 nearly 33,000 children had gone into foster care, and yet only 5,417 had returned alive to the foundling home for schooling.[4] Seeing this and the unsatisfactory oversight for the wet nurses, Empress Maria, the new director of foundling care for the empire, decided that better supervision was needed and ordered the governing board to develop more intrusive methods.

Two years later, the foundling homes established the village departments and appointed circuit overseers and doctors to check on the children in the countryside. The homes also began to supply wet nurses with standardized printed booklets in which officials could record monthly payments and jot down comments about the care and condition of the child in a woman's charge. It was about this time, too, that the institutions divided up the regions of fosterage into the administra-

[2] Ibid., 2–3.
[3] Ibid., 29.
[4] Ibid., 6.

tive units known as okrugs. In both Moscow and St. Petersburg, the main roads out of the city formed the backbone of the okrugs, which were made up of villages along the highway and smaller roads off to either side. This arrangement served well enough in the beginning, but later the homes defined more precise boundaries among the okrugs to end confusion about the inclusion in one or another okrug of villages lying near the midpoint between main roads and also to balance the administrative burdens among the okrugs.

The St. Petersburg program started with eight okrugs, each outfitted with a doctor and later with a circuit overseer as well. (The doctors from the St. Petersburg Foundling Home were the first medical officers to be regularly stationed in the Russian countryside.)[5] They were to see that children went all the way to their destination in the conveyances provided for them by the government and that the local priest was notified immediately of the arrival of a new foundling child in his parish. This measure was to curb laxness on the part of drivers not wishing to take women the entire distance to their homes and also to see that the women themselves did not sell or exchange babies en route. Collusion

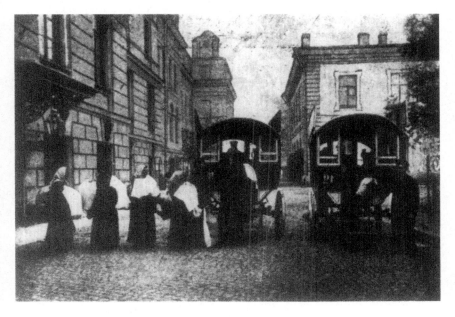

9.1 Dispatch of infants to the okrugs.

[5] Amburger, *Ingermanland* 1:454–55.

between women and drivers to deliver babies to unintended destinations also occurred, and the doctors had instructions to report this abuse. Other responsibilities of the doctors and overseers included guarding against the removal of the identifying tags placed around the necks of the children, affixing a shield of the foundling home to the doorway of homes in which fosterlings resided, and maintaining good records. The duties of the doctors and the overseers also included making periodic checks on the children, and in these early years frequent checking was the rule. The regulations at St. Petersburg directed the okrug doctors to visit sick children at least twice a month and to bring those needing intensive care back to their medical stations (*lazarety*). The overseers were to visit all the nurslings and foster children in their okrug twice a month and to notify the doctor in their area of any who were ill. Even the director of the village department was expected to visit the children in the okrugs at least twice a year, and he was encouraged to go out to the okrugs and check on matters there as often as possible.[6] It is doubtful that checking took place with this frequency, if only because of the difficulty of moving about the Russian countryside in some seasons, but it seems that the supervision was closer to the prescribed norms early in the century, when the fosterling population was manageable, than it was later on.

In Moscow province, an okrug system was likewise set up at the turn of the century but with ten instead of eight okrugs and without medical doctors being stationed in the countryside. Moscow also operated under slightly different administrative arrangements. Subsequently, the two homes diverged further in their policies and organization, and by the 1830s significant differences were evident in the operations of the two fosterage programs.

The Afanas'ev Report

In 1810, under a directive from Empress Maria, the village departments were abolished, and the St. Petersburg home's practice of stationing doctors in the countryside was ended, though the overseers remained. In 1816, however, a separate village department was reestablished in St. Petersburg and the doctors were returned to the countryside. The Moscow system continued to operate without a separate village department and, as before, without overseers and doctors residing regularly in the okrugs. Overseers went out from Moscow periodically to check on the

[6] From the rules published in 1817: Tarapygin, *Materialy*, part 1:88–89.

children, and children who were in need of medical treatment had to be brought to the city.

In 1834, the governing board of the St. Petersburg home asked whether its more expensive form of administration had helped to improve recruitment of wet nurses or to preserve the lives of the foundling children, and if so, whether the benefits justified the additional costs. The board noted that mortality among older children had declined regardless of the form of administration—from 23 percent in the 1799–1810 period to 21 percent in 1811–1820 and 17 percent in 1823–1832—but that the mortality of nurslings was about 10 percent lower when doctors were stationed in the countryside than when they were not (46 and 45 percent during the earlier and later periods, respectively, compared to 51 percent in the intervening period).[7] From this ambiguous record, officials concluded that the type of administration was less important than the provision of doctors and medical stations in the okrugs. Illness was what killed the children, and the officials believed that medical treatment helped, especially in the case of syphilis, which they believed to be a major problem among these children of "immoral" parents.[8] This view appeared sensible at the time but revealed a poor understanding of the causes of infant death and an exaggerated notion of the effectiveness of the treatments then available for syphilis. Only much later did officials adopt more sophisticated approaches to controlling disease among the foundlings.

By 1833, the cost of upkeep for the fosterlings and of maintenance of medical stations and staffs in the St. Petersburg okrugs was more than 780,000 rubles annually, yielding a much higher per-child expense than was being incurred in Moscow. The Moscow system supplied no doctors or medical stations in the okrugs yet recorded lower death rates. The St. Petersburg board resolved to determine why this was so and appointed a certain Dr. Afanas'ev to compare the operations of the two homes. He submitted his report in November 1834.[9]

One of the first differences noted by Afanas'ev was the provision for taking wet nurses from the central home to their villages. St. Petersburg used special equipages furnished with guards for this purpose. The method was expensive but was considered necessary for curbing abuses by independent drivers and the wet nurses. Moscow saved money by contracting out this service to drivers who hauled liquor and other

[7] Ibid., 89. The mortality rates were calculated in the somewhat misleading way used by the St. Petersburg home (see chap. 4).

[8] Ibid., 89.

[9] Ibid., 90. Tarapygin, who used sources in St. Petersburg, believed the report to be lost, but I found it in the Moscow city archives.

goods to the villages.[10] These teamsters earned extra cash by making room for up to four wet nurses and infants in their hooded carts and sledges (*kibitki*). The loading of this cargo was described by a German traveler who visited the Moscow home not long after Afanas'ev's study tour:

> A long string of peasants' carts, filled with straw, was stationed in the open court; each in its turn drove up to the door, and in tumbled, sometimes two, sometimes three or four stout clumsy women; these were the nurses. A little baby was next handed to each of them, and she instantly gave it the breast. The little imp set bravely to work, and away drove the rustic equipage in gallant style. Two men on the steps were checking the name of the nurse and the number of the child as they entered the carts; for here children are counted pretty much as sheep are elsewhere. The little creatures were swaddled up as tight as pounds of butter going to market.[11]

In response to questions about the security of this method of transport, wrote Afanas'ev, the people in Moscow assured him that the wet nurses "could and should" file a complaint against drivers who did not convey them all the way to their destinations. Since no one had heard of any complaints, they assumed that everything was working well. This naive assurance failed to convince the director of the St. Petersburg home, who was familiar with cases of collusion in the St. Petersburg area between wet nurses and drivers to deliver babies to their birth mothers by prearrangement or to sell the babies and their pay booklets to third parties. In view of the absence of guards on the Moscow transports, he remarked in the margins of the report, "What [the drivers and wet nurses] do along the way God only knows; even here we have had trouble enough, and how could it be better there?"[12] This comment accorded with Afanas'ev's conclusion that the Moscow method, though less costly, was far less certain to attain its ends.[13]

The Moscow program also did nothing to certify women in the villages for wet-nurse duty. In the St. Petersburg system, the doctors and overseers, who had direct contact with the peasants, acted as recruitment officers. They were supposed to identify women capable of serving as wet nurses by visiting homes and noting the "general way of life and condition of the home." They were not, for example, to consider

[10] TsGIAgM, f. 108, op. 1, d. 444, p. 67.
[11] Bremmer, *Excursions* 2:73–74.
[12] TsGIAgM, f. 108, op. 1, d. 444, pp. 61ob–62.
[13] Ibid., p. 67.

women in families that "showed signs of scabs, mange, or skin eruptions."[14] On the other hand, qualified women were to be encouraged to go to the central home and take a child. Before dispatching the women, the officials examined them to see if they were healthy and well supplied with breast milk. If so, officials gave the women a ticket of approval to bring to the foundling home.[15] These procedures afforded some protection against abuses of the program by unqualified women and left a reliable record of the women's residence so that officials could check later to determine if the women returned home with babies taken from the institution. The Moscow system, in contrast, had no officials stationed regularly in the countryside to perform these tasks. Women wishing to nurse a child simply turned up at the home and registered with a clerk, who had to take their word about where they lived and where they planned to take the child. The revelation of the looseness of controls in the Moscow program shocked the director in St. Petersburg, who noted that "even with our strict supervision, fraud occurs—how could it not be still more frequent and harmful in Moscow?"[16] The St. Petersburg officials would have been more disturbed if they had learned that the Moscow home sometimes used even more questionable methods to recruit wet nurses. In times of short supply, the Moscow home offered parish priests a one-ruble commission—in other words, a bounty—for each wet nurse they could induce to go to the home.[17]

What most distinguished the Moscow and St. Petersburg fosterage operations was the number and location of supervisors. Moscow had an assistant chief overseer in charge of the village department, two circuit overseers, and thirteen okrug overseers. All of these people resided in Moscow; only the okrug overseers made regular trips into the countryside—and then they visited all the foster homes in their area only four times a year, if that.[18] The infrequent contact is not surprising. About 30,000 children were being cared for in the Moscow okrugs at this time, which meant that on the average each okrug overseer carried a caseload of well over 2,000 children. The contrast with St. Petersburg was striking. Not only did the overseers for the St. Petersburg program visit the fosterlings much more often—once a month in the 1830s (and that was

[14] TsGIA, f. 758, god 1799, op. 9, d. 3, p. 9.
[15] Tarapygin, *Materialy*, part 1:88–89.
[16] TsGIAgM, f. 108, op. 1, d. 444, p. 56. The director was nevertheless impressed with the number of wet nurses these methods produced: more than 10,000 per year. "If only we could have the same!" he exclaimed.
[17] *MIMVD* 1, part 2:15.
[18] Ibid., 59. At another point in this collection, the authors note that inspections occurred only twice a year between 1837 and 1862: ibid., 131.

down from the twice-a-month visits that had been prescribed earlier[19]—but they also had administrative assistants and doctors, who like the overseers lived full time in the okrugs.

A higher degree of administrative centralization also characterized the Moscow system. The village department there was not a separate organization but a subsection of the central office.[20] The same desire for central control was apparent in the one function of the village program that the Muscovites staffed more heavily than St. Petersburg: the distribution of pay to the village wet nurses and foster mothers. This task occupied two guards, two bookkeepers, four scribes, and six administrative officials—fourteen people in all. The St. Petersburg home did the same job with just two persons, an official and a bookkeeper.[21] It seems as if the Moscow home, because of its otherwise weak supervision, saw a need to check especially well at the time of payment.

During his examination of the Moscow operation, Afanas'ev looked closely at one of the more populous okrugs, the First Mozhaisk, which lay to the west of Moscow astride the Smolensk highway and extended over portions of the Mozhaisk, Vereia, Moscow, and Zvenigorod districts. His tour took him to 103 villages in nine days. The report of this inspection is of special interest, because it contains the earliest available description of the communities that took nurslings and foster children in the Moscow system.

The peasants he found there were of three types. The largest number were "economic" peasants, former monastery serfs who were now under the jurisdiction of the government's Economic Collegium. The other two categories were landlord peasants on quitrent (*obrok*) and landlord peasants on labor obligations (*barshchina*). The economic peasants had little land in relation to their numbers and did not rely on agriculture for their livelihood. Most of the men worked at trades (*promysly*) or artisan crafts; the women were largely occupied with home handicrafts. "Though not wealthy, these peasants for the most part live decently and neatly; naturally, you can find drunkards and indigents among them," Afanas'ev reported, "but the number is not large. . . . They provide reasonably good and tidy care for 600 fosterlings (about half the number in the okrug), and in addition, since they may adopt children, they take more pains with them than do the landlord peasants, who normally must give up the foster children when they reach their teens."[22] (The

[19] TsGIAgM, f. 108, op. 1, d. 444, p. 59.
[20] *MIMD* 1, part 2:64–65.
[21] Ibid., 53.
[22] Ibid., 62ob–63.

foundling children enjoyed the status of free people and therefore could not legally be left among the enserfed peasants.)

The landlord peasants on quitrent in the area visited by Afanas'ev were mainly religious schismatics and quite well off. They rarely took in foundling children, but if they did, the children were well cared for, Afanas'ev said.[23] It is worth noting that, in 1834, the year of Afanas'ev's visit, the Moscow home introduced a policy forbidding both the placement of fosterlings with women adhering to the schism and the adoption of fosterlings by schismatic families.[24] By the 1850s, although concern about the influence of Old Believers on fosterlings continued, the home seemed willing to allow foster children who had inadvertently ended up with schismatic families to stay with them if the families did not prevent the children from participating in Orthodox rites.[25] Since the policy against Old Believers was not in force prior to Afanas'ev's visit, the low number of fosterlings among these families may have had more to do with the relative material well-being of the schismatics. If they did not need the monthly stipends for child care and could not, because of their status as serfs, look forward to adopting the grown children and adding them to the village labor pool, the schismatics would have little incentive to participate in the fosterage program.

Among the landlord peasants on labor dues, families were either well off or very poor. Afanas'ev noted that both types took in children from the foundling home, but the treatment of the children varied. Some families provided good care, while others allowed the children to live in filth and disarray.[26] Apart from this last point, Afanas'ev presented a generally satisfactory picture of foundling care among both the economic and the landlord peasants of the Mozhaisk okrug. It is impossible to say if this picture was typical of the Moscow system altogether; material on other okrugs is not available for this period. Later in the century, the best okrugs were on the opposite side of Moscow from Mozhaisk; if this was also the case in the 1830s, Moscow officials had at least avoided the temptation to steer their guest toward the more attractive but less characteristic areas of the fosterage system.

In reviewing the report, the director in St. Petersburg was struck by the great difference between the peasants Afanas'ev described from the Moscow area and those employed in the St. Petersburg fosterage program. The St. Petersburg system attracted exclusively court, appanage, and landlord peasants, all of them on labor dues and all of them agri-

[23] Ibid., 63.
[24] Ibid., 21.
[25] TsGIAgM, f. 108, op. 1, d. 472, pp. 132ob–133.
[26] Ibid., d. 444, p. 63.

culturalists; none of them worked on quitrent and none engaged in crafts.[27] (Court and appanage peasants were those inhabiting lands that belonged to the imperial family and the tsarist court.) This curious disproportion may be an indication of the relative strength of agriculture and craft work in the two regions. In the Moscow areas, the widely developed production of crafts and small industrial goods created competition severe enough to force the cottage workers into other means of adding to family income. In the north, infertile land may have caused the agriculturalists to feel the pinch first, especially in the dacha regions close to the city, where little specialization of crafts had occurred in the pre-emancipation period; it was in these dacha regions that the bulk of the foster children resided during these early decades.[28]

The differences noted up to this point did not go very far in answering the main question posed by the authorities in St. Petersburg: Why were the death rates lower for children in Moscow fosterage than for those in St. Petersburg fosterage? As it turned out, another policy evidently played the chief role here: the amount of time nursing infants were held in the Moscow home before being sent out with wet nurses to the countryside. In Moscow, children were not released before the expiration of a twelve-day examination period; for nursing infants, this period extended to at least three weeks and usually lasted six or more weeks. In addition, the wet nurse normally took home the baby she was nursing at the central institution. If that infant was not healthy enough to be released, the nurse was given another child and expected to stay on an additional twelve days before departure.[29] In periods of inadequate supply of wet nurses, the Moscow home settled for shorter stays of three or four days with a wet nurse before release. This happened most often in the summer months, when women could not long stay away from household and farming chores. In these instances, according to Afanas'ev, the home furnished the wet nurses with older and stronger children.[30]

The director of the St. Petersburg home sprinkled the margins of this part of the report with positive comments: "This is excellent!" "Excellent! It is a pity that we do not and cannot do this."[31] He noted that a rule against releasing to fosterage infants under six weeks of age would cause overcrowding in the central home, yet he strongly supported the practice of sending to villages only children who were completely

[27] Ibid., p. 62ob.
[28] Vyskochkov, "Vliianie Peterburga," 136–37.
[29] TsGIAgM, f. 108, op. 1, d. 444, pp. 55ob–56.
[30] Ibid., pp. 55ob–56, 71ob.
[31] Ibid., pp. 55ob–56.

healthy and vigorous. "This can and should be done; but unfortunately it is not, God only knows why." Then, answering his own question, he wrote: "Out of consideration for the wet nurses."[32]

This last comment revealed one of the problems faced by the officials. Most peasant women could not be absent from home for long periods. They preferred to go to town, "hatch" a child from the foundling home, and return with the least possible delay. At St. Petersburg, where the supply of wet nurses was tighter than at Moscow, officials released the women back to villages in less than a week. Some officials even contended that the fresh air of the villages offered better conditions than the central home for the healthy growth of the foundling babies. Dr. Afanas'ev referred to this view in his report and argued against it:

> You have only to see the lack of facilities and filth of the peasants' chimneyless homes [to understand the effects]. Every morning in whatever weather the door is left wide open while the stove heats up; in the evening . . . smoke descends in clouds; for lack of water, the wife sets out tubs of melting snow, which fill the house with a penetrating dampness; finally, there is a barrel of kvas brewing, a tub with fermenting cabbage, raw potatoes, chickens, piglets, in a word, everything needed for the peasant household. Into this atmospheric blend, you place in a filthy cradle on the floor a three-week old baby wrapped in dirty rags. . . . The rapid change from clean to filthy conditions is especially devastating for young infants.[33]

Afanas'ev was of course not aware of the deadly effects that institutionalization could have on small children and urged that wet nurses ought to spend a longer time at the central home with their nurslings before departing with the children to the village. Acknowledging that officials could not alter the general factors of supply and demand, he thought that at a minimum they could insist on a seven-day waiting period before release of children to the villages.[34] This was the one practice of the Moscow system that Afanas'ev found especially beneficial.

Here was the crux of the difference in mortality rates at the two fosterage operations. The higher survival rate of children in the Moscow okrugs bore no apparent relationship to supervision, methods of payment, or even the type of peasant families involved in the system. In most respects, the situation in Moscow fosterage was inferior to that in St. Petersburg. Although Afanas'ev and the people in St. Petersburg

[32] Ibid., p. 72.
[33] Ibid., pp. 72–72ob.
[34] Ibid., p. 71ob.

seemed only dimly aware of it, the difference in mortality rates resulted from the policy on release. Because St. Petersburg dispatched infants to the countryside earlier, more of them died in fosterage. If they had stayed in the central home longer, the mortality rate there would have gone up. The officials who evaluated mortality in the fosterage program evidently considered the situation in isolation. If they had compared death rates for the entire population of foundling children entering the two homes in this period, they would have seen that the difference in overall death rates was insignificant.[35] The rates were slightly lower at Moscow, but this difference probably resulted from Moscow's policy of allowing admissions at ages later than the first few weeks, including, as Afanas'ev reported, the acceptance of children at ages six months, one year, and sometimes even two years and older. St. Petersburg did not permit such late admissions; moreover, according to Afanas'ev's observations, it received greater numbers of premature, disabled and "weak" infants.[36]

Try as they might, the homes could not escape the high mortality among the foundlings caused by their policies on release. Just a few years earlier, in 1827, Empress Maria had urged upon the St. Petersburg home a speedier release of children to the countryside because of the problems of overcrowding and high mortality in the central facility. The director of the village department at that time feared the consequences of sending any but fully healthy children to the okrugs and on the slightest pretext refused to dispatch infants to the villages. Any mark or blemish on a baby's body was ground for refusal. The upshot was that the empress pushed that official aside and demanded that children be sent out sooner. To compensate for the earlier arrival of infants in the countryside, she expanded the medical facilities there. It was at this time that the St. Petersburg home began building small hospitals (thirty-bed facilities) in the center of each okrug and assigning a physician's assistant (*fel'dsher*) to work with each okrug doctor.[37]

In ordering these changes, the empress also laid down specific guidelines for recruiting wet nurses. She was convinced that officials could carefully calibrate their handling of these women. For example, she gave

[35] The sources do not indicate what method officials were using to calculate mortality in the okrugs at that time. My own calculations reveal little difference between mortality in the fosterage programs of the two homes. A potential problem is that records for Moscow were kept in a way that tended to underestimate the death rate there. Compare the methods of displaying figures for Moscow in *MIMVD* 1, part 2:22, and for St. Petersburg in S. E. Termen, *Prizrenie neschastnorozhdennykh*, appendixes.
[36] TsGIAgM, f. 108, op. 1, d. 444, pp. 68–69.
[37] TsGIA, f. 758, op. 9, d. 115, pp. 26–28.

permission for women to fetch infants without staying the usual period at the institution when the supply of wet nurses was insufficient, and in this connection she remarked that the okrug doctors knew who the trustworthy women were who could take children after only a three- or four-day stay at the home without officials needing to fear that harm would come to the children. Also, women whose own children had died or been nursed for nine months could be certified for a short stay at the central home. If there was doubt about the death of a woman's child, a short stay could not be authorized because, the empress noted, "we know that women with newborn babies will hire a wet nurse briefly, go to get a nursling [from the foundling home], return and again nurse their own child while placing the foundling baby on the bottle."[38] Women who could have had a nursing infant at home had to stay four weeks in the central home before departing with a nursling. Finally, the empress labeled some other categories of women as unfit to take a child back to the village. These included women without property in the village (landless peasants, soldiers' wives, unmarried adult women) and women who had taken three fosterlings within one year and allowed them all to die without seeking medical assistance.[39] Women from these categories could be certified only for wet nursing in the central home.

The empress believed that tight control by the doctors from their rural outposts could permit the early release of infants from the foundling home without endangering the lives of the children. Maria's belief may have been justified in those early years, but as the program expanded in numbers and territory, the kind of strict control she sought proved to be impossible, and the St. Petersburg home eventually followed Moscow in delaying longer the release of nurslings to the countryside. The insistence by the empress on adequate medical care for the foster children close to the places they lived and on regular supervision locally did nevertheless pay dividends in improved care and acculturation to modern notions of hygiene among both the foster families and the rural population generally in the areas covered by the foundling system.

SERFOWNERS: BENEFITS AND OBJECTIONS

A matter of importance for the fosterage programs in the era prior to the abolition of serfdom was the attitude of the serfowners. There was potential for conflict between the goals of the foundling homes and the interests of the serfowners, since the homes sought to create free citi-

[38] Ibid., pp. 29–30,
[39] Ibid., pp. 29–30ob.

189

zens. The foundling programs could provide a dangerous model of liberation for landlord peasants, while from the point of view of the foundling homes the placement of foster children on serf estates risked the absorption of fosterlings into the serf population. Despite these potential difficulties, foundling-home officials allowed and sometimes even sought the employment of landlord peasants as wet nurses and foster mothers. This was especially true in the early decades of the program, when surviving fosterlings returned to the central home for formal schooling. In theory, at least, during that period the children were in little danger of being absorbed into the serf population and so the homes could hope to make good on their promise of freedom for all foundling children.

In some instances, the homes made a special effort to encourage landlords to allow their peasants to participate in the fosterage system. A case of this sort occurred at the end of the eighteenth century, when the Moscow home was going through one of its periodic shortages of wet nurses. The governing board first allowed expansion of the geographic reach of fosterage, extending it to include the city of Moscow and its immediate suburbs (despite the belief that the countryside was healthier) and villages lying outside Moscow province. The board also added to the categories of people who could take children by permitting soldiers' wives to serve as wet nurses. Hoping to enlarge the pool of available wet nurses still more, they decided to include women from the serf estates; in this effort, they enlisted the civil governor of Moscow and the marshal of the nobility in the district of Ruza, in the western part of Moscow province, and these leaders of the local nobility persuaded serfowners to allow their peasants to participate in the fosterage program.[40] The immediate results of this appeal are not recorded, but it may well have contributed to the situation reported on by Dr. Afanas'ev a generation later during his tour of the western area of Moscow province, where he found a large number of landlord peasants in the program.

Winning the cooperation of serfowners was not always difficult. An assistant to the director of the St. Petersburg home took a trip to Novgorod province in the 1850s to recruit wet nurses and achieved great success working through local serfowners. He reported having visited more than two hundred settlements and despite some obstacles having persuaded seven thousand persons to take infants from the foundling home. A close look at the report makes clear that his real success was in persuading serfowners, since five thousand of the people included in his toll were peasants on landlord estates whom, according to the official,

[40] *MIMVD* 1, part 2:10.

the serfowners could more or less force to participate in the program. His salesmanship even extended to convincing a local landlord, Count Musin-Pushkin, to donate land for a medical station.[41] The fosterage program grew in size in Novgorod province in subsequent years; how much the increase owed to this official's arrangements for "forcing" peasant women into the work is unclear.

As mentioned earlier, the recruitment of wet nurses from serf estates could be risky, for it placed the pledge of freedom for the foundlings in jeopardy. Despite the solemn imperial grant of freedom, children from the home who were fostered with landlord peasants in some cases ended up being used as replacements for serf children who had died. In the first decades of the foundling homes, the seepage of foster children into the serf population was substantial. During the thirty-two years of Betskoi's rule, for example, when more than 30,000 children were sent into village fosterage by the Moscow home, 7,458 of them evidently survived early childhood, since no death registrations were filed for them; but only 4,966 returned to the central home for schooling. The remaining 2,492, or a third of the survivors, vanished without a trace. Some of them had probably died, and their deaths went unreported, but the number of such cases would have been limited by the desire of foster parents to collect a burial fee provided by the home for the disposal of the bodies of the dead children. In view of these conditions, it seems likely that, as officials at the time believed, landlords were "appropriating" many of these children.[42] St. Petersburg apparently experienced the same problem. The draft rules approved in 1799 for the village department of the St. Petersburg home enjoined "the strictest possible attention to prevent foundlings being substituted for dead infants belonging to serfowners or people of other ranks."[43] Even after officials strengthened supervision, the problem continued. A survey in 1836 revealed that over one-hundred foster children in the Moscow program could not be accounted for.[44]

Difficulties with landlords also appeared in a different guise. In the late 1830s, landowners in the St. Petersburg area banded together to demand that some of the functions of the okrugs be ended. The affair began in May 1838, when a landlord in the Oranienbaum area, Baron Ikskul', issued an order in which he accused wet nurses of neglecting their own and the foundling home's children and forbade okrug doctors to certify women from his estates for work as village or staff wet nurses

[41] TsGIA, f. 758, op. 9 d. 533, pp. 12–13.
[42] Miller, "Iz proshlogo Moskovskogo Vospitatel 'nogo Doma," 69.
[43] TsGIA, f. 758, god 1799, op. 9, d. 3, p. 8.
[44] *MIMVD* 1, part 2:21.

of the foundling home. The order threw the governing board of the St. Petersburg home into confusion. The board feared that the idea could spread to other serfowners and eventually bring the fosterage program to a halt. The position of Baron Ikskul' as marshal of the nobility in the Oranienbaum district heightened concern about the effects of his action.[45] Officials in the village department alerted the governing board of the St. Petersburg home about the danger to their program and also assured the board that the arguments made by Baron Ikskul' did not hold water. Ikskul' had complained about the neglect of children when the foster mothers were off doing labor on the landlord's estate. The officials pointed out that even when the foster mothers were away from home, the department "could not wish for better care than that provided by the older women—mothers and mothers-in-law of the foster mothers," and they noted several cases in which from four to eight foster children had grown up in homes that used multiple mothering of this type.[46]

The governing board convinced the chairman of the St. Petersburg province nobility to ask Baron Ikskul' to reconsider his decision in light of the fact that the emperor had already looked into the matter and was reviewing measures to reduce the number of children being abandoned. But this tactic backfired. It gave the baron an opportunity to state his case fully in the much larger forum of the St. Petersburg provincial assembly of the nobles. In a letter to the assembly, he stressed that his responsibility was first of all to see to the welfare of the people entrusted to his care and that he had long observed the harmful moral and physical effects of the nursing business.

> Peasant women, motivated by laziness and greed, abandon their families soon after the birth of a child and head for St. Petersburg and the foundling home, where they stay with no work, free room and board, plus one ruble a day. They give to other infants the nourishment they so inhumanly deny to their own. They do not consider the fact that they are breaching the most sacred obligation of a mother and a Christian and that their own children are often sacrificed to this unforgivable neglect. That is why we see so many childless families, who lose their children in the early years, if they survive at all, having been deprived of the early nourishment that nature requires and often rendered weak, sickly, and unfit for physical labor or military service. It is for this reason that the St. Peters-

[45] Minutes of the meeting of the governing board of the St. Petersburg home, May 24, 1838, in TsGIA, f. 738, op. 9, d. 204, p. 3.
[46] Ibid., p. 1ob.

burg area is so short of proper recruits. Moreover, it also under-
mines agriculture. . . . Not only are the women away at work times
but the peasants figure that they can count on the income from the
foundling home and need not bother with field or cottage work. In
addition, it should be pointed out that diseases heretofore un-
known have arrived in the villages with the foundlings.[47]

Baron Ikskul' not only refused to change his position; he even an-
nounced that if others followed his example he would regard himself as
a benefactor of still more peasants in the region.[48]

The response the baron wished for was not long in coming. Early in
1839, the assembly of the nobility of St. Petersburg province joined him
and asked that okrug doctors be forbidden to certify women for work
as village or staff wet nurses at the foundling home without approval of
the local landlord. Following this assembly, the eight district marshals
of the nobility signed a letter that described the evils of the fosterage
program in much the same terms as the baron had. The peasants, they
wrote, have an unfortunate inclination to use any means other than
work to earn money, however small the amount. So mothers leave their
infants soon after they are born to go and fetch a baby from the found-
ling home. This baby then shares the milk intended for the woman's
own child. This practice "upsets the peasant household and increases the
mortality of [the mother's] own children, [and brings] illnesses to her
other children, weakness and often infertility to the peasant woman her-
self."[49] Moreover, the marshals contended, the health of the peasants in
the area generally suffered, as was shown by the higher mortality in dis-
tricts to which foster children were sent and the gradual diminution of
the number of souls on many estates. The marshals did not cite concrete
evidence but instead advanced circumstantial arguments. A woman
wore herself out by nursing two infants, they wrote, and therefore could
not be expected to have healthy children. Furthermore, the children
would be unfit for hard work because of their inadequate nourishment
in early life.[50] Although these were impressions, not facts, later studies
confirmed the wisdom of some of the marshals' observations.

The insight of the marshals did not extend, however, to an under-
standing of the peasants' need to earn cash by any convenient means.
The marshals were concerned about the size, fitness, and character of
their labor force. In their view, the peasants were naturally shiftless, ig-

[47] Letter of July 6, 1838: ibid., pp. 10–11ob.
[48] Ibid.
[49] Ibid., d. 526, pp. 67–71.
[50] Ibid.

norant, and irresponsible about the welfare of their own families, and they had to be imbued with the values of hard work and strong family ties—in short, with all the bourgeois values that were part of the new family regime and that had entered Russia from the West first in St. Petersburg province and especially among the many German and Germanized nobles of that region.

The campaign to restrict use of landlord peasants as wet nurses posed a serious threat to the fosterage program, and foundling home officials had to redouble their efforts to deflect the nobles from their course. In this difficult moment, the foundling home, a state institution under special imperial protection, might have expected assistance from the government. But the reverse happened. Tsar Nicholas had learned of and heeded the alarms spread by Baron Ikskul', and a short time after the nobility had met to discuss the matter, the tsar issued the following order to the Ministry of the Imperial Court:

> It has come to my attention that great numbers of peasant women in the court domains are becoming wet nurses at the foundling home or are taking children from there to nurse, and that as a result their own children are left completely unsupervised and die in significant numbers. Finding this practice, which is motivated by the desire for gain, to be immoral and unnatural, I decree that henceforth forever it be forbidden on all court estates, be they here or in Moscow province.[51]

This unassailable support for the objectives of the marshals left the governing board of the St. Petersburg Foundling Home no choice but to agree not to certify wet nurses without the approval of local landlords. The result was greater difficulty in attracting an adequate supply of nurses and accordingly a need to raise pay for women working the fosterage program and to expand the okrugs into more remote areas, which had special ethnic and administrative problems of their own.[52] One of these areas was the Grand Duchy of Finland.

THE FINLAND OKRUG

To compensate for the loss of wet nurses in St. Petersburg province, the home opened a new okrug in 1840 that encompassed four parishes in Finland. Yet within a few years, here, too, community leaders objected to the foundling traffic. In 1857, the governor general of the Finnish

[51] Ibid., p. 49.
[52] S. E. Termen, *Prizrenie neschastnorozhdennykh*, 96–97.

Grand Duchy, Count Berg, asked that it be ended. "It has reached a point in [these] parishes that in addition to various kinds of family squabbles we also perceive a relatively higher mortality among the inhabitants," he reported.[53] Local officials who were asked to evaluate the effects of the fosterage program, according to Count Berg, concluded that it was having a devastating impact on the family life and health of the peasants: "First, syphilis is spreading in these areas, in part by being transferred from infected nurslings to their wet nurses, in part by the wet nurses infecting the infants; second, unmarried women are openly prostituting themselves in order to become paid wet nurses; and, third, peasant women taking children from the foundling home for nursing so desire to make the most of this occupation that they put their greatest efforts into rearing [the foundling children] and they neglect their own."[54] To make matters worse, the peasants had become financially dependent on the foundling trade, so that its cessation, according to the governor general, was bound to bring temporary hardship. He nevertheless urged an end to it as in the best long-term interests of his people.

This new threat to the St. Petersburg fosterage program provoked a rebuttal by a top official of the home, Maksim Tseimern. He pointed out that the accusations of Count Berg did not rest on a statistical foundation. If the officials in Finland would do a study of comparative mortality, wrote Tseimern, they would probably find, as the staff of the home had found in examining the last two censuses of St. Petersburg province, that the death rates were about the same for villages with fosterlings as for those without them. Syphilis could scarcely be a big problem, he noted, since children are checked carefully for it before being sent to fosterage. As for young women prostituting themselves, he questioned "whether it really happened, for it is improbable that this form of depravity could appear in Finland, which is distinguished generally by the purity of [its people's] morals."[55] Tseimern also remarked that the stories about mothers neglecting their own children to care for foundlings simply did not ring true.[56]

Tseimern nevertheless granted that special problems of language and religious training made operations in Finland difficult and that the home should close the Finnish okrug, but not until after new areas for fosterage were opened in Russian provinces to the south and east of the capital—a recommendation approved by the governing board in the fall

[53] Letter of February 23, 1857, in TsGIA, f. 758, op. 9, d. 446.

[54] Ibid.

[55] Letter to A. I. Gofman, state secretary for the institutions of Empress Maria, May 31, 1857: TsGIA, f. 758, op. 9, d. 446, pp. 60–67.

[56] Ibid.

of 1857. Annoyed by what he took to be a delaying tactic, Count Berg collected further information to bolster his indictments about syphilis and higher mortality in villages with foundlings, and the following spring he renewed his appeal to halt the traffic in Finnish parishes.[57] By the end of 1858, he broke through the resistance, and the board agreed to close the Finnish areas to new deliveries of infants and to phase out over the next ten years the more than two thousand children currently in the okrug.[58]

CONCLUSION

The first century of the fosterage programs of the foundling homes saw a steady expansion of the numbers of children and foster families. By the middle of the nineteenth century, hundreds of thousands of people were involved. The arena in which the foundling trade took place also occupied an ever-widening space. The St. Petersburg program, which started with eight okrugs, had grown to eighteen by the 1870s; Moscow, with ten okrugs at the beginning, had expanded to twenty-one. Both systems continued their growth in the next two decades. The fosterage programs encompassed vast areas of northwestern and central Russia, spreading into Finland in the north and the black earth belt to the south of Moscow province. The cost of the programs increased accordingly, running to well over a million rubles annually.

The first one hundred years also brought to light many difficulties in operating programs of this nature and magnitude. Some problems were specific to the era of serfdom. The arrogation of foundling children into the serf population to replace deceased serf children was an intractable and particularly painful difficulty in view of the promise of freedom to foundlings. In some ways more threatening still was the refusal of the governor general of Finland and the landlords in St. Petersburg province to allow foundling children to be placed with their peasants, for this could lead to a collapse of the fosterage program altogether. This region was, however, exceptional, for it was strongly influenced by the Protestant values of personal and corporate responsibility, and so the foundling program ran into the same kind of resistance that large centrally run operations of this kind had encountered in the Germanic lands of western and central Europe after the Reformation.

For a time, the government itself revealed a great deal of ambivalence about the fosterage program. While the tsar was acting through one of

[57] TsGIA, f. 758, op. 9, d. 446, pp. 80–81.
[58] The decision was made on December 2, 1858, and final approval was given in August 1859: ibid., pp. 88–89ob, 152–54.

his agencies as the protector and guarantor of the foundlings, he refused through another, beginning in 1839, to allow the nurslings and foster children to be cared for on his court or family estates. Although the government lifted the ban on settling foundlings on tsarist estates in 1867, the decision to impose it in the first place indicated great concern about the social and demographic consequences of placing the foundling children among the enserfed population. Later in the century, the demographic and medical effects of the programs emerged as the chief target of critics of the foundling homes.

Other difficulties up to midcentury generally involved manipulations on the part of wet nurses, foster families, and various middlemen to wring what income they could from the economic opportunity presented by the urban welfare institutions. The end of serfdom in 1861–1863 and the lifting of the tsarist prohibition against settling foster children on court estates were accompanied by an enlargement and intensification of the fosterage programs from the 1860s through the 1880s. During this period, many of the abuses and manipulations of the fosterage system observed sporadically in the past received closer examination, and the character of the programs as an economic system became evident. Officials began to see more clearly that caring for foundling children was regarded by the peasants as just another auxiliary trade and that the fosterage program had become a part of the systems of exchange that operated in the hinterland of the two capital cities. This important and complicated subject receives treatment in the next two chapters, which focus on the period after the emancipation of the serfs.

The Foundling Market:
A Network of Exchange
between Town and Village

THE PROGRAMS of village fosterage may be called a "foundling market," because they were essentially commercial mechanisms carrying on a traffic in children. The women drawn to the work of wet nursing and fosterage were rarely motivated by charitable instincts or even by the desire for children they could not have themselves. They regarded it as a job, an opportunity to earn needed cash or goods. The children served as a means to this end. As was pointed out earlier (chapter 4), not very many of the children survived beyond the first four years of life; hence, far from being objects of tsarist solicitude nurtured for a productive life, as the imperial government liked to advertise, the children functioned in reality as a perishable commodity in a system of exchange between the city and the village.

The commercial character of fosterage operations is obvious in all the countries in which they appeared. The Russian system has particular interest, however, because of its extraordinary volume and the thoroughness of its integration with other trades in regions of the capital cities. The economic side of this system can be analyzed under four rubrics: the recruitment of wet nurses and foster families, the exchanges or transfers of nurslings and foster children, the emergence of intermediaries in the trade, and the shifting economic geography of the fosterage programs. This chapter treats the first three of these; the economic geography will be taken up separately in the next.

RECRUITMENT OF WET NURSES AND FOSTER FAMILIES

The chief task of the foundling homes was the provision of nourishment and care for the thousands of children admitted each year. At the height of their activity in the 1880s, the Moscow home was taking in 17,000 and the St. Petersburg home over 9,000 children annually. This burden required the mobilization of a large number of wet nurses and foster mothers. The homes found that a market for the services of these

women operated in accord with normal supply and demand factors and that, as would be expected in any labor market, it functioned as part of a wider set of opportunities for female employment.

The foundling homes were never free from concern about the supply of wet nurses. Recruitment in some years was more difficult than in others, but every year saw periods of special difficulty. The most troublesome time was the season of field work, when peasant families needed all their labor resources and could not afford to have their women away in the city working at the foundling home or even going to fetch a child and having to stay at the institution for a period of examination and acclimatization with the infant. An interruption in the supply of wet nurses put tremendous pressure on the nurses who were available in the foundling homes and often meant placing some of the babies on the bottle, with usually fatal consequences.

Another reason for concern about the supply of wet nurses was a correlation between the quantity and quality of nursing and foster care. When the homes were not attracting a sufficient number of wet nurses because of the demands of field work or because of low pay scales, the character and commitment of the nurses that could be recruited deteriorated. Accordingly, the mortality suffered by the foundling children was greater under these conditions than would have been expected from a reduced number of nurses alone.

True to the economic model, pay was the critical factor. Early in the century, a member of the staff of the St. Petersburg home prodded its director, Grigorii Villamov, about the need to raise pay generally and the need for a raise in particular during the summer months, when the supply of wet nurses dwindled dangerously. It was clear even then that foundling care, like other peasant occupations, moved in a seasonal rhythm. The staff member who made the proposal for increased pay, Arkadii Il'in, pointed out to his reluctant superior that the pay scales had been determined many years before and that conditions had since changed: twice as many children now came to the home as in those times, requiring a corresponding increase in the number of wet nurses. The expedients the homes had tried before had not worked. For example, the introduction of a one-time bonus to induce women to fetch a child in the summer months had increased the number of wet nurses, but scarcely with the results that had been hoped for. The women, in effect, merely took the children from the institution to an early burial; they were happy to fetch infants and collect the bonus but saw no profit in maintaining the children afterwards on the inadequate wages they were receiving. The refusal to raise pay for village wet nurses also meant that the women the home could recruit were going to be those in the

neediest circumstances, the kind who had so much work on their farm-
steads that they were away from the house for long stretches and had to
put the foundling baby on deadly bottle feeding.[1]

Eventually, the homes worked out a method to enlarge the supply of
nurses in critical periods. They introduced automatic temporary pay in-
creases keyed to the percentage of children having to share a single wet
nurse. This method was in place at least by the middle of the century.
Under normal circumstances, when there were more infants than wet
nurses arriving at the foundling homes, the women who nourished two
nurslings received extra pay, but under the new arrangement, whenever
more than 15 percent of the nurses were feeding two babies, pay raises
went to all nurses then at the home, until this incentive brought in
enough additional nurses to catch up with the demand.[2]

The general problem of keeping pay scales at adequate levels contin-
ued, however, as did the connection between the erosion of the value of
compensation for wet nurses and the deterioration of care. In 1873,
officials at the Moscow home complained that only the poorest families
were agreeing to take children at the pay scales then in effect, for the
rates set fifteen years earlier had effectively been reduced by inflation.
The declining quality of care and consequent greater loss of life among
the children prompted sufficient concern that Moscow officials ap-
pointed a commission, composed of all those involved in the adminis-
tration of the okrugs, to study the problem, and the commission rec-
ommended a major increase in the pay scale.[3] This improvement
worked for a while until altered conditions later demanded still further
changes.[4]

In addition to these periodic adjustments of pay scales, the foundling
homes responded in other ways to the difficulty of obtaining wet nurses.
One was simply to intensify recruiting efforts, especially in the summer
months. From time to time, officials of the central home would order
the overseers in the okrugs to beat the bushes for additional nurses and
if necessary to offer to pay for their transportation to the city.[5] But these
efforts enjoyed only limited success. Some okrug overseers reported that

[1] Il'in to Villamov, March 11, 1818, in TsGIA, f. 758, op. 9, d. 29, pp. 46ob–50.

[2] *MIMVD* 2, part 2:125–26. In the 1860s, the wet nurses were paid 15 kopecks per
day and 10 more for a second nursling. When the 15-percent point was reached, pay for
all nurses rose to 30 kopecks per day.

[3] In response, 173,000 rubles were added to the annual pay fund. *Otchèt M. Vos. Doma*
(1873), 66–67.

[4] For a discussion of the economic condition of foster families in the Moscow system
over several decades, see chapter 11.

[5] TsGIAgM, f. 108, op. 1, d. 406, pp. 77–79.

the women in their areas refused outright to leave their farms during sowing and reaping, though they might agree to do so after the summer field work was completed.[6] A special campaign to recruit nurses was made in the Moscow okrugs in May 1869, and the official for Dmitrov okrug reported the enlistment of seventy-seven wet nurses, to some of whom he gave money for the trip to Moscow. By the next month, however, only twenty of the women had turned up at the foundling home.[7]

These observations suggest that the value of women's work during the agricultural season was very high, perhaps crucial to the survival of the farmstead, so that the opportunity cost of releasing lactating women to go to the foundling home was greater than the highest level of compensation that the homes could offer. The picture also shows that lactating women played an important role in the work of the farmstead; breast-feeding did not free women from heavy tasks. Of course, cultural constraints may also have contributed to the intractability of the problem. Even with pay scales for foundling care that would have fully compensated for the withdrawal of the wet nurse's labor input, the peasant family may have regarded the farmstead as the higher priority.

Another tactic used during the campaign just mentioned was to seek women who were qualified for wet nursing in villages that did not normally participate in the fosterage program. But this, too, proved less fruitful than anticipated. A circuit overseer who combed villages in this category found that many of them were farming communities in which, again, "the wet nurses noted the difficulty they had in leaving home during this [summer] period of hard work."[8] He concluded that it was easier to find additional wet nurses in the villages that already housed foundlings. He evidently meant that people in these villages had come to rely on baby farming as much as on regular farming; women were therefore more available for and more in need of auxiliary employment. In other words, he discovered that certain villages specialized in foundling care, just as the German scholar Haxthausen had found at about the same time that other villages in Russia specialized in carpentry, painting, and even begging.[9] Villages that specialized in carpentry, for example, were able to achieve economies of scale by establishing a training base and labor-market connections. Villages that had invested heavily in the foundling care had probably developed similar economies of scale in the form of networks of women who provided knowledge about and links to the foundling home and its agents, support systems of middle-

[6] Ibid., d. 455, pp. 24, 44.
[7] Ibid., d. 406, pp. 82–84ob.
[8] Report by Gnezderov, July 7, 1869, in ibid., pp. 102–3.
[9] Haxthausen, *The Russian Empire* 1, chap. 5, pp. 141–42.

men who could pick up pay and advance credit, and informal arrangements for the sharing of child care and household chores.

Still another approach to an improvement in the supply of wet nurses was to extend the area of recruitment by adding okrugs or enlarging existing ones. An inspector from the St. Petersburg home, in a report on Verebynsk okrug, pointed out that there were advantages in seeking wet nurses in villages that were not in the immediate vicinity of the main roads and rail lines. Peasants living near highways and railroads had more opportunities for auxiliary employment as well as better markets for their farm produce than did peasants living farther away. "Those in isolated places remote from the railway take more [foster] children," he reported, "because even if they happen to find [other] work, the pay is low," and they make nothing from their farm products, since "there is no place to sell them and no one to sell them to."[10] Even in the early nineteenth century, when the supply of wet nurses was adequate, Prince Nikolai Shakhovskoi, then head of the St. Petersburg home's village department, had urged extending the okrugs simply as a prudent fiscal measure. Pay for wet nurses was at its highest level ever, he noted, and an increase in the supply of nurses would drive labor costs down.[11] The okrugs did in fact undergo considerable change and expansion in response both to fiscal considerations of this sort and to changing opportunities for female employment.

Low pay created other problems besides difficulties in the recruitment of wet nurses. Families fostering older children regularly complained about the compensation they received. Sometimes the protests concerned payments for clothing for the fosterlings;[12] at other times, inadequate payment for the upkeep of children who had reached the age at which the monthly payments were reduced. For example, in January 1812 a trustee of the Moscow home, Nikolai Baranov, reported dissatisfaction on the part of foster families with the cut in pay at age seven. The peasants complained that children even as old as nine contributed nothing to the domestic economy and yet consumed a great deal. In response to inquiries about what would satisfy them, the peasants said that the fee of two rubles a month allotted for children of ages two to seven should be continued through age ten. Their discontent also affected the supply of wet nurses, since about six hundred families in the

[10] Inspection report of Verebynsk okrug (1871), in LGIA, f. 8, op. 1, d. 187ch2, pp. 157ob–59.

[11] Report to governing board, August 23, 1817, in TsGIA, f. 758, op. 9, d. 115, pp. 10–11.

[12] Report of governing-board member Baranov, April 1812, in TsGIAgM, f. 127, op. 2, d. 437, pp. 9–10.

Moscow okrugs were refusing to send women in to work as wet nurses until this matter was settled.[13] As a result, Empress Maria ordered that the payment of two rubles a month be extended to fosterers of children ages eight to ten.[14] Passive resistance of this type called the attention of the authorities to peasant grievances and demonstrated that the peasants, however needy they may have been, could occasionally mount a boycott with some effect.

Later in the century, foster families simply returned children when the cost of caring for them moved too far out of line with the monthly pay from the foundling homes. Returns occurred on a small scale all the time but became especially troublesome at times of high bread prices. In 1881, the price of bread rose steeply in the St. Petersburg region, and the okrug medical stations quickly filled up with returned children—mostly eight- to ten-year-olds, because the foster families received only one ruble a month per child over age seven at a time when it cost at least three rubles a month just to feed a youngster of this age, not to mention the costs of shoes and clothing.[15] The decision to return children at this time made clear again that the foster families, though rural dwellers and designated as "peasants," were more consumers than producers of foodstuffs and were to some extent specialized in the occupation of wet nursing and child care.

The children the peasants returned at these times were very hard to place. The homes found that sending the children back to the original foster parents was seldom an option, since after many years of caring for a child and having as a result a financial and emotional investment, the peasants had not given it up lightly. But other families were reluctant to take a new foster child of intermediate age. Because the home subsidies at this age were well below the cost of upkeep, families were apt to regard such a youngster mainly as a source of farm labor; yet children of this age were not capable of doing a full load of farm labor, especially after months of inactivity at a medical station. As a result, one official noted, even if a child was taken, "frequently the new family throws it out after a short time or the child itself leaves, not having developed a bond there, and ends up among the runaways that cause the foundling home so much trouble and expense, and, the main point, [the child ends up] morally impaired and without a family or other attachments."[16]

This same official told the story of an old woman who was rearing two foundlings, ages nine and ten, until poverty forced her to give them

[13] TsGIAgM, f. 127, op. 2, d. 437, pp. 1–20b.
[14] *MIMVD* 1, part 2:16.
[15] Inspector's report of October 2, 1881, in LGIA, f. 8, op. 1, d. 187ch4, p. 138.
[16] LGIA, f. 8, op. 1, d. 187ch4, p. 138.

up to the medical station. Before taking this step, she had tried for a week to support them by begging. "Their farewells rent the heart as the old woman took her leave," the official wrote. "You had to see this to understand the full force of habit that even these rude and callous people apparently acquire."[17] Two days later, the woman returned and took the children back. Finding the separation unbearable, she had sold her cow to be able to support her fosterlings until the next harvest. Although the official who told this story attributed the feelings of peasants to mere "force of habit," he could understand the peasants' misery. He recommended a small increase in the one-ruble monthly fee as an encouragement to foster families to hold on to the children longer. Otherwise, he warned, returned children would crowd the medical stations; okrug overseers would not be able to enforce proper standards of care on foster families for fear of provoking more returns; and peasants might stop taking infants from the home. Moreover, the high cost of bread weighed on the medical stations just as it did on the peasants. At the stations, board alone for a returned child ran to 4.50 rubles per month.[18] It made sense to increase the stipend paid to foster families in order to keep the children in a noninstitutional and less costly setting. Higher pay to help the foster families through difficult times was to everyone's advantage.

The connection between pay and foster care can also be seen in the case of the foundling shelters run by the zemstvo governing boards. The pay scales varied from province to province, and it is difficult to fix a clear picture of the zemstvo shelters as a whole. But for most of them, pay for foster care ended before the children reached their teens, and as soon as pay ended, many families returned the children to the shelters. According to a zemstvo official who compiled figures on the number of returns, they demonstrated beyond any doubt that the peasants treated foster care as an ordinary auxiliary trade, like hauling or a cottage industry. This attitude was especially prevalent in regions where reductions in crop yields periodically drove up the cost of foodstuffs and made an extra child a burden. In these conditions, he wrote, zemstvo workers had no way of forcing unwilling foster parents to keep a child, even if they had legally adopted it.[19]

A special difficulty confronted the metropolitan foundling homes in finding foster care for crippled or mentally incompetent children, and

[17] Ibid., p. 139.
[18] Ibid.
[19] The problem, wrote this official, lay not with the half-starving peasant family, but with the authorities, who failed to regularly reassess the conditions affecting foster families and to adjust policy and pay scales accordingly. Oshanin, *O prizrenii pokinutykh detei*, 86–90.

an even greater one in finding care for disabled fosterlings who had
grown to adulthood. The reports of okrug inspectors are filled with no-
tifications of families' refusals to keep a disabled person unless the pay
were increased. The common complaint again was that the cost of bread
was up and the person being cared for "brought no benefit whatso-
ever."[20] One okrug official, pointing out that current pay levels did not
cover the costs of foster families, declared that "in these cases peasants
invariably set economic considerations (*raschet*) ahead of their sympathy
for the foundling children, even if they had reared the children since
infancy and had formed attachments to them."[21]

As a rule, the foundling homes took a pragmatic approach to this
matter. For example, in 1878 a woman in the St. Petersburg system who
was caring for an "idiot" asked for an increase of her monthly pay from
the two rubles she was then receiving to three and a half. Although the
okrug inspector at first suggested that instead of meeting this demand
the home might send the child to an almshouse, he was overruled by his
superior, the director of the village department, who understood that
upkeep in an almshouse cost four or five rubles a month. The director
instructed the okrug official to ask the woman if she would be willing
to keep the retarded child for three instead of three and a half rubles.[22]
This type of negotiation conformed to a policy established in 1822 by
Empress Maria. She wanted no set policy or pay for these children, be-
cause, as she wrote, "if it happens that a foster parent does not want to
keep a crippled child, then the particular circumstances can be the sub-
ject of a special agreement with the foster parent, who might be pre-
pared to keep the child for less than [some standard] wage, already hav-
ing the child at home and having become accustomed to it."[23] Flexibility
was the key. In this area of government, in which the authorities needed
but could not demand peasant cooperation, they learned to treat com-
mon people with consideration and wisdom.

If the considerations already discussed can be viewed for the most
part as factors of demand, others might be identified as factors of sup-
ply. These touch the motivation of women and families for taking up
foundling care, and they reflect the conditions of the peasant family
economy. Three matters are most important for evaluating the supply
side: the structure of the peasant household, the nature of a family's cash
requirements, and the opportunities for and attitudes toward female
employment.

[20] LGIA, f. 8, op. 1, d. 187ch2, p. 137.
[21] Ibid., d. 187, pp. 232–33.
[22] Ibid., d. 187ch4, pp. 31–32.
[23] *MIMVD* 1, part 2:19 (see also 12, 18, 23, and 25).

The structure of the household played a role because it was far easier for women in large extended or joint family households to engage in foundling care than it was for women in nuclear households. Women in nuclear households could not leave their children and hearths for the length of time it normally took to travel to the foundling home and stay through the required period of adjustment with a nursling. After the emancipation of the serfs in 1861, the increasing tempo of household partitions (the division of large joint families into nuclear units) meant a reduction in the opportunities for many women to work in foundling care, an issue discussed in more detail in chapter 11.

The nature of a family's financial needs determined whether foundling care would be a temporary or an enduring occupation. Many families worked the foundling trade for only short periods, when they needed extra money or credit to replace a dead draft animal, to purchase farm implements, or to recover from a poor harvest. Lactating women in these families moved in and out of the foundling-care business as such needs arose. Other families came to rely on the traffic as a more or less permanent subsidy. The allocation of women's labor to this work on a regular basis indicated that few other outlets for their efforts existed. As already mentioned, this condition affected whole villages. These villages came to specialize in foundling care, and their economic survival depended on their ability to generate a continued supply of wet nurses and foster mothers for the foundling homes. The governor general of Finland, Count Berg, recognized that some of his parishes had become dependent on the foundling traffic and that closure of the okrugs would bring economic distress to the region (see chapter 9).

As important as cash was for some families, a consideration for many was not income from child care but the access the job gave to credit. A secret report on the fosterage program in 1856 explained:

> Pay is not high enough for child care to constitute a profitable trade for the peasants. Nursing does not occasion the peasants any expense but takes the woman away from household work, and keeping a non-nursing child requires considerable outlays for food and especially clothing. Children are taken, for the most part by poor families, not because of the money they expect to earn but because they plan to use the pay booklet from the foundling home as collateral for loans to acquire things they need for the household, such as livestock, seed, and buildings.[24]

In other words, the needs of the peasant household broadly conceived were the central consideration, and the family adapted the work inputs

[24] Golitsyn inspection report, in TsGIA, f. 108, op. 1, d. 447, pp. 130–31.

of its women in order to meet its cash and credit requirements with the least displacement of the women from their important role in the home. For this reason, wet nursing and foster care may have been preferred by some families, especially so if the only alternative work available would take the woman outside the home. Of course, for families that needed to draw the greatest possible cash earnings from their women, baby care could also supplement crafts carried on in the home.

Finally, the peasant families had to consder the "opportunity cost" of this type of work. They had to weigh its benefits against other opportunities for women's employment, an evaluation that involved more than merely a comparison of the cash returns. Several types of women's work paid better than foundling care, but they also demanded more of a woman's time and took her farther from the household and the important services she performed there. Baby care, however commercialized, was an extension of a peasant woman's household duties in a way that woodcutting and hauling and the manufacture of envelopes or cigarette tubes were not. Although, as noted earlier, it is true that the opportunity cost of dispatching women to the foundling home during the summer may have been very high for families heavily engaged in farming, this cost during other times of the year was probably low. A woman had to travel to the foundling home, spend some time there, and share some of the proceeds of her pay booklet with intermediaries who fetched her pay, but once that was over with, she could produce a regular income without leaving her own home.

EXCHANGES AND TRANSFERS

Despite the difficulty the homes experienced in keeping a full complement of nurses, the work never failed to attract a considerable number of women. At the height of the homes' activities in the 1870s and 1880s, more than 12,000 women were being added each year as wet nurses at the Moscow home (in 1885, the number rose to over 15,000) and over 9,000 were added at the St. Petersburg home.[25] The majority of these women had breast milk and had become qualified to serve as wet nurses by virtue of having weaned or lost either their own children or nurslings previously taken from the foundling homes. But the work was so desperately needed by some women that they resorted to actions that could only raise questions about the effects that the homes were producing in peasant society. For example, some women abandoned

[25] According to the annual reports of the two homes, as many as 30,000 women sought to become wet nurses each year during this period, and a total of more than 70,000 wet nurses and foster mothers was employed annually.

their own infants in order to take another child to the village to nurse for a fee or to qualify as staff wet nurses at the foundling home (which paid better than village care). There were even cases of nonlactating women who prostituted themselves to become pregnant and be in a position to give up the illegitimate child and obtain work as a wet nurse (see chapter 8).

A more common way for women to become involved in the foundling trade on an irregular basis was to acquire a fosterling by arrangement with a qualified wet nurse. This method spared women the trip to the home, the required medical examination, and the loss of time at the home for acclimatization with the infant. In some cases, this was simply a matter of a relative or friend picking up a child for a woman who could not leave her home for the time required to stay at the foundling facility. The homes did not discourage this practice altogether, as it was useful in filling the demand for wet nurses. Officials recognized that many qualified women wished to become wet nurses but were unable because of family responsibilities to come to the home personally, and so the Moscow home went along with exchanges of this nature when it could obtain reasonable assurances of the ultimate foster mother's qualifications to nurse.[26]

Many transfers of this type did not, however, have the approval of the authorities. Some of them involved illegal placement of infants with their biological mothers. In order to make money from her breast milk, a mother would bring her baby to the foundling home but then make an agreement with an employee at the home either to be allocated her own child as a fosterling or at least to be informed about where the child was being placed so that she could arrange a switch with the foster mother who received the baby.[27] The practice was evidently common. A report from an inspector in the St. Petersburg system in 1874 estimated that approximately 50 percent of the half-year wet nurses serving at the home were mothers of children left at the home and "inside they easily learn the name and whereabouts of the foster parents of their child." The other half of this wet-nurse group, the inspector went on, act as agents for mothers who leave babies at the home. "They learn where the infants are being sent and then on Sundays they meet with

[26] Cases from the Moscow home are in TsGIAgM, f. 108, op. 1, d. 406, p. 112 (report by Inspector Sheremetevskii, June 16, 1869), and op. 3, d. 178, pp. 31–32 and 69–70 (reports from May and June 1890). On the policy question, see Lebedev, "Ocherk deiatel'nosti," 39–40.

[27] For cases in Moscow, see the report by Inspector Sheremetevskii, May 30, 1868, in TsGIAgM, f. 108, op. 1, d. 460, pp. 25ob–26; for cases in St. Petersburg, see the inspection report of September 25, 1874, in LGIA, f. 8, d. 187ch3, pp. 71–73.

the mothers to tell them where to look for their children.[28] Not all the
mothers who made contact in this way were able to take custody of their
infants; some merely kept track of their children's development, visited
on occasion, and brought gifts.[29] At the time of this report, there were
about 2,500 half-year wet nurses working for the St. Petersburg found-
ling home, or about one-third of the total number of wet nurses. In
other words, if this report can be believed, about one-sixth of the wet
nurses maintained links to their children or even ended up nursing
them.

The transfer of a nursling back to its biological mother presented a
dilemma for officials. They acknowledged that it was better for the baby
to be with its own mother, and yet to turn a blind eye to this illegal
practice encouraged misuse of the program. Judging from cases re-
ported in the St. Petersburg system, officials usually allowed the mother
to continue collecting wet nurse pay and then tried to curb the abuse by
going after the employee in the institution who had arranged (usually
for a fee) the illegal placement.[30]

The most common type of exchange was not the transfer of a child
back to its biological mother but another type known as the "passing
from hand to hand" of foster children within a village and even beyond
the confines of a single community. This practice was first reported to
be occurring on a large scale by the director of the Moscow Foundling
Home, Dr. A. I. Klementovskii, when he encountered it on inspection
tours of the Podol'sk and Vereia districts of Moscow province in the
early 1860s. He observed that many of the nurslings and foster children
were living at the homes of women who were not registered as their wet
nurse.[31] Further investigation revealed two principal methods by which
this had come about. The first occurred through the agency of a cate-
gory of women known as "peddlers" (*torgovki*), who made a business
of fetching children from the metropolitan foundling homes and selling
them to women in the villages. Often a torgovka and a woman struck
an agreement ahead of time, and the torgovka used the passport of the
buyer in her dealings with the foundling home. All the paperwork was
then in the name of the woman who ended up with the child. It
frequently happened also that a torgovka picked up a child on her
own account and then sought out a buyer, sometimes simply selling

[28] LGIA, f. 8, op. 1, d. 187ch3, pp. 32ob–35.
[29] Surveys made by the St. Petersburg home revealed that many fosterlings and foster
families knew the identity and whereabouts of the biological mother. See the lists of in-
stances in ibid., d. 50, pp. 1–121.
[30] Ibid., d. 187ch3, pp. 72–73.
[31] *MIMVD* 2, part 2:136–37.

the child on the way home or even at the gates of the city. Along with the child, the buyer received the pay booklet entitling her to the monthly stipend from the home. In all these transactions, there was no guarantee that the eventual foster mother would have breast milk to feed the child; more often than not, the infant fell into the hands of a woman who fed it on the bottle or with solid food—practices that almost invariably brought an early death. Nevertheless, the buyer could continue to claim the monthly subsidy until the okrug overseer's infrequent rounds led him to the discovery that the child had died.[32]

Within the fosterage system, the torgovki formed a special class of poor, unattached women. Since their fees were not large—an initial stipend while at the the foundling home, and a two- to four-ruble profit (in the 1860s) on the sale of a child—the work attracted only the neediest women who were unqualified for other jobs. Furthermore, they had to have breast milk to pass muster at the foundling home and yet be free of family responsibilities in order to travel to and fro, picking up children and seeking out customers. The torgovki were most often widows whose only infant had died, or unwed mothers and soldiers' wives who delivered their illegitimate children to the home and then returned to pick up a foundling before losing their breast milk. It was more unusual for a married woman to be a torgovka, although this too occurred, especially in families in which the husband was absent for long periods as a migrant laborer. Here again, the woman had either lost a child to death or abandoned her infant in order to be free to engage in the trade.[33] Despite frequent trips to the foundling home a torgovka could escape detection for a long time because of shifting staff assignments and the large number of women applying for children.[34]

It is difficult to determine the scale of the activities of the torgovki. Data on them did not appear until some years after their discovery and the initiation in 1869 of efforts to control them through indictments and penalties for the miscreants. Despite these measures, there were still substantial numbers of them. Between 1873 and 1875, approximately 12 percent of the children taken from the Moscow home were turned

[32] In addition to Klementovskii's observations in *MIMVD* 2, part 2:130–35, see those of Chief Doctor A. I. Blumenthal', in *MIMVD* 2, part 2:128; Lebedev, "Ocherk deiatel'nosti," 40; and Peskov, *Opisanie durykinskoi volosti*, 110; and in *Detskaia pomoshch'*, 1890, no. 6:200.

[33] Klementovskii, in *MIMVD* 2, part 2:131–32. Apart from this testimony, reference to the pay appears in a volost court case in which a torgovka was accused of taking the pay and not delivering the baby. *Trudy kommissii po preobrazovaniiu volostnykh sudov* 2:328.

[34] See the discussion of the method and of the problem of detection in "Detopromyshlenniki."

over to women other than those who had come to the home to fetch them (table 10.1). Close to half of these deliveries were made without the knowledge of home officials, and later investigations showed that more than a quarter of this subset of nurslings ended up in the care of women with no breast milk and were fed on the bottle.[35] A survey done by the Moscow home in 1869 had revealed that for infants transferred in this way to women for bottle feeding, the survival rate was barely 2 percent.[36]

The second type of exchange of children occurred even more frequently: the passing of a child from one wet nurse or foster mother to another. Women in the Moscow program, for example, transferred children in this fashion 1,161 times in 1873 and over 1,400 times in 1875.[37] The majority of these transfers were made without the knowledge or approval of the okrug officials, and according to an inquiry into the problem by the Moscow home, "it can be stated with assurance that [the exchanges] were made for money."[38] For a small fee, the unapproved foster mother received the child and the accompanying pay booklet to use for as long as she could escape detection by okrug officials. P. A. Peskov, the author of a detailed public-health survey of one area of Moscow province where the foundling traffic was active, described a combination of the torgovka-type sales and these other transfers as they operated in 1867:

TABLE 10.1.
Placement of Infants in Moscow Okrugs, 1873–1875

Year	Number of Children Placed	Person Receiving the Child		Others Received the Child	
		Foster Mother	Others	With Permission	Without Permission
1873	8,243	7,153	1,090	588	503
1874	9,187	8,016	1,171	706	465
1875	8,886	7,918	968	497	471

Sources: *Otchet M. Vos. Doma* (1873), 33; (1874), 38; (1875), 52.

[35] *Otchet M. Vos. Doma* (1873), 33; ibid. (1874), 39.
[36] Ibid. (1869), 27.
[37] Ibid. (1873), 35; ibid. (1875), 54.
[38] Ibid. (1869), 27–28; see also ibid. (1875), 54.

Having abandoned their own children and attracted by the pay, peasant wet nurses appear at the foundling home and after a month or more they return with fosterlings in carts to their villages. But some of them resell the foster children right at the gates of Moscow and then return for additional children. Or other women, carried to the gates and deserted there by the cart drivers, are compelled to return home on foot with babies in their arms, sometimes in inclement and wintry weather. On arrival at the village the women again resell the fosterlings to a third or even a fourth person; thus children from the foundling home in the country towns of the Moscow region constitute a special type of disgraceful commerce that reminds one of pagan times or prehistoric conditions.[39]

The reports of okrug inspectors devote much attention to accounts of these transfers and of the measures introduced after 1869 to curb abuses. The normal recourse was to report an offender to a local justice of the peace (*mirovoi sud'ia*).[40] The frequency of prosecution and punishment is difficult to pin down, but isolated cases noted by officials indicate that penalties could be severe. A trial resulting from a report of this type in the St. Petersburg program, for instance, led to a two-week prison term for a woman who had illegally obtained a fosterling, although the child had evidently not died as a result of the transfer.[41]

A comparison of the reports from okrug officials in the two fosterage programs suggests that enforcement was stricter in the St. Petersburg area, and perhaps for this reason the number of abuses also seemed to be smaller there. Officials in the St. Petersburg program vigorously pursued the unsanctioned transfers they turned up.[42] A good example may be found in a report on the inspection of Izvarsk okrug in August 1867. Upon finding an emaciated infant, the inspector inquired into the cause and learned that a woman had illegally obtained the foundling from a woman in another village. Not only was this current foster mother incapable of breast-feeding the baby, but she had borne no children of her own and had no experience even with bottle feeding. "When I asked her husband how he could permit his wife to engage in such deceit and

[39] Peskov, *Opisanie durykinskoi volosti*, 110n. He was drawing on reports that had appeared in the newspaper *Moskva*.

[40] Examples from the Moscow program are in TsGIAgM, f. 108, op. 1, d. 455, pp. 45–45ob, and d. 460, p. 145, and op. 3, d. 96, pp. 35–39, and d. 538, pp. 34–35. See also Krasuskii, *Kratkii istoricheskii ocherk*, 151–53.

[41] Report by the home's doctor for the Ropsha okrug, January 6, 1870, in LGIA, f. 8, op. 1, d. 187ch2, pp. 48–49.

[42] Examples are in LGIA, f. 8, op. 1, d. 187, p. 209; d. 187ch2, pp. 28, 48–49, 231ob–32, 244–45; and d. 187ch3, pp. 135ob–36.

commit an act of premeditated murder," wrote the inspector, "he responded with utter naivete: 'What am I supposed to do when my wife can't give birth and money is needed?' " The inspector turned the baby over to a qualified wet nurse, but he held little hope of its recovery. He demanded the return of money paid to the unsanctioned foster family and pressed for prosecution on grounds of "premeditated deceit leading to the possible death of an innocent child, the victim of this woman and her accomplices, who condemned it cruelly and coldbloodedly to a slow death."[43] The peasant couple may well have wondered why they were singled out and deprived of a source of income, since most of the foundling babies died in any case.

The campaign begun in 1869 to end the illegal transfer of foundling children apparently achieved some positive results. The most obvious improvement came with the decision in the Moscow program to have an official accompany the transport of wet nurses back to their villages. St. Petersburg had used this method much earlier. At least this measure put a stop to the sale of foundling babies by torgovki at the gates of Moscow.[44] It was more difficult to halt the exchanges that occurred once the children were settled in the villages. Officials admitted the virtual impossibility of rooting out this practice, for it had been sanctified by long-established custom and was protected by collusion among villagers, who knew how to circumvent most of the legal prohibitions. One stratagem commonly used by the peasants to get around the tougher enforcement practices after 1869 was for a family to declare that it no longer wished to foster a child. These "refusals" accounted for about one-quarter of the transfers in the Moscow program after 1869. But the home's annual report declared that "there is no doubt that all these refusals were merely a pretext for transfers of children to other women with whom an agreement had been struck before the arrival of the [okrug] overseer. Disclosure of the details of agreements of this sort can occur only by chance, since in general women of the same community have many interests in common and very rarely turn one another in."[45] Officials wisely accepted that they could not penetrate village solidarity and for the most part went along with these deals, confining their role to seeing, if possible, that the children involved in them did not fall into the hands of the most destitute women or those without breast milk.[46]

[43] Ibid., d. 187, pp. 167–68.
[44] *Otchet M. Vos. Doma* (1869), 28.
[45] Ibid. (1873), 36–37.
[46] Ibid.

CHAPTER TEN

INTERMEDIARIES

Another indication of the commercial character of the foundling-care system was the emergence of intermediaries, or middlemen, who organized the trade for profit. There were several types.

On the intake side of the activity—the initial delivery of children to the homes—a carting service was performed by women who prowled the villages and district towns picking up unwanted children and for a fee transporting them to the metropolitan homes. This service appeared as a matter of course in other countries with large central foundling hospitals. In early modern Germany, carters of this type formed a regular artisan group with set rates.[47] They were probably best known, however, from eighteenth-century France, where they had plied their trade over long distances in bringing children to the Paris foundling hospital from every corner of the country. The French carters included both men and women, known respectively as *meneurs* and *commissionnaires*. In Russia, as already mentioned (see chapter 5), they were labeled kommissionerki, the use of the feminine gender for the Russified term indicating that it was women who performed the service.

For some time, the kommissionerki, using the back roads, remained out of sight of "respectable people." In the late nineteenth century, however, their activity came to public notice as the result of a change in their mode of transport from horse carts to the railways. A report in 1887 of the shocking conditions in which one woman had brought several infants by train from far-off Penza to Moscow produced an uproar in the press.[48] A child-welfare magazine launched an investigation and revealed that the kommissionerki had turned their service into "a highly profitable business." "They collect children locally," the magazine reported, "care for them in the most horrible conditions, and then, having gathered enough to make the journey profitable (each mother pays a certain sum to the carter) she hauls them to the capital."[49] Tolstoy described a transaction with a kommissionerka in his novel *Resurrection* (1899) and noted that she charged a fee of twenty-five rubles to deliver Katerina Maslova's illegitimate child to the foundling home. If that was the going rate, the business paid well.

Following the public outcry, the Ministry of Internal Affairs announced strong measures to curb what it called this "criminal trade" in children. More important in controlling the activity, no doubt, were the foundling-home reforms of the early 1890s that required revelation of

[47] A. L. Schlözer, *Briefwechsel* 7:150, cited in Werner, *Unmarried Mother*, 7.
[48] *Russkie vedomosti*, May 31, 1887.
[49] *Detskaia pomoshch'*, (1887), no. 23:754.

the identity of abandoning mothers. These two actions evidently re-
duced the commerce directed toward the metropolitan homes.[50]

Intermediaries were also involved in the placement side of the found-
ling homes' work. Reference has already been made to the torgovki,
who delivered or sold children that they had obtained from the found-
ling homes on false pretenses. Two other types of intermediaries played
a role in the distribution of pay to the wet nurses and foster mothers.
They were known as runners (khodaki) and brokers (zakladchiki). Like
the kommissionerki and torgovki, many of the runners were women.

Runners made their money by going to the distribution points and
bringing back the monthly pay. Their services were required because
many of the foster mothers lived far from the towns in which their pay
was disbursed, and the distance as well as family responsibilities made it
difficult for them to appear regularly to receive their pay. The runners
normally earned from 5 to 10 percent of the value of the monthly pay
for each booklet they carried.[51] More prosperous than the runner was
the broker, usually the owner of a tavern or shop. Many of the brokers
had started out as runners and, after acquiring some capital, set up their
business in a fixed locale. Like the runner, the broker took advantage of
the immobility of the wet nurses and foster mothers by arranging to
pick up their pay, but the broker also took advantage of their poverty
by advancing them credit. In effect, the wet nurses pawned their pay
booklets with the broker, who deducted a carrying charge and a large
interest payment—which in the Moscow region ran from 5 to 50 per-
cent per month, with an average of about 20 to 25 percent (see table
10.2)—and then paid out the rest in goods from his or her shop figured
at inflated prices.[52] In these cases, the women did not see any cash at all
and realized only a portion of their actual pay.

Brokerage of this type was not incidental to the system but formed a
pervasive and inextricable element of the fosterage program, as it did of
many other rural trades and much of cottage industry.[53] In the mid-
1850s, the head of the Moscow fosterage program learned that no less
than 70 percent of the pay booklets of wet nurses and foster mothers

[50] Ibid., no. 6:200. Some of the trade may have been redirected toward the zemstvo
foundling shelters, which were becoming more active in this period.

[51] Otchet M. Vos. Doma (1869), 39; Ibid. (1873), 65.

[52] TsGIAgM, f. 108, op. 3, d. 96, pp. 44ob–45; Otchet M. Vos. Doma (1869), 40. In
St. Petersburg, interest rates went as high as 40 percent: Meder, "Polozhenie pitomtsev,"
44–45.

[53] Cf. the "buyers" in the silk industry in the Bogorodsk district and in the toymaking
industry in Podolsk: Statisticheskii ezhegodnik moskovskoi gubernii za 1900 god (Moscow,
1900), sec. 2:23–27. See also Lenin's remarks in his Development of Capitalism, 372.

TABLE 10.2
Pawning of Pay Booklets in Moscow Fosterage Program, 1869

Okrug	Number of Brokers	Number of Pawned Booklets	Interest Rate
Mozhaisk	17	2,291	5 to 35%
Klin	15	up to 800	15 to 25
Podol'sk	22	up to 2,000	10 to 50
Ruza	20	up to 2,000	10 to 20
Serpukhov	15	up to 610	15 to 25
Dmitrov	13	up to 580	5 to 20
Vereia	30	1,153	10 to 20
Zvenigorod	a	up to 2,000	5 and up
Volokolamsk	22	400	5 to 15
Kolomna	3	35	5 to 15
Bogorodsk	a	15	5 to 10
Borovsk	20	937	6 to 10
Bronnitsy	7	—	20 and up
Total	184	up to 12,821	

Source: *Otchet M. Vos. Doma* (1869), 40.

a Information on the number of brokers in Moscow (not listed), Bogorodsk, and Zvenigorod okrugs was not submitted by the overseers because most of the brokers serving those okrugs were shopkeepers in the city of Moscow.

in that system had been pawned.[54] This discovery prompted measures to control the practice in the following years, but despite these efforts, a rough survey made at the end of the 1860s revealed that nearly 13,000 pay booklets, or about 40 percent of the total then in effect, were registered as being pawned (table 10.2), and officials admitted that this accounting was far below the actual number.[55] Reports from okrug doctors in the St. Petersburg system during this era make clear that brokers played an integral role in the operation of the foundling traffic there as well.[56]

The practice of pawning pay booklets had begun much earlier. Dur-

[54] Report to the chief overseer, November 1, 1856, in TsGIAgM, f. 108, op. 1, d. 444, pp. 82–82ob.

[55] *Otchet M. Vos. Doma* (1869), 40-41.

[56] LGIA, f. 8, op. 1, d. 187, p. 92; ibid., d. 187ch3, pp. 29ob–32.

ing the era of serfdom, many foster families either had pawned the pay booklets or had turned them over to stewards on the serf estates as a means of paying taxes and rents.[57] The brokers represented a capitalist version of the same system. The brokers often advanced a wet nurse as much as fifteen or twenty rubles, the equivalent of several months pay, to gain control of her pay booklet. There was a possibility that the child in her care might die and the monthly payments cease, but the risk to the broker was small, because the foundling homes always needed wet nurses. A woman who had pawned her pay booklet could return for another child as often as she wished and so keep her booklet valid. The broker merely had to convince the woman to fetch a new child and continue in the fosterage program.[58] If this tactic failed, the lender could bring the wet nurse before the local volost court, which handled these cases like any other contract and regularly ordered foster families to repay advances they had received from brokers.[59]

The brokers by no means played a wholly negative role in the system. Without their participation, the foundling homes would have had difficulty recruiting wet nurses from areas beyond the immediate vicinity of the towns in which pay was disbursed. Okrug overseers—if not their superiors in the city—were well aware of the importance of this service, and they resisted the introduction of strong measures to control the pawning of pay booklets, arguing that the policy would sharply reduce the number of women applying to be wet nurses.[60]

Since it thus appeared unwise to ban the pawning of pay booklets, some people advised that the government establish its own credit facilities to take the business out of the hands of the brokers. As early as 1869, the Moscow home did provide occasional small subsidies to families that suffered a temporary crisis like a fire.[61] But a regular fund for small loans was not set up until later, and then not under government auspices. The impetus came from volunteers who supported the work of the foundling homes in local areas. For example, in 1875 a philanthropist active in the Gzhatsk okrug auxiliary (Popechitel'stvo nad pitomtsami Gzhatskogo okruga), Anna Voeikova, offered to contribute

[57] A report from 1799 is in Tarapygin, *Materialy*, part 1:82. For other instances of use of this financial device during the era of serfdom, see the secret inspection report by Golitsyn, October 7, 1856 in TsGIAgM, f. 108, op. 1, d. 447, pp. 130–32.

[58] LGIA, f. 8, op. 1, d. 187ch3, 29ob–32.

[59] See the cases in *Trudy kommissii po preobrazovaniiu volostnykh sudov* 2:277–78, 519, 582, 583, 589. I am grateful to Barbara Engel for calling these cases to my attention.

[60] TsGIAgM, f. 103, op. 3, d. 96, pp. 31–32; LGIA, f. 8, op. 1, d. 187ch3, pp. 29ob–32.

[61] *Otchet M. Vos. Doma* (1869), 40.

1,000 rubles at no interest to help start a local lending operation for foster families. A facility of this type had already gone into operation under zemstvo auspices in Podol'sk okrug, an area south of Moscow with an especially high concentration of pawned booklets.[62] This approach won support in zemstvo circles, because the local governing bodies understood the need to control exploitation of the most vulnerable peasants. In the St. Petersburg area, the zemstvos developed a plan to provide foster families with loans at the moderate rate of 6 percent annual interest, and they even tried to buy back pay booklets that were already in the hands of brokers. By 1885, the St. Petersburg foundling home agreed to collaborate with the zemstvos in this effort and contributed a substantial sum to the loan fund.[63]

Eliminating the brokers was not easy, however, because the pawning of pay booklets was merely a symptom of the foster families' underlying difficulties. The need to undertake burdensome travel to collect the monthly pay and the low wage itself provided a favorable environment for the brokers. Consequently, little changed. At a meeting of Moscow okrug officials early in 1902, the overseers painted a familiar picture. At that time foster mothers had to travel either to Moscow, Serpukhov, or Tula to receive their pay—a journey of over 100 kilometers for some women. The overseers reported:

> The system of paying at only a few distant towns produces the problem of the kommissionerki-zakladchiki, and into their hands falls a significant portion of the pay intended for the foster families. The battle with this evil is one of the most difficult jobs for overseers, since the evil is rooted in the very economy and conditions of daily life of the peasants. This requires the population, which does not have access to cheap small credit, to pawn the foundling care pay booklets just as they have to sell their labor or their standing crops. It is impossible to figure precisely how much of the pay remains in the hands of these brokers, but the assumption that 50 percent and more does not reach the persons for whom it is intended seems altogether probable.[64]

These discussions produced a decision in 1902 to raise the pay for foster care and to plan for a reorganization of the method for distributing pay, which officials wanted to pursue in cooperation with the zemstvos and which they hoped would undercut the business of the runners as well as

[62] TsGIAgM, f. 108, op. 3, d. 96, pp. 44–45.

[63] Meder, "Polozhenie pitomtsev," 49.

[64] Minutes of the meeting of February 13, 1902, in TsGIAgM, f. 103, op. 3, d. 96, pp. 65–66.

the brokers.[65] The reality fell far short of their hopes. As late as 1910, a former zemstvo official, V. P. Obninskii, reported to a convention of social workers that the brokers were still quite active; one retailer in his district town earned as much as 5,000 rubles annually in interest from the pay booklets.[66]

Finally, the foundling homes themselves sometimes acted as intermediaries in supplying drafts of free labor to Russian villages. One of the benefits to families that fostered a child and brought it safely past the early years was that they could count on using the child's labor until it reached full maturity. This was the case, at any rate, for Russian foster families. In the case of non-Russian families, this boon was less certain. Many of the children from the St. Petersburg home, for example, went for nursing and foster care not to Russian villages but to Finnish, Ingrian, and Karelian ones, in which the people spoke Finnic languages. The home had a rule that children in these placements had to be taught to speak Russian and to learn their prayers in Russian. The rule, laid down in 1866 as part of a broader imperial policy of Russification, directed that children who had not mastered these skills by age fourteen be taken from their Finnic foster families and placed in Russian villages.[67] Some of the Russian villages that benefited from this practice refused to take infant foundlings and rear them, yet they were eager to obtain the Finnic teenagers, and by all accounts they exploited the children as servants and laborers and treated them as if they were serfs.[68] An okrug official who had witnessed painful scenes of foster children being separated from their Ingrian families and the abuse of the children in Russian villages argued that if the Russian villagers wanted cheap labor to exploit, they should at least have the decency to take nurslings and bring them up to working age.[69] In this type of transfer, unlike the other intermediary operations, the children no longer served as a perishable exchange commodity. With age, they became producers, adding valuable labor to the peasant economy, and it was this labor resource rather than goods or cash that the peasants sought to earn from the urban welfare institutions.

The objection of the official in the instance just mentioned was similar to that of many other officials who supervised the foster families. They

[65] TsGIAgM, f. 103, op. 3, d. 96, pp. 79–81.

[66] Obninskii, "Patronat nad pitomtsami," 558.

[67] LGIA, f. 8, op. 1, d. 187ch2, pp. 16–17; ibid., d. 187, pp. 91ob, 304–4ob.

[68] Ibid., d. 187ch2, pp. 104ob–5. See also the complaints of the St. Petersburg district zemstvo, in Meder, "Polozhenie pitomtsev," 48–49.

[69] LGIA, f. 8, op. 1, d. 187ch2, pp. 105–6. For further discussion of the children in Finnish families, see chapter 11.

seemed surprised and even indignant to find that the peasants behaved in just the way the foundling homes' economic incentives motivated them to act. But since the whole system was based on economic motives, not charitable ones, it should scarcely have been surprising that the peasants responded as they did. As a rule, the wet nurses and foster families operated on a rough calculation of the value of the children in their care, including both the current monthly stipends or line of credit and the future value for each year that the child could be expected to survive and contribute to the family economy. When the present outlays exceeded the value of present and expected returns, the families returned the child and acquired one of a different age (either an infant, which brought a higher stipend, or an older child, which could contribute labor), or they left the business altogether.

CONCLUSION

The behavior of the institutions and the foster families in regard to the recruitment of wet nurses, the exchanges and transfers of children, and the actions of intermediaries reveal clearly the commercial character of the fosterage programs. The capital for this commerce, which was mobilized through the endowment and lending agencies of the metropolitan foundling homes and supplemented by government subsidies, came initially largely from landowners' gifts or payments and then flowed out of the central institutions toward the peasant foster families in the countryside. But it reached only a portion of the families—in the Moscow system during the 1860s, fewer than one-third of them—in the form of cash. Instead, most foster families received credit for the purchase of goods in shops either locally, in a nearby market town, or in Moscow or St. Petersburg. In these cases much of the value of the pay was siphoned off by intermediaries who were in a good position to facilitate the goals of the foundling homes and of the foster families while at the same time taking advantage of both of them.

The length of time a family engaged in foundling care also depended on economic considerations. Many people became involved only temporarily, in a time of crisis. If their home burned down, the horse died, or seed was insufficient for planting, they took a foundling and repaired their losses with the stipend or, more often, with the credit to which the pay booklet gave them access. By the time the crisis was over, the child either would have died or, if still alive, could be passed on to another needy family in the village.[70] In other cases, families worked at fosterage

[70] Arkangel'skaia, "Rezul'taty pervoi popytki," 277.

as a steady job. As soon as one fosterling died, they returned for another or, if the mother's milk had dried up, obtained a child through a tor-govka. Sometimes whole villages engaged in the traffic, either tempo-rarily (after a bad harvest) or as a regular business stretching over many years, in the latter case with the effect that the child-care stipends came to constitute a kind of permanent state subsidy, even if a considerable portion of the value of this subsidy remained in the hands of interme-diaries.

The perishable commodity in the system of exchange—the foundling children—circulated in much the same manner as the capital. Half of the children came to the foundling homes from people in small towns and villages and the other half largely from recent migrants to the cities; in nearly all cases, the mothers were the victims of social changes that left many women in distress. The foundling homes recirculated the chil-dren back to the countryside through the provision of cash or, indi-rectly, credit to the wet nurses and foster mothers. Although most of the children died, the pipeline remained full, and until the reforms of the early 1890s, the pressure in the line maintained a continuous and intensive demand for wet nurses. Even after a respite following the sharp drop in admissions induced by the reforms, recruitment again be-came a problem and remained so until the end of the imperial era.

An understanding of the commercial character of the foundling traffic and especially of its integration with the economic and social develop-ment of the two metropolitan regions cannot be complete, however, without an investigation of the economic geography of the fosterage programs.

ELEVEN

Geography of the Fosterage System

THE FOSTERAGE SYSTEM WAS dynamic. The actions of foundling-home officials, wet nurses, and middlemen did not remain within a fixed arena and the boundaries of the areas served shifted over time. The concentrations and spread of foster children among the okrugs tell much about the character of the foundling traffic, the motives of the people engaged in it, and the nature of its social and economic integration with the urban fields of influence.

The maps on the following pages are intended to portray this dynamism. The "regions" shown on the maps are units of analysis created for this study; they are made up of a single administrative district (*uezd*) or group of districts corresponding to a group of foundling-home okrugs having similar social and economic characteristics. Each of these districts bore the name of the city that served as its administrative center, and these cities are shown on the first map for St. Petersburg (figure 11.1) and the first map for Moscow (figure 11.5). The values shown in the legends of the maps apply to the entire region, not to the separate districts, with two exceptions: (a) values for the three districts constituting region 2 of the St. Petersburg program are shown in figure 11.2, and (b) districts in which no foster children were resident in a particular year are unshaded (as, for example, the Shlissel'burg district of region 1 in figure 11.2).

Population data for these maps were obtained from government statistical surveys and abstracts, which provide district-by-district breakdowns. Unfortunately, data on the foster children from the foundling homes were not available in the same form. The children were registered according to the foundling-home okrugs, which branched off from highways and railroad lines and did not conform to district boundaries. However, since the foundling-home records do show the villages in which the foster children were living, it was possible to plot the boundaries of most of the okrugs and thus determine reasonably well the districts in which they were located. There was a degree of uncertainty, especially at the outer reaches of the fosterage areas, where an okrug might include too small a portion of a district to justify including the entire district in that okrug. In such cases, judgments had to be made

222

about inclusion and exclusion. The important point is that the villages taking in fosterlings tended to be clustered close to main roads and rail lines, while the populations against which they are measured covered whole districts. Hence, the density of foundlings in the areas that housed them was much greater on the average than is indicated in the data from which the maps were constructed. Despite these limitations, the maps give a reasonably accurate picture of the movement and intensity of the foundling traffic.[1]

THE ST. PETERSBURG AREA

Early in the nineteenth century, the St. Petersburg home set up eight okrugs along the main roads leading out of the city. The area they embraced was entirely within the boundaries of St. Petersburg province. By the end of the century, the eight okrugs had grown to four times that number. Even as early as the 1850s, the territory of the okrugs had expanded far beyond St. Petersburg province into most of the districts of Pskov and Novgorod provinces, and to the southeast recruiters had begun to press beyond Novgorod into Tver province (figure 11.1). They had moved so far that they ran up against the okrugs of the Moscow Foundling Home, which were spreading into Tver province from the south, and officials were compelled to work out a boundary between the two systems.[2]

Figures 11.2 and 11.3 show the proportion of foundlings who were living in each district or region for selected years between 1822 and 1908. The dynamic expansion of the fosterage system is quite evident. In 1822, virtually all of the foundlings were resident in the district of St. Petersburg itself and a few nearby districts—Petergof, Tsarskoe Selo, and Iamburg. By 1875, though these districts still held the largest proportions of foundlings, substantial numbers were living in districts to

[1] Sources for the maps were: *MIMVD* 1, part 2:5; *Otchet M.Vos. Doma* (1872, 1885, 1897, and 1912); Tarapygin, *Materialy*, part 1:74–93 and appended foldout tables; *Otchet S.P. Vos. Doma* (1875, 1885, 1896, 1897, and 1908); *Nalichnoe naselenie rossiiskoi imperii*, ser. 2 (St. Petersburg, 1875), 10:5–20; *Dvizhenie naseleniia v evropeiskoi Rossii za 1872 g.*, ser. 2 (St. Petersburg, 1882), 18:2–17; *Dvizhenie naseleniia v evropeiskoi Rossii za 1885 g.* (St. Petersburg, 1890), 11:2–11; *Sbornik svedenii po Rossii za 1884–1885 gg.* (St. Petersburg, 1887), 1:2–15; *Dvizhenie naseleniia v evropeiskoi Rossii za. 1897 g.* (St. Petersburg, 1900), 50:2–11; *Pervaia vseobshchaia perepis' naseleniia rossiiskoi imperii 1897 g.*, ed. N. A. Troitskii, part 4, *Okonchatel'no ustanovlennoe pri razrabotke perepisi nalichnoe naselenie imperii po uezdam* (St. Petersburg, 1914), 5–16; *Statisticheskii ezhegodnik Rossii 1913 g.* (St. Petersburg, 1914), 10:33–45; *Dvizhenie naseleniia v evropeiskoi Rossii za 1908 g.* (St. Petersburg, 1910), 88:2–15.

[2] Report by Assistant Director Ivanov, in TsGIA, f. 758, op. 9, d. 533, pp. 13–13ob.

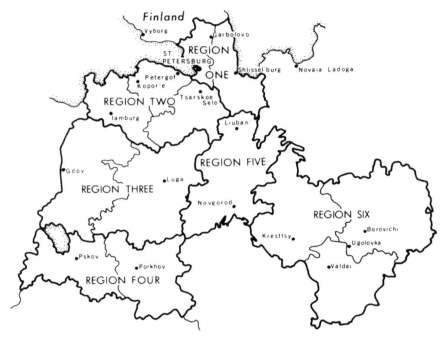

Fig. 11.1 "Regions" and districts of St. Petersburg Fosterage Program

the south and east. Ten years later, they were even more dispersed. The largest numbers remained in the districts around St. Petersburg, but the numbers in the Luga district of St. Petersburg province (region 3) and the Kresttsy, Borovichi, and Valdai districts of Novgorod province (region 6) were not far behind. This trend continued for the rest of the century. By 1908, there were more foundlings in regions 3 and 6 than there were in the districts closer to St. Petersburg.

Figure 11.4 shows changes in the number of foundlings per 1,000 inhabitants of each region. From this perspective, in 1875 the districts around St. Petersburg are still seen as carrying a high concentration of foster children, but so also was the Kresttsy district in the eastern part of Novgorod province. In subsequent years, the "load" was gradually evened out, though in 1908, despite the large number of foundlings being sent to the eastern districts of Novgorod province toward the end of the period, on a per capita basis the Luga and Gdov districts of St. Petersburg province had the highest concentrations of foundlings.

What accounts for these patterns in the placement of foster children?

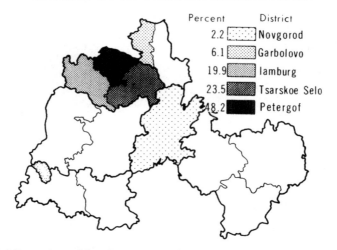

Fig. 11.2 Proportions of foundlings resident in districts of St. Petersburg Fosterage Program, 1822. (For sources of data for maps in this chapter, see n.1.)

Policy Decisions

The objections of landlords about their serf women working as wet nurses forced the St. Petersburg home to look farther afield for placements as early as the 1830s. Pressure from the governor general of Finland led to the closing of okrugs in the Grand Duchy of Finland in the 1850s. (See chapter 9.) The opening of new okrugs to the south and east of the capital at that time was linked directly to the need to withdraw the fosterage program from Finland.

After the 1850s, the problem of Finnish foster families continued in another form, for people of Finnic language and culture lived in large concentrations throughout St. Petersburg province. In addition to Finns proper, there were Vots, Ingrians, and Karelians. The linguistically related Estonians also resided in some areas but were counted as a separate group. The Finnic settlements described a broad ring around the capital city, and, as table 11.1 indicates, in some townships (*stany*) Finns constituted a large majority.

Inevitably, many of these Finnish settlements became involved in the foundling traffic, and the children reared there grew up as Finns. As noted earlier (chapter 10), in connection with the exchanges of these children for purposes of acculturation, the Russian government from the 1860s on increasingly regarded this "seepage" of children into Fin-

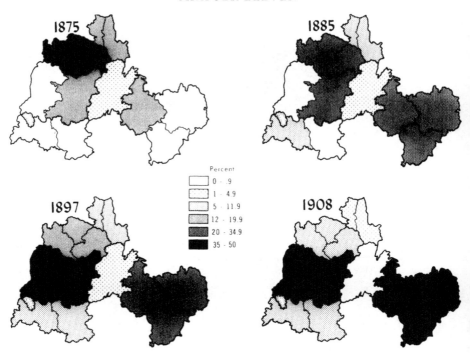

Fig. 11.3 Proportion of foundlings resident in districts and regions of St. Petersburg Fosterage Program, 1875, 1885, 1892, and 1908

nish culture as a serious matter, for it flew in the face of the imperial policy of russifying the non-Russian Christian peoples of the country. Inspectors frequently encountered foster children in these villages who did not know their prayers in Russian or even how to cross themselves properly, as was required by the home, let alone have any facility in the Russian language. Children as old as nine years could not say their names in Russian but knew them only in their Finnish form—Peko instead of Petr, Miko instead of Nikolai, Auka instead of Evdokiia. Even some fully grown wards of the home (ages eighteen and nineteen) knew no Russian prayers.[3]

The employment of Finnish foster families also made it difficult for the okrug doctors and inspectors from the foundling home to perform their duties. One inspector reported that several of the children he vis-

[3] LGIA, f. 8, op. 1, d. 187, pp. 78, 91ob, 227, 304.

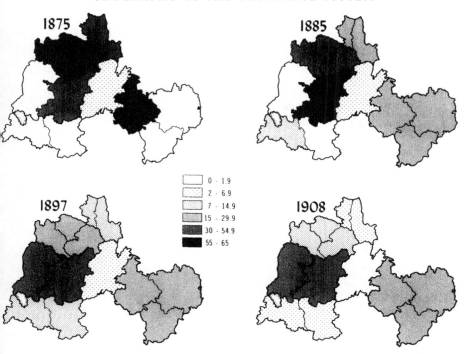

Fig. 11.4 Number of foundlings per 1,000 inhabitants resident in regions of St. Petersburg Fosterage Program, 1875, 1885, 1897, and 1908

ited did not seem to be with the people who had taken them from the foundling home, but he could not discover the truth because neither he nor the okrug doctors working in the area (Garbolovo okrug, northwest of the capital city) could speak Finnish.[4] It is clear, too, that the Finnish peasants, who must have viewed the foundling-home officials as intruders capable of depriving them of their livelihood, did not make an effort to communicate with them. An inspector in the Shlissel'burg area in 1869 wrote:

> It is understandable that in Finland and Garbolovo okrugs where most villages are Finnish the people do not know Russian, but here there is a striking and you might even say weird situation: in a majority of villages you hear a more or less proper Russian spoken.

[4] Ibid., p. 228.

TABLE 11.1
Finnish and Estonian Population Groups in St. Petersburg Province, 1862

District	Township No.	Finnish Population		Number of Estonians
		Number	Percentage	
St. Petersburg	1	700	6.7	
	3	4,300	34.5	
	4	9,800	94.4	
Gdov	3			750
Petergof	1	16,000	64.3	
	2	10,300	49.4	
Tsarskoe Selo	1	10,600	36.6	
	2	4,100	20.0	
	3	10,550	50.7	
Shlissel'burg	1	2,350	14.4	
	2	12,000	85.5	
Iamburg	1	7,000	26.2	
	2	12,200	52.0	
Total		100,250	20.0	750

Source: Sanktpeterburgskaia guberniia, *Spisok naselennykh mest*, xliii–xliv.
Note: Only townships in which there were Finnish or Estonian population groups are shown.

But then, riding out from a Russian village four or five kilometers, you come upon a Finnish one [*chukhonskaia*] in which you cannot find a single person who understands Russian.[5]

No one who spoke Russian in this village was going to let the inspector know about it.

The peasants were using the most effective tactic they knew to protect their livelihood and the system of village relations that supported it, but in the larger context of the government's desire for control of foundling care and for Russification, their approach may have been counterproductive. Incidents of the type just reported convinced the directors of the foundling home that they had to phase out the employment of Finnish foster families. By the 1880s, a policy was in place to allot nurslings

[5] Ibid., p. 304ob.

to Finnish families only if there was a great shortage of wet nurses. The results can be seen in table 11.2. In 1885, there were 5,596 foster children living with 3,746 Finnish families, 498 with Karelians of Novgorod province (an isolated pocket of a Finnic people far to the south of Karelia proper), 51 with Germans, 4 with Estonians, and 1 with a Latvian family. The children in Finnish families constituted 21 percent of all fosterlings in the St. Petersburg okrugs at that time, or nearly 23 percent if the Novgorod Karelian families were included. From that point on, a steady decline set in. Russification took many forms, but this method, which began with infants at the breast, was certainly the most effective.

This phasing out of the Finnish foster families must have contributed to the softening of the policy, also referred to earlier, of uprooting Finnicized children from their foster families at age twelve to fourteen and sending them to Russian villages, ostensibly for acculturation but also as a free labor draft for the receiving villages. The okrug doctors and inspectors who had to enforce these transfers evidently did not feel very happy about doing so. The report of one inspector tells of the "heartbreaking scenes of weeping, bellowing, and prostration" that he had to witness when the children were torn from the foster families that had reared them "as their own children." The inspector at first termed the policy "a sad necessity," but an even greater sense of ambivalence toward it was apparent in his statement that, if this Russification could not be ended altogether, something should be done to improve the treatment

TABLE 11.2
Foster Children in Russian and Non-Russian Families of
St. Petersburg Okrugs, 1885–1905

| Year | Percentage of Foster Children in Families That Were | | |
	Russian	Finnish	Other
1885	75.8	21.0	2.2
1888	79.4	18.5	2.0
1890	82.2	17.2	1.6
1895	87.3	11.6	1.1
1900	87.9	10.3	1.8
1905	91.6	6.1	2.3

Source: *Otchet S.P. Vos. Doma* for the years indicated.

of the Finnicized children after they went to Russian villages.[6] The St. Petersburg zemstvo also complained about the policy and asked that the children be left with their Finnish foster families until their majority, a recommendation that the foundling home's governing board agreed to implement in the 1890s in places with schools that could teach the Russian language and Orthodox religion to the foster children.[7] Thus, a combination of the policy-directed phase-out of Finnish foster families and an increase in the number of provincial schools gradually eliminated the need for forced transfers of the Finnicized children to Russian villages.

Economic Considerations

If the unusual ethnic mix in the St. Petersburg area accounted for much of the movement of the foundling traffic to the south and southeast into the Luga and Gdov districts of St. Petersburg province, into the northern areas of Pskov province, and into Novgorod province, economic conditions in the region also contributed. In this northern region, with its poor soils and drainage problems, villagers could not produce enough from agricultural work alone to support themselves. Only the areas close to the large market of the capital city could do well with truck- and dairy-farming operations. Virtually all other peasants in the region farmed with the three-field system and received a return on seed inadequate to supply their needs. Potatoes did better than grain, and this relatively recent arrival was a great help. The only other agricultural product of importance was flax.[8] The generally poor yields in agriculture meant that most of the peasants had to earn additional income in industry or auxiliary trades.

Factory work and cottage industry were, however, not as well developed as they were in the Moscow region. Most of the factories in St. Petersburg province were in the capital city or its immediate suburbs. Cottage industry existed but was not significant; the main items produced were leather goods and fish nets, and there were also various types of woodcrafts, reflecting the importance of fishing and forest products in the economy. Much auxiliary employment was in minor extractive work, like sand, bark, and berry gathering, or in the service sector: housemaids, janitors, carters, taxi drivers, and the like. Cutting

[6] Report from Garbolovo okrug, September 1872, in LGIA, f. 8, op. 1, d. 187ch2, pp. 104ob–06.

[7] Meder, "Polozhenie pitomtsev," 45, 48–49.

[8] Strokin, L'novodstvo pskovskoi gubernii. See also Semenov-Tian'-Shanskii, Rossiia 3: 134–37.

and hauling of wood to St. Petersburg was one of the major nonfarm enterprises.[9]

The foundling traffic offered an important income supplement to many families in this poorly developed rural economy. In Shlissel'burg district, in which typically over 90 percent of the families engaged in some form of nonagricultural activity, foundling care occupied about 18 percent of these families and was the fifth largest trade, surpassed in the number of families involved only by dairy production, forest work, gathering of berries and mushrooms, and agricultural labor.[10] In Luga district, to the south and somewhat farther from the capital city market than Shlissel'burg, foundling care occupied third place in the number of people employed; only the hauling of wood and the production and sale of flax were of greater significance.[11]

Proximity to St. Petersburg presented some peasants with options for urban service work or, in the case of villages that had specialized in truck farming, the sale of foodstuffs in the urban market. Other villages close to the city that had come to rely more on the foundling trade, aside from those that were being eliminated from the fosterage program because of their non-Russian character, were becoming saturated with foundlings. This was evident, for example, in the Garbolovo and First Iamburg okrugs, two of the earliest areas of placement. An inspector reported in 1874 that in these two okrugs, the peasants, "not having other opportunities to earn nonfarm income (*zarabotki*), find in the children from the foundling home their sole source for acquiring money and take four or five foster children in a single home."[12] These circumstances turned the search for wet nurses toward Luga district and the adjoining northern areas of Pskov province, where auxiliary trades were weakly developed, and made this region a major growth area for the foundling trade in the last three decades of the tsarist era. Peasants there were poor and much in need of auxiliary work to pay their taxes and rents, as reports of okrug doctors and inspectors in the region attest.[13] And again, even for those families that had other options, the employment of their lactating women as wet-nurse fosterers may have been preferable to sending them out for service work or woodcutting, since the care of children

[9] *Materialy po statistike narodnogo khoziaistva v s.-peterburgskoi gubernii* 5:238–44, 270; Iakovenko, "Sankt-Peterburgskaia guberniia"; Iukhneva, *Etnicheskii sostav*, 146–50.

[10] Amburger, *Ingermanland* 1: 300.

[11] *Materialy po statistike narodnogo khoziaistva v s.-peterburgskoi gubernii* (1891), appendix: 2–21.

[12] LGIA, f. 8, op. 1, d. 187ch3, p. 16.

[13] Ibid., 17ob–18 (Pliuskii okrug, 1874); ibid., d. 187ch4, pp. 244–44ob (Novoselskii okrug, 1886) and 271–72 (Pliuskii okrug, 1888).

was more consistent with sex-role divisions and the women could spend more time in the household and in the garden and field.

The other area of expansion for the foundling traffic was the southeastern reaches of Novgorod province (region 6), including the Kresttsy, Borovichi, and Valdai districts. Again, as in St. Petersburg province, agriculture was not strong; the amount of land under cultivation in fact declined during the nineteenth century. In 1843, there were 1,219,000 desiatinas under cultivation; in 1860, the figure was down to 1,142,000, and in 1894, to 925,000—a drop of nearly 25 percent in a half century.[14] The more southerly districts of Staraia Russa and Demiansk boasted a healthier agricultural economy than the districts just to the north of them that were more heavily involved in the foundling traffic. But the economic differences were not so great as to account for the variance in the amount of baby farming. Far more important was the fact that the main railroad line ran through Kresttsy, Valdai, and Borovichi districts, allowing the foundling home and the peasants in these areas much better access to one another.

Other economic conditions may have played a larger role. Cottage industry was not widely developed in Novgorod province, and least so in the districts of Kresttsy and Valdai. A similar pattern appears in the statistics on migrant labor. The highest proportions of peasants on passport out of their communities toward the end of the century were in Demiansk, Kirillov, Beloozera, and Ustiug districts; the lowest proportions were in Kresttsy and Valdai districts.[15] The shortage of these other opportunities for earning money in an area of declining agricultural production could help to explain the attractiveness of the foundling trade in this region, but the fact that relatively few peasants were taking out passports to work elsewhere could also indicate that these districts were more nearly agriculturally self-sufficient than others in the region. If this was the case, the conditions there would reinforce the notion that the attractiveness of the foundling trade stemmed from its compatibility with the agrarian economy, in which it could serve to supplement household income without interfering with the normal services provided by women.

An intriguing exception to the rule that poverty and the lack of other non-farm options for women's extra earnings drove peasants to take nurslings from the foundling home is found in Liuban' okrug, the only okrug in region 5 (conterminous with the Novgorod district) with any appreciable number of foundlings. The inspection reports from this

[14] Rikhter, "Novgorodskaia guberniia," 238.
[15] From 1894 registers; see ibid., 239.

232

okrug in the 1870s indicated that the peasant families involved in the fosterage program made a good income working at the numerous manor houses in the area and did not need the baby farming to pay their taxes and rents. They took a child from the foundling home usually only when their own child died, they gave good care to the fosterlings they did take, and they rarely took more than one child at a time. The child care provided by the people of this area was well enough respected that some of them were able to set up on their own as private care centers and in this way earned nearly twice what the foundling home was paying.[16] This exceptional situation may, however, have proved the rule, since, as the maps reveal, region 5 came to form an island of inactivity in the foundling trade after the 1870s. The trade flourished only in areas of economic need.

Some distance down the rail line to the south, between the towns of Valdai and Borovichi, lay Ugolovka okrug, whose development demonstrated another dynamic of the fosterage program. In the 1870s, not many fosterlings resided there, because the peasants near the railroad earned a good income from work in cottage industry, at country manor houses, and at the nearby Okulovke railroad depot.[17] Within ten years, however, the okrug grew to be one of the largest in the St. Petersburg system. Officials found that as they moved away from the railroad, they encountered just what an inspector, in a report on Verebynsk okrug mentioned in chapter 10, had described in 1871: the outlying villages had less access to markets and auxiliary employment, and the families there seized the opportunity offered by the foundling trade to earn supplementary income. A report from Ugolovka okrug in 1885 noted that the people in the villages away from the rail line valued the right to take children from the foundling home, and many women sought to do so, even women from villages not then in the program. In fact, the program in Ugolovka okrug had to be limited somewhat as the demand for participation threatened to expand it beyond an area that one official could supervise effectively.[18]

Another consideration affecting the growth and shift of the concentrations of foster children may have been the desire on the part of officials to find more "innocent" foster families. It is difficult to know how much weight to give to this matter, since the demand for wet nurses usually outran the supply and the home was in no position to be selective. The inspectors' reports nevertheless reveal a preference for working

[16] LGIA, f. 8, op. 1, d. 187ch3, pp. 15ob (1874) and 212–12ob (1876).
[17] Ibid., pp. 144ob–45.
[18] Ibid., d. 187ch4, pp. 238–38ob.

with newly opened areas of the fosterage program. The peasants in villages new to the program gave better care, were more scrupulous about following the home's rules, and were "even fearful of the responsibility," as one report noted. "The women have not yet learned to deceive, to take children by means of a substitute [wet nurse] and then put them with another woman on bottle feeding."[19] But attitudes were changing, the report went on. Word was getting out to the villages in this new okrug that the responsibilities were not worrisome and could be lucrative. "Soon," the inspector concluded, "they will become accustomed to this commerce [*promysel*] and take more and more children."[20]

Efforts to explain this dynamic can be no more than speculation. Possibly a demoralization set in. The peasants may initially have expected that the foundling babies would do as well as their own, but then, seeing the fosterlings dying at a much higher rate, the women learned to treat them as a perishable commodity that brought income. Feelings of this kind could have been reinforced by a seeming indifference on the part of the officials, who visited the villages infrequently and who prosecuted only the most flagrant breaches of the rules, such as illegal transfers. Infants who died in the absence of violations of the home's regulations caused little concern. A more cynical interpretation is that the peasants had no intention of exerting themselves to keep the nurslings alive and initially were merely feeling out the rigorousness of oversight and rule enforcement. When they discovered that the foundling home needed their services and would tolerate minimal care, that is what the women gave. The impression one receives from the reports, however, is that the first hypothesis is more likely to be correct. Given the official acceptance of a high mortality rate and the peasants' own lack of confidence in their ability to keep the fosterlings alive, it is not surprising that many of them adopted a commercial approach to foundling care and took as many children as they could manage in order to realize the highest financial return. Since the system was constructed on material incentives, officials who expected the peasants to behave with a philanthropic spirit were deluding themselves.

It would be wrong to leave an unrelievedly grim picture of foundling care in the St. Petersburg region. Some communities provided excellent care. These were usually prosperous villages with few families that wanted to take in foster children in view of the modest fees paid by the home. During an inspection of one of these communities in Luga okrug, an official asked the women why so few of them worked as wet

[19] Ibid., 187ch3, pp. 17ob–18.
[20] Ibid.

234

nurses for the home, and "they answered with one voice that it was not worth taking on the trouble to bring up a child for such paltry pay."[21] Yet even in these situations there was an occasional anomalous case, as in Kopor'e okrug, on the southern coast of the Gulf of Finland. In this area, the peasants not only lived in clean, wholesome circumstances and kept mortality among the foundling children below that in most other communities, but the number of wet nurses increased during the 1880s, when the demand was the greatest.[22]

For the most part, however, market forces played an important role. For example, in the Kopor'e okrug, just noted for its excellent care, the home later had difficulty recruiting wet nurses, because it ran into competition from another urban welfare service. The St. Petersburg city administration not long before World War I established a program of farming out the mentally disabled to foster care in the villages and provided (in addition to shoes, clothing, and linen) a stipend of ten rubles a month, at a time when the foundling home paid only four rubles for infants and three for children ages one to fifteen.[23] The foundling traffic may even have been a school for capitalism among the peasants. It has already been noted that some families in Liuban' okrug went into business as private wet nurses and foster-care providers after having begun in the foundling-home program and earned praise for the quality of care they provided. Indeed, by the end of the century there were five private agencies in St. Petersburg that offered wet-nursing services and that employed about ten thousand nurses. Five other agencies in Moscow employed about half as many nurses.[24] By responding to the relative advantages of one or another type of foster-care work, the villagers forced urban institutions to adjust to supply and demand factors.

THE MOSCOW AREA

The geography of the Moscow fosterage program is more complex than that of St. Petersburg. Figure 11.5 shows the district, provincial, and regional boundaries in the area of the Moscow fosterage program. Figure 11.6 shows that the foster children in this program were concentrated in the regions west and north of Moscow at the end of the eight-

[21] Ibid., d. 187ch4, p. 228.

[22] Ibid., p. 236.

[23] *Otchet S.P. Vos. Doma* (1914), 111–13.

[24] Puteren, *Istoricheskii obzor prizreniia*, 491. On the competition between private wet nursing and the foundling homes, see LGIA, f. 8, op. 1, d. 187ch3, pp. 29ob–32. On this type of competition in France, see Fuchs, "Abandoned Children in Nineteenth-Century France," 190–96; and Sussman, *Selling Mothers' Milk*, chapters 5 and 6.

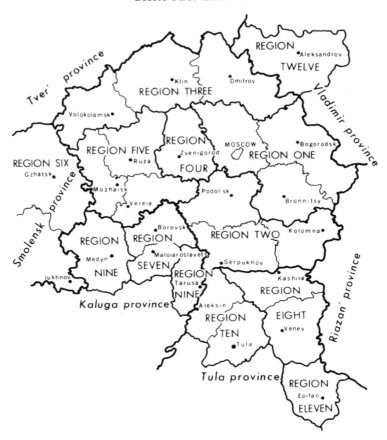

Fig. 11.5 Provinces, districts, and "regions" of Moscow Fosterage Program. (The districts of Medyn' and Tarusa, even though not contiguous, are construed as forming a single region—region 9—because they had similar social and economic characteristics.)

eenth century. During the early decades, the entire program remained within Moscow province. By the next time point at which the program can be mapped, in 1872, it had grown to cover a vast area (figure 11.7). It had long before spread beyond the boundaries of Moscow province into all six surrounding provinces. If all of the nearly three dozen administrative districts involved were shown, the maps would be even more sprawling than they are, but for convenience some of the marginal areas have been eliminated and the foundlings in those districts added

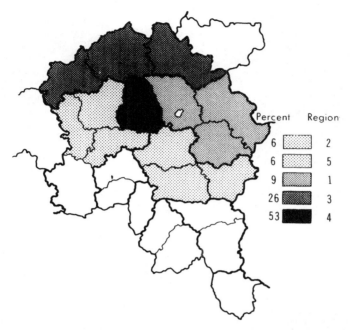

Percent	Region
6	2
6	5
9	1
26	3
53	4

Fig. 11.6 Proportion of foundlings resident in regions of Moscow Fosterage Program, 1796

to the totals for adjoining ones that make up the twelve regions created for purposes of this analysis. Insofar as possible, the regions are composed of districts with similar economic and demographic characteristics.

Figure 11.7 shows that there was a concentration of foundlings to the west of Moscow, in regions 4 and 5 (the districts of Zvenigorod, Ruza, Mozhaisk, and Vereia), throughout the nineteenth century, but it weakened and dissolved after the turn of the century. In Moscow district itself, and in the districts of Bogorodsk and Bronnitsy just to the east of the city, few foundlings resided at any one time. But around this relatively static center, the concentrations of foster children move in an arc beginning in the northern districts of Dmitrov, Klin, and Volokolamsk in Moscow province and shifting westward through the districts of Smolensk province before settling in the south, in the districts of Kaluga and Tula provinces. The same pattern emerges in figures 11.8 and 11.9, which shows respectively, the percentage of foundlings entering each region and the number of foundlings entering per 1,000

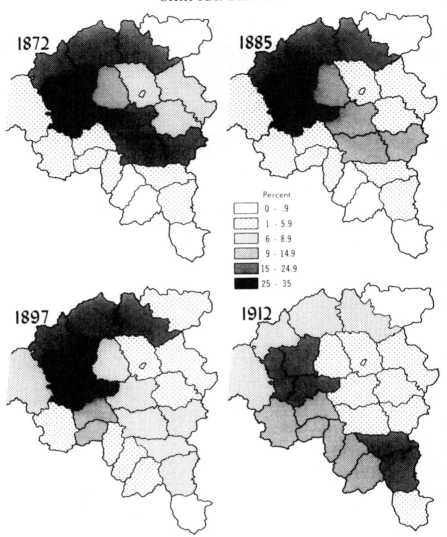

Fig. 11.7 Proportion of foundlings resident in regions of Moscow Fosterage Program, 1872, 1885, 1897, and 1912

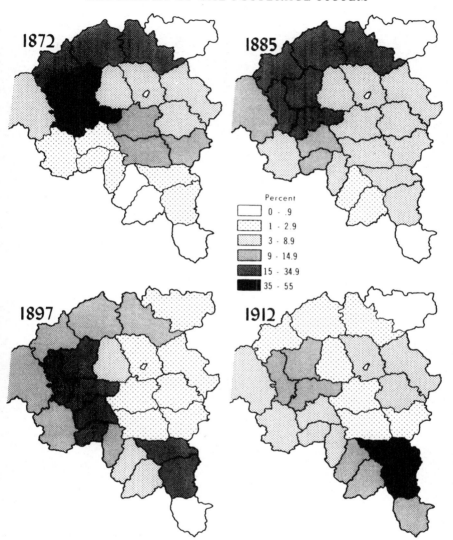

Fig. 11.8 Proportion of foundlings entering regions of Moscow Fosterage Program, 1872, 1885, 1897 and 1912

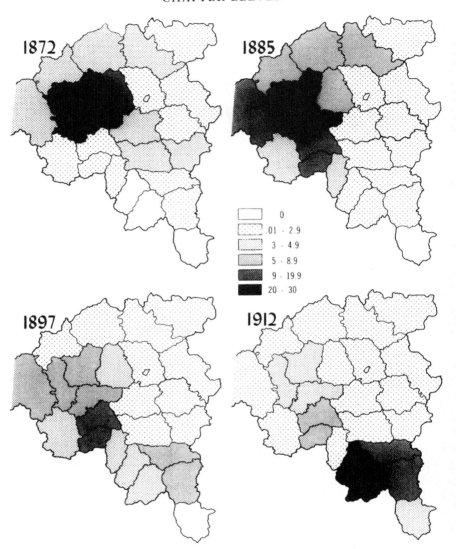

Fig. 11.9 Number of foundlings per 1,000 inhabitants entering regions of Moscow Fosterage Program, 1872, 1885, 1897, and 1912

persons in the local population. Since these maps count only the infants being sent into fosterage in the year designated, rather than the population of foster children accumulated over many years, they reveal at an earlier point the shift of concentrations among areas. For example, the movement away from the core to the west of Moscow in region 5 can be seen occurring as early as the 1880s, and the very heavy reliance on the northern districts of Tula province as the chief depository of infant fosterlings at the end of the period comes out forcefully.

Within this general pattern, there were year-to-year fluctuations brought on by periodic crises. In 1871, placements in the Volokolamsk, Ruza, and Borovsk districts rose sharply as the result of poor crops and an epidemic among farm arnimals. Peasants needed cash or credit with which to buy seed for the next year's planting and to replace lost animals. The same year saw a drop in placements in the Klin, Dmitrov, Serpukhov, and Maloiaroslavets districts, where outbreaks of cholera carried away many families and reduced the number of women available for nursing while at the same time opening additional work opportunities to the survivors.[25] In 1884, the combination of a poor harvest in the Moscow region and a recession that ended or cut back work at many factories brought women from areas not heavily involved before in the foundling traffic into Moscow in search of a nursling to tide the family over a difficult time.[26] A disastrous harvest in northern Tula province in 1905 caused a sudden rise in the foundling traffic to that area, although baby farming had been increasing in that province in recent years for other reasons.

If periodic subsistence crises explain the short-term fluctuations in the foundling trade, the evolution of social and economic conditions in the region generally shed light on the larger pattern of change in the shape of the foundling trade over time. A number of factors are of importance, including household partitions, saturation of certain areas with the trade, transport conditions, and foundling home policy, but underlying all of these is the economic geography of the region.

Economic Activities

With the opening to cultivation of the black-soil regions of southern Russia in the late eighteenth century, agriculture in the Moscow area began to give way in importance to cottage industry and various crafts and trades in the peasant economy. At first, these activities were spread

[25] *Otchet M. Vos. Doma* (1871), 41–42.
[26] Ibid. (1884), 6–7.

widely throughout the region, but in time differentiation set in. The districts east of Moscow saw an early development of large factories and plants, which were served by clusters of small workshops and jobbers in the same region.[27] Close to Moscow, truck gardening and haying operations provided a good income, but farming in the districts of Bogorodsk and Bronnitsy east of the city was not a major occupation. In comparison to the rest of Moscow province, these districts had a lower-than-average ratio of land to workers,[28] and households were more crowded.[29] Even so, people lived fairly well because of the many opportunities for well-paid auxiliary employment.

The differences in employment opportunities can be gauged from the data in table 11.3. The two large districts east of Moscow—Bogorodsk

TABLE 11.3

Factories and Looms in the Textile Industry of Moscow Province, 1878–1879

District	Number of Textile Factories	Percentage of Looms
Bogorodsk	143	48.8
Bronnitsy	62	16.4
Kolomna	50	5.0
Dmitrov	40	8.8
Volokolamsk	56	8.0
Serpukhov	78	4.0
Klin	36	4.2
Vereia	21	2.0
Moscow	140	1.5
Zvenigorod	14	0.8
Mozhaisk	8	0.2
Podol'sk	19	0.2
Ruza	21	0.1

Source: *Promysly moskovskoi gubernii*, 6.

[27] *Promysly moskovskoi gubernii*, 20–33.

[28] The ratio was about four desiatinas per worker, compared to over six elsewhere: ibid., 13.

[29] There were 6.4 persons per household, as compared to 5.5 in the Ruza district, west of the city: Matveev, *Ocherk statistiki*, 35.

and Bronnitsy—were far in the lead in virtually all branches of this industry. Another district in this area, Kolomna, shared in this development and also boasted a number of other large factories, producing starch, bricks, finished leather goods, and iron, and it was in addition the site of the large Struve foundry, which made railway cars and locomotives.[30] The dominance of Bogorodsk and Bronnitsy in industrial production lasted into the next century. These two districts, along of course with the district of Moscow, far surpassed all others in the percentage of families engaged in industrial labor (93.5 percent in Bogorodsk and 72.1 percent in Bronnitsy).[31] None of these districts east of the city took many foundling children for home care. Since the men and young people could earn good wages in the local mills and workshops, the women could choose to stay at home or, if they needed to work, could do so at higher-paying jobs than baby farming. The few foster children who went to these areas received good care, the result directly and indirectly of the relatively high living standard there. The families who took foster children often did so not for the income supplement but because they wanted children.[32]

West of the city, conditions were not so favorable. There was more land per worker, but the soil was poor and in many areas the men left the village to work in the city or went south to work as migrant agricultural laborers. Farming in these western villages, such as it was, was left to the women and old people. Factories scarcely existed at all in most of the western okrugs in the 1870s, when the foundling home made a survey of the area. Zvenigorod okrug (covering southern Zvenigorod district and northern Vereia district) contained no factories or mills whatever. People worked at village crafts, chiefly the making of brushes, hooks, toys, and icon casements, and at woodworking trades of various sorts. The two Ruza okrugs, which abutted Zvenigorod to the west, had only two large factories, one producing cloth and the other paper. Small manufacturing plants were scattered through the area, and cottage production was widespread; in some villages, virtually every household worked in cottage industry. Weaving of various kinds was the mainstay, and women were the workers. The men either migrated out or worked at cutting and hauling firewood, distilling tar, and similar forest trades.[33] In the other two okrugs to the southwest of Moscow, Mozhaisk and Vereia, the story was much the same. Mozhaisk had two factories but otherwise relied on small pottery and textile operations,

[30] *Otchet M. Vos. Doma* (1875), 34–37.
[31] *Moskovskaia guberniia po mestnomu issledovaniiu*, 470–74.
[32] *Otchet M. Vos. Doma* (1875), 35–36.
[33] Matveev, *Ocherk statistiki*, 9–10; *Otchet M. Vos. Doma* (1875), 30–31, 38.

CHAPTER ELEVEN

and even these were closing down as early as the 1870s due to high costs and poor market access. Vereia okrug contained not a single factory, and the people, apart from engaging in an agriculture that was too unproductive to support them, had to rely on hand weaving and various small trades, in addition to earnings from the men who migrated to factory work elsewhere.[34]

To the south of the city, in the Podol'sk and Serpukhov districts, economic conditions were a blend of those in the eastern and western sectors. Close to the city, truck gardening was important. Farther out, the soil conditions worsened and manufactures played a larger role than agriculture. There were a few large textile factories and a wide variety of small craft works scattered about. Beyond Moscow province, south of the Oka, Protva, and Tarusa rivers in the northern districts of Kaluga and Tula provinces began the open plains of the black-soil region; here, agriculture was the mainstay and factory work almost nonexistent.[35]

The Shifting Concentrations of Foster Families

Among the influences that produced the shift from the okrugs north of Moscow around to the west and from there eventually to the south were policy decisions by the Moscow home.

The northern okrugs had grown during the middle years of the nineteenth century in part because of the development of railways between the two capital cities. But beyond the vicinity of the rail line, the area was sparsely settled, and the foster children were widely dispersed through a large territory. This made supervision difficult and costly. As a result, the Moscow home decided in the early 1870s to phase out this northern area, a decision that was made easier by a quickening at about the same time of interest in the foundling trade to the west of the city.[36]

The foundling traffic had been active directly west of the city for many decades, and it had come to extend well beyond the borders of Moscow province into the Gzhatsk district of Smolensk province. Again the railroad was an important factor, for it facilitated the journey of the wet nurses to these more remote areas. Earlier, they had had to rely on horsecart.[37] By the 1880s, it was clear that the eastern districts of Smolensk province had fallen securely within Moscow's field of influence. A substantial portion of the population in this area was migrating out to

[34] *Otchet M. Vos. Doma* (1875), 37–38. See also Johnson, *Peasant and Proletarian*, 18–26, for data comparing the western and eastern sectors of Moscow province.
[35] *Otchet M. Vos. Doma* (1875), 32–34.
[36] Ibid. (1871), 42–43.
[37] Ibid. (1875), 50.

work, and contacts made by the migrants no doubt brought to the attention of local women the opportunities for earning money in the foundling trade. Cottage industry was poorly developed in the area; three times as many families sent laborers out for jobs elsewhere as worked in their homes.[38] It was at this time, too, that the traffic built up rapidly in the similarly constituted western sectors of Moscow province—the Ruza, Mozhaisk, and Vereia districts. As the foundling home annual report for 1874 noted, "Only in the localities where there are no factories or industrial plants and where cottage industry is not developed will women apply at the foundling home to be wet nurses, since in the absence of any other opportunities for earning money the pay now given for child care can be of some help."[39] Though perhaps a form of special pleading, suggesting that the pay of wet nurses should be raised to more competitive levels, this statement accurately described the relationship between the lack of local development and the baby-farming trade. This relationship can be observed not only in the larger pattern already noted for Moscow province as a whole but also in particular locales.

A good example is Dmitrov okrug, directly north of Moscow. Divided in 1883 for ease of administration into two sectors with approximately the same number of fosterlings in each, the okrug soon underwent a sharp differentiation. The first sector took ever fewer nurslings, until by 1889 families from there accepted less than one-sixth the number going to the second sector (see table 11.4). According to the okrug overseer, the reason was clear: "The first sector in recent times has seen a rapid development not only of factory and industrial production but even of various types of cottage industry, which are giving a far more significant income than the pay for the upbringing of foundlings."[40] As was true elsewhere, the growth of industry was important both in itself and in creating additional jobs for local suppliers in small shops and home production.[41] Consequently, living standards in the area rose rapidly. The second sector of the okrug, which did not share in this development, continued to rely on the meager returns from the foundling trade. In some parts of the second sector, child care must have been the chief source of income. One village, Sin'kovo, cared for over 50 found-

[38] Shperk, "Smolenskaia guberniia," 549; *Sbornik statisticheskikh svedenii po Smolenskoi gubernii*, 83–85.

[39] *Otchet M. Vos. Doma* (1874), 7–8n.

[40] Inspection report, August 24, 1890, in TsGIAgM, f. 108, op. 3, d. 178, pp. 127–28ob.

[41] Lenin observed the same process a few years later; see his *Development of Capitalism*, 395.

TABLE 11.4
Nurslings Entering Sectors of Dmitrov Okrug, 1885–1889

Year	First Sector	Second Sector
1885	217	409
1886	154	475
1887	138	345
1888	95	358
1889	57	365

Source: Inspection report by the director of okrugs, August 24, 1890, in TsGIAgM, f. 108, op. 3, d. 178, pp. 127–28ob.

lings; two others, Vedernitsy and Goliadi, for over 40; and more than twenty-five villages in this sector had 15 or more fosterlings from the foundling home.[42]

The type of saturation seen in the second sector of Dmitrov okrug was another factor influencing the shift in the concentrations of foster children to the west and then to the south. At first, saturation affected communities close to Moscow and to the north. By the late 1860s, areas farther to the west were beginning to carry the heaviest burden. One inspector noted:

> I often encounter throughout [Vereia okrug] homes in which people are fostering from 3 to 5 children, for example in the villages of Iastrebovo, Semenychi, Obukhovo, Diut'kovo, and others. In the village of Anashkina I saw 5 fosterlings with a single wet nurse and in the same village 4 fosterlings, plus her own children, with another [wet nurse]; in the village of Zhikhorevo, one woman had 4 plus her own children, in Eremina likewise. The number of fosterlings in each of the villages mentioned is at least 23 and the largest numbers are in the village of Kubinskoe with 120 and the village of Modenova with 89.[43]

In the mid-1870s, the western okrugs of Vereia, Mozhaisk, and Gzhatsk experienced a leveling-off in the number of nurslings sent there, which the foundling-home officials attributed in part to a virtual ex-

[42] TsGIAgM, f. 108, op. 3, d. 178, pp. 124ob–25.
[43] Ibid., op. 1, d. 406, pp. 103–03ob. For similar reports on other areas, see ibid., d. 464, pp. 45ob–46, and *Otchet M. Vos. Doma* (1870), 31.

haustion of the supply of wet nurses in these areas.[44] Still, the traffic to the region continued at these high levels for the next two decades.

In the years around 1880, the district of Ruza was taking in more than two thousand nurslings a year, with the result that nearly every village housed children from the Moscow home. Of the 414 villages in the district, 378 were engaged in foundling care.[45] Some villages had very high concentrations. The foundling-home registers of 1878 show that the western okrugs of Ruza-1, Ruza-2, and Mozhaisk each had from eleven to fifteen villages with over fifty fosterlings; four villages in Mozhaisk okrug made room respectively for 125, 140, 194, and 316 fosterlings.[46] A vivid illustration of the intense activity in a single village was provided in a detailed study, published at about the same time, of Bogorodskaia, a township in the Vereia district. This township, which contained only 643 families and a population of 3,350, took nearly one thousand nurslings in the five years from 1876 through 1880. Bogorodskaia was precisely the kind of community that one would expect to fall into dependence on the foundling traffic. Crafts were not developed, several hundred passports for migration out to other jobs were issued annually, and the poor soil yielded so little grain that 500 of the 643 families reported that their bread supply lasted only until Christmas.[47] As late as 1887, the western okrugs, to which this township belonged, were continuing to maintain high concentrations of foundlings, with over 50 fosterlings in each of nine villages of Vereia okrug, fifteen villages of Ruza, and seventeen villages of Gzhatsk.[48] The region was earning a vital income supplement from foundling care, but the process was exhausting the available supply of lactating women and making it necessary for the foundling home to seek new ones farther afield.[49]

Still another factor affecting the geography of the foster-child population was household division: the partition of the large joint-family household, common in the era of serfdom, into smaller stem or nuclear family units. Under serfdom, pressure from landlords kept the large

[44] Otchet M. Vos. Doma (1875), 50.
[45] Mikhailov, "K voprosu o vliianii pitomnicheskogo promysla," 145.
[46] Otchet M. Vos. Doma (1878), 25.
[47] Zarin, "Bogorodskaia volost'," 182–87.
[48] Otchet M. Vos. Doma (1887), 46–48.
[49] This type of saturation could also be found near other cities that were served by local, usually zemstvo-supported, foundling shelters. A report from the Kiev district in 1911 said that in two villages there, nearly every house had a fosterling, some had two or three, and a few had five. The same can be seen in Saratov province, whose administration reported in 1909 that villages in the fosterage program there "had reached a point of saturation; nearly every single family in them has either a nursling or a fosterling, or one and even two adopted children." Oshanin, O prizrenii pokinutykh detei, 92–93.

households intact, for in that economic system they were more efficient and productive than smaller units. Landlords may also have regarded this type of household as preferable for purposes of control.[50] But many young peasant couples wanted to establish their own households and escape the domination of the family patriarch, and the abolition of serfdom, which was accompanied by a reduction in the power of the household head, made this possible. Greater opportunities for earning money outside the large household system likewise facilitated this move, and this circumstance helps to explain why the breakup of peasant joint families occurred earlier and on a larger scale in the districts close to Moscow, with its ready market for off-the-farm labor.[51]

But while household division answered to the emotional needs of young couples, it created a less desirable milieu for the operation of the foundling home's fosterage program. In large households, several adult women co-resided, and so the release of a lactating woman for a time to go to the foundling home and fetch a nursling caused no great burden. The household could function in her absence, and her children would be cared for along with the others in the extended family. In nuclear households, it was virtually impossible for the mother to get away, for no one was available to fill in for her. As early as 1870, the foundling home's annual report expressed concern about the effects of this change in family structure.[52]

The situation was even more difficult than this description implies, because the women in nuclear families often had to manage not only without the help of other women but without the help of their husbands as well. Although conditions affecting family structure in this period have not been investigated as thoroughly as one would wish, it seems that the same influences that led to household partitions also acted to take young men away from their homes to jobs in Moscow and surrounding towns, leaving their wives entirely on their own. This gave some scope for the work of the torgovki, described earlier, who could arrange to deliver nurslings to women isolated in nuclear households and keep some of them in the trade.[53] But the altered conditions tended to discourage the flow of fosterlings to the more developed areas with their dwindling number of large households. Moscow okrug, close to

[50] See the discussions in two recent works: Bohac, "Family, Property, and Socioeconomic Mobility," chapters 4-6, and Hoch, *Serfdom and Social Control*, especially 58–90.
[51] *Otchet M. Vos. Doma* (1870), 31. For a general consideration of partitions in this period, see Mironov, "Russian Peasant Commune."
[52] *Otchet M. Vos. Doma* (1870), 31.
[53] Ibid. (1872), 33, and (1873), 34.

the city on the north and west, was one of the first to feel the effects. With greater job opportunities for the men (and women) and less adult help in the household, this okrug came to resemble the okrugs to the east of the city, which earlier had seen the growth of factories and therefore a reduction in the need for the financial support of the foundling trade. The report of the overseer for this area in 1890 noted that foster care was not a commercial venture in Moscow okrug. "In most cases the peasants take children due to the lack of their own or a desire to have a boy or girl they do not have. On the whole, the children are well dressed and appear well cared for."[54] The average number of foster children per village was less than four; the total of 420 children in the okrug were cared for by 400 separate families, and nearly half of the 107 villages involved in foster care had only one or two children.[55] By this time, much the same situation had also developed in Klin okrug, which lay to the north along the Moscow-St. Petersburg rail line.[56] So, in contrast to areas farther west, where exhaustion of the supply of wet nurses slowed the delivery of infants from the home, in areas closer to the city, altered social and economic conditions made the trade less viable and forced the fosterage program to look elsewhere for placements.

It should be clear by now that shifts in economic conditions and work opportunities exerted the greatest influence on the direction of the foundling trade. The saturation of some areas with nurslings and the reduction of the foundling traffic in other areas as households partitioned into smaller units were themselves the consequence of larger changes in the economic geography of the region. In the early decades of the fosterage program, the people of the Moscow region supported themselves by a combination of farming and cottage industry or small commodity production. But as agriculture became less competitive and industry developed in the eastern and northern sectors of the province, the people in the western districts had to find new means of support. Farming was not enough and their craft production was losing markets to industrial goods. This may have been especially true of women's work. By 1900, factory machines were taking over much of the flax and wool spinning and the winding of cotton as well as other female cottage work.[57] As early as 1883, the number of people employed in "female

[54] Report by okrug overseer, September 20, 1890, in TsGIAgM, f. 108, op. 3, d. 178, pp. 143–46.
[55] Ibid. See also TsGIAgM, f. 108, op, 3, d. 1876, for evolution of the okrug from the 1860s to the 1880s.
[56] TsGIAgM, f. 108, op. 3, d. 178, pp. 87–92.
[57] A. S. Orlov, *Kustarnaia promyshlennost' moskovskoi gubernii*, 7, 8, as cited in Glickman, *Russian Factory Women*, 41.

trades" was relatively low in the western districts of Moscow province,[58] and the opportunities for "women's work" declined ever further in these areas by the turn of the century.

The data in table 11.5 serve as a rough measure of the relationship between local opportunities for work and the foundling trade. The table shows the ranking of districts in Moscow province on the basis of the percentage of men working in their own villages or migrating out, the percent of women in paid employment (wherever located), and the number of fosterlings per 1,000 inhabitants. By and large, the districts

TABLE 11.5

Rank of Districts in Moscow Province by Men's Work Location, Percentage of Women in Paid Employment, and Number of Fosterlings per 1,000 Inhabitants, End of the Nineteenth Century

District	Rank According to Percentage of Men Who Were Working			Rank According to Percentage of Women in Paid Employment	Rank According to Number of Fosterlings per 1,000 Inhabitants
	In Own Village	Elsewhere	Both		
Bogorodsk	1	12	1	1	13
Moscow	2	10	2	2	12
Bronnitsy	3	13	3	3	11
Podol'sk	4	11	4	4	8
Serpukhov	6	2	5	5	9
Dmitrov	7	1	6	6	5
Zvenigorod	5	8	7	7	4
Klin	8	3	8	8	7
Volokolamsk	9	5	9	9	6
Kolomna	10	6	10	10	10
Vereia	11	4	11	11	1
Ruza	12	9	13	13	3
Mozhaisk	13	7	12	12	2

Sources: Constructed from data in *Moskovskaia guberniia po mestnomu issledovaniiu*, 470–72; *Otchet M. Vos. Doma* (1897), 132–33, 166–67; *Pervaia vseobshchaia perepis' naseleniia rossiiskoi imperii 1897 g.*, ed. N. A. Troitskii, vypusk 4 (St. Petersburg, 1905), 5–16.

[58] *Sbornik statisticheskikh svedenii po moskovskoi gubernii, otdel khoziaistvennoi statistiki* 7, no. 3: 26–27, 30–31.

that ranked low by proportion of men employed locally and by proportion of women employed at all were those in which the foundling traffic flourished. The only exception was Kolomna, possibly because the foundling trade had not shown much activity in that area in the past; living conditions for the peasants there had apparently been better than in most other areas of Moscow province,[59] and so people had not developed the networks that gave access to baby farming when conditions changed and work of this type was needed.

The final shift to the south into Kaluga, Tula, and Riazan' provinces was due to the increasing opportunities for better-paid work in the areas closer to Moscow, expansion of the transportation network to the south, and the growing distress in the agricultural lands south of the Oka and Tarusa rivers. At the end of nineteenth century, despite the fact that substantial numbers of nurslings were still going to the okrugs west and southwest of Moscow, the foundling home was encountering increasing problems in this region. The home's annual report for 1898 noted that the low pay for foundling care made it difficult to attract wet nurses from these and other long-established okrugs, and as a result unplaced infants crowded the central nursery and drove up the mortality rate. At this time, the pay for nursing and foster care stood at three rubles per month for infants up to one year of age, gradually diminishing until the stipend for children ten years and older became one ruble per month and then ended altogether at age fifteen for girls and age seventeen for boys. According to home officials, this pay scale was attractive only to those in dire need or temporary distress and so produced wide fluctuations in the supply of wet nurses. "A downturn in auxiliary jobs in one area and a food shortage at the same time, caused by a poor harvest, impel the peasants to turn to the unprofitable foundling trade," said the report. "But a new harvest, the establishment of a factory or industrial plant close by . . . sharply reduces the outflow" of nurslings to that locality.[60]

This assertion about volatility finds some corroboration in the annual statistical surveys for Moscow province, which show considerable movement in wages for women's work during this period of intermittent recession and growth. The wage for weaving cheesecloth in the Ruza area, for example, had fallen in a short time from 16–20 kopecks a day to 8–10 kopecks. In districts as widely scattered as Kolomna, Bronnitsy, and Serpukhov, cottage or small workshop textile manufacture was paying only about 40 kopecks a week. These jobs, even when

[59] *Otchet M. Vos. Doma* (1875), 34–35.
[60] Ibid. (1898), 108–9.

available, scarcely paid better than foundling care. By contrast, steady factory work could bring a woman up to 13 rubles a month.[61] As work picked up in the Moscow region after 1905 and especially as it became more mechanized, the foundling home had little chance of recruiting women who could earn four and five times as much at nearby industrial plants. The home could no longer count simply on bad times to stimulate recruitment. The problems of administering the fosterage program in this volatile market motivated officials to press into regions farther south, where mechanized industry lagged and the traditional agricultural life provided a better setting for recruitment of wet nurses.

The extension of the transport network facilitated this expansion of the recruitment area. Railways had first developed in central Russia (following construction of the line between St. Petersburg and Moscow) on an east-west axis. The main southern line went into operation in the 1860s, but the big push to fill out the central region with branch lines came much later, between 1899 and 1913.[62] It was then that the movement of wet nurses into Moscow from the areas south of Moscow province became much easier, as did the opportunity for supervision of these areas by officials from the foundling home.

The areas beyond the Oka and Tarusa rivers that then came into the fosterage system have not been studied as thoroughly as Moscow province, and it is more difficult to evaluate the "push" factors bringing peasant families into the foundling trade. However, the general demographic and economic condition of the region may by itself explain the success of the traffic. These areas relied heavily on agriculture and on income from migrant laborers. Manufacture was confined chiefly to the provincial capitals and their immediate environs. There was some mining activity, especially in the Tula area, but it was not expanding. The population, meanwhile, was increasing at a rapid rate. In the period from 1857 to 1910, the central black earth region, of which this area was a part, saw the largest population increase of any region in the empire except the Ukraine.[63]

The northern districts of Tula province can be taken as typical for the areas coming into the fosterage program after the turn of the century. The population had increased less rapidly than in the province as a whole but still quite substantially (22 percent in the thirty-six years from 1858 to 1894); arable land per capita had as a result declined sharply.

[61] *Statisticheskii ezhegodnik moskovskoi gubernii za 1900 god*, section on *promysly*, 19–20, 35–36.

[62] Ames, "Russian Railway Construction," 60.

[63] Parker, *An Historical Geography of Russia*, 310–11; Munting, "Outside Earnings in the Russian Peasant Farm."

Land in these northern districts was also less productive than the land in the rich black-soil districts to the south. In short, a growing population was pressing on a relatively poor land resource. Many people had no land of their own at all. The two northernmost districts of Tula province, Aleksin and Kashira, were characterized by the highest incidence of sharecropping in the province, an insignificant amount of arable land per household, and very low crop yields.

In these conditions, and with little factory work or cottage production available locally, one would expect to find a large exodus in search of jobs elsewhere, and indeed in 1899 the highest percentages of people from among the registered agricultural population to be migrating out to work were in Kashira and the adjoining northern district of Venev, with 41 and 26 percent respectively (the provincial average was under 17 percent).[64] Along with Aleksin, these were the two districts of Tula province that were also most heavily involved in the foundling traffic. These indicators fit the pattern observed earlier for other areas: the foundling traffic was concentrated in localities with declining agriculture, weak development of industry, and high levels of out-migration.

One further index suggests the economic distress in these northern areas of the central black earth region. From the 1890s onward, the Moscow foundling home kept records in which each foster family was described as belonging to one of four categories: well-off, satisfactory, poor, and landless. Between 1898 and 1912, the proportion of poor and landless families in the areas south of the Oka and Tarusa rivers increased from 41 to 50 percent. An increase in these categories also occurred for all the other okrugs combined, but it began from a lower base and increased less: from 33 to 39 percent. Moreover, the combined reckoning for the areas north of the black-earth provinces masked wide variations; some—like Voskresensk, with 16 percent poor or landless foster families by 1912, and Vereia, with 21 percent—showed a much better social profile for foundling care as the outflow of nurslings to these okrugs decreased (perhaps the grown foster children were now contributing to the well-being of their households). In the lands south of the Oka and Tarusa, however, the proportions of poor and landless families were consistently in the 30 percent range and higher, frequently between 40 and 60 percent and more.[65] In the last years of the tsarist era, these southern okrugs were providing the same kind of stable welfare class dependent on the regular foster-care stipends as the western

[64] "Tul'skaia guberniia," *Entsiklopedicheskii slovar'* (Brokgauz-Efron) (St. Petersburg, 1902), 34:48–50.

[65] All percentages in this paragraph were computed from data in *Otchet M. Vos. Doma* (1898), 117, and (1912), 110–11.

okrugs had delivered consistently during the decades from the 1870s until the end of the century.

CONCLUSION

The foundling traffic constituted one aspect of the economic geography of the hinterlands of St. Petersburg and Moscow. Although conditions differed in the two regions, the foundling trade played much the same role in both. It was an occupation that allowed women or families to supplement their income from farming and other trades. The peasants usually calculated the "benefit" of caring for the children. The women who worked at fosterage moved in and out of the trade in response to their own or their family's financial needs, the fluctuating pay levels within the system, and the wage differential between this work and alternative forms of employment. The children were viewed primarily as an exchange commodity to be passed around the village, sold, or returned to the foundling home as economic need dictated.

Since it was an integral part of the economic geography of the metropolitan regions, the foundling trade was sensitive to changes occurring within the regions. Administrative policy, influenced by state or provincial politics or by demographics and the patterns of settlement in various areas, in turn affected the movement of the trade. The overpopulation or saturation of some okrugs with foster children inhibited further exploitation in these areas. Household partitions, which gained momentum after emancipation, especially in areas close to urban centers, forced shifts in the foundling traffic. Most important, however, were changes in the character of agriculture, manufacture, and industry. The foundling trade thrived in places where agriculture was at an increasing competitive disadvantage or where rural overpopulation was pressing on land resources and where at the same time alternative forms of employment were little developed or unprofitable and wet nursing was an occupation compatible with the traditional agricultural economy. The progressive integration of more distant areas into the sphere of urban mechanized manufacturing and ready access to the capital cities with their large service and industrial sectors undermined the foundling trade and impelled officials to search ever farther afield for a supply of wet nurses and foster families.

The foundling trade was well suited to a particular stage of social and economic development, and the traffic moved in waves across the St. Petersburg and Moscow regions following the emergence of that stage in successive areas. Four conditions characterized the stage: contact with the urban field of influence, low availability of well-paying indus-

trial jobs, continued importance of the traditional life of the farmstead, and continued existence of large households in significant numbers. Areas with these characteristics provided fertile ground for the foundling trade. With the penetration of urban culture and the increase of household partitions and modern jobs, baby farming decreased in importance relative to other options for supplementing family income.

Social and Medical Consequences of Fosterage

THE FOUNDLING CARE SYSTEM in Russia began as a program for producing urban artisans and professionals. But as hopes for this program waned and the homes redirected children to long-term rural fosterage, people became concerned about the impact of the foundling children on the families and communities that hosted them. By the second half of the nineteenth century, with over 40,000 fosterlings in the Moscow system and 30,000 in the St. Petersburg program, it was difficult to deny that the presence of this large population in the okrugs could have serious effects. The objections to the fosterage program voiced even earlier by the nobles in St. Petersburg province and by the governor general of Finland have already been mentioned. These people believed that the foundling traffic was causing harm to the native children of their regions and that it was also undermining the moral and physical well-being of the peasant communities for which they were responsible. Concerns of this nature persisted in the period following the emancipation of the serfs and even sharpened with the arrival of zemstvo doctors and public-health officials in the countryside. They collected and presented in scientific forums data that suggested a strong relationship between the foundling traffic and medical and social ills in the villages. Naturally, foundling-home officials disagreed with these findings and saw other causes for the problems identified by the critics of their institutions. These debates are of interest not only for the insights they afford into the effects people feared from the foundling traffic but also for the light they shed on child care, health conditions, and medical problems in central Russian villages during the late tsarist era.

The larger issue can be viewed from two angles: (1) that of the foundling-home officials, who were concerned about the treatment and condition of the foster children sent to the villages; and (2) that of the local doctors, who were concerned about the effect of the presence of these children on the families native to the village. The foundling homes looked critically upon the conditions in which their charges lived and, as a rule, died. The local officials and doctors viewed the foster children as disease vectors, who carried to the villages the seeds that caused not only their own deaths but also those of the villagers. Both sides in the controversy could marshal evidence for their point of view.

CONDITIONS FOR NURSLINGS AND FOSTER CHILDREN

The survival rates of the children in village fosterage did not inspire foundling-home officials with confidence in the quality of peasant child care. The situation was so grim that the homes for most of their history did not provide an accurate accounting of the mortality of the nurslings and foster children in the villages, presumably because to do so would have demoralized everyone connected with the enterprise. It is therefore difficult to determine what was happening to the foundlings living in foster care in the okrugs. Even for the overall foundling population, including those in the central facilities as well as those in fosterage, the methods of reporting used by the institutions disguised the true death rates. This was especially the case for the most common form of reporting, which compared the mortality in any one year to the total foundling population of that year. This type of accounting often yielded mortality rates of 20 to 30 percent.

However, toward the end of the nineteenth century, the homes reported mortality in a more accurate way, showing what proportion of children entering in a given year survived for a specified period of time. The St. Petersburg home found that, among the cohorts entering from 1869 to 1873, between 84.4 and 85.4 percent had died by the age of twenty-two.[1] A study made for the governing board of the Moscow home revealed in 1880 that nearly 88 percent of the children who had entered during the previous ten years (103,481 out of 117,854) had died.[2] My own checks in the Moscow archives of the personal histories of foundlings at the Moscow home in the early 1820s indicated a survival rate of just 15 percent up to the age of five.[3] Evidently, the next sixty years brought no improvement. Only after the reforms of the 1890s did the survival rate begin to increase, reaching 25 percent in the early twentieth century.

Mortality rates for the subset of foundlings who went out to fosterage can be calculated from scattered data. Records of deaths for all foundling children in the Moscow okrugs were published for a portion of the pre-reform period, and these can be adjusted downward by an index of first-year mortality to yield an infant mortality rate for each year.[4] The

[1] Gratsianskii, "Pitomnicheskii promysel," 40.

[2] Pfel', "Programma dlia pereustroistva," 30.

[3] TsGIAgM, f. 108, op. 3, d. 1520, "Glavnye knigi" (by year).

[4] In detailed breakdowns of deaths by age for each cohort that were reported for particular okrugs for 1859, 1860, 1867, and 1868, an average of 72 percent of all deaths occurred in the first year after birth. TsGIAgM, f. 108, op. 3, d. 39, pp. 2–2ob, 8–13; op. 1, d. 453, pp. 9, 12, 14–15, 17, 22, 26, 29, 32–33, 38, 42, 49, 53, 56, 64ob, 73, 82, 90–91, 105–6, 123, 130–31, 137, 149–50, 164, 172, 182, 184ob; d. 449, pp. 2–10, 14–15.

results can be checked against a secret report in the Moscow archives submitted to the governing boards of the foundling homes in 1856 by Prince Golitsyn, which includes year-by-year figures for the 1840s and 1850s that appear explicit enough to be of some value. Since these figures apparently record deaths among each entering cohort only up to the end of the calendar year, they need to be adjusted upward to take account of mortality among children who entered the okrugs late in the year, in order to yield mortality rates to age one. These two procedures lead to approximately the same rates and so give one confidence in the results. First-year mortality rates for the St. Petersburg home up to 1857 had to be derived from two different sources and may be somewhat less accurate. Figures for St. Petersburg from 1857 to 1866 are given in Tarapygin's detailed accounting of the first-year mortality experience of each cohort in each okrug and appear to be quite reliable. Mortality rates to age one for both homes are given in table 12.1.

It may be noted that mortality for the St. Petersburg cohorts was slightly higher than for the Moscow cohorts, and this does not seem unreasonable. Compared to the Moscow facility, the St. Petersburg home during these years received a higher percentage of very young children and sent them to the okrugs at a correspondingly earlier age.[5] One would therefore expect that more of the St. Petersburg children would die in the okrugs. The discrepancy between the Moscow and St. Petersburg rates is thus not an indication of poorer care at St. Petersburg. The survival rate for the entire foundling population in this period was better at Moscow, probably also as a result of receiving somewhat older children, but the difference in overall death rates at the two homes was less than two percentage points.

When data are examined on mortality among foundling children in the okrugs during the 1870s and then the 1890s and beyond, the difference between Moscow and St. Petersburg is seen to have reversed. Death rates for infants in the okrugs of both homes have fallen, but much more so for St. Petersburg. (See figure 12.3.) The decrease in the rate for infants going out to the St. Petersburg okrugs was probably a result of the later dispatch of infants from the home, in response to concerns about preventing the spread of syphilis, and so it did not signal a change in the mortality experience of the total cohort. A sustained reduction of infant mortality among the foundlings in the okrugs did not occur until the turn of the century. In other words, just as in the case of the foundling population as a whole, the second half of the nineteenth

[5] See the Afanas'ev report, in TsGIAgM, f. 108, d. 444, pp. 68–69.

TABLE 12.1

Mortality to Age One of Infants Sent to Okrugs from Moscow and
St. Petersburg Foundling Homes, 1846–1866

	Moscow Home		St. Petersburg Home	
Year of Entry	Number Sent to Okrugs	Mortality to Age One (Percent)	Number Sent to Okrugs	Mortality to Age One (Percent)
1846	6,707	58	4,708	69
1847	5,932	68	4,203	70
1848	6,232	72	4,061	73
1849	6,532	58	3,968	69
1850	6,928	62	4,164	79
1851	7,085	64	4,111	79
1852	7,846	61	4,395	73
1853	8,191	65	4,520	75
1854	9,019	65	4,810	73
1855	8,915	72		
1856	9,086	65		
1857	8,425	69	5,364	73
1858	9,858	72	5,194	70
1859	11,335	64	5,346	69
1860	9,979	71	5,407	70
1861	9,664	65	5,250	73
1862	8,396	69	4,877	73
1863			4,847	71
1864			4,502	65
1865			4,352	70
1866			4,839	67
Yearly average	8,243	68	4,680	72

Sources: For Moscow home: number going to okrugs, *MIMVD* 1, part 2:35; number of deaths, report by Prince Golitsyn, October 7, 1856, in TsGIAgM, f. 108, op. 1, d. 447, p. 155 (as adjusted). For St. Petersburg home, 1846–1854: number going to okrugs, report by Prince Golitsyn, October 7, 1856, in TsGIAgM, f. 108, op. 1, d. 447, p. 155; number of deaths, S. E. Termen, *Prizrenie neschastnorozhdennykh*, appendixes. For St. Petersburg home, 1857–1866: number going to okrugs and number of deaths, Tarapygin, *Materialy*, foldout tables opposite p. 38.

century brought no improvement in the survival rate of infants sent for care to the okrugs.

HOUSING AND ECONOMIC STATUS

Recognizing the importance of the environment in which the foster children were reared, officials of the Moscow home made observations of the characteristics of the foster families and their houses over a long period and left a record of how these were changing. One concern was the number of foster families that lived in houses lacking chimneys, a circumstance that was thought to do great harm to the health of the children—and indeed of everyone in the house—and that was linked especially to disorders of the eyes and even to blindness.[6] Russian authorities believed that chimneyless houses led to a significant reduction in the life expectancy of their inhabitants.[7] The percentages of foster families in the Moscow okrugs living in these "smokey houses" (*kurnye izby*) from the early 1870s to 1913 are plotted in figure 12.1, which differentiates between families occupying the smokey houses year-round and those occupying them only in the winter.

As the total number of foster families grew in the 1880s, during the last great spurt of admissions to the foundling home, the percentage of foster families with chimneyless houses also rose. In the mid-1880s, nearly 40 percent of all foster families lived in these smokey houses during the winter and well over 20 percent did so year-round. After the foundling home reforms of the early 1890s and the sharp reduction in admissions, the number of foster families living in smokey houses declined rapidly. Indeed, it declined more rapidly than did the number of admissions, and the decline in smokey houses continued after the number of foster families leveled off and turned upward toward the end of the period shown. The result was, of course, a steep fall in the proportion of foster families occupying chimneyless houses.

This fall seems to have resulted from two broad changes, one technological and one geographic. Chimneyless houses had been the common form of dwelling found in the northern and central areas of Great Russian settlement until the middle of the nineteenth century. In some parts of the central region, this type of house continued to prevail until after the Revolution of 1917, but elsewhere the Great Russian peasant house evolved toward urban models, including the use of chimneys.[8]

[6] LGIA, f. 8, op. 1, d. 187ch4, pp. 204ob–5.

[7] "Kurnaia izba," *Entsiklopedicheskii slovar'* (Brokgaus-Efron) (St. Petersburg, 1896), 27:91.

[8] Zelenin, *Russische (Ostslavische) Volkskunde*, 272; S. P. Tolstov, "Izba."

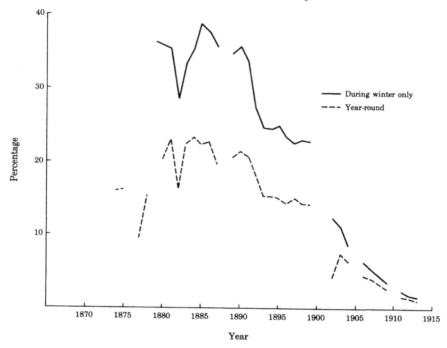

Fig. 12.1 Foster families living in chimneyless houses, Moscow okrugs, 1873–1913

The diminution in the percentage of foster families in smokey houses undoubtedly owed a great deal to this technological change. But another, perhaps more important, factor was the shift in the geography of the fosterage system already noted (chapter 11), from the north and west of the Moscow region to the south into Kaluga, Tula, and Riazan' provinces. In the areas south of Moscow and especially in the black earth region, chimneyless dwellings were the exception; here the different design of the southern Russian house predominated.[9] As the center of gravity of the Moscow fosterage system moved into this southern region in the early twentieth century, the foundlings were more often to be found in houses vented by chimneys.

The rapid fall in the number of smokey houses was thus a stylistic and geographic change, not an indicator of any improvement in the economic conditions of the foster families. In fact, the opposite was occurring. Surveys made by officials of the Moscow okrugs categorized the

[9] *Russkie* 2:62–64 and maps on 31, 32, 36, and 37.

foster families as being well-off, average, poor, or landless. Unfortu-
nately, the reports did not spell out the criteria defining these classifica-
tions, except to say that families had to own at least one cow to qualify
as "average."[10] In any case, the percentages of families in each category
from 1871 to 1914 are shown in figure 12.2.

At the beginning of the period, nearly 90 percent of the foster families
were said to be "average." By the end of the period, that category had
fallen to 41 percent and was equaled by the proportion of families iden-
tified as poor. Even if the categories represent impressions rather than
objective measures, the steady deterioration over the period surveyed is
convincing and corroborates the complaints of okrug officials, noted in

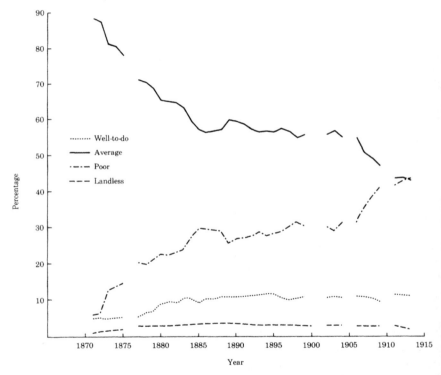

Fig. 12.2 Economic category of foster families in Moscow Fosterage Program, 1871–
1914

[10] *Sbornik svedenii po obshchestvennoi blagotvoritel'nosti* 7: 13, 31; Lebedev, "Ocherk deia-
tel'nosti," 41.

the previous chapter, that it was becoming difficult to place foundlings with any but poor families. This picture also confirms other references to the transparent financial motivation for foundling care, something villagers admitted openly. In a survey of the Moscow fosterage system in the late 1880s, for example, the responses of the five hundred families interviewed to the question of why they took a foundling echoed again and again: "Due to poverty" (*po bednosti*).[11]

The declining economic position of the foster families probably indicated that middling and better-off peasants had found more lucrative pursuits for their nonfarm labor. But it also meant that the foundling children were not so well cared for as they had been in the past. Experience had taught officials that well-to-do peasant families usually took better care of the nurslings and foster children than did the poorer families. Occasionally, overseers remarked that poor foster mothers were giving excellent care and that it was more important that a child be wanted and tended to than that its foster mother be well off.[12] Yet this type of observation was the exception in a litany of laments about the small number of well-to-do families taking foundlings and about the miserable conditions in which many of the wards of the foundling homes were living.[13] Without being able to assess the biases that marked the reports of official observations of peasant life, one can conclude that toward the end of this period the foundling home was dealing with foster families that lived in less favorable economic circumstances but in what, because of the better-ventilated housing, may nevertheless have been more salubrious conditions for the upbringing of children.

Even so, it is apparent that the shift to better-ventilated housing after 1890 was not immediately manifested in a reduction in the infant mortality rate among the children sent to the okrugs of the Moscow system. This came only a decade later, when there was not only a second sharp drop in the number of chimneyless houses but, probably more significantly, the beginning of a decline in infant mortality in Russia generally. Although the first drop in chimneyless houses in the early 1890s may have exerted a positive impact on the survival rate of the Moscow foundlings, that effect must have been offset by the declining economic status of the households. This hypothesis is corroborated by the fact

[11] Arkhangel'skaia, "Rezul'taty pervoi popytki," 277.

[12] See, for example, *Otchet M. Vos. Doma* (1871), 40. The same type of comment was made—though in a populist spirit that raises questions about its accuracy—in Obninskii, "Patronat nad pitomtsami," 557.

[13] For a few of the many examples, see *Otchet M. Vos. Doma* (1871), 47–48; Arkhangel'-skaia, "Rezul'taty pervoi popytki," 278–79; *Detskaia pomoshch'*, 1891, no. 18: 549; LGIA, f. 8, op. 1, d. 187ch4, pp. 81ob–82.

that a further sharp decline in the economic status of foster families after 1905 (see figure 12.2) corresponded to a new rise in infant mortality among the foundlings in Moscow fosterage (see figure 12.3).

The pattern shown in figure 12.3 likewise raises questions about the effects of the foundling-home reforms of the early 1890s. Despite the efforts to provide each infant in the homes with a single wet nurse, and despite the reduced numbers of infants entering the village fosterage programs, infant mortality rates among the children who ended up in the okrugs failed to show sustained improvement until the turn of the century and then only at the St. Petersburg home. By that time, infant mortality generally in the territories making up the okrugs was beginning to decline.[14]

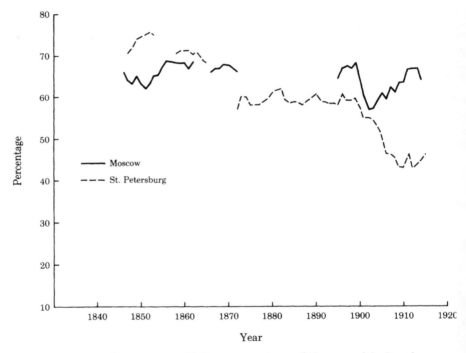

Fig. 12.3 Mortality to age one of infants sent to okrugs of Moscow and St. Petersburg foundling homes, 1846–1914 (five-year moving averages)

[14] According to figures compiled by the demographer S. A. Novosel'skii, mortality to age five in the fifty provinces of European Russia did not begin to fall until the period from 1898 to 1902: Novosel'skii, "K voprosu o ponizhenii smertnosti," 346–47. For Moscow, see Kurkin, *Detskaia smertnost'*, xxvii–xxix, 37.

The mortality experience of the entire foundling population was somewhat more favorable. The cohorts of the 1890s saw a slight improvement in survival chances, and after the turn of the century the overall mortality rates at both homes showed a substantial and sustained decline. A supporter of the foundling homes, Dr. S. E. Termen, was perhaps justified in pointing to the progress that the homes had made. Writing in 1912, he noted that in the eighteenth century only a small fraction of an entering cohort had survived to adulthood. By the 1880s, the survival rate had risen to 15 percent, and it continued to rise gradually thereafter, reaching 20 to 25 percent by the early years of the twentieth century. "Mortality remains quite high," he admitted, "but it is hardly much worse than that which normally exists in the rural areas."[15] Termen was understating the difference, but not by a great deal. As late as the 1890s, the proportion of children who survived to age five in the provinces of European Russia inhabited predominantly by Great Russians (as distinct from those with large populations of Ukrainians, Belorussians, Poles, and Balts) was less than 50 percent.[16] The rate of survival to adulthood was of course even lower. In the districts of Moscow province in the 1880s, the proportion of males surviving to the age at which they were subject to military recruitment averaged just over 31 percent, and in some districts it was as low as 24 percent (see table 12.2). The high death rate of the foundlings evidently affected these figures, since the corresponding rate for European Russia as a whole was 43 percent in 1875 and 49 percent in 1894, and the districts in Moscow province with the lowest rates were those with large contingents of foundlings.[17] Nevertheless, the survival rates for males even in the districts with very few foundlings scarcely rose above 40 percent. Considering this high loss of life among the young people of imperial Russia, the record of the foundling homes after 1890 does not seem so dismal, especially in view of the fact that illegitimate children, even when reared by their own mothers, died in higher proportions than did legitimate children.[18]

With regard to the children in fosterage, despite the drop in the economic position of foster families, the combination of improved housing and a more reliable supply of wet nurses for foundlings who entered the homes after 1890 may have contributed to holding first-year mortality

[15] S. E. Termen, *Prizrenie neschastnorozhdennykh*, 171–72.
[16] Calculated on the basis of figures in Rashin, *Naselenie Rossii*, 198, and *Detskaia meditsina* 6 (1901): 257.
[17] Sokolov, "K kharakteristike fizicheskogo razvitiia," 12.
[18] Tagantsev, "O detoubiistve," 236, citing studies from England and Germany; Gorokhov et al., *Detskii organizm*, 9–10.

TABLE 12.2
Survival Rate of Males to Age of Military Recruitment
in Districts of Moscow Province, 1885

District	Percentage Surviving to Recruitment Age
Ruza	24
Vereia	25
Dmitrov	26
Zvenigorod	27
Kolomna	30
Moscow	30
Podol'sk	31
Klin	31
Mozhaisk	33
Serpukhov	34
Volokolamsk	36
Bronnitsy	41
Bogorodsk	41
Average	31

Source: Sokolov, "K kharakteristike fizicheskogo razvitiia,"
11.

at or slightly below previous levels. But it also seems clear that significant improvement was retarded—apart from the limiting influences of illegitimacy and temporary institutionalization—not by the policies of the foundling homes so much as by the effects of ignorance and disease in the Russian countryside, which is to say by the Russian peasant child-care culture.

Peasant Child-Care Culture

The major obstacle to the survival of the foundlings was not that their mothers abandoned them but that they abandoned them *in Russia*. In France, nurslings sent out under administrative intake and outplacement procedures similar to those in Russia survived at a much higher rate than did the Russian foundlings; indeed, babies sent out to nurse in France survived at a higher rate than did ordinary Russian peasant

children born and reared in their own homes.[19] An objective measure of the effects of the Russian child-care culture is the infant and childhood mortality rates cited earlier. A mortality rate of 50 percent by age five and survival to adulthood in some cases of as few as 30 or 35 percent are among the highest rates ever recorded anywhere. Moreover, these rates were high not only in comparison to those farther to the west and south, including the rates among Poles, Balts, Jews, and Ukrainians of the Russian empire as well as those in western and central European countries; the mortality of Russian children was high even by comparison with the mortality of children among the Tatars, Bashkirs, and Votiaks (Udmurts) of the Volga basin and the Ural Mountains to the east of the center of Great Russian settlement.[20]

Russian settlement was widespread, and the quality of child care undoubtedly varied a good deal from village to village and even from house to house. Some women were able to look after themselves during pregnancy and did not carry a full load of work. After the birth, they stayed close to their small children, nursed them for the prescribed period of three consecutive fasts, or about eighteen months, counting only the great fasts of the Assumption and Lent.[21] But this is not the picture normally drawn by doctors and welfare officials who visited the homes of peasants. More typically, they reported that Russian women carried on their regular chores and even participated in field work right up to the time of confinement, many of them going into labor while on the job. Childbirth took place in the absence of any notion of hygiene. The use of the bathhouse for a delivery room—a matter of ritual cleanliness—in some cases improved the situation, but just as often the birth occurred in a stuffy, dirty hut, and on occasion out of doors in the field or woods.[22] Instead of looking to sanitation or even to the comfort of the mother, Russian villagers seemed to regard as more important the proper relationship of the child to authority. For example, women frequently wrapped the newborn baby in the dirty clothes of its father in

[19] Sussman, *Selling Mothers' Milk*, 30, 120–21; Fuchs, "Abandoned Children in Nineteenth-Century France," 256.
[20] Novosel'skii, *Smertnost' i prodolzhitel'nost' zhizni v Rossii*, 144–46; *Detskaia meditsina* 6 (1901): 257; *Detskaia pomoshch'*, 1892, no. 13: 461–62; Popov, *Russkaia narodno-bytovaia meditsina*, 4.
[21] Demich, "Pediatriia," 193–95.
[22] Ibid., 5–6, 126; Semenova-Tian'-Shanskaia, *Zhizn' "Ivana,"* 7–9. For observations from informants living among peasants, see GME, f. 7, op. 1, d. 1832, pp. 14–15 (hygiene notions only recently entering village), and d. 1747, p. 26 (women at end of pregnancy still carrying on heavy work as late as 1897).

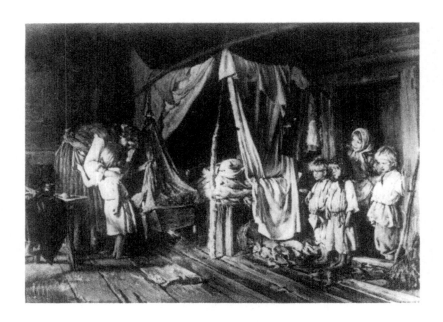

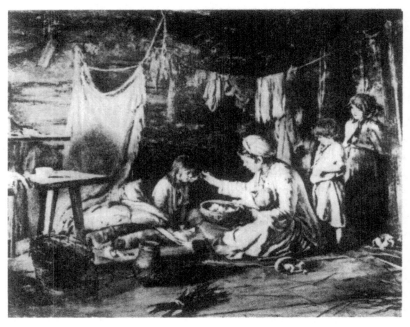

12.1 Two paintings by Karl Lemokh (b. 1841). *Top*, "Novoe znakomstvo" (New Aquaintance), showing the typical peasant crib, suspended from a pole or rafter and covered with a cloth; next to it is the bed in which the mother gave birth. *Bottom*, "Vyzdoravlivaiushchaia" (The Convalescent Girl), depicting the children's sleeping quarters in a peasant home.

order to strengthen the submission of the child to the paternal will.[23] From there, the child went to a fly-infested crib suspended from a rafter and filled with rags. The baby was left among the rags and its own waste products or, more often, swaddled, and in either case was infrequently washed.[24]

Feeding practices were another contributor to infant mortality. Apart from epidemic disease, digestive disorders accounted for the bulk of infant deaths in nineteenth-century Russia, and a major cause of these disorders was the habit of quickly putting babies onto solid food. To judge from the many reports of the early use of solid food and of efforts by government and the church to combat it, the practice was widespread.[25] It was apparently adopted for the convenience of the household, whose members required the mother's work services. Sources note that members of the household resented the attention a mother gave to her newborn child; they believed that she was using child care as an excuse for neglecting other tasks.[26] The brief growing season in Russia meant that important agricultural tasks demanded intensive effort and the participation of every able-bodied person in a family. Solid food for babies was thus seen as a necessity, enabling mothers to join in the field work. According to a time-budget study done in the 1920s, Russian peasant women spent nearly as many hours at farm labor (as distinguished from household tasks) as did the men.[27] When the work of the women took them to the field, they had to leave their young children at home in the care of older siblings or a grandparent. In poor families, the separation continued into the off-season as well, for young mothers went out with the men to cut wood or sought work as day laborers.[28]

Still, something more than the need imposed by the mother's absence accounted for this method of feeding, since Russians fed solid food to

[23] Popov, *Russkaia narodno-bytovaia meditsina*, 358; Pokrovskii, *Ob ukhode za malymi det'mi*, 13–20.

[24] Popov, *Russkaia narodno-bytovaia meditsina*, 352–61, and Khotovitskii, "O nekotorykh pogreshnostiakh." These are just two examples of a large literature describing such scenes.

[25] The practice was noted and condemned by a Russian doctor as early as 1780: Zybelin, *Slovo o sposobe*, 13–18. For the late nineteenth century, see Gubert, "Ob ustroistve gorodskoi stantsii," 20; Sokolov, "Sanitarnyi ocherk," 196–99; Bogoslovskii, "Zadachi vrachebno-sanitarnoi organizatsii," 215–16; *Detskaia pomoshch'*, 1891, no. 14: 435–36; Arkhangel'skaia, "Resul'taty pervoi popytki," 278–79; Makarenko, *Materialy po narodnoi meditsine*, 45–46.

[26] Popov, *Russkaia narodno-bytovaia meditsina*, 356; LGIA, f. 8, op. 1, d. 187ch4, pp. 183–84; Sokolov, "Sanitarnyi ocherk," 198.

[27] Bol'shakov, *Sovremennaia derevnia v tsifrakh*, 100.

[28] Arkhangel'skaia, "Resul'taty pervoi popytki," 279; Gubert, "Ob ustroistve gorodskoi stantsii," 19; Semenova-Tian'-Shanskaia, *Zhizn' "Ivana,"* 13–14.

infants even when the mother was at home and was nursing. When asked why they used solid food, peasants claimed to believe that a child could not survive on breast milk alone.[29] It is difficult to say if this response revealed an unreflective projection of adult nutritional needs onto the baby or whether the peasants were acting on the belief that the mothers could not provide enough milk to sustain an infant. The observations of doctors who worked among the peasants confirm that the women were often poorly nourished and as a consequence produced inadequate amounts of breast milk.[30] Even so, doctors warned against the introduction of solid foods before the child's digestive system was able to utilize them, since the food caused intestinal disorders that obstructed absorption of essential nutrients, leaving the babies prey to the disease agents that filled the environment.

Another deadly element in Russian child care was the pacifier (*soska*). This ubiquitous instrument consisted of a piece of cloth filled with grain or other foods partially chewed by a member of the family and placed in the baby's mouth. To judge from the following report, the pacifier went into a peasant baby's mouth within hours of its birth. A doctor described this scene shortly after he delivered a baby in a peasant home:

> Then in came the proud grandmother, chewing a rag in which was pocketed bacon rind and baked flour; this she was about to pop into the child's mouth to be the first intruding touch from the outside world when I stopped her, and asked her to consider whether it was as nice and clean a comforter as the mother's breast; and, besides, had she not got pyorrhoea (her gums were awash with pus)—in fact, the usual hygienic pleas. It was an ill-judged if not unkind interruption, because in any case the cosy rag would be thrust in the moment our backs were turned and by giving the babe something she had herself chewed she was in an animal sort of way binding her love to it as best she knew how.[31]

In the summer, when the mother's help was needed outside the home, the bacteria-infested pacifier received constant use. Many times it was the child's only source of nourishment from early dawn until the return of the mother late in the evening. During this time, the baby remained in the care of young children or of a grandmother too feeble to be of

[29] LGIA, f. 8, op. 1, d. 187ch4, pp. 183–84; Popov, *Russkaia narodno-bytovaia meditsina*, 356; Zybelin, *Slovo o sposobe*, 16. See also GME, f. 7, op. 1, d. 1790, p. 2, noting that even when women breast-fed infants for two years they began giving solid food from the day of birth.

[30] Benzengr, "K voprosu o pitanii grudnykh detei," 139–40.

[31] Rickman, "Russian Camera Obscura," 50–51.

use in other tasks or sometimes too visually or physically disabled to assist a baby choking on a pacifier or beset by some other emergency.[32]

In an unfortunate conjuncture, the summer months, when Russian infants had the least access to their mothers, were also the time when disease was most prevalent and bacteria most virulent. The murderous effects of summer disease outbreaks and child neglect reached appalling proportions in some parts of rural Russia during the late nineteenth century. A study of one area of the Vereia district of Moscow province during the 1870s found that, of one hundred children who were born in the summer, sixty-seven died within a month. Another study, of the Borovichi district of Novgorod province in the 1860s, found that only two out of ten children born in the summer work season survived.[33]

Seasonal patterns in the number of births in rural Russia aggravated the effects of this link between absence of the mother and prevalence of disease. Russian peasants were sexually most active in the fall, during the immediate post-harvest weeks of abundance, and so the number of births peaked in July and August, just when the survival chances for the children were the poorest.[34] This unhappy combination of factors goes far toward explaining Russia's exceptionally high infant mortality rate.

Another factor, one not as easily measured, was a feeling of fatalism about the death of small children. Even the "normal" toll of about one-half the children under the age of five discouraged parents from investing more than minimal emotional and physical energy in a child. Resignation was the parents' shield against the potentially traumatizing impact of the carnage that surrounded them. Virtually every doctor who wrote about the experience of working among peasants remarked on the fatalism with which they greeted the death of an infant. Typically, doctors saw only peasant children who were in serious condition, because the parents who bothered to seek the relatively expensive help of a trained physician did so only after they had tried more familiar and cheaper remedies. According to a specialist on folk medicine, not only peasants residing in the countryside but even those who had moved to towns waited until the last minute to seek professional medical advice. When asked why they delayed so long when a doctor was readily avail-

[32] Pokrovskii, *Ob ukhode za malymi det'mi*, 41–46. See also the field reports from foundling-home officials in *MIMVD* 2: 133–34; LGIA, f. 8, op. 1, d. 187ch2, p. 242ob, and d. 187ch4, pp. 140–41; and TsGIAgM, f. 108, op. 1, d. 444, pp. 69–69ob.

[33] Both studies are cited in Karamanenko, "O sanitarnom znachenii," 134–35. The annual rate for the Borovichi district was 53 percent mortality in the first year. See also Demich, "Pediatriia," 126–29.

[34] P. I. Kurkin, "Smertnost' malykh detei," in his *Publichnye lektsii*, 28–31; Osipov, "Neskol'ko statisticheskikh faktov," 120–21.

271

able, the peasants replied, "If God so wills, the child will get better; if not, it will die."[35] Even parents who fostered children from the found-ling homes and who received payment for bringing a sick child to a medical station did so reluctantly. "If God won't help," said a peasant in one case, "then medicine is not going to help."[36] Sympathy for the pains of an expiring infant also influenced the peasants' decision to avoid med-ical assistance. Though hardened to the death of their children, peasants understood the pain caused by harsh medications and heroic therapies, and they saw no point in further tormenting a child who was already suffering from disease.[37]

A British doctor who worked among Russian villagers tried to ex-plain the seeming contradiction between fatalism about disease and the seeking of medical help at the last moment. He said that the peasants understood illness as coming from some bad thing inside, a foreign body. "This alien thing within may be sent from God as a punishment for sins or may be picked up in folly as one gets pricked with brambles if heedless," but in any event these forces are beyond the control of peo-ple. "This fatalism would have been their practice," the doctor went on, "if another force had not worked on their spirit from within. The love they bore each other made the sight of illness painful and they were glad to get the skilled help of doctors and nurses for those they held beloved and (with inward reservations) for themselves as well. Such help was called only when the condition was past their comprehension, i.e. when the approach of death had been heralded by symptoms that were alarm-ing."[38]

On the other hand, peasants sometimes brought harm to themselves by a too ready acceptance of modern medicine. One specialist told of a peasant who found on the road a medicine phial containing veratrina, a mixture of alkaloids in powder form that was used in the treatment of neuralgia and rheumatism but chiefly externally as an ointment. Know-ing only that it was a medicine and not wanting it to go to waste, the finder gave half to his son, who was having difficulty breathing, and dabbed the other half into the ailing eyes of his uncle. The boy died and the uncle went blind.[39] This story, and the fact that peasants did seek medical help as a last resort, would indicate that they conceived of mod-

[35] Demich, "Pediatriia," 127–28. See also the field reports of foundling-home inspec-tors in LGIA, f. 8, op. 1, d. 187ch4, pp. 83–84, and TsGIAgM, f. 108, op. 1, d. 444, pp. 73–74.

[36] *Otchet M. Vos. Doma* (1869), 29–31.

[37] Demich, "Pediatriia," 127–28.

[38] Rickman, "Russian Camera Obscura," 47–48.

[39] Krapivina, "Narodnoe samolechenie," 291.

ern medicine as a powerful form of magic but avoided it because of inconvenience, expense, and resignation.

Even though treatment of foster children from the foundling homes was free, doctors from these institutions also complained about the failure of the peasants to seek medical help until the very last moment. In this case, the peasants' delay may have resulted from the costs to the foster family in the form of labor time lost in transporting the child to and from the medical station and the revenue for baby care lost during the time the child was there.[40] As early as 1834, Dr. Afanas'ev explained this economic constraint in his detailed report on the operation of the Moscow fosterage system.

> The peasant looks on the money he receives for foster care as his true property and knows that he will lose it if his foster child is at the medical station. Can one assume that he would then gladly bring an ailing child to the medical station in good time? No! In order somehow to keep as much pay as possible, he puts off the trip to the doctor from day to day, consoling himself with the thought that the child might get well. By the time the child is brought in, it is struggling for life.[41]

Only many years later did the foundling homes introduce changes in the rules that made it possible for foster families to continue earning pay for children temporarily in the care of the medical stations, but this still did not overcome the difficulty of bringing children to the stations, especially in the years before the turn of the century, when medical facilities in the countryside were few and widely scattered.

The attitude of resignation and fatalism toward the death of children was even more difficult to change, at least so long as childhood death rates continued to be in the 50 percent range, as they did until the end of the century. A particularly poignant sign of this resignation is found in old Russian lullabies. A Leningrad folklorist found an entire category of lullabies with the motif of wishing death on babies; the infants to whom women sang the lullabies were often those who appeared sickly, weak, or crippled.[42] Collections of Russian proverbs and sayings also contain many examples reflecting a fatalistic attitude toward the death of children and a sense of the unimportance of the life of very small

[40] See the field reports from Moscow in 1855, in TsGIAgM, f. 108, op. 1, d. 444, pp. 79–79ob, and from St. Petersburg in 1879, in LGIA, f. 8, op. 1, d. 187ch4, pp. 83ob–84ob.

[41] TsGIAgM, f. 108, op. 1, d. 444, pp. 73ob–74ob.

[42] Martynova, "Otrazhenie deistvitel'nosti," 145–55.

children.[43] It is hardly surprising that doctors and officials, hearing these sayings, would regard the peasants as careless, not to say callous, about the health of their children.[44] In the Moscow Foundling Home's annual report for 1871, officials apologized for the unwholesome conditions of foster care in which the foundling children had to live and which were so costly in lives. The conditions were unfortunately bound up with the ageless peasant way of life, the report said; this included the filth, the harsh winter, the feeding of babies with "various undigestible substances, and many other things causing the death of infants, which is regarded as of nothing by a village woman, and she observes the death of a child, though with sadness, also with a clear conscience."[45]

To sum up, the survival chances of the foundlings depended not only on the action of the homes. The condition and treatment of the foundlings at the central institutions improved greatly after the reforms of the early 1890s, but the institutions could not as easily alter the conditions of village fosterage. A large proportion of the children still ended up in fosterage, where they continued to be subject to the assaults on their health inherent in the child-care culture of the peasants, including poor feeding practices, disease, neglect, ignorance, and resignation about the death of children. Until the chances of survival for all Russian rural children improved, the chances for the foundlings also remained precarious.

Supervision in the Okrugs

Although the foundling homes lost most of their influence over the well-being of their charges once the children went out to fosterage, the work of okrug officials and doctors could to some small degree affect the quality of the care the children received. The extent to which this supervision benefited the foster children depended on the character and commitment of the persons involved. Some of the doctors and officials did not bestir themselves to visit the foster families often enough to act as an effective check on abuses and see that the fosterlings were given adequate care. For example, when the okrug official in the Podol'sk district of Moscow province during the late 1860s fell ill and could not make his rounds, the number of unauthorized exchanges of children increased greatly.[46] Reports from the St. Petersburg system indicated that a lack of conscientious supervision also led to a higher death rate among the fosterlings. In Krasnoe Selo okrug in the 1860s, the found-

[43] Ivanovskaia, "Deti v poslovitsakh," 120–24.
[44] Demich, "Pediatriia," 128.
[45] Otchet M. Vos. Doma (1871), 47–48.
[46] TsGIAgM, f. 108, op. 1, d. 406, p. 112.

ling home's doctor indiscriminately distributed tickets to women to fetch new nurslings as soon as the one they were nursing had died; he evidently gave no consideration to whether the women in question had demonstrated any success in caring for previous nurslings. The inspector for that region complained that the doctor's indulgence was "weakening further the already low level of concern the peasant women have for the children they are nursing. The result is a death rate in some of the villages so high that nearly every nursling brought to them in the past three years has died."[47] In other okrugs, infrequent checking by the officials allowed the peasants to substitute their own children for the nurslings or foster children from the foundling home who had died.[48]

Elsewhere, problems arose from arbitrary and insulting treatment by an official. A noteworthy case was the behavior of a doctor in the Shlissel'burg okrug in the 1860s. He frequently moved foster children from one family or village to another to serve his own convenience. If families failed to pick up a child quickly from his medical station after its stay there, he turned the child over to some other family. In the case of older children, families could easily be found who were happy to exploit the child's labor until the original foster family could track down the youngster and go through the formalities for reclaiming it. The displaced foster child in one of these instances was clever enough to extort from the new family certain indulgences, such as allowing him to get drunk, in return for not filing a complaint against the new foster family before it could get from him the amount of work it wanted. It was an arrangement, remarked the inspector who discovered it, "that was not good for the morals of either party."[49] The same doctor who made the ill-considered exchanges terrified children and berated their foster parents at medical examinations. After finishing with a child, he threw the parents' pay booklets on the ground for them to pick up. He also refused to certify the booklets on the spot for payment, the normal practice, and forced the peasants to travel to his medical station for his signature; sometimes the foster parents made the trip only to find that the doctor was not in.[50] Supervision of this kind did little to win the peasants' cooperation with the goals of the foundling homes.

While poor supervision could harm the children, it is difficult to say whether good supervision added significantly to the survival chances of the foundling children in fosterage. The work of an official by the name

[47] LGIA, f. 8, op. 1, d. 187, p. 92.
[48] Examples from Izvarsk okrug in 1873 are in LGIA, f. 8, op. 1, d. 187ch2, pp. 245–47; and from Garbolovo in 1868 in ibid., d. 187, pp. 224–25.
[49] Other similar cases are in LGIA, f. 8, op. 1, d. 187, pp. 32–35.
[50] LGIA, f. 8, op. 1, d. 187, pp. 36–38ob, and d. 187ch3, pp. 5–13.

of Ivanov in the St. Petersburg system during the 1870s is a case in point. He had responsibility for a relatively large okrug, Vereb'insk, and yet was able to maintain tight control by dint of his consideration for the local people. Field reports by inspectors record many instances of his intervention when families were mistreating foster children and of his good judgment in protecting parents whom difficult foster children unfairly accused of abuses.[51] In summarizing one of these reports, an inspector marveled that everything in Ivanov's okrug was in very good order:

> He knows every fosterling and wet nurse by name and makes his rounds often and well. He knows the peasant way of life and spirit well and has been able to teach [the peasants] to adhere strictly to the obligations they have undertaken—and [he does this] without swear words or unpleasantness but simply by a clear, firm hold on things and prompt action in cases of abuse. He also convinces them that they need do nothing more than treat the fosterlings just as they do their own children. The peasants treat him with respect, and there has not been a single complaint from the children or the foster parents.[52]

If this effective and well-intentioned supervision helped to reduce mortality, the result is not strongly marked statistically. The mortality rate for the okrug at the time of Ivanov's tenure, though lower than average for the okrugs in the St. Petersburg system, does not appear to be significantly better than that for several other areas. The rates would be greatly influenced by the proportions of children in particular age groups, since the youngest ones were at much higher risk of death, and unfortunately, the available data do not give the necessary details.[53] At any rate, Ivanov's behavior was more likely to have contributed to good relations between foster parents and older foundling children than to have had an effect on the mortality of the nurslings. Good supervision, although it may have marginally improved the survival chances of the fosterlings, probably played a larger role in increasing the opportunities of the surviving youngsters for success and happiness in life.

The kind of constant, close supervision necessary to aid in the survival of nursing infants was simply not attainable in late nineteenth-century Russia. Even with energy and commitment, okrug officials and doctors could not overcome the physical obstacles to regular examinations on

[51] Ibid., 187ch2, pp. 239–40, and d. 187ch3, pp. 282–90.
[52] Ibid., d. 187ch2, pp. 241–41ob.
[53] Tarapygin, *Materialy*, provides only total mortality by okrug for these years.

the spot. During three months of the year, the roads into the country-side were impassable. Poor weather at these times made the sharp drops and rises and the narrow passages difficult to traverse even on foot. Distances shown on maps seldom reflected the reality of travel in the Russian countryside; the need to avoid obstacles, follow detours, and double back to find out-of-the-way villages meant that the actual distance covered was often twice what was anticipated.[54] A report on the Moscow okrugs in the 1860s, for example, declared that the okrug official for Klin had to travel more than 3,000 versts (about 2,000 miles) to cover his okrug and that officials in some other areas had to travel still farther.[55] If an official could cover 40 versts a day (over 25 miles), in addition to carrying out his visits and examinations—a heavy schedule under the best of conditions—a single circuit would have taken him two and a half months. Besides these rounds, officials and doctors labored under a burden of paperwork, meetings with colleagues and superiors, and often the management of a medical station. Low wages and inadequate expense accounts made it unlikely that officials would have inspected their okrugs regularly even if conditions had been better. The failure of expense allowances to keep pace with inflation sometimes left the real cost of traveling around the okrugs at more than five times the amount allotted.[56] So not only was it impossible for the local officials to make the once-a-month circuit that was prescribed in the foundling-home regulations, but even a round once every two months, as superiors hoped they might be able to do in the best of circumstances, was uncommon; in the latter half of the nineteenth century and the beginning of the twentieth, a complete survey of an okrug usually occurred no more than twice a year.[57]

When the okrug official finally did arrive on the scene, he did not always accomplish much. An official from the Vereia district of Moscow province reported in the late 1860s that "in many villages, wet nurses did not appear with the children [as required] and did not even come to explain where the fosterlings were, especially in the village of Kubin-skoe, in which I waited from 3 in the afternoon until the next morning."[58] By the end of the following week, the official had somehow learned that most of the "no-shows" at Kubinskoe were children that

[54] *Otchet M. Vos. Doma* (1871), 35–36.

[55] TsGIAgM, f. 108, op. 1, d. 464, pp. 45ob–46.

[56] Ibid., pp. 47–51, for a report in 1857. Adjustments made in the 1860s did not solve the problem: ibid., d. 472, pp. 69–70.

[57] Ibid., d. 464, pp. 45ob–46 (report from 1868), and Obninskii, "Patronat nad pitom-tsami," 557 (1910).

[58] TsGIAgM, f. 108, op. 1, d. 460, pp. 1–2ob.

had died or had been moved elsewhere, but his earlier report on the inabililty of the other wet nurses in the village to tell him what had happened to the missing ones reveals the failure of trust that marked relations between officials and peasants.[59] At about this same time, an official from another Moscow okrug reported that the accounts given to him had shown an official record of 2,212 fosterlings in his okrug, whereas his own check in the field turned up only 2,083, a difference of 129.[60] It is impossible to say how much of this discrepancy arose from errors in counting and how much from the unexplained disappearances of the infants sent to the okrug.

In sum, it seems that good supervisory work by foundling-home officials in the field might have made a small difference in the survival chances of the children sent into fosterage and possibly a great deal of difference in their adjustment to their foster families as they grew up, but that even in the best of circumstances, the size of the caseload, the territory to be overseen, and the conditions of existence in the Russian countryside limited the good that an okrug official or doctor could accomplish. The highly praised Ivanov from Vereb'insk okrug was able to overcome many of the obstacles, but officials of his character, commitment, and intelligence were rare.

EFFECTS OF THE FOSTERAGE PROGRAMS ON THE VILLAGERS

If foundling-home officials and doctors believed that village conditions endangered their charges who were living among the peasants, the public-health doctors responsible for the people in the countryside saw a threat to the peasants from the presence of the foster children. Not long after the start of zemstvo medical services in the countryside, doctors practicing among the peasants began to denounce the foundling traffic as a menace. Although they recognized the problems for the foundling children themselves, the doctors expressed much greater concern for the well-being of the wet nurses and their families. The nurse's own child, if at breast, had to share its mother with the fosterling, the doctors complained. Moreover, the extra demands on the mother drained energy she owed to her own children. Worst of all, the fosterling could bring to the peasant family diseases contracted in the city or in the metropolitan foundling home. The disease that most captured the attention of the zemstvo doctors was syphilis. This concern was not new; it will be recalled that, as early as the 1830s and 1840s, nobles in St. Petersburg

[59] Ibid., pp. 2–3.
[60] This official was from Serpukhov okrug. Ibid., d. 453, pp. 141–41ob.

278

province and officials in the Grand Duchy of Finland had objected to the placing of foundling children in their villages in part because they feared that the infants were spreading syphilis. By the 1870s, doctors who worked among the peasants were marshaling evidence that seemed to confirm these fears.

Syphilis and Mortality

At the first congress on public health of St. Petersburg province in 1875, several doctors launched a discussion of the topic. A zemstvo doctor from the St. Petersburg district by the name of Komin led off with a report that he found syphilis most often among women who were caring for children from the foundling home. In the case of these women, he went on, the disease appeared to be localized around the breast nipples, while the infants they were tending exhibited a more generalized disease process. If men in the house suffered from syphilis, they usually showed it at an earlier stage of development than did the women. These observations convinced Dr. Komin that the source of infection lay in the children. He was seconded in this opinion by a doctor from the Petergof district, who told of whole families that had contracted syphilis from fosterlings. A doctor from the Tsarskoe Selo dis-

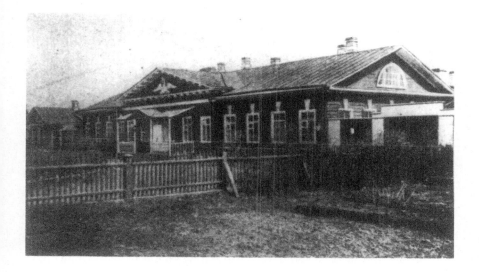

12.2 Gatchina Medical Station of the St. Petersburg Foundling Home.

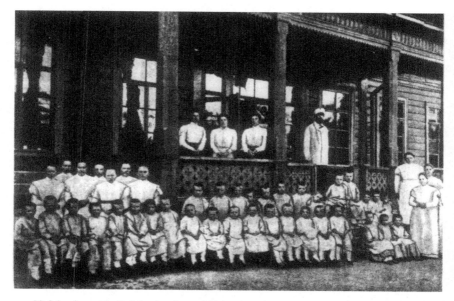

12.3 Iamburg Medical Station for syphilitic children and women, St. Petersburg Foundling Home.

trict noted the same problem, and one from the Luga district reported that since the establishment a year earlier of a new foundling-home okrug in his region, the incidence of syphilis in his district was on the increase. Finally, in a statement that said much about sociability in one peasant community, a doctor from the Gdov district announced his discovery that eight women from his area who had served as wet nurses at the foundling home had, upon their return to their villages, spread the infection to sixty other persons.[61]

At the time these doctors made their reports, they were evidently not aware that the foundling home in St. Petersburg had recently taken steps to contain the spread of syphilis through the agency of the abandoned children. The concern of the home officials seemed to have stemmed initially from information that their program of inoculation for smallpox could, if not carefully supervised, transmit syphilis to unsuspecting victims. Officials knew of cases in Europe of transmission through inoculation, and in the neighboring Grand Duchy of Finland, a woman traveling the villages to inoculate children had spread syphilis

[61] "Protokol," *Zdorov'e* 2 (1875): 221–22.

in this fashion to at least seventy children, necessitating the establishment of a temporary hospital to treat the victims.[62] The Moscow Foundling Home even acknowledged publicly that on occasion its workers had infected children through inoculation material tainted by admixture of blood from a syphilitic child.[63]

In 1873, two years before the discussion at the public-health congress, the foundling homes had introduced measures to prevent transfer of the disease from the nurslings to their wet nurses. The St. Petersburg home, for example, forbade the assignment to a wet nurse of any babies with signs of syphilis. Instead, the home put the children on bottle feeding with a nurse who lived close to a rural medical station and instructed her to take the child there for regular checkups. When, soon after, the home found it difficult to recruit these "dry nurses" because they received lower pay than wet nurses, officials equalized pay for the two types of nurses and offered to pay mileage for nurses who brought infected children into a medical station at the first sign of chancres or other suspicious skin eruptions. In 1875, the St. Petersburg home dispatched to a large okrug two midwives trained in the detection of syphilis and directed them to inspect infants and wet nurses regularly for symptoms of the disease.[64]

By the time of the next congress of public-health doctors in 1877, the participants had learned more about the efforts of the foundling home, and Dr. Komin even apologized for some of the criticisms he had made two years earlier, adding that zemstvo doctors should thank the foundling home for the care it took in removing syphilitic babies from the breast. But despite their greater recognition of the actions of the foundling homes, the doctors continued to express concern about the impact of the foundling children on the villages and about what they saw as a lack of cooperation by the homes with the zemstvos.[65]

These concerns sharpened in the 1880s and 1890s, when a number of public-health surveys raised anew questions about the danger to public health presented by the fosterage programs. Frequently cited at discussions during medical congresses were two studies dealing with parts of Moscow province: P. A. Peskov's, on the Durykinskaia volost of the Dmitrov district (1879), and S. P. Matveev's, on the Ruza and Mozhaisk districts (1881). Both these regions had taken large numbers of nurslings from the Moscow Foundling Home, and both suffered a high mortality among the local population. Although the authors found that

[62] Miller, "Iz proshlogo Moskovskogo Vospitatel' nogo Doma," 64–65.
[63] *MIMVD* 2:126–28.
[64] Gratsianskii, "Pitomnicheskii promysel," 10–11.
[65] Puteren, *Istoricheskii obzor prizreniia*, 478–79.

the death rates were more closely related to the economic status of the population than to the foundling traffic, they were convinced that the foundling traffic harmed the local people, even if the exact extent of the harm could not be calculated. Poverty produced the need for the foundling traffic as well as for other gainful pursuits, such as migration to work in the cities and the hauling trades, that acted as conduits of disease to the village.[66]

About this same time, Dr. P. I. Zarin presented to the Fifth Provincial Congress of Moscow Zemstvo Doctors the results of a village-by-village survey of the foundling traffic and infant mortality in one volost of Vereia district. Zarin's findings, presented in table 12.3, showed that as the percentage of fosterlings in a village went up, so too did the mortality of the children native to the village. The correlations seemed to be persuasive evidence of the adverse effects of the fosterage programs. A few years later, at the eighth congress of the same organization, the zemstvo doctor N. F. Mikhailov mounted an assault on the programs, placing particular emphasis again on their role in the spread of syphilis. He told of a wet nurse from the Moscow foundling home who had contracted syphilis from her nursling. When the child died, the woman nursed in turn three children from her own village and infected them all with syphilis. These infants then passed the disease on to their own mothers, one of whom subsequently infected her husband.

TABLE 12.3

Concentration of Foster Children and Mortality of Native Children in Villages of Bogorodskaia Volost, 1870–1879

Village	Number of Foster Children per 100 Native Villagers	Mortality of Native Children to Age One (percentage)
Zolot'kovo	3.5	14.3
Polchevo	8.6	36.3
Merchalovo	13.0	40.0
Denis'evo	26.0	44.4
Modenovo	43.0	87.5

Source: Zarin, "Bogorodskaia volost'," 192.

[66] Peskov, *Opisanie durykinskoi volosti*, 110–17; Matveev, *Ocherk statistiki*, 93–94.

In response to this attack, a defender of the work of the homes, Dr. I. A. Sobolevskii, pointed out that many of the syphilitic infants came to the homes from a countryside where the disease was already widespread, yet the zemstvos refused to deal seriously with it and treated syphilitics only on an outpatient basis. It was therefore unwarranted for the zemstvos to thrust the entire blame for the spread of the disease on the foundling homes. The foundling homes, Sobolevskii went on, at least took concrete measures to limit the disease by placing infected children on bottle feeding. In rebuttal, Mikhailov rejected the bottle-feeding measure as worthless because of the poor supervision of foster children in the okrugs and the peasants' habit of passing them around from one woman to another. To Mikhailov's argument that the foundling homes had a duty to see that infants did not infect their nurses, Sobolevskii replied that the zemstvos had an equal obligation to see that the nurses did not pass the disease on to the children, which certainly happened in view of the prevalence of the scourge in the population.[67] The debate finally degenerated into a shouting match. In the end, despite Mikhailov's plea that the congress accept his resolution declaring that the current administration of the fosterage system was "abnormal," the congress instead passed a resolution in favor of an investigation into the system to be carried out by zemstvo physicians in cooperation with the administration of the foundling homes.[68] The following year (1887), Mikhailov took his cause to the Second Congress of Russian Physicians in Moscow, where, having abandoned the controversial call to declare the fosterage operation "abnormal," he pressed for and won unanimous acceptance of a proposal for a systematic examination of the fosterage program and a request to the foundling-home administration for assistance to the investigators.[69]

Within two years, a certain Dr. Zachek had carried out such an investigation in the St. Petersburg fosterage region, and he presented a sensational yet persuasive report at a St. Petersburg medical congress. Dr. Zachek had surveyed an area of approximately two volosts in the region, comparing the mortality among the biological children of 536 mothers who were in the foundling trade with the mortality among the children of 546 mothers not in the foundling trade. He found that the mortality rates to age four were 59 percent for the children with mothers in the trade and 41.3 percent for the other children. He even suggested that the 59 percent figure might be an underestimate, in view of the reticence

[67] *Trudy vos'mogo gubernskogo s"ezda vrachei moskovskogo zemstva* (Moscow, 1886), 89–90.
[68] Ibid., 91.
[69] *Trudy vtorogo s"ezda russkikh vrachei v Moskve* (Moscow, 1887), 2:64–82.

of the peasants when asked about anything involving the foundling trade.

In analyzing the causes of the higher mortality among children of mothers in the trade, Zachek noted that 17.3 percent of these mothers breast-fed their own infant and a foundling simultaneously. He went on to say that mortality among the foster children themselves was the highest of all the groups: 71.9 percent to age five. The chief reason for this high mortality was inadequate or inappropriate foods. He found that 10 percent of the foster mothers were incapable of nursing a child adequately and that in the summertime even mothers who could nurse seldom did so, because they had to spend the entire day away from the house.[70] Unfortunately, Zachek failed to take into account the economic status of the households he surveyed. This critical variable is missing in all the studies of the effects of the foundling trade, yet it is needed for an accurate assessment of the contribution of the trade to mortality among the village children. Since the foundling trade especially attracted women from poor households who lacked other options for earning nonfarm income, poverty and the high illiteracy rates that accompanied it would surely have played a role in the higher infant-mortality rates among these families.

In the years after the criticism by Dr. Mikhailov and the study by Dr. Zachek, virtually every public-health survey included a consideration of the impact of the foundling traffic. Among the most important of these studies was K. I. Shidlovskii's work on the Dmitrov district of Moscow province from 1885 to 1894, which found that an initial rise and then a leveling off of infant mortality in the district accompanied the rise followed by a sharp decline in the number of fosterlings there. He saw this correlation as confirmation of the deadly effects of the foundling care program.[71] P. I. Kurkin devoted an entire chapter of his lengthy study of infant mortality in Moscow province between 1883 and 1897 to the relationship between the foundling traffic and the death of village children. He compiled data on the entry rate of foundlings and the rate of infant mortality in each district of the province, and the figures are presented in table 12.4; they may, however, be skewed by the possible inclusion of fosterling deaths along with those of the village children. Kurkin also compared the magnitude of reduction in the foundling traffic with the magnitude of reduction in infant mortality in the same

<hr/>

[70] Zachek, "O vliianii pitomnicheskogo promysla na zdorov'e naseleniia," reported in Puteren, *Istoricheskii obzor prizreniia*, 480–81, and in Oshanin, *O prizrenii pokinutykh detei*, 94.
[71] Shidlovskii, *Dmitrovskii uezd*, 56–57.

TABLE 12.4

Entry of Foster Children, 1885–1895, and Infant Mortality, 1883–1897,
in Districts of Moscow Province

District	Number of Entering Foster Children per 100 Live Births, 1885–1895	Infant Mortality 1883–1897[a]
Ruza	30.6	48.9
Mozhaisk	30.0	45.7
Vereia	22.3	42.4
Zvenigorod	12.9	36.2
Dmitrov	10.9	38.8
Volokolamsk	8.6	36.7
Klin	6.9	36.0
Serpukhov	6.2	31.2
Podol'sk	2.7	31.3
Bronnitsy	2.3	31.9
Kolomna	0.7	31.3
Moscow	—	35.9
Bogorodsk	—	33.7
Moscow province	10.3	36.3

Source: Kurkin, *Detskaia smertnost'*, 178.
[a] Number of deaths by age 1 per 100 live births.

districts (see table 12.5), and he interpreted the findings as evidence of
the ill effects of the traffic. Since these figures, too, may include some
fosterling deaths, the relationship, though suggestive, is not conclusive.
Moreover, while it is true that the four districts that had the greatest
decline in the foundling traffic were also among the five that experienced
the largest reductions in infant mortality, the reduction in the latter was
not always proportional to the decline in the former. One district, Klin,
actually showed a slight rise in infant mortality while the rate of entry
of foster children was declining. Finally, it is interesting to observe, in
table 12.4, that the relationship between the rate of entry of foster chil-
dren and infant mortality among the village children did not hold when
the incidence of entering fosterlings fell below 6 per 100.

TABLE 12.5
Decline in Entry of Foster Children, 1885–1895, and Reduction in
Infant Mortality, 1883–1897, in Districts of Moscow Province

District	Decline Entry of Foster Children, 1885–1895[a]	Reduction in Infant Mortality, 1883–1897 [b]
Ruza	47.5	7.93
Mozhaisk	33.1	8.65
Vereia	20.7	2.10
Volokolamsk	16.9	4.39
Zvenigorod	16.5	1.05
Dmitrov	13.0	0.29
Serpukhov	8.4	2.69
Podol'sk	7.0	1.17
Klin	6.2	[c]
Bronnitsy	4.0	0.59
Kolomna	1.2	0.55
Bogorodsk	—	0.28
Moscow	—	1.03

Source: Kurkin, *Detskaia smertnost'*, 19–20, 177, 179–80.

[a] Difference between the first and last years of the period in number of entering foster children per 100 live births.

[b] Difference between 1883–1887 and 1893–1897 in number of deaths by age 1 per 100 live births.

[c] Shown in the source as an increase of 0.24 in the data on pp. 19–20 and as an increase of 0.75 in the table on p. 179.

Remedial Efforts

The barrage of criticism at medical congresses and in the press put the foundling homes under pressure to devise some remedial measures, especially with regard to the problem of syphilis. The Moscow home, for example, took steps to isolate children diagnosed as having syphilis and those suspected of harboring the disease—about 2 percent and 7 percent, respectively, of those admitted. At a special congress on syphilis held in 1897, a report was presented on a detailed study of the problem that the Moscow home had made for the period from 1890 to

1894. According to this study, only 657 persons had contracted syphilis as a result of the home's activity during that period, a time in which the home had received more than sixty-two thousand children and had employed tens of thousands of wet nurses.[72] The report declared that the home's policy of isolating children who had or were suspected of having the disease was having the desired effect. In view of its sponsorship, the study may have been biased, but the critics of the homes could not cite many more confirmed cases of syphilis being passed from foundlings to wet nurses or from wet nurses to foundlings and frequently relied on anecdotal accounts.[73] In any event, data collected haphazardly in the villages could scarcely be taken at face value, since examiners on the one hand often missed cases in remission and on the other counted as syphilis skin eruptions resulting from other causes.[74] It seems clear, nevertheless, that the percentage of syphilitics coming to the foundling homes was roughly equivalent to the percentage in the population at large and that the homes, after the introduction of measures to isolate the syphilitic infants, did more to contain the disease than to spread it.[75] The continuing preoccupation with the role of the homes perhaps stemmed less from a real danger than from fears fed by the insidious action and symbolic significance of the disease—and by the growing revulsion against the foundling traffic.

Paradoxically, the foundling-home reforms of the early 1890s, which improved the survival chances of the children admitted (see chapter 6), at the same time thwarted an important control on the spread of syphilis. The reforms policy excluded as many as nine thousand infants per year who previously would have gained admittance to the homes. These children thus escaped the screening procedures that the homes applied to isolate the infants who showed signs of syphilis. At the homes, these children were placed on bottle feeding, and 61 percent of them died in the institution. If the rate of confirmed and suspected cases of syphilis was 9 percent among the nine thousand infants excluded by the reforms, as it was among those admitted, each year after 1890 about eight hundred children who otherwise would have been removed from the

[72] The data are presented in great detail in the appendixes to the report: Gratsianskii, "Pitomnicheskii promysel," 42–48. For further comment, see Puteren, *Istoricheskii obzor prizreniia*, 486–87.

[73] Oshanin, *O prizrenii pokinutykh detei*, 95.

[74] For some of the problems with reporting, see the analysis by Dr. M. P. Manassein of the Military Medical Academy presented at the 8th Congress of Zemstvo Public-Health Doctors of St. Petersburg Province, in *Otchet S.P. Vos. Doma* (1900), 112–16.

[75] See the data in B—skii, "Ocherk prostitutsii v Peterburge," 95–99, and Puteren, *Istoricheskii obzor prizrennia*, 510–11.

towns and villages remained there as sources of infection for their families and caretakers.[76] In making the reforms, the homes unintentionally traded off an increased rate of illness and death among the population at large for lower mortality within the institutions. In other words, the exclusion of children from the homes may have contributed more to the increase of syphilis than did the foundling traffic, which received the blame.

Despite efforts to satisfy the zemstvo doctors, the foundling homes found it impossible to comply with a demand that all infants be held in the institutions until cleared of any suspicion of syphilis. In addition to isolating and removing from the breast infants who showed signs of congenital syphilis, the homes did agree to delay the dispatch of nursing infants to the countryside for up to six and eventually eight weeks in order to allow more time for signs of the disease to erupt. But even eight weeks were not enough to catch many cases. Signs of syphilis often did not appear until the third month of life, and zemstvo doctors therefore wanted the homes to keep all infants under observation in the institution for at least three months. Some doctors pressed for as much as a two-year delay in the dispatch of children to the countryside.[77] Officials of the homes, however, were not willing to accede to even a three-month delay, because they were aware of the fatal effects of institutionalization itself. Long experience in observing the development of infants had taught doctors at the foundling homes about the problem of "hospitalism," and their findings received confirmation in a report made in 1900 and 1901 under the auspices of the pediatricians of Moscow University. The report urged that babies not be kept in the institutions longer than six weeks, since after that period of time they ceased to thrive and showed insufficient weight gain and higher rates of morbidity and mortality.[78]

The foundling homes took the further step of asking the foster families to watch for signs of disease, but that won little support from doctors who had worked among the peasants and regarded their understanding of child care and illness with a mixture of fascination and horror. The doctors could point to the failure of the policy of the St. Petersburg home of placing infants suspected of having syphilis with dry nurses who had instructions to bring them into the medical stations. As one doctor commented, "It is obvious that as much as these measures would have been good and practical in a more enlightened milieu, so

[76] Puteren, *Istoricheskii obzor prizreniia*, 488–91.

[77] Ibid., 483, 502; *Otchet S.P. Vos. Doma* (1914), 46.

[78] The report was made by Dr. Sabinin of Voronezh: Puteren, *Istoricheskii obzor prizreniia*, 467–68; Oshanin, *O prizrenii pokinutykh detei*, 64–66.

did they prove ineffective among the village populace."[79] The success of the policy required a level of rural development equal to that of western Europe, a level of development that Russian villages had not attained. As late as 1912, a Russian authority on abandoned children could write that the climate, the social conditions, and especially the understanding of hygiene in Europe were so different from what they were in Russia that policies used in Europe would produce altogether different results in "our filthy and ignorant native village, in which *women do not even recognize that an infant can have the sinful disease.*"[80] Even so, the information presented at the congress of 1897 tempered, if it did not entirely allay, the worst fears about the role of the foundlings in the spread of the dreaded disease.

Another area of concern for doctors and state officials was the impact of the fosterage programs on the rate of natural increase of the population—the excess of births over deaths. Some studies found a relatively low rate of natural increase in districts with high concentrations of fosterlings. One cause was thought to be the increase of deaths among the local populace attributable to the presence of the foundling children, either as a result of infection or as a result of undernourishment of the biological children of the area. A second, more subtle, agent was the suppression of fertility among lactating mothers. Breast-feeding reduces fertility among women practicing it by roughly 25 percent, and where a large proportion of women was involved in wet nursing, a measurable decrease in fertility could occur. Medical authorities noted this effect as early as the 1880s.[81] Kurkin later traced it to lower fertility among wet-nurse foster mothers in his study of infant mortality in Moscow province.[82] Although Russia's overall high rate of population growth at this time should have eased these concerns, Russian publicists and officials were under the influence of a general European fear of population decline and were eager to join the competition to promote fertility and lower infant death rates. The effect of wet nursing in reducing fertility therefore became another stick with which to belabor the fosterage programs.[83]

Debate on the effects of the foundling traffic continued at medical congresses and in the press right up to the end of the imperial regime.

[79] Gratsianskii, "Pitomnicheskii promysel," 10.

[80] Oshanin, *O prizrenii pokinutykh detei*, 93 (emphasis Oshanin's).

[81] *Trudy vtorogo s"ezda russkikh vrachei v Moskve*, vol. 2, Otdel. obshchestvennoi meditsiny, 79; *Detskaia pomoshch'*, 1887, no. 23:755.

[82] Oshanin, *O prizrenii pokinutykh detei*, 94.

[83] See, for example, Meder, "Polozhenie pitomtsev," 43–44; Oshanin, *O prizrenii pokinutykh detei*, 94.

Investigators failed to focus with scientific rigor on a number of key variables. Childhood survival correlates with wealth, cultural level (especially literacy of the mothers), and access to modern medical care. Evidence presented earlier (see especially chapter 11) shows clearly that the foundling traffic moved—and moved increasingly over time—toward villages and families that were poor and only marginally integrated into the urban sphere of influence. Mortality was high among even the biological children of the women in the foundling trade. But without more data, it is impossible to separate the amount of mortality in these families attributable to their poverty and ignorance from the amount attributable to the effects of working in the foundling trade. Peskov's study of Durykinskaia township, which included an exhaustive analysis of mortality among the children, placed the principal blame on poverty and regarded foster care as just one of several harmful practices that poor families engaged in to earn needed cash.[84] Although he could not determine the exact degree of harm wrought by the traffic, he assessed its effect metaphorically in concluding that the foundlings contributed a very large admixture of infectious material to a substance that was already badly inflamed.[85] Despite the absence of a precise measure, it seems clear that parents who worked in the foundling trade placed the welfare of their own children at risk. It was one of the many ironies of the foundling system that the efforts of these families to improve their desperate economic position at the same time menaced their physical survival.

CONCLUSION

The action of the foundling homes in attracting unwanted children, processing them, and sending them out to poor village families placed at risk the health of the foundling children and their host families. A program that was intended to save the lives of young children ended as a conduit of disease and death. Unwanted babies, whether born in the country or the city, ended up in the care of villagers who helplessly witnessed the deaths of half of their own children and who had much less success in keeping the foundlings alive. The doomed foundlings avenged themselves on the foster families, as it were, by reducing the available nourishment and care for the village children and in some cases by carrying disease agents to the villagers.

But there was more to the medical consequences of the foundling

[84] Peskov, *Opisanie durykinskoi volosti*, 114–17.
[85] Ibid., 111.

system than this melancholy story. The homes also played a central role in the development of pediatric medicine and of the delivery of medical services to the public, services that ultimately helped transform the peasant villages. The earliest and most successful program of the homes was the variolation (and later the vaccination) against smallpox of all the children who passed through the facilities. Although the inoculation weakened the foundlings during the initial period of inflammatory reaction and undoubtedly contributed to their mortality at that stage, after recovery the results were dramatic and instructive to the villagers among whom they lived. During a smallpox epidemic in 1879, for example, some villages of northern Russia lost every native-born youngster to the disease, whereas most of the children from the foundling home residing in the same areas survived.[86] Incidents of this kind brought home to the villagers the benefits of medical intervention and promoted the acceptance of vaccination among the rural populace.

Moreover, the foundling homes established the first schools for midwives. These schools opened in the first years of the nineteenth century and for sixty years remained the only significant training ground for professional midwives.[87] Although until late in the tsarist period midwives from the foundling-home schools practiced more often in the large cities and towns than in the countryside, where there was little demand for their services, they added an important component to the poorly developed medical work force of nineteenth-century Russia. The foundling homes were also the first institution outside the military to train paramedics. In 1845, they opened schools for medical assistants (fel'dshery), which turned out hundreds of graduates over the following decades. In the case of both the midwife and the paramedic schools, most of the students were foundlings.

Another important contribution of the foundling homes to the provision of rural medical services was the stationing of physicians in the countryside. In this effort, the St. Petersburg home led the way. At the beginning of the nineteenth century—seventy years before the establishment of medical services by the zemstvos—the St. Petersburg home stationed doctors in its okrugs on a continuing basis for the observation and care of the foundlings and their foster families. The Moscow home also provided medical services to the villages but until late in the century only on an occasional basis during tours of inspection. The doctors employed by the zemstvos after the 1860s were joining a campaign for the enlightenment of the rural population that the foundling homes' doc-

[86] Inspector's report in LGIA, f. 8, op. 1, d. 187ch4, pp. 77–77ob.
[87] Krasuskii, *Kratkii istoricheskii ocherk*, 221; Ramer, "Childbirth and Culture," 219–21.

tors had been waging for many decades, albeit in a more limited territory. The two corps of physicians sought the same ends, despite their disagreements over the role of the foundling population. They were both engaged in raising the standards of hygiene, nurture, and medical treatment among the peasants, and the progress made in these areas by the time of the revolution of 1917 was almost exclusively the result of their work.[88]

The foundling homes made yet another type of contribution through their medical research. The handling of tens of thousands of children each year gave the homes unequaled opportunities for the collection and analysis of data on child development, nutrition, pediatric care, childhood diseases, and medical intervention. The detailed annual surveys of morbidity and mortality that the homes conducted among the children and adults under their care pointed the direction to needed research and treatment. Experiments on the characteristics of mother's milk and the effectiveness of various substitutes were among the first done anywhere. The homes provided information on the effects of "hospitalism." A great deal of work was accomplished on specific diseases and disorders. The studies already noted of syphilis and its spread clarified much of the confusion surrounding this issue, but syphilis was just one of many diseases that received intensive investigation. Gastrointestinal disorders were by far the greatest killer of the children for whom the homes were responsible, and the institutions devoted a great deal of attention to discovering the causes of these disorders and to instructing foster families in their prevention.[89] Although it would be difficult to argue that the contributions by the foundling homes to medical knowledge saved a large number of children from death, the policies that did exert a favorable influence on mortality rates—for example, the reform of admissions procedures and the engagement of mothers in nursing their children—resulted from the knowledge about child nurture acquired at least in part from the experiments and observations made by the foundling home doctors and researchers.

The most accurate capsule assessment of the social and medical consequences of the foundling-home programs would be that the founders established them in the hope of saving children from desertion, disease, and death; the institutions unwittingly fostered an increased incidence

[88] On the efforts of zemstvo doctors to improve child care among the peasants, see Frieden, "Child Care."

[89] In addition to the annual medical reports of the foundling homes and the papers that doctors from the homes frequently prepared for medical congresses, specialists also published monographs on the basis of research data from the homes; see, for example, E. Termen, *O prichinakh smertnosti detei.*

of desertion, disease, and death; yet in the process they created for the study of these afflictions a laboratory that pointed the way to their alleviation. Most important ultimately was the continuous contact that the homes had with the countryside. This engagement with peasant life gave the homes and through them the educated public an awareness of the ignorance and misery of Russian villagers, and it gave the villagers knowledge of hygiene and child care that was previously unavailable to them. The direct influence of the homes on child nurture among the villagers was not great, and perhaps the fosterage program of the homes on balance brought more harm than good to the health of the peasants in the short run. But the information collected by the homes both made a positive contribution in itself and spurred action on behalf of the peasants by other agencies such as the zemstvo, private charitable societies, and government departments.

THIRTEEN

Conclusions

A PUBLICIST WRITING about the Russian foundling homes in the early twentieth century commented that these institutions came to Russia too soon. If he meant that they were a borrowing from Europe artificially cultivated in Russia before the conditions of native life required this type of welfare agency, he was partially right. The huge establishments that Catherine II and Ivan Betskoi built in the second half of the eighteenth century aimed at much more than saving the lives of the children then being deserted in the streets. Betskoi planned the homes as laboratories of social engineering with the purpose of creating in them a third estate of enlightened artists and craftspeople, and he seemed at first to encourage child abandonment so that he would have enough raw material to put his plan into action. The monumental structures erected for the foundling homes and the advertising that accompanied the project also showed that the founders had more in mind than the salvation of a few unwanted children. The foundling homes functioned as one of the chief symbols of tsarist solicitude for the unfortunate. In these respects, the foundling homes sought to do more than meet an immediate social need. Russia could have done with a great deal less. But it is not true that Russia could have done without foundling homes or some functional equivalent or that the only reason for the homes was the desire of the throne to proclaim its civilized values by borrowing a Western institution that was perceived as enlightened.

If Russia had remained a country of villages, the problem of unwanted children would have continued to be taken care of as it was in many villages until the twentieth century: by midwives who took upon themselves the unpleasant chore of making sure that illegitimate or otherwise unwanted pregnancies were aborted or ended in stillbirths.[1] But Russia was changing. Cities grew in importance, and the methods

[1] The task was more than unpleasant; this occupation of midwife was both needed and despised, much as that of the public executioner was. The midwives who served in this capacity and their families were regarded as cursed by the very peasants who availed themselves of their services, a circumstance that indicates the strong norms against abortions and killing of newborns. Cases of village "abortion mills" are described in GME, f. 7, op. 1, ed. kh. 1471, 22ob–23. On the frequent occurrence of abortion and infanticide in the villages, see Semenova-Tian'-Shanskaia, *Zhizn' "Ivana,"* 39–41.

294

of disposing of unwanted children in the villages did not operate as effectively in the towns. Peter the Great forced open the old Russian family, demanding that the men serve away from home for long periods and that the women engage, if not in gainful pursuits, at least in social life. The mores of the upper classes changed, and the families could no longer shelter their women and guarantee their honor within or outside of marriage. Peter also initiated national recruitment for a standing army and uprooted peasants to work in factories and urban construction. A byproduct of these changes was the displacement of women and the production of unwanted children. Women removed from the protection and obscurity of the village could no longer so easily dispose of the product of unwanted pregnancies and resorted to deserting their children in the towns.

It is uncertain whether desertion of this kind had occurred before and been regarded with tolerance. In any event, the same influences from the West that were causing changes in upper-class mores and in the economic structure also brought the humanistic values that condemned urban disorder and the exposure of infants. Whatever may have happened before, by the late seventeenth century the sight of infants abandoned in the streets was regarded as disgraceful and, moreover, a waste of a scarce human resource. Although the foundling homes begun by Catherine II and Betskoi may have been more than Russia needed at the time, it should not be forgotten that at least sixty years earlier Metropolitan Iov had created a generous program for receiving and caring for abandoned children. The westernizing regime of Peter I assisted Iov with funding and used Iov's institutions as models for the state-sponsored hospitals that the government subsequently established. The care facilities of Metropolitan Iov grew out of native conditions and needs recognized by Russians at the time.

Welfare institutions, especially those as well endowed and advertised as the Russian foundling homes, easily become hostages to their own desperate clientele. The women who seek the protection or a share of the financial resources of the institutions exert a strong influence on the dynamics of their development, and the institutions can come to have effects far different from those anticipated by their founders. The divergence of outcomes from aims was greater in the case of the Russian foundling homes than in other institutions of this type because of the utopian expectations with which the Russian homes were launched. In seeking to create from cast-off children an enlightened class of urban workers and artists, Betskoi sought the impossible. Although he built well, providing his homes with generous financial and physical resources, he could not purchase the fragile lives of abandoned and insti-

tutionalized infants, nor could he direct the needs and ambitions of women who used the homes either as dumping grounds for excess children or as a means of earning cash in wet nursing or in the foundling traffic. Instead of institutions for the salvation of unwed mothers and the nurturing of an industrious artisan class, Betskoi's homes soon became processing points for the disposal of unwanted children supplemented by a program of subsidies to needy peasant families, and indeed to whole villages, that temporarily offered shelter to the infant foundlings. The Russian experience was exceptional only in its utopian beginnings and in the vast scope of resources devoted to the metropolitan foundling homes. In every country that opened large central foundling homes with unrestricted admissions, the results were so murderous that, unless the church or civil authorities gave priority to a compelling need to protect the sanctity of the family, the homes either closed after a short time or reverted to tightly controlled admissions procedures.

To the question, then, of why the Russian government did not discard or at least modify the foundling-care system until the end of the nineteenth century, part of the answer lies in the Russian family regime, which was similar in many respects to that of the several, mainly Roman Catholic, countries of southern Europe that retained foundling homes with open admissions over a long period in order to protect the sanctity of the family. Even though for the sake of state security the Russian government, following the example of Peter I, occasionally assaulted the family and even came close to destroying it among military recruits, the law sought to strengthen the old family system by rendering divorce nearly impossible, depriving wives of rights apart from those exercised for them by their husbands, condoning brutal discipline of children, and condemning affronts to the dignity and authority of the father. In the rapidly changing social environment of eighteenth- and nineteenth-century Russia, the maintenance of paternal authority required, just as in European countries with similar social regimes, an outlet for the disposal of the evidence of the family's inability to control its members. The foundling homes provided this service. But in Russia the foundling homes played an even more important role in shoring up beliefs in the control of the ruler and the solicitude of the tsarist family for ordinary Russians.

State institutions can become prisoners of their rhetoric. When Catherine II established the Moscow and St. Petersburg foundling homes with great fanfare, furnished them with monumental structures, and attached them to the tsarist house as symbols of her motherly concern for unwanted children and of her wise solicitude for fallen women, she created a set of expectations and obligations that her successors had diffi-

culty retreating from. The circumstances were all the more urgent in that the old forms of tsarist almsgiving had gone out of style and yet the government had scarcely begun to move toward modern methods of support for the needy.[2] The foundling homes therefore stood as one of the few symbols of the royal family's care for the unfortunate. But before long, Catherine herself understood that the homes were not producing the anticipated results. Empress Maria Fedorovna recognized the same problem and even worked against the principle of protecting family honor by attempting to reinforce the bond between mother and child. The officials and tsarist leaders who looked closely at the work of the homes realized that they produced more harm than good. Yet no one could muster the courage to make radical changes, because to do so would threaten to destroy a more powerful myth than that of the sanctity of the family: the paternal authority of the tsar. The fear was always that reform would fill the streets of the capital cities with dead and dying children and so reveal the loss of control of the tsarist father in policing his domain and the abandonment of his commitment to care for the unfortunate.

In time, the demands imposed by the need to maintain obeisance to the ideas of paternal authority in the family and tsarist charity and control in the nation bred conditions that forced reforms in the policies of the homes. The compulsion to uphold the appearance of control rendered the homes vulnerable to the kinds of misuse that undermined the fiction of tsarist control and solicitude in other arenas. In other words, the practice of open admissions that officials so feared to discard lest they create a scandal of children deserted in the streets led to worse scandals. After the great reforms of the 1860s, Russian journalists and social critics could give the foundling homes closer scrutiny than had been possible in the past. They found not only that the loss of life among the children given to the homes was higher than previously thought but also that the homes were producing other results contrary to those advertised. Analyses by critics of the homes revealed that as many as one-third of the children admitted by the homes were legitimate, and so the homes were doing as much to assault the sanctity of the family as to uphold it. When doctors employed by the zemstvos came to the countryside—the first educated persons besides noble landlords, priests, police, and foundling home officials to have regular contact with the peasants—they discovered that the fosterage program was having adverse effects on the local people. Nobles and priests had in the past occasionally complained about the harm wrought by the fosterage programs, but

[2] This story is documented in Lindenmeyr, "Public Poor Relief."

their objections did not reach the broad public. The zemstvo doctors, in contrast, not only had the means of generating public concern through reports in their journals and at medical congresses, but they also could bolster their case with the tools of scientific verification and medical observation. Their studies of the effects of the fosterage programs as conveyors of disease from the city to the village, and especially their hue and cry about the spread of syphilis, drew strength from the powerful metaphor of the corruption of national life by the diseased city. The evidence of massive misuse of the fosterage programs by women without breast milk and by various types of intermediaries, including women who bought and sold babies on the highways and at the gates of the capital, added to public revulsion at the system. The program of foundling care in Russia, it was revealed in the late nineteenth century, had developed a dynamic of its own that belied the solicitude of the imperial family for unfortunate women and children. All that was left was the symbolism and the impressive urban structures that embodied it, while in reality the homes served as processing points for the disposal of tens of thousands of unwanted infants each year. The disclosure of this situation by journalists, doctors, and popular authors turned the foundling homes into more of a liability for the regime than an asset and, as a consequence, sparked the major reforms undertaken in the early 1890s.

Apart from these issues of the perception and use of the homes by educated society, the records of the foundling homes tell much about the behavior of the common people of Russia. Unlike the people of the West in modern times, Russians until well into the nineteenth century took the sex of a child into account in deciding whether to abandon it. Many more of the infants given to the homes in the eighteenth century were female than male, a difference that only gradually diminished during the next one hundred years, finally disappearing in the 1870s. The achievement of normal sex ratios at the St. Petersburg home earlier than at the Moscow home suggests that the elimination of gender as a factor in the decision to abandon a child resulted from the increasing cultural influence of western Europe, where a preference for the killing or abandonment of girls had declined long before.

Over the century and a half of the homes' operations, they attracted a changing clientele of abandoning mothers. Mirroring changes in the social and especially the urban order, the parentage of children given to the homes shifted from predominantly soldiers' wives and urban dwellers, including a substantial proportion of people from privileged groups, to predominantly peasant women, especially recent migrants to the towns who worked as domestic servants and day laborers. Since this

change paralleled the changing sex ratios for children given to the foundling homes, one is tempted to seek some connection between the two. It is understandable that servant women isolated in the towns could not choose to keep a child of either sex if they were to retain their employment. The shift to more mothers of this type fits with the change in sex ratios. It is less obvious, however, why soldiers' wives, who formed a large percentage of the abandoning mothers before the military reforms of the 1860s and 1870s, would have kept boys and abandoned girls, since the boys were subject to military service. Moreover, legislative changes that improved the chances of soldiers' wives to derive some benefit from their sons occurred in a trend contrary to the trend in sex ratios. As the chances to retain sons increased, so too did the percentage of male admissions to the foundling homes. The variable that could possibly be the link between the changing clientele of the homes and the changing sex ratios is the behavior of the urban dwellers, but, unfortunately, the record is much too spare to reveal what role, if any, the attitudes of these people may have played. Unless more information on their behavior can be obtained, it seems that a shift in cultural values influenced by Western practices offers the most compelling hypothesis for the change in sex ratios.

Of particular interest in understanding the behavior of the common people are the economic operations that sprang up in response to the opportunities presented by the foundling homes. These operations reveal the ability of people to capitalize on government initiatives for private purposes. The kommissionerki who brought infants to the homes from the countryside were one example. The government, in its desire until 1890 to shield the identity of unwed mothers and thereby avoid the scandal of desertion in the streets, established an ideal system for generating foundlings. Just as in other countries that had tried unrestricted admissions, this method gave scope to the enterprise of those who spread the word about the services of the foundling homes and then profited from providing transportation to them from the villages. The kommissionerki operated from the earliest years of the foundling homes and brought a good income to the women hardy enough to work the trade.

The fosterage program was another case in which the government intended to achieve one purpose but learned that the peasants could adapt the mechanism to other ends. Specifically, the government sought through the programs to find villagers who would nurture and bring to adulthood the unwanted children of the country, and it contracted with the peasants through the agency of the pay booklet. In creating this mechanism, however, the government instituted a property right that

the people put to other uses. Officials wanted to make the foundling children better off, but the peasants wanted to make themselves better off. The peasants simply behaved in a normal self-interested manner and generated a set of roles and institutions to serve their needs, including peddlers to deliver nurslings to village women tied down at home, runners to facilitate the distribution of monthly stipends, and systems of brokerage that supplied credit and goods to the wet nurses and foster families. Apart from the fact that children and mother's milk were the commodities in these systems of exchange, there was nothing unusual in their functioning. The peasants treated the foundling traffic like any other nonfarm trade. They organized the commerce through the same types of credit and delivery networks that operated in the case of other commodities, and when disputes arose between brokers and wet nurses, they adjudicated them in the peasant courts just as villagers did other business transactions. The officials from the foundling homes, though they complained about this arrangement, also recognized the commercial character of the fosterage programs. What is remarkable is the moral outrage occasionally expressed by officials when they observed the peasants acting in this self-interested manner. Since the government had established the system on the basis of material and not moral incentives, it was scarcely surprising that the peasants behaved as the system induced them to do and worked out a set of institutions that allowed the fosterage programs to meet their needs most effectively.

An unexpected finding of the study was the important role of women in the organization of the intermediary services in the foundling system. It was clear from the female forms of the names that the carters and peddlers were women; indeed, the peddlers had to be women who could qualify as wet nurses. But I at first suspected that behind the sex-neutral designations of "runners" and "brokers" stood men who were exploiting the poverty and immobility of the peasant wet nurses. A look at the court records detailing disputes between foster families and these intermediaries, however, revealed that many of the runners too were women. References to brokers were rare, and those I found were to male brokers. But since officials of the foundling homes reported that brokers often began as runners, it is likely that women also acted as brokers. The foundling traffic on both its incoming and outgoing sides was largely the preserve of enterprising women. The officials of the foundling homes were for the most part men, and they operated within the rules of a state bureaucratic organization created and dominated by men. The unofficial agents of the foundling traffic were most often women, who operated within both formal and informal systems of private initiative that they helped to create and maintain.

CONCLUSIONS

Finally, the fosterage programs provide a corrective to the notion that the preindustrial city lived at the expense of the countryside—that while a few of the products of urban manufacture reached the villages, the city received "far more from the rural hinterland, subsisting largely on the fruits of the peasant's labor—the 'surplus' food and raw materials he produces and the taxes or tribute he renders."[3] The structure of exchange between city and village was much more complex, at least in the case of Russia, where a large portion of manufacturing work was done outside the cities. The foundling traffic, though unusual among the trades operated by peasants, turned one of the money flows between city and village in the direction of the countryside. By offering a service to urban welfare institutions, needy peasant families were able to reap financial returns, amounting in the case of the two metropolitan foundling homes to well over one million rubles annually in the second half of the nineteenth century. For the villages that were heavily involved in the foundling trade, these transfer payments from the cities constituted a continuing state subsidy over many decades and a major source of nonfarm income. Whether or not this income was ultimately worth the costs to the villagers remains a question. Involvement in the trade exposed the villagers to a variety of potentially harmful social and demographic consequences whose exact measure cannot be taken.

THE STORY of the imperial foundling homes ends soon after the establishment of the Bolshevik regime in 1917. As a practical matter, without the support of the tsarist family and the rich endowment that funded the work of the homes, they could not continue to operate. But more important, the new regime rejected the former approach to the unwed motherhood. The Soviet government did not recognize illegitimacy. All children, whatever the circumstances of their birth, were regarded as legitimate and entitled to equal treatment. Offices of maternity and infant support gave assistance to mothers in need, and orphan homes took in children who had lost their parents altogether. Foundling homes for the reception of unwanted infants ceased to exist. The institutions and their assets, in accordance with a decree issued on January 31, 1918, by the Council of People's Commissars, were incorporated, along with all other child-care facilities, into the Department of Maternal and Infant Welfare (Otdel po Okhrane Materinstva i Mladenchestva).[4]

But the problem of orphaned and unwanted children did not end. In fact, for a time it increased manyfold. The turmoil that accompanied the

[3] Sjoberg, *The Preindustrial City Past and Present*, 198.
[4] Drobizhev, *U istokov sovetskoi demografii*, 109.

war, revolution, and civil war spawned an unprecedented number of orphans and abandoned children, the "homeless children" (*besprizornye*) of the first years of Soviet rule, whose numbers have been estimated at as high as six or seven million. These waifs were not infants but youngsters who had survived the devastation of the wars, and they presented a different set of problems from that of infants deserted on streets and doorsteps. The attempts to save and rehabilitate these children generated a number of fascinating experiments in institutional child-rearing, including rural colonies of collective learning and enterprise. Although the general purpose of making cast-off children into productive citizens remained the same as the goal Betskoi had started with 160 years earlier, the rejection of the former categorizations of children and the collectivist and egalitarian rationales of the new kind of training formed a context so different from that in tsarist Russia that the Soviet experience deserves separate study and evaluation.

APPENDIX

Annual Admissions and Deaths, St. Petersburg Foundling Home, 1770–1915,
and Moscow Foundling Home, 1764–1913

| | St. Petersburg | | Moscow[a] | |
Year	Admissions	Deaths	Admissions	Deaths
1764			523	424
1765			793	597
1766			742	494
1767			1,089	1,073
1768			1,114	912
1769			1,237	942
1770	181	141	1,002	824
1771	514	437	842	943
1772	483	422	761	455
1773	602	538	1,354	1,332
1774	542	508	1,284	1,177
1775	539	507	1,516	1,195
1776	627	548	1,221	1,113
1777	651	546	1,401	1,179
1778	655	475	1,321	1,098
1779	651	525	1,288	1,102
1780	658	417	1,106	958
1781	730	495	1,078	826
1782	728	578	1,164	865
1783	843	700	1,155	885
1784	911	584	1,091	809
1785	975	782	1,107	795
1786	1,065	932	1,444	962
1787	1,103	955	1,461	1,097
1788	1,285	1,124	1,185	857
1789	1,198	1,029	1,303	997
1790	1,281	1,129	1,360	1,858

TABLE A-1 (*cont.*)

Annual Admissions and Deaths, St. Petersburg Foundling Home, 1770–1915, and Moscow Foundling Home, 1764–1913

Year	St. Petersburg		Moscow[a]	
	Admissions	Deaths	Admissions	Deaths
1791	1,359	1,151	1,399	1,429
1792	1,326	981	1,695	1,782
1793	1,467	1,240	1,397	1,221
1794	1,579	1,363	1,551	1,443
1795	1,558	1,370	1,921	2,319
1796	1,647	1,433	1,763	2,013
1797	1,547	1,371	2,003	2,386
1798	1,731	1,481	2,134	847[b]
1799	1,650	1,558	2,031	451[b]
1800	1,564	1,471	2,097	312[b]
1801	1,798	1,622	2,390	396[b]
1802	2,071	1,792	2,486	503[b]
1803	2,172	1,880	2,598	612[b]
1804	2,385	2,056	2,742	995[b]
1805	2,411	1,957	2,960	928[b]
1806	2,460	1,963	3,175	989[b]
1807	2,634	1,913	3,202	935[b]
1808	2,707	2,913	3,337	1,030[b]
1809	2,826	2,358	3,570	1,209[b]
1810	2,857	2,481	3,740	3,073
1811	2,149	2,481	3,605	3,095
1812	2,319	2,092	2,612	3,064
1813	2,153	1,959	1,674	2,158
1814	2,491	2,220	2,387	2,000
1815	2,740	2,454	3,082	2,621
1816	2,933	2,608	3,518	2,860
1817	3,023	2,547	3,784	3,170
1818	3,063	2,621	4,340	3,585
1819	3,126	2,695	4,260	3,642
1820	3,309	2,563	4,227	3,301
1821	3,501	2,668	4,326	2,803

Table A-1 (cont.)
Annual Admissions and Deaths, St. Petersburg Foundling Home, 1770–1915, and Moscow Foundling Home, 1764–1913

| | St. Petersburg | | Moscow[a] | |
Year	Admissions	Deaths	Admissions	Deaths
1822	3,430	2,766	4,600	2,777
1823	3,767	3,071	4,655	2,978
1824	3,791	3,144	5,207	2,767
1825	4,060	3,206	5,591	3,485
1826	4,080	3,254	5,532	3,668
1827	4,024	3,188	5,691	3,125
1828	4,072	3,304	5,520	3,254
1829	3,993	3,117	5,383	3,454
1830	4,091	3,083	4,946	3,474
1831	4,182	3,298	5,739	3,728
1832	4,323	3,367	6,370	4,565
1833	4,515	3,352	6,898	4,949
1834	5,183	3,979	8,312	4,913
1835	5,226	3,025	7,173	4,980
1836	5,360	4,454	7,678	5,091
1837	5,371	4,260	7,070	5,629
1838	5,273	4,380	6,565	5,647
1839	5,474	4,520	7,249	5,345
1840	4,604	4,155	6,965	5,746
1841	4,615	4,331	6,437	5,742
1842	5,156	4,117	6,986	5,415
1843	5,032	4,307	7,274	5,784
1844	5,277	4,199	7,801	6,212
1845	5,808	4,848	8,235	6,343
1846	5,536	4,953	8,579	6,583
1847	6,162	5,079	8,446	7,360
1848	6,227	5,524	8,845	7,988
1849	5,790	5,594	8,951	7,123
1850	6,060	5,222	9,702	7,963
1851	6,117	5,213	9,500	7,873
1852	6,237	5,848	9,820	7,693

TABLE A-1 (*cont.*)
Annual Admissions and Deaths, St. Petersburg Foundling Home, 1770–1915,
and Moscow Foundling Home, 1764–1913

	St. Petersburg		Moscow[a]	
Year	Admissions	Deaths	Admissions	Deaths
1853	6,231	5,328	10,305	8,502
1854	6,372	5,290	10,719	8,836
1855	6,410	5,810	10,993	9,636
1856	6,885	5,466	11,672	9,775
1857	6,934	5,158	12,602	11,076
1858	6,651	5,325	13,262	11,875
1859	7,064	5,681	14,227	11,705
1860	7,052	5,895	13,211	11,946
1861	6,791	5,749	13,113	10,872
1862	6,281	5,018	12,021	10,695
1863	6,189	5,327	11,664	3,194[b]
1864	5,971	4,740	11,702	3,113[b]
1865	5,768	4,685	11,634	9,586
1866	6,168	5,081	11,361	10,458
1867	6,473	4,733	12,055	3,693[b]
1868	6,644	6,028	12,490	3,774[b]
1869	6,799	5,353	11,140	9,441
1870	6,814	5,336	10,661	8,799
1871	7,212	5,455	10,756	8,839
1872	7,582	6,280	11,234	9,446
1873	7,526	5,752	11,324	10,136
1874	7,689	6,358	11,818	9,959
1875	7,640	6,068	12,383	11,013
1876	7,576	6,088	12,526	3,470[b]
1877	7,794	5,592	12,559	10,020
1878	8,065	6,172	13,453	11,878
1879	8,360	5,935	13,669	13,089
1880	8,664	6,820	13,860	11,994
1881	9,025	7,164	13,196	11,345
1882	9,232	7,761	14,128	13,287

TABLE A-1 (cont.)

Annual Admissions and Deaths, St. Petersburg Foundling Home, 1770–1915,
and Moscow Foundling Home, 1764–1913

Year	St. Petersburg		Moscow[a]	
	Admissions	Deaths	Admissions	Deaths
1883	9,258	7,171	14,514	12,968
1884	9,742	7,179	15,994	13,414
1885	9,433	6,791	16,145	13,994
1886	9,774	6,334	15,947	14,058
1887	9,788	6,902	16,895	15,550
1888	9,933	7,437	17,279	15,117
1889	9,728	7,395	16,791	16,176
1890	9,593	6,361	16,587	14,613
1891	8,900	6,177	13,879	12,054
1892	6,874	4,850	10,915	9,373
1893	6,549	3,948	10,815	9,065
1894	6,527	3,773	10,059	8,785
1895	6,591	3,960	9,814	8,622
1896	6,811	4,179	10,018	8,651
1897	6,836	3,830	10,395	8,177
1898	6,833	4,034	10,583	9,324
1899	7,085	3,605	10,502	9,106
1900	7,409	3,963	10,452	5,625[b]
1901	7,619	3,819	10,301	5,284[b]
1902	8,015	3,519	10,934	7,869
1903	8,074	3,851	10,987	7,816
1904	9,757	3,929	11,715	8,390
1905	10,323	2,803	12,442	3,959[b]
1906	7,410	2,810	11,891	8,422
1907	7,836	2,832	10,072	7,519
1908	7,918	2,980	10,363	7,811
1909	7,087	2,796	10,223	7,942
1910	7,619	2,858	—	—
1911	6,094	2,286	9,848	8,273
1912	5,898	2,106	9,770	7,000

APPENDIX

TABLE A-1 (*cont.*)
Annual Admissions and Deaths, St. Petersburg Foundling Home, 1770–1915, and Moscow Foundling Home, 1764–1913

Year	St. Petersburg		Moscow[a]	
	Admissions	Deaths	Admissions	Deaths
1913	5,463	1,934	9,306	7,251
1914	5,388	1,499		
1915	4,860	1,871		

Sources: For St. Petersburg, 1770–1901, *Otchet S.P. Vos. Doma* (1901), 153–54; 1902–1915, *Otchet S.P. Vos. Doma* for each year. For Moscow, admissions and deaths in home, 1764–1862, *MIMVD* 1, foldout table; deaths in okrugs, 1764–1862, *MIMVD* 1, part 2:6, 22, 35; admissions and deaths, 1862–1866, *MIMVD* 2, part 2:75–76, 86–87, 107; admissions and deaths,1867–1913, *Otchet M. Vos. Doma* for each year.

[a] Includes all admissions where known—legitimate, illegitimate, and those admitted under special rules for concealing identity.

[b] Deaths in the foundling home only.

BIBLIOGRAPHY

Archival Sources

Tsentral'nyi Gosudarstvennyi Istoricheskii Arkhiv goroda Moskvy (TsGIAgM)

- fond 16, Kantseliariia moskovskogo general-gubernatora, 1771–1917
- fond 46, Kantseliariia moskovskogo gradonachal'nika, 1873–1917
- fond 108, Moskovskii vospitatel'nyi dom, 1764–1918
- fond 127, Moskovskoe prisutstvie Opekunskogo soveta uchrezhdenii imperatritsy Marii, 1763–1917
- fond 179, Moskovskaia gorodskaia duma, 1871–1917
- fond 184, Moskovskaia gubernskaia zemskaia uprava, 1864–1918
- fond 199, Moskovskii stolichnyi i gubernskii statisticheskii komitet, 1835–1917

Tsentral'nyi Gosudarstvennyi Arkhiv Drevnikh Aktov (TsGADA)

- fond 16, Vnutrennee upravlenie
- fond 196, Dela opekunskogo soveta moskovskogo vospitatel'nogo doma, 1765–1786
- fond 199, G. F. Miller ('Portfeli')

Gosudarstvennyi Muzei Etnografii (GME)

- fond 7, Etnograficheskoe biuro V. N. Tenisheva

Leningradskii Gosudarstvennyi Istoricheskii Arkhiv (LGIA)

- fond 8, Petrogradskii vospitatel'nyi dom, 1785–1918

Tsentral'nyi Gosudarstvennyi Istoricheskii Arkhiv SSSR (TsGIA)

- fond 758, Opekunskii sovet, uchrezhdeniia imperatritsy Marii, 1764–1916

Printed Sources

Adams, John Quincy. *Memoirs of John Quincy Adams.* Vol. 2. Edited by C. F. Adams. Philadelphia, 1874.
Aleksandrov, V. A. *Sel'skaia obshchina v Rossii.* Moscow, 1966.
Amburger, Erik. *Ingermanland. Eine junge Provinz Russlands im Wirkungbereich der Residenz und Weltstadt St. Petersburg-Leningrad.* 2 vols. Cologne, 1980.
Ames, Edward. "A Century of Russian Railway Construction." *American Slavic and East European Review* 6 (1947):57–74.

Amsterdamskii, A. "Prizrenie pokinutykh detei v zemstve." *Zemskoe Delo*, 1910, no. 5:397–403.

Anners, Erik. *Humanitet och rationalism: Studier i upplysningstidens strafflagreformer*. Rättshistoriskt Bibliotek, vol. 10. Stockholm, 1965.

Ariès, Philippe. *Centuries of Childhood: A Social History of Family Life*. Translated by Robert Baldick. New York, 1962.

Arkhangel'skaia, A. G. "Rezul'taty pervoi popytki po issledovaniiu vliianiia pitomnicheskogo promysla na zdorov'e naseleniia," In *Trudy deviatogo gubernskogo s"ezda vrachei moskovskogo zemstva*, 270–81. Moscow, 1888.

Attenhoffer, Heinrich Ludwig von. *Medizinische Topographie der Haupt- und Residenzstadt St. Petersburg*. Zurich, 1817.

Avramenko, P. "Iz istorii tserkovnoi blagotvoritel'nosti v sinodal'nom periode." *Trudovaia pomoshch'*, 1916, no. 3:227–242, no. 4:359–86.

Babikov, V. *Prodazhnye zhenshchiny: Prostitutsiia i razvrat v antichnom mire, v srednie veka, i v nastoiashchee vremia*. St. Petersburg, 1908.

Bater, James H. *St. Petersburg: Industrialization and Change*. London, 1976.

Benzengr, V. N. "K voprosu o pitanii grudnykh detei i ob ukhode za nimi." In *Trudy, chetvertyi gubernskii s"ezd vrachei moskovskogo zemstva*, 138–45. Moscow, 1880.

Beskrovnyi, L. G. *Russkaia armiia i flot v XVIII v.* Moscow, 1978.

"Besprizornye deti v Moskve." *Prizrenie i blagotvoritel'nost' v Rossii*, 1915, nos. 3–4:242–46.

Betskoi, Ivan Ivanovich. "General'noe uchrezhdenie o vospitanii oboego pola iunoshestva." St. Petersburg, 1764.

———. *General'nogo plana Imperatorskogo Vospitatel'nogo Doma ispolnitel'noe uchrezhdenie vdov'ei, ssudnoi, i sokhrannoi kazny, v pol'zu vsego obshchestva*. St. Petersburg, 1772.

———. *Kratkoe nastavlenie vybrannoe iz luchshikh avtorov s nekotorymi primechaniiami o vospitanii fizicheskom detei ot rozhdeniia ikh do iunoshestva*. St Petersburg, 1766.

———. *Uchrezhdenie Imperatorskogo Vospitatel'nogo Doma dlia prinoshykh detei i goshpitalia dlia bednykh rodil'nits v stolichnom gorode Moskve*. St. Petersburg, 1763.

Björnfot, Britt, and Marja Sjöberg. "Ensamma med skammen: Barnamorderskor i Västernorrlands län 1861–1890." *Historisk tidskrift*, 1980, no. 3:320–38.

Blackstone, William. *Commentaries on the Laws of England*. 4th ed. Chicago, 1899.

Bogoslovskii, V. G. "Zadachi vrachebno-sanitarnoi organizatsii v bor'be s letneiu detskoiu zabolevaemost'iu i smertnost'iu." *Trudy piatnadtsatogo gubernskogo s"ezda chlenov vrachebno-sanitarnykh organizatsii moskovskogo zemstva*, no. 1:213–23. Moscow, 1903.

Bohac, Rodney Dean. "Family, Property, and Socioeconomic Mobility: Russian Peasants on Manuilovskoe Estate, 1810–1861." Ph.D. diss., University of Illinois, 1982.

BIBLIOGRAPHY

Boiarkovskii, A. G. "O vrede sredstv, prepiatstvuiushchikh zachatiiu." *Vrach*, 1893, no. 32:886–87.

Bol'shakov, A. *Derevnia, 1917–27*. Moscow, 1927.

———. *Sovremennaia derevnia v tsifrakh*. Leningrad, 1925.

Bremmer, Robert. *Excursions in the Interior of Russia*, 2 vols. London, 1839.

Brissaud, Y.-B. "L'infanticide à la fin du moyen âge, ses motivations psychologiques et sa repression," *Revue historique de droit français et étranger* 50 (1972):229–56.

B--skii, N. "Ocherk prostitutsii v Peterburge," *Arkhiv sudebnoi meditsiny*, 1868, no. 4:61–99.

Buffini, P. Andrea. *Ragionamenti storici economico-statistici e morali intorno all'ospizio dei trovatelli in Milano*. Parts 1 and 2, Milan, 1844.

"Chelobit'e tatar o razreshenii prodavat' detei po sluchaiu goloda." *Etnograficheskoe obozrenie*, 1906, nos. 3–4:373.

Cherepnin, L. V., ed. *Pamiatniki russkogo prava*. Vol. 7, *Pamiatniki prava perioda sozdaniia absoliutnoi monarkhii, vtoraia polovina XVII v.* Moscow, 1963.

Cherepnin, N. P. *Imperatorskoe vospitatel'noe obshchestvo blagorodnykh devits: Istoricheskii ocherk 1764–1914*, 3 vols. St. Petersburg, 1914–1915.

Chulkov, Mikhail. "Prigozhaia povarikha ili pokhozhdenie razvratnoi zhenshchiny." In *Khrestomatiia po russkoi literature XVIII veka*, compiled by A. V. Kokorev, 587–607. Moscow, 1965.

Clarke, Edward Daniel. *Travels in Russia, Tartary, and Turkey*. Edinburgh, 1839.

Coleman, Emily R. "L'infanticide dans le Haut Moyen Age." *Annales ESC* 29 (1974):315–35.

Corberon, Marie Daniel Bourée de. *Journal intime: Un diplomate français à la cour de Catherine II, 1775–1780*. 2 vols. Paris, 1901.

da Costa, Agostino Rebello. *Descripcão topografica e historica da cidade do Porto*. Oporto, 1789.

Coxe, William. *Travels into Poland, Russia, Sweden, and Denmark*. 4th ed. 5 vols. London, 1792.

Czap, Peter. "Marriage and the Peasant Joint Family in the Era of Serfdom." In *The Family in Imperial Russia: New Lines of Historical Research*, edited by David L. Ransel, 103–23. Urbana, Ill. 1978.

Davis, Natalie Zemon. *Society and Culture in Early Modern France*. Stanford, Calif. 1975.

Davydov, N. V. *Zhenshchiny pered ugolovnym sudom*, Moscow, 1906.

Delasselle, Claude. "Les enfants abandonés à Paris au XVIIIe siècle." *Annales ESC* 30 (1975):187–217.

Demich, V. T. "Pediatriia u russkogo naroda." *Vestnik obshchestvennoi gigieny* 11 (1891):125–45 and 187–212, and 12 (1892):66–76, 111–23, and 169–85.

Depauw, Jacques. "Illicit Sexual Activity and Society in Eighteenth-Century Nantes." In *Family and Society: Selections from the Annales*, edited by Robert Forster and Orest Ranum, 145–91. Baltimore, 1976.

"Detopromyshlenniki" *Otechestvennye zapiski*, 1885, no. 12.

Domashnev, N. P. "Osmotry kormilits, kak predupreditel'naia mera po otnosheniiu k sifilisu." *Trudy obshchestva russkikh vrachei v Moskve za 1884 g.*, no. 1:88–100.

Dorwart, Reinhold August. *The Prussian Welfare State before 1740*. Cambridge, Mass., 1971.

Drazhusov, V., ed. *Materialy dlia istorii Moskovskogo Vospitatel'nogo Doma*. 2 vols. Moscow, 1863–1868.

Drobizhev, V. Z. *U istokov sovetskoi demografii*. Moscow, 1987.

Durkheim, Émile. *L'évolution pedagogique en France*, 2nd ed. Paris, 1969.

Eck, Alexandre. "La situation juridique de la femme russe au moyen âge." *Recueils de la société Jean Bodin*, vol. 12, part 2:405–20. Brussels, 1962.

Efimenko, A. A. *Issledovaniia narodnoi zhizni*, Part 1, *Obychnoe pravo*. Moscow, 1884.

Ekk, Nikolai. *Opyt obrabotki statisticheskikh dannykh o smertnosti v Rossii*. St. Petersburg, 1888.

Engman, Max. *S:t Petersburg och Finland: Migration och influens, 1703–1917*. Helsinki, 1983.

Erisman-Gasse, S. Ia. "K voprosu o vskarmlivanii detei v vospitatel'nykh domakh i priiutakh." In *Trudy deviatogo gubernskogo s"ezda vrachei moskovskogo zemstva*, 261–69. Moscow, 1888.

Fairchilds, Cissie. "Female Sexual Attitudes and the Rise of Illegitimacy: A Case Study." *Journal of Interdisciplinary History* 8 (1978):627–67.

———. "Masters and Servants in Eighteenth-Century Toulouse," *Journal of Social History* 1 (1979):368–93.

Fedorov, V. A. *Pomeshchich'i krest'iane tsentral'no-promyshlennogo raiona Rossii kontsa XVIII–pervoi poloviny XIX v.* Moscow, 1974.

Felber, Alfons. *Unzucht und Kindsmord in der Rechtsprechung der freien Reichsstadt Nördlingen vom 15. bis 19 Jahrhundert*. Bonn, 1961.

Flandrin, Jean-Louis. *Families in Former Times: Kinship, Household, and Sexuality*. Translated by Richard Southern. Cambridge, 1979.

Fomon, Samuel J. *Infant Nutrition*. 2nd ed. Philadelphia, 1974.

Frieden, Nancy M. "Child Care: Medical Reform in a Traditionalist Culture." In *The Family in Imperial Russia: New Lines of Historical Research*, edited by David L. Ransel, 236–69. Urbana, Ill., 1978.

———. *Russian Physicians in an Era of Reform and Revolution*. Princeton, N.J., 1981.

Fuchs, Rachel Ginnis. "Abandoned Children in Nineteenth-Century France: Institutional Care and Public Attitudes." Ph.D. diss., Indiana University, 1979.

Georgi, Johann Gotlieb. *Description de la ville de St. Petersbourg et de ses environs*. St. Petersburg, 1793.

Germen, I. F. "O chisle zhitelei v Rossii." *Statisticheskii zhurnal* 1 (1806): part 2:16–19.

Gertsenshtein, G. M. *Sifilis v Rossii: Materialy k meditsinskoi geografii i statistike Rossii.* Vol. 1, part 1, *Sifilis sel i bol'shikh gorodov.* St. Petersburg, 1885.

Gessen, V. Iu. *Trud detei i podrostkov v fabrichno-zavodskoi promyshlennosti Rossii ot XVII veka do oktiabr'skoi revoliutsii,* vol. 1, Moscow 1927.

Giliarovskii, F. V. *Issledovaniia o rozhdenii i smertnosti detei v novgorodskoi gubernii.* St. Petersburg, 1866.

Ginzburg, N. N. "Prizrenie podkidyshei v Rossii." *Trudovaia pomoshch'*, 1904, no. 4:491–518, May 1904:595–621, and June 1904:72–102.

Glickman, Rose L. *Russian Factory Women: Workplace and Society, 1880–1914.* Berkeley and Los Angeles, 1984.

Gorbunova, M. K., comp. *Zhenskie promysly moskovskoi gubernii.* Part 4, vol. 7, *Otdel khoziaistvennoi statistiki, Sbornik statisticheskikh svedenii po moskovskoi gubernii.* Moscow, 1882.

Gorokhov, D. E., et al. *Detskii organizm v bor'be s boleczniami i smert'iu.* Moscow, 1910.

Gouroff, M. de. Introduction to "Istoria imperatorskikh vospitatel'nykh domov." *Chteniia v Imperatorskom Obshchestve Istorii i Drevnostei Rossiiskikh pri Moskovskom Universitete,* 1860, no. 2:93–160. Translated excerpts from M. de Gouroff, *Essai sur l'histoire des enfants trouvés depuis les temps anciens jusqu'à nos jours.* Paris, 1829.

Granville, A. B. *St. Petersburgh: A Journal of Travels to and from That Capital.* 2nd ed. 2 vols. London, 1829.

Gratsianskii, P. I. "Pitomnicheskii promysel i vliianie ego na rasprostranenie sifilisa sredi gorodskogo i sel'skogo naseleniia." *S''ezd po obsuzhdeniiu mer protiv sifilisa v Rossii: Trudy,* 7–59. St. Petersburg, 1897.

Gregori, A. V. *Materialy k voprosu o detoubiistve i plodoizgnanii po dannym varshavskogo okruzhnogo suda za 20 let 1885–1904 gg.* Warsaw, 1908.

Griaznov, Pavel. *Opyt sravnitel'nogo izucheniia gigienicheskikh uslovii krest'ianskogo byta i mediko-topografiia cherepovetskogo uezda.* St. Petersburg, 1880.

Gubert, V. O. "Ob ustroistve gorodskoi stantsii dlia prigotovleniia i razdachi detskogo moloka bednym materiam." In *Trudy obshchestva detskikh vrachei v S.-Peterburge za 17 (1902) i 18 (1903) gody,* 19–24. St. Petersburg, 1904.

Hamilton, Harriet Georgina. *My Russian and Turkish Journals.* London, 1917.

Haxthausen, August von. *The Russian Empire: Its People, Institutions, and Resources.* 2 vols. Translated by R. Faire. London, 1856.

Hellie, Richard. "The Petrine Army." Paper presented at the Tercentenary Conference on Peter the Great and His Legacy, Chicago, November 18–19, 1972.

———. *Slavery in Russia, 1450–1725.* Chicago, 1982.

Herlihy, David. "Vieiller à Florence au Quattrocento." *Annales ESC.* 24 (1969):1338–52.

Hoch, Steven L. *Serfdom and Social Control in Russia: Petrovskoe, a Village in Tambov.* Chicago, 1986.

Hoffer, Peter C., and N.E.H. Hull. *Murdering Mothers: Infanticide in England and New England, 1558–1803.* New York, 1981.

313

Hufton, Olwen. *The Poor in Eighteenth-Century France, 1750–1789.* Oxford, 1974.

Hügel, Franz Seraph. *Die Findelhäuser und das Findelwesen Europa's: Ihre Geschichte, Gesetzgebung, Verwaltung, Statistik, und Reform.* Vienna, 1863.

Iablokov, N. V. "Prizrenie detei v vospitatel'nykh domakh," *Trudovaia pomoshch'*, March 1901:294–324; April 1901:417–43; June 1901:1–18.

————. "Usloviia prizreniia detei v nashikh vospitatel'nykh domakh," *Dnevnik shestogo s"ezda russkikh vrachei*, 1896, no. 13:44–51.

Iakovenko, V. "Sankt-Peterburgskaia guberniia." In *Entsiklopedicheskii slovar'* (Brokgaus-Efron) (St. Petersburg, 1900), 56:281–84.

Ianson, Iu. E. *Sravnitel'naia statistika naseleniia.* St. Petersburg, 1892.

Iatsevich, A. *Krepostnoi Peterburg pushkinskogo vremeni.* Leningrad, 1937.

I————ov, A. "Vospitatel'nye doma v Rossii." *Vestnik Evropy*, 25 (1890):485–542.

Isaev, A. *Istoricheskii ocherk maloletnogo otdeleniia Imperatorskogo Moskovskogo Vospitatel'nogo Doma, nachinaia so dnia ego otkrytiia i po 1878 god.* Moscow, 1878.

Issledovaniia o vospitatel'nykh domakh (izvlechenie). Vol. 2. St. Petersburg 1868.

Istoriia Moskvy. 6 vols. Moscow, 1952–1959.

Iukhneva, N. V. *Etnicheskii sostav i etnosotsial'naia struktura naseleniia Peterburga, Vtoraia polovina XIX–nachalo XX veka.* Leningrad, 1984.

Ivanovskaia, T. "Deti v poslovitsakh i pogovorkakh russkogo naroda." *Vestnik vospitaniia* 19 (1908):112–62.

Johnson, Robert Eugene. *Peasant and Proletarian: The Working Class of Moscow in the Late Nineteenth Century.* New Brunswick, N.J., 1979.

Kabuzan, V. M. *Izmeneniia v razmeshchenii naseleniia Rossii v XVIII–pervoi polovine XIX v. (po materialam revizii).* Moscow, 1971.

————. "Izmeneniia v udel'nom vese i territorial'nom razmeshchenii russkogo naseleniia Rossii v XVIII–pervoi polovine XIX veka." In *Problemy istoricheskoi demografii SSSR*, 186–97. Tallin, 1977.

————. *Narodonaselenie Rossii v XVIII–pervoi polovine XIX v. (po materialam revizii).* Moscow, 1963.

Kahan, Arcadius. *The Plow, the Hammer, and the Knout: An Economic History of Eighteenth-Century Russia.* Chicago, 1985.

Kaipsh, E. I. "Dvizhenie narodonaseleniia v Rossii s 1848 po 1852 gg." *Sbornik statisticheskikh svedenii, izdavaemykh statisticheskim otdeleniem russkogo geograficheskogo Obshchestva*, no. 3:429–64. St. Petersburg, 1858.

Kaizer, A. G. "S"ezd 11–18 maia 1914 g. o. prizrenii detei." *Prizrenie i blagotvoritel'nost' v Rossii*, 1914, no. 8–10:1053–88.

Kamen, Henry. *The Iron Century: Social Change in Europe, 1550–1660.* London, 1971.

Kapustin, M. Ia. *Osnovnye voprosy zemskoi meditsiny.* St. Petersburg, 1889.

Karamanenko, S. N. "O sanitarnom znachenii otkhozhogo promysla v Rossii." *Zhurnal russkogo obshchestva okhraneniia narodnogo zdraviia* 5 (1895):127–42.

Karste-Liikkanen, Greta. *Pietari-suuntaus kannakselaisessa elämänkentässä 1800–luvun loppupuolelta vuoteen 1918.* Helsinki, 1968.

Khotovitskii, Stepan. "O nekotorykh pogreshnostiakh i predrassudkakh kasatel'no soderzhaniia detei, v pervoe vremia ikh zhizni." In *Trudy Sanktpeterburgskogo Obshchestva Russkikh Vrachei,* part 1:160–66. St. Petersburg, 1836.

Khromov, P. A. *Ocherki ekonomiki feodalizma v Rossii.* Moscow, 1957.

Kimerling, Elyse. "Soldiers' Children, 1719–1856: A Study of Social Engineering in Imperial Russia." In *Forschungen zur Osteuropäischen Geschichte,* vol. 30. Berlin, 1982.

Kohl, J. G. *Russia and the Russians in 1842.* 2 vols. London, 1842.

Kopanev, A. I. *Naselenie Peterburga v pervoi polovine XIX veka.* Moscow, 1957.

Krapivina, S. "Narodnoe samolechenie." *Zdorov'e* 2 (1875):289–91.

Krasuskii, V. *Kratkii istoricheskii ocherk Imp. Moskovskogo Vospitatel'nogo Doma.* Moscow, 1878.

Kratkoe nastavlenie vybrannoe iz luchshikh avtorov s nekotorymi fizicheskimi primechaniami o vospitanii detei ot rozhdenii ikh do iunoshestva, St. Petersburg, 1766.

Kurkin, P. I. *Detskaia smertnost' v moskovskoi gubernii i ee uezdakh v 1883–1897 gg.* Moscow, 1902.

———. *Publichnye lektsii,* Moscow 1911.

Lallemand, Léon. *Histoire de la charité.* Vol. 4, *Les temps moderne du XVIe au XIXe siècle.* Paris, 1912.

———. *Histoire des enfants abandonnés et delaissés.* Paris, 1885.

Lappo, I. I. *Listy-zapisy v litovskom prave XVI stoletiia.* Tartu, 1935.

———. *Litovskii statut v moskovskom perevode-redaktsii.* Yurev. 1916.

Lappo-Danilevskii, A. "L'idée d l'état et son évolution en Russie depuis les troubles du XVII siècle jusqu'aux réformes du XVIII." In *Essays in Legal History,* edited by Paul Vinogradoff. London, 1913.

Lebedev, A. I. "Ocherk deiatel'nosti Moskovskogo Vospitatel'nogo Doma (1764–1896gg.)." *Izvestiia moskovskoi gorodskoi dumy* (July-August 1898), no. 1, section 2:1–65.

Lenin, V. I. *The Development of Capitalism in Russia.* Moscow, 1956.

Lichkus, L. G. "Iskusstvennyi prestupnyi vykidysh." *Russkii vrach,* 1913, no. 9.

Lindenmeyr, Adele. "Public Poor Relief and Private Charity in Late Imperial Russia." Ph.D. diss., Princeton University, 1980.

Liubavskii, A. D. *Iuridicheskie monografii i issledovaniia,* 4 vols. St. Petersburg, 1867–68.

Loewe, Karl von, ed. *The Lithuanian Statute of 1529.* Leiden, 1976.

McBride, Theresa M. *The Domestic Revolution: The Modernization of Household Service in England and France, 1820–1920.* New York, 1976.

McGrew, Roderick E. *Russia and the Cholera, 1823–1832.* Madison, Wis., 1965.

McNally, Susanne Janosik. "From Public Person to Private Prisoner: The Changing Place of Women in Medieval Russia." Ph.D. diss., State University of New York at Binghamton, 1976.

Maikov, P. M. *Ivan Ivanovich Betskoi: Opyt ego biografii.* St. Petersburg, 1904.

Makarenko, A. A. *Materialy po narodnoi meditsine.* St. Petersburg, 1897.

Makarii, (Arkhimandrit), comp. "Materialy dlia geografii i statistiki nizhego-rodskoi gubernii." *Sbornik statisticheskikh svedenii, izdavaemykh statistiche-skim otdeleniem Russkogo Geograficheskogo Obshchestva,* no. 3:503–657. St. Petersburg, 1958.

Maksimov, E. D. "Nachalo gosudarstvennogo prizreniia v Rossii." *Trudovaia pomoshch',* 1900, no. 1:40–58.

———. *Ocherk zemskoi deiatel'nosti v oblasti obshchestvennogo prizreniia,* St. Petersburg 1895.

Malcolmson, R. W. "Infanticide in the Eighteenth Century." In *Crime in England, 1550–1800,* edited by J. S. Cockburn, 187–209. London, 1977.

Malthus, Thomas R. *An Essay on the Principle of Population.* London, 1803.

Man'kov, A. G. *Ulozhenie 1649 goda: Kodeks feodal'nogo prava Rossii.* Leningrad, 1980.

Martynova, A. N. "Otrazhenie deistvitel'nosti v krest'ianskoi kolybel'noi pesne." In *Russkii fol'klor,* vol. 15, 145–55. Leningrad, 1975.

Materialy po statistike narodnogo khoziaistva v s.-peterburgskoi gubernii. Vol. 5, *Krest'ianskoe khoziaistvo v s.-peterburgskom uezde,* and vol. 6, *Krest'ianskoe khoziaistvo v luzhkom uezde,* part 2. St. Petersburg, 1887 and 1891.

Matveev, S. P. *Ocherk statistiki narodonaseleniia ruzskogo i mozhaiskogo uezdov.* Sbornik statisticheskikh svedenii po moskovskoi gubernii, otdel sanitarnoi statistiki, vol. 2, sec. 1. Moscow, 1881.

Maza, Sarah C. *Servants and Masters in Eighteenth-Century France: The Uses of Loyalty.* Princeton, N.J., 1983.

Meder, N. B. "Obshchestvo popecheniia ob uluchshenii byta pitomtsev Imper-atorskogo S.-Peterburgskogo Vospitatel'nogo Doma, vospityvaemykh v derevniakh garbolovskogo okruga." *Vestnik blagotvoritel'nosti,* 1899, no. 7–8:79–93.

———. "Polozhenie pitomtsev Vospitatel'nogo Doma, nakhodiashchikhsia v derevniakh s.-peterburskogo uezda." *Vestnik blagotvoritel'nosti,* 1898, no. 11:43–51.

M. G.***. "O detoubiistve." *Arkhiv sudebnoi meditsiny,* 1868, no. 1:21–55.

———. "O vospitatel'nykh domakh v Rossii." *Arkhiv sudebnoi meditsiny,* 1868, no. 4:99–112, and 1869, no. 1:79–102, and no. 3:36–61.

Mikhail, Ieromonakh. "Prizrenie broshennykh detei na Rusi 200 let tomu na-zad." *Vestnik blagotvoritel'nosti,* 1902, no. 4:36–44.

Mikhailov, N. F. "K voprosu o vliianii pitomnicheskogo promysla na krest'ianskoe naselenie." In *Trudy vos'mogo gubernskogo s"ezda vrachei mos-kovskogo zemstva,* 135–48. Moscow, 1886.

Miller, N. T. "Iz proshlogo Moskovskogo Vospitatel'nogo Doma." In *Trudy moskovskogo otdela Russkogo Obshchestva Okhraneniia Narodnogo Zdraviia,* vol. 4:32–80. Moscow, 1892.

Mironov, B. N. "The Russian Peasant Commune after the Reforms of the 1860s." *Slavic Review* 44 (1985):438–67.

Morton, E. *Travels in Russia and a Residence at St. Petersburg and Odessa in the Years 1827–1829.* London, 1830.

Moskovskaia guberniia po mestnomu issledovaniiu, 1898–1900. Vol. 1, *Poselennye tablitsy i pouezdnye itogi.* Moscow, 1904.

M——T. "Zemstvo i bezprizornye deti-podkidyshi." *Trudovaia pomoshch',* 1905, no. 4–5:395–410.

Munting, R. "Outside Earnings in the Russian Peasant Farm: The Case of Tula Province, 1900 to 1917." *Journal of Peasant Studies* 3 (1976):428–46.

Nichols, R. H., and F. A. Wray. *History of the Foundling Hospital.* London, 1935.

Nicolai, A. P. "Mnenie pochetnogo opekuna Barona Nikolai po voprosu ob umenshenii skopleniia grudnykh detei v vospitatel'nykh domakh i o luchshem sokhranenii ikh zhizni." In *Sbornik svedenii po obshchestvennoi blagotvoritel'nosti,* vol. 7:25–28. St. Petersburg, 1886.

Noonan, John T., Jr. *Contraception: A History of Its Treatment by the Catholic Theologians and Canonists.* Cambridge, Mass., 1966.

Novosel'skii, S. A. "K voprosu o ponizhenii smertnosti i rozhdaemosti v Rossii." *Vestnik obshchestvennoi gigieny, sudebnoi i prakticheskoi meditsiny* 50 (1914):339–52.

——. *Smertnost' i prodolzhitel'nost' zhizni v Rossii.* Petrograd, 1916.

Obninskii, V. P. "Patronat nad pitomtsami Moskovskogo Vospitatel'nogo Doma." In *Trudy pervogo s"ezda russkikh deiatelei po obshchestvennomu i chastnomu prizreniiu,* 555–61. St. Petersburg 1910.

Okenfuss, Max J. *The Discovery of Childhood in Russia: The Evidence of the Slavic Primer.* Newtonville, Mass., 1980.

Okol'skii, A. "Vospitatel'nye doma" *Iuridicheskii vestnik,* 1889, no. 3.

Opisanie dokumentov i del, khraniashchikhsia v arkhive Sviateishego Pravitel'stvuiushchego Sinoda za 1740 g. 31 vols. St. Petersburg, 1869–1917.

Orlov, A. S. *Kustarnaia promyshlennost' moskovskoi gubernii.* Moscow, 1913.

Orlov, D. "Obshchestvennoe prizrenie vnebrachnykh detei i sirot." *Izvestiia moskovskoi gorodskoi dumy, otdel obshchii* 31 (1907):1–15.

Orlov, D. I. "Ob uchastii zemstva v vospitanii detei" In *Trudy piatogo gubernskogo s"ezda vrachei moskovskogo zemstva,* 248–58. Moscow, 1881.

——. "O zhelatel'noi postanovke voprosa ob obshchestvennom prizrenii vnebrachnykh detei i sirot." In *Doklady pravlenii Obshchestva Russkikh vrachei v pamiat' N. I. Pirogova, X s"ezd,* 22–30. Moscow, 1907.

Oshanin, M. "O postanovke prizreniia pokinutykh detei v zemstvakh." *Zemskoe delo,* 1912, no. 1:686–93.

——. "O prizrenii pokinutykh detei." *Zemskoe delo,* 1912, no. 13–14:843–55.

——. *O prizrenii pokinutykh detei.* Yaroslavl, 1912.

Osipov, E. A. "Neskol'ko statisticheskikh faktov otnositel'no smertnosti, rozhdaemosti, i brakov v moskovskoi gubernii." In *Chetvertyi gubernskii s"ezd vrachei moskovskogo zemstva (Protokoly zasedanii i trud),* 111–24. Moscow, 1880.

BIBLIOGRAPHY

Palme, Sven Ulric. "Samhället och barnen på änglamakerskornas tid." *Fatabu-ren*, 1971, 47–62.

Parker, W. H. *An Historical Geography of Russia*. Chicago, 1968.

Pentikainen, Juha. *The Nordic Dead-Child Tradition: Nordic Dead-Child Beings, A Study in Comparative Religion*. Folklore Fellows Communications, vol. 85, no. 202. Helsinki, 1968.

Pervaia vseobshchaia perepis' naseleniia rossiiskoi imperii, 1897 god. 89 vols. St. Petersburg, 1899–1905.

Peshch——v. "Moskovskii Vospitatel'nyi Dom v sovremennom ego polozhenii." *Vestnik blagotvoritel'nosti*, 1898, no. 12:66–77; and 1899, no. 10:25–34.

Peskov, P. A. *Opisanie durykinskoi volosti moskovskogo uezda v sanitarnom otnoshenii*. Sbornik statisticheskikh svedenii po moskovskoi gubernii, otdel sanitarnoi statistiki, vol. 1, section 3. Moscow, 1879.

Peterson, T. *Översikt över allmänna barnhusets historia*. Stockholm, 1927.

Petrov, L. N. "Blagotvoritel'nost' v drevnei Rossii." *Vestnik blagotvoritel'nosti*, 1898, no. 8:24–43, and no. 9:37–42.

Petrovich, Michael Boro. *The Emergence of Russian Panslavism, 1856–1870*. New York, 1956.

Pfel', V. K. "Programma dlia pereustroistva nashikh stolichnykh vospitatel'nykh domov." In *Sbornik svedenii po obshchestvennoi blagotvoritel'nosti* 7:29–36. St. Petersburg, 1886.

Phan, Marie-Claude. "Les déclarations de grossesse en France (XVI-XVIIIe siècles): Essai institutionnel." *Revue d'histoire moderne et contemporaire* 17 (1975):61–88.

Piatkovskii, A. P. "Nachalo vospitatel'nykh domov v Rossii." *Vestnik Evropy*, 1874, no. 11:260–305.

———. "S.-Peterburgskii Vospitatel'nyi Dom pod upravleniem I. I. Betskogo, 1772–1791." *Russkaia starina*, 1875, no. 1:146–59; no. 2:359–80; no. 4:665–80; no. 6:177–99; no. 8:532–53; no. 11:421–43; and no. 12:618–38.

Pokrovskii, E. A. *Ob ukhode za malymi det'mi*. Moscow, 1889.

Poludenskii, M., ed. "Podrobnoe donesenie ee imperatorskomu velichestvu, gosudaryne imperatritse, Marii Feodorovne, o sostoianii Moskovskogo Vospitatel'nogo Doma v bytnost' nepriiatelia v Moskve 1812 goda." *Chteniia v Imperatorskom Obshchestve Istorii i Drevnostei Rossiiskikh pri Moskovskom Universitete*, 1860, no. 2:161–92.

Popov, G. I. *Russkaia narodno-bytovaia meditsina*. St. Petersburg, 1903.

Popov, I. V. "O rasprostranenii, razvitii, i proiavlenii sifilisa v uezdakh moskovskoi gubernii v 1880–1882 gg." *Trudy deviatogo gubernskogo s"ezda vrachei moskovskogo zemstva*, 525–50 Moscow, 1888.

Pospelov, A. "K diagnostike sifilisa kormilits." *Trudy Obshchestva Russkikh Vrachei v Moskve*, 1881, no. 1:1–5; discussion, 70–75.

Potash, Janet Ruth. "The Foundling Problem in France, 1800–1869: Child Abandonment in Lille and Lyon." Ph.D. diss., Yale University, 1979.

318

Promysly moskovskoi gubernii: Sbornik statisticheskikh svedenii po moskovskoi gubernii, vol. 7, part 3. Moscow, 1883.

Ptukha, M. V. "Bespriiutnye deti-podkidyshi i nashe zemstvo." *Trudovaia pomoshch'*, 1911, no. 7:123–48; no. 8:231–53; and no. 9:367–89.

Pushkarev, L. N. "Volneniia pripisnykh krest'ian vo vtoroi chetverti XVIII veka." *Istoricheskie zapiski*, vol. 102:360–67. Moscow, 1978.

Puteren, M. D. van. *Istoricheskii obzor prizreniia vnebrachnykh detei i podkidyshei i nastoiashchee polozhenie etogo dela v Rossii i drugikh stranakh*. St. Petersburg, 1908.

——. *Kratkii ocherk razvitiia detskikh lechebnykh kolonii*. St. Petersburg, 1896.

——. "O sposobakh prizreniia nezakonorozhdennykh i bespriiutnykh detei v Rossii i zagranitsei." *Zhurnal Russkogo Obshchestva Okhraneniia Narodnogo Zdraviia*, 1893, no. 6–7.

——. "Sposoby iskusstvennogo vskarmlivaniia i ukhoda za grudnymi det'mi za granitsei." *Vestnik obshchestvennoi gigieny* 10 (1891):1–29, 71–93, and 121–36.

Radishchev, A. N. *A Journey from St. Petersburg to Moscow*. Translated by Leo Wiener. Cambridge, Mass. 1958.

Raeff, Marc. *The Well-Ordered Police State: Social and Institutional Change through Law in the Germanies and Russia, 1600–1800*. New Haven, 1983.

Ramer, Samuel C. "Childbirth and Culture: Midwifery in the Nineteenth-Century Russian Countryside." In *The Family in Imperial Russia: New Lines of Historical Research*, edited by David L. Ransel, 218–35. Urbana, Ill., 1978.

Ransel, David L. "Problems in Measuring Illegitimacy in Prerevolutionary Russia." *Journal of Social History*, 16 (1982):111–27.

Ransel, David L., ed. *The Family in Imperial Russia: New Lines of Historical Research*. Urbana, Ill. 1978.

Rashin, A. G. *Naselenie Rossii za 100 let (1811–1913)*. Moscow, 1956.

Reshetnikov, F. M. *Izbrannye proizvedeniia*. 2 vols. Moscow, 1956.

Rikhter, D. "Novgorodskaia guberniia." *Entsiklopedicheskii slovar'* (Brokgaus-Efron), 26:235–44. St. Petersburg, 1897.

Rickman, John. "Russian Camera Obscura: Ten Sketches of Russian Peasant Life (1916–1918)." In Geoffrey Gorer and John Rickman, *The People of Great Russia: A Psychological Study*, 21–89. New York, 1949.

Robbins, Richard G. *Famine in Russia, 1891–1892: The Imperial Government Responds to a Crisis*. New York, 1975.

Romanov, B. A. *Liudi i nravy drevnei Rusi: Istoriko-bytovye ocherki XI–XIII vv.* Moscow, 1966.

Runkevich, S. G. *Prikhodskaia blagotvoritel'nost' v Peterburge: Istoricheskie ocherki*, St. Petersburg, 1900.

Russell-Wood, A.J.R. *Fidalgos and Philanthropists: The Santa Casa da Misericórdia of Bahia, 1550–1755*. Berkeley and Los Angeles, 1968.

Russkie: Istoriko-etnograficheskii atlas. 2 vols. Moscow, 1967–1970.

Ryndziunskii, P. G. *Gorodskoe grazhdanstvo doreformennoi Rossii*. Moscow, 1958.

Sa——ch, N. F. "Detopromyshlenniki (iz chastnogo pis'ma)." *Otechestvennye zapiski*, 1865, no. 12:327–32.

Sagarra, Eda. *A Social History of Germany, 1648–1914*. New York, 1977.

Sanktpeterburg po perepisi 10 dekabria 1869 goda, part 2. St. Petersburg, 1872.

Sanktpeterburgskaia guberniia. *Spisok naselennykh mest po svedeniia 1862 goda*. Edited by I. Vil'son. St. Petersburg, 1864.

Sbornik statisticheskikh svedenii po smolenskoi gubernii. Vol. 3, *Gzhatsk uezd*. Smolensk, 1887.

Sbornik svedenii po obshchestvennoi blagotvoritel'nosti v Rossii, vol. 7. St. Petersburg, 1886.

Semenova, L. N. *Ocherki istorii byta i kul'turnoi zhizni Rossii, pervaia polovina XVIII v*. Leningrad, 1982.

Semenova-Tian'-Shanskaia, O. P. *Zhizn' "Ivana": Ocherki iz byta krest'ian odnoi iz chernozemnykh gubernii*. Zapiski Imperatorskogo Russkogo Geograficheskogo Obshchestva po otdeleniiu etnografii, vol. 39. St. Petersburg, 1914.

Semenov-Tian'-Shanskii, V. P. *Rossiia: Polnoe geograficheskoe opisanie nashego otechestva*. Vol. 3, *Ozernaia oblast'*. St. Petersburg, 1900.

Semevskii, V. I. *Krest'iane v tsarstvovanie imperatritsy Ekateriny II*, vol. 2. St. Petersburg, 1901.

Sergeevich, V. *Lektsii i issledovaniia po istorii russkogo prava*. 4th ed. St. Petersburg, 1910.

S"ezd po obsuzhdeniiu mer protiv sifilisa v Rossii: Trudy. St. Petersburg, 1897.

Shashkov, S. S. *Istoricheskie sud'by zhenshchiny: Detoubiistvo i prostitutsiia*. St. Petersburg, 1871.

Shchapov, Ia. N. "Brak i sem'ia v drevnei Rusi." *Voprosy istorii*, 1970, no. 10:216–19.

Shchapov, Ia. N., ed. *Drevnerusskie kniazheskie ustavy XI-XV vv*. Moscow, 1976.

Shcherbatov, M. M. *On the Corruption of Morals in Russia*. Edited and translated by A. Lentin. Cambridge, 1969.

Shengelidze, V. "Iasli S.-Peterburgskogo Vospitatel'nogo Doma." *Trudovaia pomoshch'*, 1909, no. 2:161–73.

Shidlovskii, K. I. *Dmitrovskii uezd: Ocherk dvizheniia naseleniia za desiatiletie c 1885 g. po 1894 g*. Sbornik statisticheskikh svedenii po moskovskoi gubernii, otdel sanitarnoi statistiki, vol. 6, no. 1. Moscow, 1899.

Shinn, William T., Jr. "The Law of the Russian Peasant Household." *Slavic Review* 20 (1961):601–9.

Shorter, Edward. *The Making of the Modern Family*, New York 1975.

Shperk, F. "Smolenskaia guberniia." *Entsiklopedicheskii slovar'* (Brokgaus-Efron), 30:546–54. St. Petersburg, 1900.

Shter, (Senator), comp. *Otchet po upravleniiu Moskovskogo Vospitatel'nogo Doma za 1835 god*. Moscow, 1836.

Sibirtsev, M., comp. *Materialy dlia ottsenki zemel' epifanskogo uezda tul'skoi gubernii*. St. Petersburg, 1899.

Siegel, George. "The Fallen Woman in Nineteenth-Century Russian Literature." *Harvard Slavic Studies* 5 (1970):81–107.

Sjoberg, Gideon. *The Preindustrial City Past and Present*. New York, 1960.

Snegirev, I. M. *Moskovskie nishchie v XVII veke*. Moscow, 1852.

Sokolov, N. D. *K kharakteristike fizicheskogo razvitiia i gramotnosti naseleniia klinskogo uezda*. In Sbornik statisticheskikh svedenii po moskovskoi gubernii, otdel sanitarnoi statistiki, vol. 9, no. 2. Moscow, 1903.

———. "Sanitarnyi ocherk s. Nikul'skogo-Karamysheva, mafiskoi volosti, moskovskogo uezda." *Piatyi gubernskii s"ezd vrachei moskovskogo zemstva (Protokoly zasedanii i trud)*, 195–247. Moscow, 1881.

Sokolovskii, M. N. "Blagotvoritel'nost' pri preemnikakh Petra Velikogo." *Vestnik blagotvoritel'nosti*, 1901, no. 10:50–70.

———. "Blagotvoritel'nost' v drevnei Rusi." *Trudovaia pomoshch'*, 1901, no. 6:53–76.

———. "Ekaterina Velikaia, kak blagotvoritel'nitsa." *Vestnik blagotvoritel'nosti*, 1902, no. 1:27–51, and no. 2:13–39.

———. "Petr Velikii, kak blagotvoritel'." *Vestnik blagotvoritel'nosti*, 1901, no. 7–8, 14–32.

Solov'ev, S. M. *Istoriia Rossii s drevneishikh vremen*. 15 vols. Moscow, 1960–66.

S.-Peterburg po perepisi 15 dekabria 1900 goda, part 2. St. Petersburg, 1903.

Spitz, Rene A. "Hospitalism: An Inquiry into the Genesis of Psychiatric Conditions in Early Childhood," *Psychoanalytic Study of the Child* 1 (1945):53–74.

Statisticheskii atlas goroda Moskvy: Ploshchad' Moskvy, naselenie i zaniatiia. Moscow, 1887.

Statisticheskii ezhegodnik goroda Moskvy, moskovskaia guberniia, part 2. Moscow, 1927.

Statisticheskii ezhegodnik moskovskoi gubernii za 1900 god. Moscow, 1900.

Stepanov, V. "Svedeniia o rodil'nykh i krestinnykh obriadakh v klinskom uezde moskovskoi gubernii (sobrany po programme V. N. Kharuzinoi)." *Etnograficheskoe obozrenie* 18 (1906), no. 3–4:221–34.

Stites, Richard. *The Women's Liberation Movement in Russia: Feminism, Nihilism, and Bolshevism, 1860-1930*. Princeton, N.J., 1978.

Stog, A. D., ed. *O obshchestvennom prizrenii v Rossii*. 3 vols. St. Petersburg, 1818–1827.

Storch, H. *Tableau historique et statistique de l'empire de Russie à la fin du dix-huitième siècle*. 2 vols. Basel and Leipzig, 1800.

Strange, M. [M. M. Shtrange]. "Jean-Jacques Rousseau et ses contemporains russes." *Annales historiques de la révolution française*, no. 170 (Oct.-Dec. 1962):515–28.

Strokin, N. G. *L'novodstvo pskovskoi gubernii*. St. Petersburg, 1882.

Sussman, George D. *Selling Mothers' Milk: The Wet-Nursing Business in France, 1715-1914*. Urbana, Ill., 1982.

Svavitskaia, Z. M., and Svavitskii, N. A., comps. *Zemskie podvornye perepisi, 1880–1913. Pouezdnye itogi*. Moscow, 1926.

Svodnyi katalog russkoi knigi grazhdanskoi pechati XVIII veka, 1725–1800. Moscow, 1963.

Svod statisticheskikh svedenii po delam ugolovnym. St. Petersburg, 1874, 1885, and 1905.

Szeftel, Marc. "La condition juridique de declassés dans la Russie ancienne." *Archives d'histoire du droit oriental,* vol. 2:431–42. Brussels, 1938.

―――. "Le statut juridique de l'enfant en Russie avant Pierre le Grand." *Recueils de la Société Jean Bodin,* vol. 36, part 2:635–56. Brussels, 1976.

Tagantsev, N. "O detoubiistve." *Zhurnal Ministerstva Iustitsii,* 1868, no. 9:215–50, and no. 10:341–80.

Tarapygin, D. A. *Materialy dlia istorii S.-Peterburgskogo Vospitatel'nogo Doma,* parts 1 and 2. St. Petersburg, 1878.

Tarnovskaia, P. N. *Zhenshchiny ubiitsy.* St. Petersburg, 1902.

Termen, E. *O prichinakh smertnosti detei v grudnykh otdeleniiakh S.-Peterburgskogo Vospitatel'nogo Doma.* St. Petersburg, 1893.

Termen, S. E. *Prizrenie neschastnorozhdennykh v Rossii.* St. Petersburg, 1912.

Tikhomirov, M. N., and P. P. Epifanov, eds. *Sobornoe ulozhenie 1649 g.* Moscow, 1961.

Tolstoi, L. N. *Polnoe sobranie sochinenii,* vol. 14. Moscow, 1913.

Tolstov, S. P. "Izba." *Bol'shaia sovetskaia entsiklopediia* 27:516–17. Moscow, 1933.

Tol'ts, M. S. "Brachnost' naseleniia Rossii v kontse XIX–nachale XX v." In *Brachnost', rozhdaemost', smertnost' v Rossii i v SSSR,* edited by A. G. Vishnevskii, 138–53. Moscow, 1977.

Tooke, William. *View of the Russian Empire during the Reign of Catherine the Second and to the Close of the Eighteenth Century,* 3rd ed. 3 vols. Dublin, 1801.

Trexler, Richard. "Foundlings of Florence, 1395–1455." *History of Childhood Quarterly.* 1 (1973):259–84.

―――. "Infanticide in Florence: New Sources and First Results." *History of Childhood Quarterly* 1 (1973):98–116.

―――. "Ritual in Florence: Adolescence and Salvation in the Renaissance." In *The Pursuit of Holiness and Renaissance Religion,* edited by Charles Trinkhaus, 200–64. Leiden, 1974.

Troitskii, S. M. "Dvorianskie proekty sozdaniia 'tret'ego china.' " In *Obshchestvo i gosudarstvo feodal'noi Rossii,* 226–36. Moscow, 1975.

Trudy kommissii po preobrazovaniiu volostnykh sudov. 7 vols. St. Petersburg, 1874.

Trudy vos'mogo gubernskogo s''ezda vrachei moskovskogo zemstva. Moscow, 1886.

Trudy vtorogo s''ezda russkikh vrachei v Moskve. 2 vols. Moscow, 1887.

Ulozhenie o nakazaniiakh ugolovnykh i ispravitel'nykh. St. Petersburg, 1845.

Umershie nasil'stvenno i vnezapno v evropeiskoi Rossii v 1875–1887 gg., published as *Vremennik tsentral'nogo statisticheskogo komiteta MVD,* no. 35. St. Petersburg, 1894.

Ustinov, A. N. "O smertnosti grudnykh detei v zavisimosti ot nedostatka grudnogo moloka po dannym Moskovskogo Vospitatel'nogo Doma." *Trudy*

Obshchestvo Detskikh Vrachei sostoiashchego pri Imperatorskom Moskovskom Universitete, god 8, 3–8. Moscow, 1900. (A summary was published in *Detskaia meditsina*, 1899, no. 2:146.)

Utterström, Gustaf. *Fattig och föräldralös i Stockholm på 1600- och 1700 talen.* Umeå, 1978.

Vigdorchik, N. A. "Detskaia smertnost' sredi peterburgskikh rabochikh." *Obshchestvennyi vrach*, 1914, no. 2:244–48.

Vishnevskii, A. G. "Rannie etapy stanovleniia novogo tipa rozhdaemosti v Rossi." In *Brachnost', rozhdaemost', smertnost' v Rossii i SSSR*, edited by A. G. Vishnevskii, 105–134. Moscow, 1977.

Vishnevskii, A. G., ed. *Brachnost', rozhdaemost', smertnost' v Rossii i SSSR.* Moscow, 1977.

Vodarskii, Ia. E. *Naselenie Rossii v kontse XVII–nachale XVIII veke.* Moscow, 1977.

———. *Naselenie Rossii za 400 let.* Moscow, 1973.

Vyskochkov, L. V. "Vliianie Peterburga na khoziaistvo i byt gosudarstvennykh krest'ian peterburgskoi gubernii v pervoi polovine XIX v." In *Staryi Peterburg: Istoriko-etnograficheskie issledovaniia*, edited by N. V. Iukhneva, 129–46. Leningrad, 1982.

Werner, Oscar Helmuth. *The Unmarried Mother in German Literature, with Special Reference to the Period 1770–1800*, New York, 1917.

Wodsworth, William Dudley. *A Brief History of the Ancient Foundling Hospital of Dublin from the Year 1702.* Dublin, 1876.

Wortman, Richard. "The Russian Empress as Mother." In *The Family in Imperial Russia: New Lines of Historical Research*, edited by David L. Ransel, 60–74. Urbana, Ill., 1978.

Yaney, George. "The Village." *Maryland Historian* 1 (1970):161–67.

Zabelin, A. I. *Vekovye opyty nashikh vospitatel'nykh domov.* St. Petersburg, 1891.

Zagoskin, M. N. *The Young Muscovite; or, The Poles in Russia.* Edited by Frederic Chamier. 2 vols. New York, 1834.

Zarin, P. I. "Bogorodskaia volost' vereiskogo uezda v sanitarno-statisticheskom otnoshenii," In *Piatyi gubernskii s"ezd vrachei moskovskogo zemstva (Protokoly zasedanii i trud)*, 182–94. Moscow, 1881.

Zelenin, D. K. "K voprosu o rusalkakh (kul't pokoinikov, umershikh neestestvennoiu smert'iu u russkikh i u finnov)." *Zhivaia starina* 20 (1911):357–424.

———. *Ocherki russkoi mitologii.* Vol. 1. Petrograd, 1916.

———. *Russische (Ostslavische) Volkskunde*, vol. 3 of *Grundriss der slavischen Philologie und Kulturgeschichte*. Berlin, 1927.

Zelnik, Reginald E. *Labor and Society in Tsarist Russia: The Factory Workers of St. Petersburg, 1855–1870.* Stanford, Calif., 1971.

Zenzinov, V. *Bezprizornye*, Paris, 1929.

Zhbankov, D. N. *Bab'ia storona: Statistiko-etnograficheskii ocherk.* Kostroma, 1891.

Zhbankov, D. N. *Vliianie otkhozhikh promyslov na dvizhenie naselenia.* St. Petersburg, 1895.

Zhukovskii, A. "Detoubiistvo v poltavskoi gubernii i predovrashchenie ego." *Arkhiv sudebnoi meditsiny,* 1870, no. 3:1–13.

Zybelin, Semen. *Slovo o sposobe, kak predupredit' mozhno nemalovazhnuiu mezhdu prochimi medlennogo umnozheniia naroda prichinu, sostoiashchuiu v neprilichnoi pishche, mladentsam davaemoi v pervye mesiatsy ikh zhizni.* Moscow, 1780.

INDEX

abortion, 11–12, 40, 69, 104, 128, 294n
Academy of Arts, 6n, 35
Adams, John Quincy, 148
admissions: affected by rising illegitimacy, 128; open system described, 38-41; reform (1805–15), 73–75; reform (1890s), 106–10; reform of rules (1860s–70s), 91–96
adoption, 134–42, 184–85
Afanas'ev, Dr., 140, 180–87, 190, 273
Aleksei Mikhailovich, Tsar, 12
Alexander II, Emperor, 90, 91–93
Alexander III, Emperor, 98, 105
Alexandrovskaia factory, 148
almshouses, 23, 28, 73n
American colonies, 18
Anna Karenina, 101
Anne, Empress, 37n
Archives of Forensic Medicine, 89
artisans, 151–52, 159
Asia, 9
Athens, turning cradle, 64
Austria, 5, 145

Bahia, Brazil, turning cradle, 63
Balkans, turning cradles, 64
Balts, 145, 265, 267. *See also* Estonians, Latvians
banks, belonging to homes, 43–45, 53, 91
Baranov, Nikolai, 202
Bashkirs, 267
Bavaria, 15
Belgium, 83; effects of open admissions in, 80; turning cradle, 66, 68, 82, 88, 92
Belorussians, 265
Berg, Count, Governor General of Finland, 195, 207
Betskoi, Ivan, Ivanovich, 8, 31–34, 59–61, 70, 81, 294–96, 302; contemporary reactions to, 50–59; educational policies, 35–38; end of career and death, 49–50; and financing of homes, 41–44;

and fosterage, 177, 191; foundling homes, 38–41; ideas on building third estate, 34–35; Maria Fedorovna's attack on, 70–72, 81; philosophical influences on, 36–37; wet nursing and ideas on childrearing, 36, 46–49, 118–19
Blackstone, William, 15n
Bodianskii, O. M., 85
Bolsheviks, 301
Brazil, turning cradle and, 63
breast milk, 46, 109, 112, 116–18, 176, 269–70, 292
Brittany, 66
brokers *(zakladchiki)*, 215, 218. *See also* middlemen
Bucharest, 64
Buenos Aires, turning cradle, 63
Byzantium, 11

carters of babies: in Europe, 6, 64–65, 150, 214; in Russia, 86. See also *kommissionerki*
casa da roda, 63
Catherine II, Empress, 8, 29, 58, 59, 82, 294–97; accession to throne, 31; devotee of enlightenment, 34; end of reign, 50, 70; and Europeanization, 42
Catholic Church, 4, 6, 61; mysogyny, 14; and the turning cradle, 62–67
Catholic system, 5, 296. *See also* Latin system
censuses, 131, 146
charity: in early modern Russia, 23–26, 297; new form of, 42–43
Charles V, 14
Chekhov, Anton, 101
Child Assistance (journal), 102, 104, 122
"Child Assistance" (society), 102
childbirth, 267–69
child care, 36, 47, 267–74
child welfare movement, 102–3
chimneyless houses, 260–63
China, 4
Chulkov, Mikhail, 155

INDEX

mortality (*cont.*)
ter families, 195–96, 257–60, 263–64, 282–86; of foundlings, 45–48, 58, 72–75, 86, 89, 94, 99, 188, 257–60, 265–67; of Russian population, 265–67
Moscow Foundling Home, 38, 61, 90; abandonment and, 151–56, 158–61, 170–75; admissions, 74–75, 94–96, 110–11, 119–28; and Betskoi, 35; criticism of, 85, 89; establishment of, 8, 35; financing of, 42–44; fosterage and, 176–78, 185, 190–91, 198, 200, 209–211, 244, 253; founding decree, 26n, 39; health concerns, 257–60, 280–82, 291; mortality rates, 48, 74–75, 94, 111–13, 282–86; overcrowding in, 45–46, 100; resistance to, 51; sex ratios, 131–43, 147, 162; wet nursing, 46, 108, 112–19, 198, 207, 211
Moscow okrug, 201, 202, 218, 249, 260, 277–79
Moscow province, 3, 28, 49, 100, 275, 276; fosterage and, 140, 176, 190, 196, 209, 211, 236, 245, 250–51; health concerns and, 265, 271, 281, 289; labor force sex ratios, 141, 148
Moscow University, 288
Mozhaisk, district, 184, 245; okrug, 185, 247
Munnich, Count Ch. B. von, 37n
Muscovy, 24; law code in, 11

Naples, 68
Napoleonic Wars, 60, 151
Nestlé Company, 119
Nevskaia factory, 148
Nicholas I, Emperor, 60, 81, 83, 85, 89, 138–39, 195; attitude toward foundling homes, 77, 79; laws on reclaiming, 91–92
Nicolai, Baron, Aleksandr Pavlovich, 97, 98, 102, 104
Nizhnii Novgorod: almshouses, 28; shelter, 126n, 131
nobility, 37, 146–47, 151–52, 159, 297; assembly of in St. Petersburg province, 192–93
Novgorod province, 190, 223–24, 232, 271

Obninskii, V. P., 219
Okol'skii, Anton Stanislavovich, 104–5
okrugs: described and boundaries plotted, 179, 222–23, 235–40; growth of, 196
Old Believers, 185
Oldenburg committee, 81, 90
Ol'denburgskii, Prince, Petr Georgievich, 79
Olonets province, factories in, 20
Orthodox Church, 131, 137, 185, 230

pacifier, for infancts. See *soska*
Paris Foundling Hospital, 50, 67, 104, 144, 163n
Patriarchal Department, 23
Paul, Emperor, 70, 155; as grand duke, 42
pay booklets, 178, 182, 206–7, 210, 299–300; pawning of, 215–19
payment:and foster families, 202–5, 218–19, 245, 251, 273–78; to those delivering infants to the homes, 40; to wet nurses 177–78, 184, 199–200
peddlers. See *torgovki*
Penal Code of 1845, 18
Peskov, P. A., 211–12, 281, 290
Peter I (Peter the Great), 8, 26, 50; Betskoi's criticism of, 35; infanticide laws, 17–18, 29; programs of, 20–22, 26–30, 295–96
Pfel', V. K., 97, 98, 102, 111
Pokhvisnev (agent for Betskoi), 39
Poles of Russian empire, 145, 265, 267
Portugal, 145; turning cradle and, 63, 68
Potash, Janet, 171–73
Prague lying-in hospital, 163, 171
prostitution, 14, 22, 155–56, 195, 208
Protestantism, 14; German, 72–73; and turning cradle, 65–66; values in relation to foundling homes, 5–6, 196
Protestant system, 84, 90
Pushkin, Aleksandr, 101

railways, 99–100, 161, 244, 251–52
raznochintsy, 146–47, 151–52
reclaiming of foundlings, 80, 93–94, 98, 109–10, 134–42
recruitment into military service, 21–22, 27–28, 30, 90–91, 138–40, 143–44, 155–57, 160

transport, of nurslings to villages, 181–
82, 213
Tseimern, Maksim, 91, 195
turning cradle, 62–83, 87; described, 62;
ended in Europe, 68-69, 88

Ufa, 104
Ukrainians, 265, 267
Ulozhenie, 12, 16–17
Ural Mountains, 20, 104

Venice, 68
Vienna, 92
Villamov, Grigorii, 73, 79, 199
Vladimir, almshouses in, 28n
Vladimir, grand prince, 10
Voeikova, Anna, 217
Voltaire, 15
Voronezh, almhouses in, 28n

Votiaks, 267
Vots. *See* Finnic peoples

Warsaw University, 104
wet nursing, privately operated, 93, 233,
235
Work Assistance (magazine), 125
World War I, 235
Württemberg, infanticide laws, 15
Yaney, George, 3

Zachek, Dr., 283–84
zakashchiki, 39
Zarin, Dr. P. I., 282
zemstvo, 41, 90, 102, 102n, 103, 107,
126, 141; fosterage and, 204, 218–19,
230, 256, 288, 297–98; medical serv-
ices and, 278–85, 291–93

Printed in Great Britain
by Amazon

25482532R00195